Studies in the History of Art
Published by the National Gallery of Art,
Washington

This series includes: Studies in the History of
Art, collected papers on objects in the Gallery's
collections and other art historical studies
(formerly Report and Studies in the History of
Art); Monograph Series I, a catalogue of stained
glass in the United States; Monograph Series II,
on conservation topics; and Symposium Papers
(formerly Symposium Series), the proceedings
of symposia sponsored by the Center for
Advanced Study in the Visual Arts at the
National Gallery of Art.

*Forthcoming

The Pastoral Landscape

STUDIES IN THE HISTORY OF ART · 36 ·

Center for Advanced Study in the Visual Arts

Symposium Papers XX

The Pastoral Landscape

Edited by John Dixon Hunt

National Gallery of Art, Washington

Distributed by the University Press of New England
Hanover and London 1992

q700
P293hu

This publication was produced by the Editors Office, National Gallery of Art, Washington Editor-in-Chief, Frances P. Smyth

Typeset by BG Composition, Baltimore, Maryland
The type is Trump Medieval
Printed by Wolk Press, Inc., Baltimore, Maryland
The text paper is 80 pound LOE Dull

Distributed by the University Press of New England, 23 South Main Street, Hanover, New Hampshire 03755

Abstracted by RILA (International Repertory of the Literature of Art), Williamstown, Massachusetts 01267

Proceedings of the symposium "The Pastoral Landscape," sponsored by the Center for Advanced Study in the Visual Arts, National Gallery of Art, and the Center for Renaissance and Baroque Studies, University of Maryland at College Park, 20–21 January 1989

ISSN 0091-7338
ISBN 089468-181-8

Contents

Preface

In January 1989 the Center for Advanced Study in the Visual Arts and the Center for Renaissance and Baroque Studies of the University of Maryland at College Park jointly sponsored a symposium devoted to the pastoral landscape. This gathering was held in conjunction with an exhibition on *The Pastoral Landscape* presented concurrently in two parts—*The Legacy of Venice* and *The Modern Vision*—at the National Gallery of Art and the Phillips Collection.

Thirteen papers were delivered in Washington and College Park, of which eleven are published in the present volume. This meeting undertook to assess the theme of pastoral landscape from the perspectives of music, literature, and the visual arts. The diversity of specific subjects and concerns is suggested by the general topics of the four sessions: Classical Origins; Revival in Renaissance Music and Literature; The Visual Tradition; and The Pastoral Tradition Continued, which brought the theme into the twentieth century.

The Center for Advanced Study appreciates the opportunity to work with the University of Maryland in designing and implementing scholarly symposia. The Center is also very grateful to those scholars who presented papers and to the moderators of the symposium sessions: Marie Spiro, Richard Wexler, David Alan Brown, and William L. Pressly. Finally, the Center gratefully acknowledges the substantial contribution made to this publication by John Dixon Hunt, who kindly agreed to serve as scholarly editor as well as author of the critical introduction to the volume.

The Center for Advanced Study in the Visual Arts was founded in 1979 as part of the National Gallery of Art. Through its program of fellowships, meetings, research, and publications, the Center promotes the study of the history, theory, and criticism of art, architecture, and urbanism. The present publication forms part of a separate series of Studies in the History of Art, which is intended to document scholarly meetings held under the auspices of the Center and to stimulate further research. A complete listing of published titles may be found on the opening leaf of this volume. Many of these publications are the result of collaborations between the Center for Advanced Study and sister institutions, including universities, museums, and research institutes.

HENRY A. MILLON
Dean, Center for Advanced Study in the Visual Arts

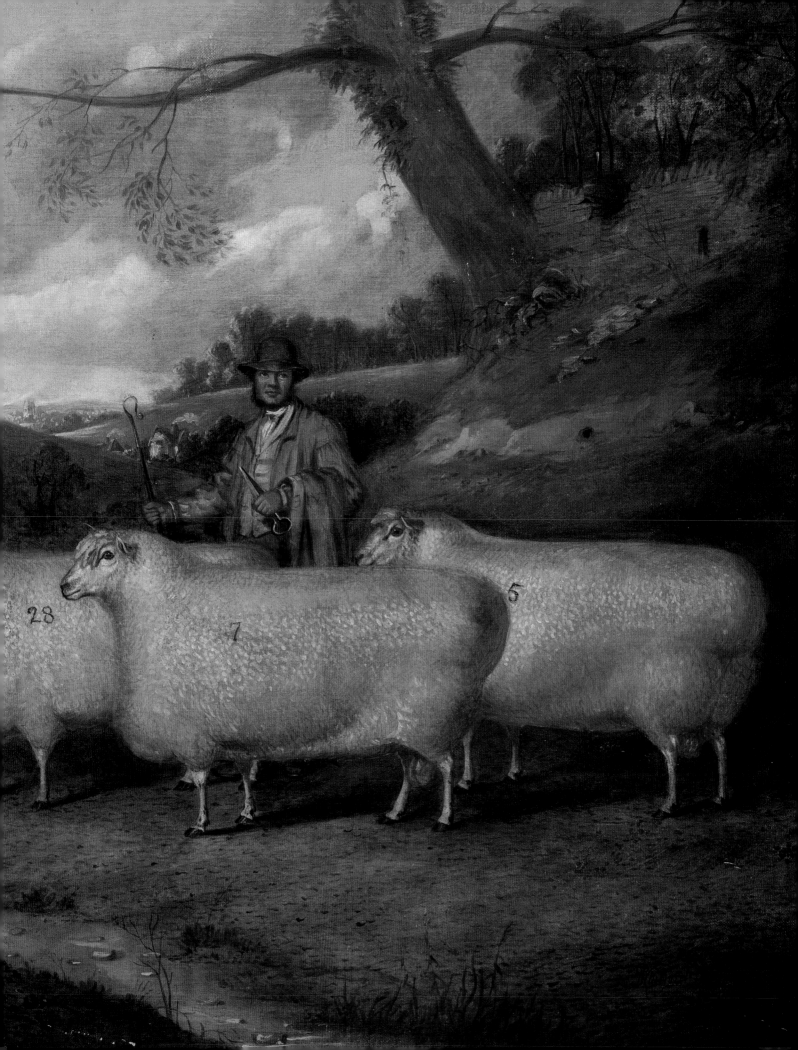

JOHN DIXON HUNT
Oak Spring Garden Library, Upperville, Virginia

Introduction: Pastorals and Pastoralisms

M. JOURDAIN:
But why shepherds again? It always seems to be shepherds.

MUSIC MASTER:
Because, if you are to have people discoursing in song, you must for verisimilitude conform to the pastoral convention. Singing has always been associated with shepherds. It would not seem natural for princes, or ordinary folk for that matter, to be indulging their passions in song.

M. JOURDAIN:
Very well. Let's hear them.

(Molière, *Le bourgeois gentilhomme*, 1670)

I

When the English Romantic poet William Wordsworth comes to meditate on the task of the modern poet within the world of nature, and particularly within the pastoral view of nature, he begins Book 8 of *The Prelude* with an account of a country fete beneath the slopes of Helvellyn.[1] Such country fairs are still held during the summer among the northern hills of Great Britain: an essential part of these multifarious events is the sheepdog trials. Watched intently and knowledgeably by the local population, whose quotidian occupation it is, and by visitors who have heard about this strange rural pastime (now even seen on TV), this event might be the modern equivalent of singing contests in Theocritus and Virgil. Nowadays shepherds together with their dog (or dogs) race each other in herding a small group of sheep from one pen to another around a course. There is even a national championship.

This pastime offers many emblematic possibilities to the reader of this collection of essays. Not least, the shepherd's task of maneuvering a group of sheep never encountered before the competition may be paralleled with an editor's task of guiding contributors to a symposium with whose structure and scope he has had nothing to do, around a course of apparently rather arbitrary shape—eventually herding them into this publication!

More seriously, the elevation of a shepherd's daily chore into a spectator sport at these northern fairs may provide some access to the difficult and slippery notion of pastoral. Herding sheep in all weathers on steep mountainsides is no fun, has no aesthetic dimension, and is of no conceivable interest to an outsider except perhaps for the skill displayed and for the extraordinary collaboration of man and dog. Yet take that same activity and give it a different context—framed as an entertainment whether on television or on a pleasant summer's day in a lowland field with a background of fells—and it is transformed into pastoral event. A new perspective endows it with fresh meaning for those who can distance it from their ordinary life; its

pastoral scope may even be visible to some of those who will be doing this same thing throughout the following weeks, provided they can abstract themselves momentarily from their usual livelihood.

Similarly, anyone who has traveled in the countryside of Italy or Greece will have encountered shepherds herding goats and sheep. Only if we view them from our urban experience, sensing their incongruence within a modern world, is their pastoral potential realized. Consider one such young Patmian shepherd (fig. 1); once we ignore his transitor radio and the electrical or telephone pylons that localize his shepherding chores in the contemporary world, and once we frame this moment in a view finder or through the windows of a holiday automobile, this young man with his dogs, sheep, and goats acquires an instant pastoral gloss.

Compare this with a totally different view of sheep and the life of sheep rearing (fig. 2): despite the apparently idealizing landscape background, this painting cannot readily be dignified with a pastoral label simply because the attitude of its artist, as presumably of whoever commissioned the picture, refuses to distance itself from a wholly pragmatic response to the material, even to the extent of numbering the sheep.[2] Such a comparison of photographic actuality and painterly celebration—with the modes actually working against this ascription of meaning to them—perhaps illuminates the subtle and elusive thing that is pastoral.

2

Pastoral may continue to be subtle and elusive, even after the following authors have put their minds to the topic, for two reasons: the first is that, if not elusiveness, at least capaciousness is one of its essential characteristics; second, as the authors all are at pains to acknowledge, it was a territory already much cultivated and with a substantial crop of critical literature before they began to write.[3] As a consequence their concern for the most part has been less to contrive new definitions than, by considering various pastoral moments, to examine how specific artists have worked within pastoral and therefore to identify variations on a given theme.

In these circumstances no introduction can accomplish what eleven experts themselves do not achieve—an overview of pastoral. Furthermore, since the critical literature is well attested in their texts and notes, a review of the salient bench marks of pastoral criticism is unnecessary.[4] In-

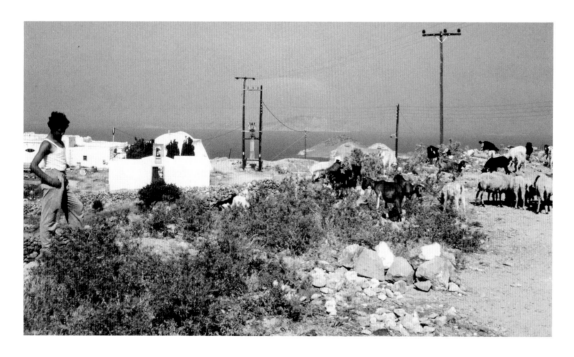

1. Young shepherd and flock on the island of Patmos, summer 1989
Author photograph

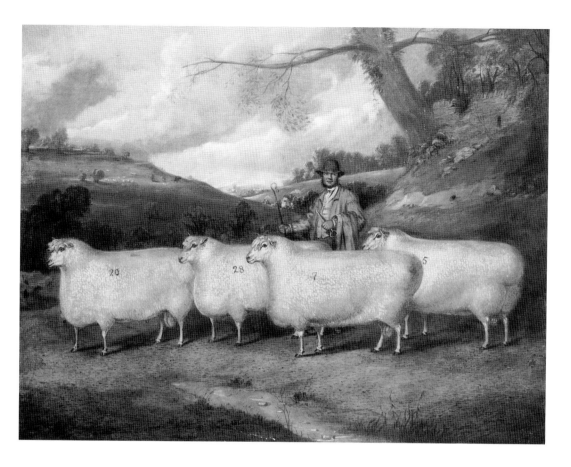

2. R. Whitford, *Mr. Garne's Cotswold Sheep, Northleach,* oil, 1866
Oxford University, Unit of Agricultural Economics

stead it would seem useful to isolate from the following essays certain aspects that have less to do with the nature of pastoral than with how we adjudicate its scope. For the way in which the map of pastoral can be redrawn—as William Empson's *Some Versions of Pastoral* did in 1935 and the fastidious taxonomy of David M. Halperin's *Before Pastoral* has done in 1983—is by asking how our understanding of it is constructed; such a comprehension is also able to illuminate subject matter other than that traditionally associated with literary pastoral. Both Leo Marx and Jeremy Strick, for example, by engaging in precisely that metacritical inquiry, effectively and excitingly rewrite in this volume the modernist pastoral in North America. Other contributors, if less radically, attest to the value of considering how pastoral has been and is viewed or experienced.

Three aspects of these pastoral inquiries will be briefly considered: what may be termed the "Lovejoy syndrome"; the visual-verbal *paragone* in pastoralism; and the congruence of pastoral and picturesque.

3

The famous essay by Arthur Lovejoy, "On the Discrimination of Romanticisms," has much to offer the critic of pastoral who despairs of establishing one coherent definition.[5] Lovejoy argues that there are many romanticisms, that "exceedingly diverse and often conflicting" views of what constitutes romanticism make one hold-all definition virtually impossible. Better, he argues, to attend to how "*each* of these distinguishable strains has worked itself out, [and] what its elective affinities for other ideas . . . have shown themselves to be." Now it may (rightly) be objected that romanticisms are many more and more various than pastoralisms; but a striking result of the analyses collected here is that they suggest how pastoralisms vary with their period, the culture that produces them, and the medium and genre of their representation.

Lovejoy's concern with "strains" and "elective affinities," which may be related to another and more philosophical scepticism of essentialist definition,[6] usefully

bears on the essays gathered here. Even if we subscribe to what one contributor calls the "fundamental conditions of pastoral," it is nonetheless possible to distinguish pastorals as well as pastoralisms. The first will be defined by foregrounding subject matter, whether dramatis personae or settings; the second privileges the mode, the perspective or mentality that is brought to bear on material. Both also depend for their scope and meaning on a particular cultural moment that enables their particular structure.

The critic of pastorals will want to insist on shepherds, arcadian landscapes, or other pastoral occasions and forms; its least strenuous manifestation consists in simply registering the presence of shepherds as sufficient explanation of a pastoral event. But read together, the following essays emphasize that shepherds and their landscapes alter in themselves and in their relationships with each other at different times and in different cultures. The figures of Theocritus are not those who take the Italian stage in the sixteenth and seventeenth centuries, let alone those who perform for Molière's Monsieur Jourdain, who in turn bear little resemblance to the characters of Honoré d'Urfé's *L'Astrée* from earlier that century. Nor are the figures of shepherds in Venetian paintings the same as singers dressed as shepherds singing Venetian madrigals, if only because we see and experience them under different conditions.

The *locus amoenus* as the site of pastoral may have more consistency, as is suggested by the history of landscape painting, with its rehearsal of visual types irrespective of different local topographies. But, David Rosand makes equally clear, the essential vocabulary of the pastoral place is modified in its transmission from the Veneto to the Low Countries and, incidentally, continues to function without obligatory pastoral dramatis personae.

Some definitions are not ontological but, as Rosand usefully puts it, operational: here we confront pastoralisms. These are constructed not so much by emphasizing genre and versions of genre, by demanding the presence of shepherds and by refusing the status of pastoral to landscape *tout pur*,[7] but instead by interrogat-ing intentions and receptions in a given art at a given time.[8] Pastoralisms are then a "habit of mind," "a way of being in the world," or a "negotiation" with actual life.[9] From this perspective we are better positioned to ask why shepherds should be invoked at all in poems, paintings, novels, and drama, or "Of what are these representations representative?"[10] or how the pastoral dress of singers of whatever class or condition might affect our reception of their song (have the modern declensions of pastoral more to do with the disappearance of any shepherd-specific garb or gear than is acknowledged?).

The inquiry that prefers to address intention and reception rather than subject matter or setting also will be able to confront other circumstances of pastoral, which do not receive much attention here: notably, the decline or "death" of pastoral in the eighteenth century, its affinities with georgic, and its frequent (and frequently ignored) status as metaphor.

Unlike Monsieur Jourdain, we probably cannot be satisfied with the answer given by his music master. Pastoral conventions by themselves are no adequate explanation for why pastoral signs should be devised, sent, or received. Indeed the confrontation of pastoral with the bourgeoisie, whether we register it in Molière's *Le bourgeois gentilhomme* or Alexander Pope's ironic celebration of "modern" pastoral verisimilitude, complete with local Somerset dialect, radically challenges pastoral conventions (as well as the bourgeoisie's pragmatic and empirical *mentalité*).[11] It is from this point in cultural history, when pastoralism collides with, for example, an increasing vogue for the realistic novel, that some commentators have marked its decease.[12] Yet rumors of its death would seem much exaggerated if pastoral motifs in English poetry and painting either side of the 1790s are considered. Such an analysis, I think, would have to consider: first, how pastoral seems to be prominent at times of particular social upheaval—pastoral as an image of social stability, a mode of dealing with a complex and demanding world; second, that in artists and writers as varied as Gainsborough, Constable, Wordsworth, and John Clare it should be possible

to trace the renegotiation of pastoralism and modern life;[13] and third, and in particular, the largely trivial worries about whether pastoral and pastoralism should contain labor and hard work would have to be addressed by demonstrating the elective affinities between pastoral and georgic at a given point in cultural history. The transmissions between these two are suitably studied in the huge vogue of the English eighteenth century for landscape painting and at the same time for Virgil as author both of eclogues and the *Georgics*.[14]

4

Eighteenth-century English pastoralisms also raise the issue of their verbal and visual discourse. A striking *démarche* in modern criticism has been to identify pastoral as existing before and after its critical moment: Halperin persuasively demonstrates that pastoral perspectives existed before critical definitions enshrined it as a literary genre;[15] Empson, equally, saw that there was life after the death of pastoral, though he confined his analyses to literature. This volume's distinctive addition to the map of pastoralism is that, besides confirming Empson's sense of its vivifying power, it highlights visual examples.

Given the authority of Theocritus and Virgil, the critical literature on pastoral has always been logocentric. This volume, given its raison d'être by an exhibition of visual examples, provides pastoral with a more extensive and a more independent visual terrain. Doubtless the traditional affinities between the arts, which Horace's "ut pictura poesis" has come to enshrine, functioned to keep visual pastoral in touch with literary formulations in the paintings and villa grounds, which Bettina Bergmann and Alfred Frazer discuss. The inter-art activity is also a strong presence in Poussin's pastoral as Eleanor Leach presents it. But beyond this verbal-visual collaboration, the essays of W. R. Rearick, David Rosand, and Jeremy Strick stake out a visual extension of pastoral territory that owes little or nothing to its sister art.

The predominantly verbal view of pastorals and pastoralisms that has largely prevailed has one further consequence concerning both their metaphoric or mythic thrust and, at their best, their dialectical structure. It is a commonplace of criticism that pastoral is constituted by tension:[16] for the critic of texts this is a tension between imagery of peace, ease, and rural refuge and some internal (for example, psychological malaise) or external (for example, death) threat to them; to the cultural historian the tension lies between the confident assertion of stability and the socio-economic climate in which it is uttered; each of these, in its turn, ensures another tension, an ambiguous response to the pastoral impulse—half celebration, half mockery—that is dramatized by Shakespeare, drawing in his turn on Montaigne, in *The Tempest* (II.i).

All of these strategies in which the mythical or metaphorical force of pastoral is countered by some threat to it can readily be illustrated by literary texts. But visual pastoral is either less willing to register the tension or finds it more difficult: Poussin's arcadian tomb and the snake that strikes in the shadows of a beautiful countryside are notable but perhaps exceptional instances in the visual arts. John Pinto's essay in this volume confirms, however, the role of ruined architecture as an active ingredient of threat or tension in visual pastoral.

This is not the place to address the crucial question of how visual art can be metaphorical and to what extent, if any, literary critical language on metaphor can be transferred to the visual arts. It might be acknowledged, however, that while literary metaphor can easily privilege tenor over vehicle, the visual insistence on the latter in painting may often distract a viewer from the former: we see the signifiers and not the signified. There were cultural pressures, too, that determined this bias: when pastoral painters in the Low Countries in the seventeenth century and in Britain during the eighteenth century gave a local habitation and a name to pastoral myth, there were many who simply enjoyed the medium's power to represent their own local landscape without bothering about the conveyed message.[17]

5

At that moment when pastoral's metaphoric, mythical, even artistic impulse

was in danger of being ignored in favor of its naturalistic representations, another vogue came quickly into fashion: the picturesque. The two have much in common, not least that both have a life *avant la lettre* of their theoretical formulation. In both, verbal and visual languages, while potentially independent, have relied much upon the other's collaboration. Both are ways of negotiating some artistic perspective on the actual world and, not surprisingly, they often collaborate, as is clear in Alfred Frazer's discussion of landscaping Roman villas and John Pinto's of painterly attitudes toward the ruins of Hadrian's Villa.

Two examples of the pervasive congruence of pastoral and picturesque during the eighteenth century will serve.[18] Richard Payne Knight noted that "Pastures with cattle, horses or sheep grazing in them, and enriched with good trees, will always afford picturesque compositions."[19] William Beckford, who when he went to live in Portugal took with him a flock of sheep to ensure an apt pastoral picture from his windows, was equally quick to find pastoral pictures during his Grand Tour: in the countryside near Haarlem in 1780, suitably armed with some pastoral text of Salomon Gessner, "I promised myself a pleasant walk in the groves, took up Gesner [sic], and began to have pretty pastoral ideas." Both pastoral and picture fractured, however, when their aesthetic distance was compromised—"when I approached the nymphs that were disposed on the meads, and saw faces that would have dishonoured a flounder."[20] Neither Gessner's text nor Beckford's own literary vocabulary ("nymphs," "meads") can sustain the illusion once its realities are borne in upon him.

The way around this threat to pastoral and picturesque from an uncooperative world was, as Beckford knew at Fonthill and realized later in Portugal, to create a landscape around oneself. Gardens, John Barrell and John Bull have told us, are the "ultimate pastoral creation,"[21] and in the period of the so-called English, natural, or picturesque garden pastoralism found yet another distinctive form. Like the herdsman, whose liminality Halperin identifies as the constituent of his privileged position,[22] the garden also is suspended between inside and outside, town and country, culture and nature. Not surprisingly, therefore, this volume also extends the lifespan of this "ultimate" pastoral place: back to the Roman villas of the late republican and imperial periods, and forward to the parkland behind René Magritte's *The Human Condition* of 1933.

6

Nobody can doubt that, like the picturesque, pastoral has enjoyed and continues to enjoy a versatile appeal. It is in the United States that pastoralism (and, incidentally, picturesque) are finally relocated by the contributors to this volume. The continuing appeal of pastoral to the colonists of North America and to the succeeding citizens of the United States, as well as their endless reformulations of its imagery, is a vast and exciting theme: to study it would be to acknowledge the influences of biblical and classical pastorals ("Like one of the Patriarchs, I have my Flocks and my Herds"[23]); to register its ideological power—the example of primitive egalitarianism; and to define the aesthetic handle that pastoralisms offered, in the beginnings, to those negotiating with a vast and often threatening country and, more recently, to landscape architects who make the power houses of corporate headquarters benign within pastoral valleys. We may end, then, with a final emblem of these traditions (fig. 3), showing the White House itself enveloped by a pastoral landscape—there sheep may safely graze.[24]

3. Sheep grazing at the
White House, late 1910s
Library of Congress

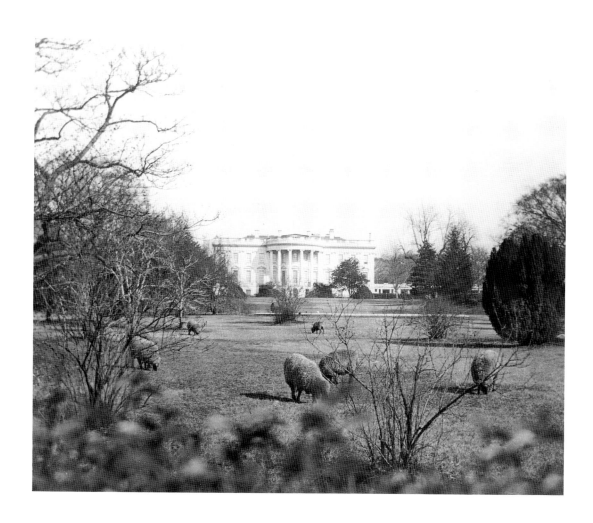

NOTES

1. William Wordsworth, *The Prelude, 1799, 1805, 1850*, ed. Jonathan Wordsworth et al. (New York, 1979), book 8 in the 1805 version of this long poem. The passage is discussed by Paul Alpers, "What Is Pastoral?", *Critical Inquiry* 8 (Spring 1982), 444–448.

2. For a whole range of such agrarian images see *This Land Is Our Land: Aspects of Agriculture in English Art*, ed. Demelza Spargo [exh. cat., Mall Galleries] (London, 1989). My example is no. 308, which alerts one to the fact that, despite the idealizing color of the landscape, the parish church is identifiable as that of Northleach and therefore localizes the scene; there is also some dispute as to whether the painting does not in fact represent Mr. Lane's sheep.

3. Alpers 1982, 437, notes that writing on pastoral is "one of the flourishing light industries of academic criticism;" but he also notes that we still "find nothing like a coherent account of either its nature or its history."

4. The bibliography of pastoral literature is constructed readily from the bibliography in Robert C. Cafritz, Lawrence Gowing, and David Rosand, *Places of Delight: The Pastoral Landscape* [exh. cat., Phillips Collection and National Gallery of Art] (Washington, 1988) and further references in essays elsewhere in this volume: see principally Bergmann, nn. 3–5, 23, 41, 44; Brown, n. 16; Clubb, nn. 2–3, 15; Frazer, nn. 3, 5; Horowitz, n. 5; Leach, nn. 9–12, 20, 42–44; Marx, nn. 1, 6; Pinto, n. 2; Rearick, n. 55; Rosand, nn. 2, 30; Strick, nn. 6, 11.

To these might be added the stimulating pastoral volume (guest editor, Robert Lawson-Peebles) of *Landscape Research* 14/1 (1989); various essays, particularly those by John Barrell and Simon Pugh in *Reading Landscape*, ed. Simon Pugh (Manchester, 1990); and the Pastoral entry by J. E. Congleton, *Princeton Encyclopedia of Poetry and Poetics*, ed. Alex Preminger, enlarged ed. (Princeton, 1974), 603–606.

5. Arthur O. Lovejoy, "On the Discrimination of Romanticisms," *Essays in the History of Ideas* (Baltimore, 1948), 228–253; my quotations come from his last two pages.

6. See Ludwig Wittgenstein on the definition of the word "games," in *Philosophical Investigations*, 3d. ed. (New York, 1958), sections 66–67: "a complicated network of similarities overlapping and criss-crossing."

7. Alpers 1982, 449, resists landscape per se as the "representative anecdote" of pastoral, insisting instead on the "lives of the shepherds."

8. As Jeremy Strick points out, in the much-cited four-point definition of pastoral by David M. Halperin (*Before Pastoral: Theocritas and the Ancient Tradition of Bucolic Poetry* [New Haven, 1983], 70–71) the first concerns subject matter, but the second and third, "formal and representional structures;" these, in turn, I am calling "intentions and receptions."

9. The terms are those used by Leo Marx and Eleanor Leach in their essays in this volume.

10. Alpers 1982, 449.

11. See Pope's satire of 1713 on pastoral poetry in *The Guardian*, no. 40, reprinted in *Literary Criticism* of Alexander Pope, ed. B. A. Goldgar (Lincoln, Nebr., 1965), 98–104. Another reason for pastoral's loss of prestige during the eighteenth century is set out by John Barrell in "Public Prospect and Private View," in Pugh 1990, 24–25.

12. It is Renato Poggioli, *The Oaten Flute: Essays on Pastoral Poetry and the Pastoral Ideal* (Cambridge, 1975) who announces the virtual death of pastoral during the eighteenth century.

13. See, for instance, John Barrell, *The Dark Side of the Landscape* (Cambridge, 1980), Ann Bermingham, *Landscape and Ideology: The English Rustic Tradition, 1740–1860* (Berkeley and Los Angeles, 1986); and Timothy Brownlow, *John Clare and Picturesque Landscape* (Oxford, 1983).

14. See, among other considerations, the works cited in the previous note and John Chalker, *The English Georgic: A Study in the Development of a Form* (London, 1969). It is not only eighteenth-century England where this phenomenon could be studied, for the Low Countries yield similar materials: see P. A. F. van

Veen, *De soeticheydt, des buyten-levens, verghesel-schapt met de boucken* (Utrecht, 1985).

15. The term pastoralism is still used by anthropologists without any aesthetizing color: see, for example, *The Walking Larder: Patterns of Domestication, Pastoralism, and Predation*, ed. Juliet Clutton-Brock (London, 1989), especially 113–276.

16. This is well canvassed by, among others, John Barrell and John Bull in their introductions to the various sections of *The Penguin Book of English Pastoral Verse* (London, 1974).

17. There is, equally, the critical hazard of writing about the complex world of pastoral while not losing sight and sound of its studied simplicities.

18. The opening chapters of Malcolm Andrews, *The Search for the Picturesque* (Aldershot, 1989), frequently address the pastoral alongside the picturesque, though, unfortunately, his index makes no such acknowledgement of the former's importance in his argument.

19. Richard Payne Knight *The Landscape*, 2d ed. (London, 1795), 45n; he even adds that "inclosures of arable are never completely ugly."

20. For Portugal see Beckford's *Journal in Portugal and Spain*, ed. Boyd Alexander (London, 1954), 205; for the Dutch encounter, see *The Grand Tour of William Beckford*, ed. E. Maw (Harmondsworth, 1986), 30–31.

21. "The Garden is the ultimate pastoral creation, the organization by man of nature into art" (Barrell and Bull 1974, 225).

22. Halperin 1983, 97.

23. William Byrd, in July 1726, writing to the Earl of Orrery, *The Correspondence of the Three William Byrds of Westover, Virginia, 1684–1776*, xx vols., ed. Marion Tinling (Charlottesville, 1977), 1:355.

24. In fact, the Wool Bureau of America persuaded President Wilson to let sheep graze the south lawn in the late 1910s. The image has rather lost the explanation of its historical occasion.

BETTINA BERGMANN
Mount Holyoke College

Exploring the Grove:
Pastoral Space on Roman Walls

The earliest surviving images of an idyllic countryside in Western art appear on the walls of Roman houses painted in the first centuries B.C. and A.D. In subject, composition, and mood these images could be models for the pastoral landscapes invented in Venice in the early sixteenth century, yet their status as details of interior wall decoration, their execution by workshop craftsmen, and their indirect relationship to literary texts have excluded them from the genre.[1] Indeed, neither literary critics nor art historians formulated a pastoral category of landscape in antiquity. Yet the lack of a critical definition does not deny the existence of artistic precedents in a cultural tradition. Specific social and economic changes in central Italy in the first centuries B.C. and A.D. stimulated the representation of one type of landscape, the sacred grove, which in subject and composition articulates the primary pastoral concerns of conflict and escape.

Normally the term "pastoral" evokes rustic scenes, shepherds tending their flocks, a quiet place and peaceful mood. Recently, however, art historians have identified pastoral not as a distinct subject matter and theme, but as certain compositional structures or relationships of pictorial features that offer spectators "inviting occasions" for escape and reverie. Such structures posit a visible dialectic between nature and civilization. In painting of the twentieth century, pastoral structures may even tran-scend subject matter—pure form evokes a privileged spot, demarcated from the world at large. Pastoral space thus becomes metaphorical, focusing on artifice itself.[2]

The inclusion of nonrepresentational space within the art historical category of pastoral painting indicates a growing concern to distinguish between mode and intent in discussions of pastoral and landscape art. Leo Marx identifies as "pastoralism" a persistent attitude throughout Western culture that has found expression in many modes and genres, while Denis Cosgrove argues that landscape art, including pastoral, along with maps and literary description, may be a manifestation of political phenomena.[3] If these broad concepts accommodate the protean nature of pastoral, they also raise questions about its parameters. How can the impulse for the creation of a landscape be distinguished from pastoralism?

Through its artifice every landscape painting harbors that paradox essential to pastoral: one is both invited and detached while involved in a process that heightens awareness of one's station in the present world. Yet a pastoral landscape is more persistent in its challenge to the viewer; its emphatic internal conflicts make the very act of viewing conflict-ridden as well. According to modern criteria, any representation promoting this particular heightened response to art and nature qualifies as pastoral.

In light of our expanded understanding of pastoral art, a reevaluation of Roman paintings is in order. Although the literary forms of ancient pastoralism, especially those of Theocritus and Virgil, are usually regarded as the heart of later revivals, the existence of an ancient visual tradition of pastoral has not been directly addressed. Perhaps wary of anachronistic projection, scholars focus on the bucolic motifs that abound in various media from the Augustan period.[4] A recent analysis of the various postclassical theories of literary pastoral, however, led David Halperin to conclude that although there was no articulated conception of pastoral in antiquity, an attitude compatible with modern concepts did exist. Halperin's four-point definition recognizes pastoralism as a broad cultural phenomenon that may include ancient and modern, literary and visual modes:

1. Pastoral is the name commonly given to literature about or pertaining to herdsmen and their activities in a country setting; these activities are conventionally assumed to be three in number: caring for the animals under their charge, singing or playing musical instruments, and making love.

2. Pastoral achieves significance by oppositions, by the set of contrasts, expressed or implied, which the values embodied in its world create with other ways of life. The most traditional contrast is between the little world of natural simplicity and the great world of civilization, power, statecraft, ordered society, established codes of behavior, and artifice in general.

3. A different kind of contrast equally intimate to pastoral's manner of representation is that between a confused or conflict-ridden reality and the artistic depiction of it as comprehensible, meaningful, or harmonious.

4. A work which satisfies the requirements of any two of the three preceding points has fulfilled the necessary and sufficient conditions of pastoral.[5]

Thus defined, a pastoral painting can range from a combination of bucolic features to certain structures of representation. Although many Roman paintings of groves satisfy Halperin's first criterion in that they depict herdsmen caring for animals, this activity is rarely their primary subject, for the figures and animals are, like the rocks and trees, an intrinsic part of a larger setting. Instead the main focus of most scenes is a structure or a mythical moment that posits a series of oppositions between the natural and the human, "between the little world of natural simplicity and . . . artifice in general," as stated in Halperin's second criterion. In this simple dialectic Roman images of groves are comparable to the "classical" pastoral paintings of art history.

An even more compelling and unexplored aspect of Roman landscapes is Halperin's third criterion of a contrast "between a confused or conflict-ridden reality and the artistic depiction of it as comprehensible, meaningful, or harmonious." If one looks beyond the contents of each scene to its location on a painted wall, to its architectural milieu, and finally to its historical moment, the groves express a complex pastoral attitude, for their setting confers on them a meaning alien to their nature.

In analyzing the Roman images, we must address the issue of ancient visuality, namely the modes of vision employed and differentiated by the Romans. In variety and kind, the pictorial structures of painted landscapes capture views that were idealized by contemporary poets, villa owners, and geographers. While the remains of private estates attest to the popularity of such views, discussions about vision, nature, and territorial control reveal a deeper, metaphorical meaning behind them. The confluence of these perceptual attitudes in the first centuries B.C. and A.D. produced a creative moment of pastoralism, of which the groves painted on domestic walls are one expression.

Pictorial Structures of the Sacred Grove

Roman landscapes have traditionally been evaluated apart from their context, an approach that is justified by the framing devices around many examples and by the apparent similarities of these landscapes to European oil paintings. Ironically this attitude has determined the present appearance of many of these works, which, cut from their settings in the eighteenth and

nineteenth centuries, now hang in wooden frames on the white walls of the Museo Archeologico Nazionale, Naples. Yet these detached images of groves, as the following analysis will show, are coherent compositions in which pictorial structures, taken in conjunction with their decorative setting, may readily be identified as pastoral.

In this discussion "grove" connotes a sacred space in nature where one or more trees, distinctive earth forms such as caves and boulders, and water in springs or brooks are designated—by a structure, by various votive objects, and by attendant figures—for veneration. Although most often an inland setting is implied, a solitary tree or group of trees surrounded by the same buildings, objects, and figures may stand beside the shore or on an island. Like its actual historical counterpart, the painted grove contains structures erected at various stages in the development of a sanctuary (figs. 1, 3–14). Monuments ranging from simple wooden frames to marble temples and ruins signal a grotto, tree, or spring as a sacred node. While the numinous ground is clearly circumscribed by a water channel, wall, or statues and objects marking the boundary, easy access to the sanctuary is implied in the bridges, porticoes, and paths that integrate the distinct areas and offer passage for shepherds, travelers, and worshippers. Once inside the precinct, flights of steps, prominent doors, and open windows invite one further into the heart of the sacred *locus*.[6]

In subject matter—resting shepherds, grazing flocks, and the still time they evoke—sacred groves offer the closest analogies to pastoral painting of later periods. In context, however, the grove was one of several segments of the natural world depicted on walls, often appearing as a pendant to mythological landscapes or to contemporary architectural views. Recent analysis of Roman landscapes, which always bear a human sign, shows that as a group they visualize contrasting attitudes toward nature. In many paintings, for instance, we observe the veneration and cultivation of natural inland sites (fig. 1), while in others, human technology triumphs over earth and sea (fig. 2). Each type of place recurs in a few basic schemes, re-gardless of scale, original placement, and quality of execution. While such schemes clearly reflect an efficient method of assembling ready-made pictorial units in the rapid technique of fresco and thereby confirm that the images were not based on direct observation of the environment, their ideal structures represent a selection from and judgment about that environment, and their repetition lends them the status of *topoi*.[7]

That the pictorial structures of Roman landscape were meaningful, even metaphorical, is evident in images of the grove. In its simplest scheme, monument and vegetation intersect in ways that bring linear, historical time into the cycles of nature. A column, portal, or enclosure beside a prominent tree stands in the center of the image, set into relief by the sun; worshippers approach the vertical, rotational axis from both sides, completing a triangle and reinforcing the magnetic pull of the spot (figs. 1, 3, 4). Significantly, the natural and constructed objects of worship—tree, statue, and monument—share the same ritual decoration of ribbons, shields, and crossed spears with torches and tablets lying at their bases. The two-columned portal, or *syzygia*, enshrines either a statue (fig. 13) or the tree itself, which splits at the trunk to rise in two separate branches on either side of the frame (fig. 3). While in some scenes the tree may be shaped by pruning and pollarding, in others the column matches the tree's diameter, appearing to merge with it (fig. 1), or the tree wraps itself around a marble shaft.

Seen alone, the pictorial unit of tree and shrine provides the eye with a central focus. Transposed to a larger environment and set off against the topographical signs of a later, more developed age, the focus extends from the delicate, vertical shrine to massive forms of ports and cities. Thus in a small panel from Pompeii, a sacred portal forms the center of a balanced foreground scene, flanked on the left by a stooped figure before a large, gnarled tree and on the right by a statue of Priapus, a display of rustic piety that is set against an expanse of sea and a bird's-eye view of a distant, walled town (fig. 4). The contrast highlights the religious sphere, affirming a

distinct order of relations while generating a sense of boundlessness and expanse. In other schemes, variations of color, scale, and descriptive detail render the grove alternately as inland or as maritime. Thus the columnar enclosure with tree appears on a rocky islet in a large, hilly sanctuary (fig. 5) and as a light and airy pavilion in sea scenes (fig. 6). Inland the eye travels to the horizon, passing over further similar groves, potential destinations; at sea it meets the urban signs of civilization that ultimately border and contain the sacred precinct.

While the column, portal, and enclosure are usually modest, often of wood and ephemeral, in other schemes architecture becomes the main focus and the tree or other natural forms a secondary feature. Here the conflict is less between growth and artifice than between the barriers and entrances to the sacred place. The square, gabled structure, which dominates the familiar rocky islet in either a freshwater or saltwater channel, invites by its steps, emphatic openings of wide doors, windows, and intercolumniations, while figures move around its decorated walls (figs. 7, 8). Multiplied and set in a staggered row, the aedicular façade builds space by leading the eye, in stages, into a numinous realm (fig. 9). Significantly, the buildings' apertures function like solid geometric forms, defining space through their overlapping and progressive diminution. Such visual

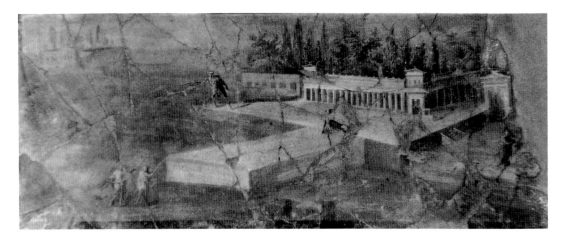

1. Landscape in vertical white panel from central section, north wall of Red Room (cubiculum 16), Villa of Agrippa Postumus, Boscotrecase, third style, last decade of first century B.C. Museo Archeologico Nazionale, Naples, 147501. Author photograph

2. Painted view of porticus complex in rectangular frame, upper zone of atrium wall, House of the Menander, Pompeii (1,10,4), fourth style, third quarter of first century A.D. Author photograph

3. Vignette on red ground, one of a paratactic series, portico of Temple of Isis complex, Pompeii, fourth style, c. A.D. 64
Museo Archeologico Nazionale, Naples, 9495. Author photograph

4. Small rectangular panel in upper zone of wall, House of Venus, Pompeii (II,3,3), early fourth style, third quarter of first century A.D.
Author photograph

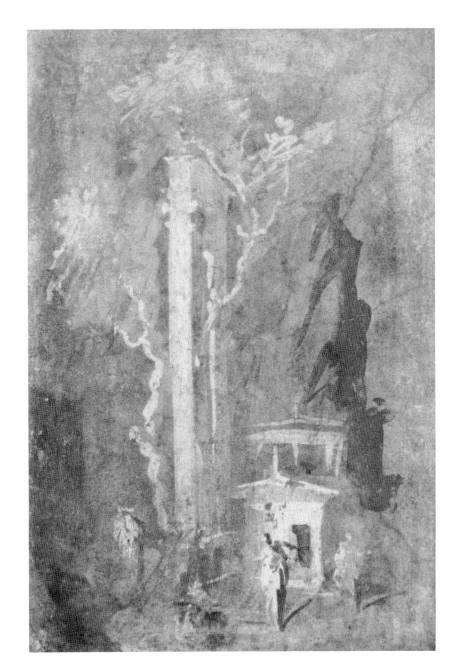

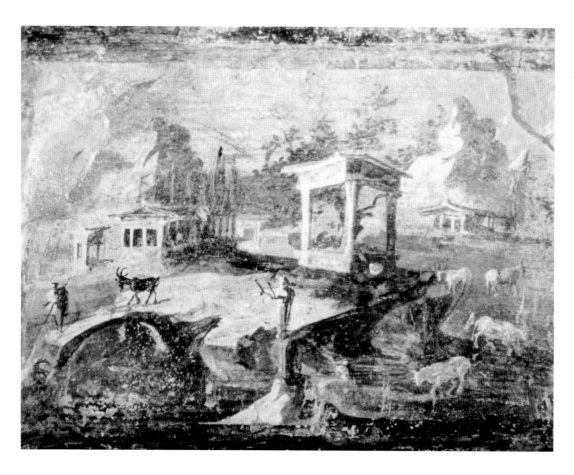

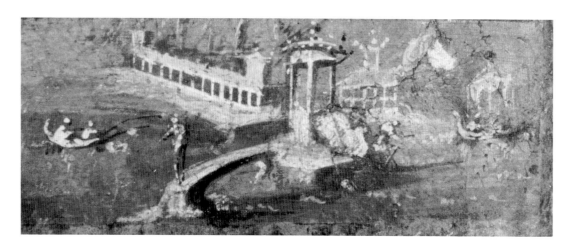

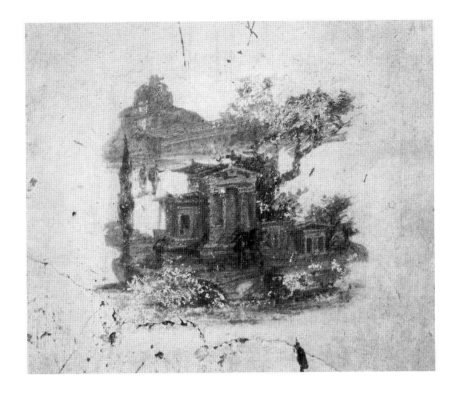

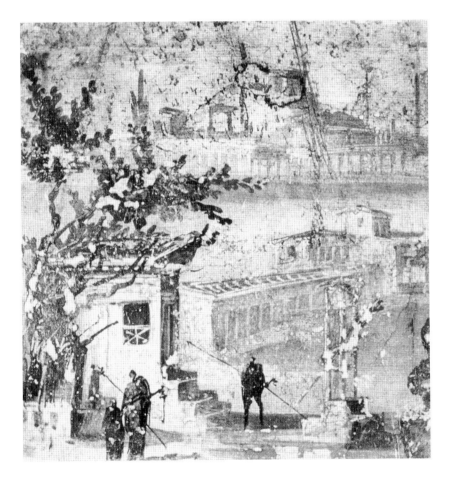

7. Vignette in center of white wall, House of the Little Fountain, Pompeii (VI,8,23), fourth style, third quarter of first century A.D.
Author photograph

8. (left) Quadratic panel from Pompeii, late third or fourth style, first century A.D.
Museo Archeologico Nazionale, Naples, 9414. Author photograph

9. (above) Vignette on black wall, north corner of peristyle, House of the Vettii, Pompeii (VI,15,1), fourth style, third quarter of first century A.D.
Author photograph

invitation was a charged one in ancient Rome, where open doors of shrines indicated ongoing ritual activity, peace, and celebration.

The most massive building in the sacred precinct, the cylindrical enclosure or tower, manifests tension and contrast through its own ambiguous form. While its heavy masonry, turrets, and slit windows connote defense and protection, open doorways decorated with ribbons or garlands and figures approaching the precinct via bridges and porticoes imply easy access and circulation (fig. 10). In some examples anachronistic forms fall into ruin. The walls of one enclosure are broken, revealing the sacred column it once sheltered and thus the age of the sanctuary, while objects and worshipping figures indicate continuous veneration of the place (fig. 11). Similarly the harbor-arm watchtower stands as a relic of defense in marked contrast to an open, monumental beachside chapel (fig. 12). Both inland and at the shore the ruined cylinder bears traces of the religious and political processes that constitute change in the landscape. Ancient cults persist, and roots of piety lie deep, despite the changes brought by a new era of peace and urbanization.[8]

The set of contrasts contained within each pictorial structure of the grove is essentially pastoral. The interplay of monument and vegetation and the fragility of the human edifice reveal a world of change: human expression of piety, the shrine, is transitory, while vegetation is in continuous renewal and human-made spaces shift center. Within these larger, intersecting temporal cycles, the figures, animals, and objects highlight ancient custom, historical continuity, and the successful negotiation between humans and nature. Anthropomorphic and natural forces are protected, represented, elevated, and decorated, and members of the pantheon assume their proper place. Protecting the sacred zone are rustic statues of Priapus and Pan, seen beneath a tree, on a rock, a base, or a bridge (figs. 1, 4, 5, 14), while images of male and female deities in gold, marble, and wood stand on pedestals, enframed and worshipped beside monumental trees and grottoes (figs. 1, 8, 13).

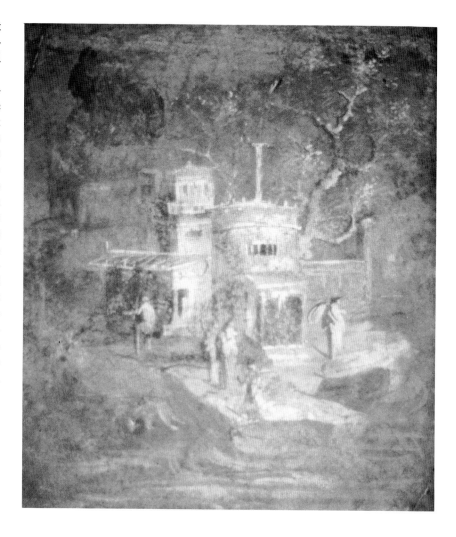

Clearly the message of the painted groves does not concern a god but the human acts and gestures of piety toward the *numen*, or wilderness, of nature. Small anonymous figures point at monuments, run over bridges or paths, or turn their backs to encourage active exploration of the sacred place. The worshipper enters a precinct and halts momentarily to gesture toward a shrine, indicating a transitory spot, perhaps a goal of pilgrimage. Women bend over altars in the moment of sacrifice. In these local, daily scenes ritual mollifies the wilderness, creating spots for sanctuary and rest. Thus the herdsman stays near enclosed, built settings, as cattle, goats, and sheep graze close by. Donkeys and oxen, common beasts of burden, are urged across a bridge or down a country road. Sometimes an animal succumbs to sacrifice (fig. 14).

10. Vignette on red ground, from porticus, Temple of Isis complex, Pompeii, fourth style, c. A.D. 64
Museo Archeologico Nazionale, Naples, 9519. Author photograph

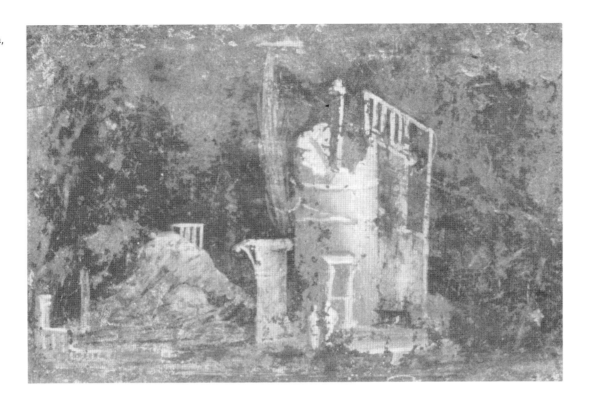

11. Vignette on red ground, from Villa San Marco, Stabia, fourth style, mid-first century A.D.
Museo Archeologico Nazionale, Naples, 9405. Author photograph

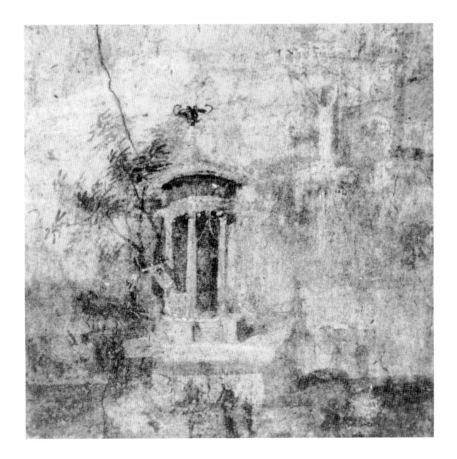

12. Quadratic panel in House of Argo, Herculaneum (II,2), fourth style, mid-first century A.D.
Author photograph

The numinous power of the site emerges most emphatically during the narration of a mythical event, usually the climactic moment in a tale. In a large panel in the House of Polybios in Pompeii the sacred portal forms the pivotal center for four stages in the story of the punishment of Dirce (fig. 13). The scheme repeats that of non-narrative scenes: the shrine, elevated on an islet and surrounded by tiny offerings and goats, is flanked on the right by a gaping cavern and on the left by the distant view of a herdsman and his flock before an enclosure. The huge portal framing the statue of Dionysus dwarfs the event with its imposing sanctity. Like the worshippers and shepherds in the grove, the mythological characters underline the need for negotiation, through proper behavior, with nature and its gods.[9]

In each mode, as in the actual ancient landscape, the grove represents one aspect of the environment that has been isolated for worship. A bounded space within boundless nature, it forms a focal point in the lives of shepherds and worshippers. When contrasted with the blocklike concrete forms structuring earth and sea, the meaning of the grove resides in its being peripheral to the political centers, an intermediate zone between country and city and between nature and society. It is one of the astonishing achievements of Roman painters to have developed the means for conveying the impression of a diversified yet unified environment into which the spectator is offered visual entry. Geometric forms, the products of human reasoning, define the physical, tactile space, while plaster and pigment produce an impression of light and transience. Details add topographical specificity. As the eye follows forms through this light-filled space, the sacred grove, characterized by its inclusive spatial structures and local features, assumes its meaning. Signaling exclusiveness and refuge, the site is quintessentially liminal, a place and moment "in and out of time" where one can have direct experience of the supernatural.[10]

In short, the pictorial structures of the grove describe the perennial *agon* of art and nature. Pastoral conflict occurs in the presence of man in the grove. Yet through inno-vative formal means, the painter extended the conflict to one between the sanctified spot and other, more urban realities. The viewer is meant to regard the grove as a segregated but intrinsic part of a larger domain. The conflict-ridden reality of the "little world" of nature worship and the civilizing harbors and cities, symbols of power and statecraft, becomes "comprehensible, meaningful, or harmonious" through visual means.

Signs of Piety and Pleasure

What would the images of groves have connoted to a Roman of the first centuries B.C. and A.D.? Surviving comments by contemporaries emphasize the visibility of ancient groves and their role in moralizing debates about the status of Roman history and religion. In contrast to the strain of nostalgia and cultural primitivism informing many such discussions, however, the scenes on

13. Large vertical panel, center of wall, House of Polybios, Pompeii (IX,13), third style, c. 10 B.C.
Author photograph

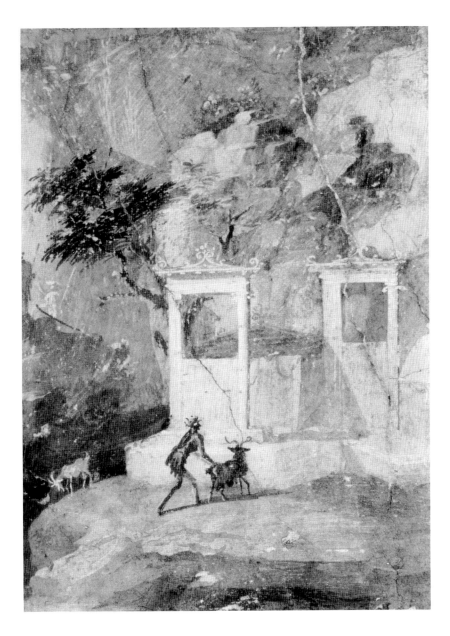

14. Quadratic panel from
Pompeii, late third or fourth
style, first century A.D.
Museo Archeologico Nazionale,
Naples, 9418. Author photograph

paintings, an artist's translation of a spe-
cific visual experience. Religious and social
habits of perception shaped the Roman
views of groves. The process of selecting
from the natural world a sacred place, de-
fining its perimeter, and marking it as dis-
tinct requires an act of recognition. In Ro-
man religion the high priest, or *augur*,
scanned the land from a high spot, drew
lines through it, took sight of certain land-
marks, and spoke out their names. Repeat-
edly in augural texts a landscape feature is
referred to as *signum*, a sign selected to
represent the place in a new, more mean-
ingful context. Once the spot was defined,
structures were erected to order the sacred
space, direct sight and movement, and
communicate with the divine. Since the
Hellenistic period private individuals dedi-
cated these buildings as a prayer and a me-
morial to their fame.[11] The paintings, com-
posed by a selective and additive process,
invite movement through a unified space,
thereby recreating the process of visually
appropriating holy terrain.

The signal value of topographical fea-
tures explains the character of Roman land-
scape, for the features not only served as
compelling visual cues in the countryside
and on the shore but also functioned as
words and as pictures, often simultane-
ously as both. A key to the grove's multiva-
lent meaning are those tablets frequently
depicted propped on tree trunks or monu-
ment bases (figs. 1, 12, 13). Such votive tab-
lets were inscribed with epigrams, painted,
or both inscribed and painted with the
same features seen on frescoed walls. The
rocks, buildings, and trees, whether in ver-
bal or visual form, were directed at those
approaching and recognizing the place as
sacred. Inscriptions name, directly address,
or personify these objects, allowing them
to speak for themselves. In fact, the com-
positional focus of most paintings, an ed-
ifice surrounded by cult objects, corre-
sponds to the integrated arrangements of
sanctuaries, where an architectural epi-
gram might be inscribed on the building
itself or on a nearby statue, altar, or tablet
pointed in its direction.[12]

Vitruvius, in his brief account of wall
painting, explicitly stated that landscapes
were composed of typical aspects selected

Roman walls do not recall an irretrievable
past but celebrate the continuity of wor-
ship. Signs of active ritual—building, dedi-
cating, sacrificing—imbue the images with
pietas and reaffirm the tradition and power
(*auctoritas*) of ancient religious customs.
The preservation of past cultural values
shown in the paintings resolves a temporal
and moral conflict between the natural
locus and its wider, more modern domain.

In our quick survey of pictorial groves it
became clear that unified space was an ab-
stract, conceptually meaningful construct
and not, as is true for many later landscape

from the visible world. Among these aspects, which he called *topia*, he included the sacred grove or wood (*lucus*), holy places (*fana*), mountains (*montes*), rivers (*flumine*), springs (*fontes*), flocks (*pecora*), and shepherds (*pastores*). Notably in his list the animated elements, flocks and shepherds, have topographical status, just as in paintings and epigrams such figures function as personifications or attributes of the place.[13] Leaning on their staffs or against a wall, reclining under a tree or an awning, gazing from a bridge (figs. 1, 4, 5), shepherds, worshippers, and wanderers epitomize a particular world and the activities that it encourages and endorses. In reality these individuals often dedicated the inscriptions and very same objects and animals depicted beside them. Among the numerous painted and verbal parallels are the scene of a herdsman leading a goat to a sacrificial altar and an epigram describing the slaughter of an old goat on an altar to Pan (fig. 14). One inscription left by two rich landowners records the dedication of an image of a goat rather than its live counterpart. Indeed, a representation may substitute for the real thing because it is the act and the symbol of offering, acknowledged in verbal and visual form, that are to be remembered.[14]

Views of groves not only stirred sentiments of piety but recalled the sensory pleasures such sites offered. Following the example of shepherds, wanderers, and worshippers, Latin poets expressed the high value they placed on cool, shady *luci*, singling out as particularly delightful the same elements, or *topia*, that appear in paintings and epigrams. A site invites and inspires; a source of pleasure, it is the classic *locus amoenus* characterized by Virgil as possessing the *topia* of springs and woods, among which goats graze on the banks of the stream.[15]

The frequent warnings inscribed on the objects and natural features in groves reinforced the value of the site. Epigrams from the third century B.C. protest the destruction of trees, funerary gardens, and cult groves. Personified, trees implore travelers and their servants to leave the place intact and move on to another resting place where shade is more abundant and the beauty greater.[16] These messages intensified in the late republic and early empire, when a new wave of building increasingly threatened groves in Italy. The sacred sites were seen not just as relics of the past but also as playing an important role in defining Rome's new religious identity. Thus in his *periplus* written in the Augustan period Strabo saw the few surviving groves, like the trees dedicated to Apollo at Actium and at Nicopolis, as landmarks of the new political structure. And in Campania, the context of most surviving paintings, ancient holy places became renowned, among them the tree of triple Hecate near Cuma, which provides a significant parallel to scenes with an image of that goddess.[17]

While superficially the sight of an ancient grove may have recalled historic change, for those sensing the spot as animated by divinity the visual image could provoke a highly charged religious experience. Instrumental in this revelatory process were the signs of previous human encounters with the sacred. Ovid, referring to a grove of Juno above Falisci that was decorated with a simple altar and old-fashioned offerings of pious pilgrims, stressed that from its very appearance it was instantly recognized as numinous. Of the sacred Arician grove he said that after putting *pinakes*, or tablets, in place, women wrapped bands and ties on the trees. And a century later Athenaeus reported that when one saw a sacred spot he or she picked a flower and hung it on the shrine or the statues themselves. Like the epigrams and paintings, such poetic and historical comments dwell on telling landmarks of a place, just as augurs selected numinous *signa* from an expansive view.[18]

Evidence of decay and organic change was especially evocative in sanctuaries. Ancient descriptions tell how age and death in trees and weathering of human-made forms increased their value. Lucan's reference to a tall, dead, leafless oak that continued to be worshipped recalls the prominent stumps and bare branches depicted in sacred zones (fig. 4). Propertius mentioned the *deserta sacraria* that were left to be tended by country folk until Augustus' reforms: "But now the shrines lie

neglected in deserted groves: piety is vanquished and all men worship gold." Martial, observing a tomb on a Roman public road that had been cleaved by a wild fig tree, regretted that nature's disintegration spared no human monument, even if erected at vast cost and constantly tended. But if the flow of time triumphed over walls built by humans, the monument still survived the human lifespan. Thus Pliny the Elder wrote: "The earth makes us also sacred, even bearing our monuments and epitaphs and prolonging our name and extending our memory against the shortness of time."[19]

Such comments express a new consciousness of the temporal dimensions of place. In fact it was in the first century B.C. that the word *antiquitates* first appeared in discourse about religion and the gods. Cicero noted that the art of the augurs was vanishing, that rituals had lost their meaning but were maintained because of their antiquity. Varro collected the foundation dates of temples, complaining that where once holy places had been now only streets bore their names, and that those remaining were confined to a smaller space. Cicero applauded Varro's books and claimed that they had restored the city for him at a time when other Romans moved like strangers through the streets. Knowledge of the past provided a key to one's own identity.[20]

While the age of the grove was stressed, its current value was also defended, its meaning redefined for a new world in which traditional religion appeared to be coming to an end. According to Varro, true veneration of the gods did not take place in houses of stone containing statues, but in sacred groves without pictures. Lucretius told how all over the world shrines, lakes, groves, altars, and images of the gods were still held sacred, and Quintilian related how men revered groves more for their *religionem* than for their beauty. Pliny, claiming that tree-worship was thriving in the late first century A.D., contrasted the material splendor of modern, organized religion with the simple shrines of the past:

The riches of the earth's bounty were for a long time hidden, and the trees and forests were supposed to be the supreme gift bestowed on her by man. . . . trees were the temples of the deities,

and in conformity with primitive ritual simple country places even now dedicate a tree of exceptional height to a god; nor do we pay greater worship to images shining with gold and ivory than to forests and to the very silences they contain.[21]

Groves painted on domestic walls affirm the status of nature cults and stress the continuity of worship that Varro nostalgically desired. Yet they record not only antiquity but also progress, acculturation, and the broadening horizon of Roman vision. A survey of the building types reveals, along with a current Graeco-Roman vernacular, primitive (aniconic), and foreign, especially Egyptian, features. Combining exotic and ancient, past and foreign customs, the cosmopolitan landscapes expand sacred space geographically. Temporally they evoke the variety of sites that would have been visible along the route of a procession, a staggered series of views that follow sequential stages of expansion and centralization within the sacred landscape.[22]

Considering the spatial and temporal range of the paintings, one should ask to which category the shepherd, the primary pastoral protagonist, belongs. It has been noticed that Roman images lack the signs of agricultural toil so prominent in contemporary handbooks for the gentleman farmer. Instead they concur with fictional accounts of Rome's origins that stress the exclusively pastoral nature of the early city. But as with sacred groves, pasturage was highly valued in Italy in the first centuries B.C. and A.D. And cultivation, epigrams tell us from the third century B.C. on, threatened the grove. Accordingly the paintings of quiet scenes with grazing sheep and cows omit any sign of danger from the plow; wool and meat accompany signs of piety, implying that peace with nature and the gods produces fertility and wealth. The shepherd, like the grove, was a poetic and topical symbol, bringing the value of the ancient and the rural into a modern milieu.[23]

Images of groves, then, signal a recognition of sacred space—initiated by the augur in siting landmarks, by the worshipper physically approaching a shrine, or by the reader of a dedicatory inscription carved on

a tree, an edifice, or a tablet deposited at the place. Such traditions developed in the Hellenistic world but in the late republic became a vehicle of moralizing historicism that perpetuated the fiction of a pure rural religion as the heart of Rome's past. By the first century B.C., when landscapes were first painted on Roman walls, the changing historical perspective inspired contrasting topographies which, when shown as coexistent, reminded the viewer of the presence of the past. The sacred grove did not belong to a distant golden age, but to an idealized current reality.

Framing the Grove

The evocation of sacred sites on Roman walls reveals an interest not in the grove per se but in a previous recognition and articulation of such places as sacred. Recreated in fresco, groves seen in views, votive tablets, and literary *topoi* become features of a new setting and thereby assume a new meaning. The implications of this fact for the viewing experience have rarely been explored. They are central to our understanding of the pastoral nature of Roman landscapes.

On Roman walls the sacred grove provided a partial perspective, a penetrable fragment complex within itself, bounded yet unresolved within a highly activated framework. That framework is a study in surfaces, beginning with the actual layers of plaster and leading the eye through a colorful display of simulated textures and overlapping planes. Painted, life-size architecture separates into distinct zones with illusionistic openings. Modeled statues and panels, integrated into the receding setting, enhance the impression of spaciousness, an effect further heightened by color and the fictive activity of light.

The grove must be understood as one aspect of this dialectic between space and surface in which replication and translation extend into multiple levels of illusion. Indeed the different spaces and styles of landscapes may refer to prototypes in wood, gold plate, stucco, and possibly in glass, papyrus, and tapestry as well. The eclectic designs are a natural result of the additive and formulaic method of fresco painters, who reduced and expanded motives, schemes, and even whole compositions to adapt to new settings. In this larger framework—as in the single landscapes—linear and atmospheric perspective, light and shadow, and the interplay of color unify the discrete parts into a harmonious whole, inviting the viewer to apprehend a new associative network. The simple nature shrine, then, achieves significance in opposition to the material splendor of the human-made forms containing it.

In each mode of wall design in the first centuries B.C. and A.D. the grove presents an antithesis to the spectator's own space.[24] This occurs in various ways. The illusionistic prospect in the vertical center of the single wall, a privileged place that relates directly to the viewer's axis, operates like a window by inviting one into a separate world (fig. 15). But the very key to its fiction, the believable corporeal forms of the foreground—usually a high socle or cultic objects placed strategically between the vista and the room—obstruct access to the desirable space. Separated by successive layers of architectural illusion, the spectator regards but cannot enter the ideal arena.[25]

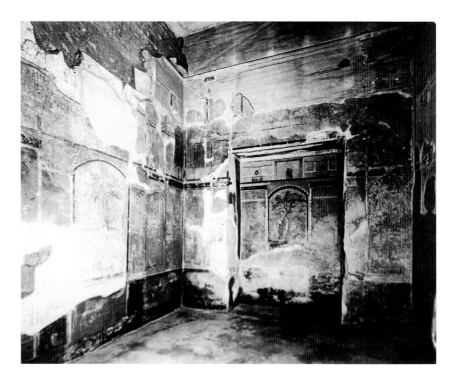

15. View of caldarium 8, Villa at Oplontis: panel on left with tree winding around column, third style; panel on back wall with Hercules in the Garden of the Hesperides, fourth style
Postcard photograph

A still more subtle play of access and denial occurs in the miniaturized vignette placed in the center of a panel (fig. 16). The purest form of Roman landscape, the vignette is the spatial unit from which all other landscapes build. Its relation to the surface reveals the layering process of fresco, and its composition, with the main axes of the scene parallel to those of the framework, binds elements to a geometrical coordinate system. But the vignette's intrinsic relation to the surface is deceptive, for on approaching or focusing on the scene the viewer observes a conflict between its internal geometry and surrounding color so that the grove recedes into and projects from the wall in a movement contrary to that of its frame.[26]

The illusionistic prospect and the miniature vignette charge the spectator with the task of gauging spatial relations while re-

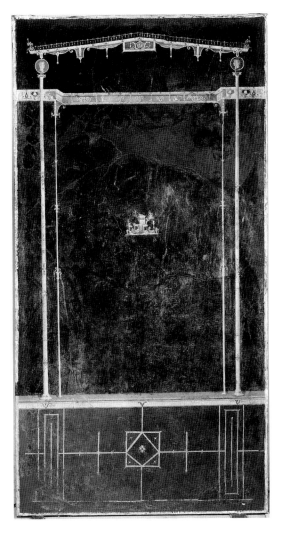

16. Portion of Black Room wall, Villa of Agrippa Postumus, Boscotrecase, third style, last decade of first century B.C. Metropolitan Museum of Art, Rogers Fund 1920

ceiving ambiguous visual cues. The use of invisible and thus immeasurable voids between depicted objects and between the viewer and the scene blurs the line between actual and painted space. Similarly, in another mode, a series of vignettes is scattered across a monochrome surface without a common horizon or reference point, so the eye oscillates between competing centers, combining the discrete scenes into a larger whole (fig. 17). The lack of static resolution or visual rest is especially pronounced on the illusionistic yellow panels of a side wall in the villa at Oplontis (fig. 18). Here illogically stacked views of sacred spots with trees towering over temples and tiny sacrificing figures confuse the effects of projection and reflection, presenting the viewer with competing and incompatible spatial realities.

The ambiguous illusions animating the central section of the wall occur above eye level as well. In the horizontal ribbon of space running around the top of the room one might glimpse groves over a *trompe l'oeil* wall, follow miniature scenes across black, yellow, or red bands, or isolate small framed panels (*pinakes*) propped on the cornice. Again, each reading requires a different perceptual process. The transparent vista raises the spectator to an impossible, elevated angle that contradicts the rules dictated by the painted architecture below. In monochromatic friezes the eye journeys laterally from object to object and forward and backward between close-up and distant views, building continuity and breadth in the landscape. The rhythmic shifts of this serial reading prevent the frieze from being taken in at one glance, effecting an optical experience like that of walking along a colonnade. The small *pinakes*, apparently straightforward in identity and thus initially accessible, also deceive in their interaction with the surrounding design. Set on a cornice, they affirm their own weight in relation to that of the framework (fig. 19), but placed between the planes suggested by the painted superstructure, they cannot be resolved within the spectator's primary frame of reference (fig. 20).

The distinct perceptual modes of landscape, while primarily determined by

the larger design, may also be explained by their intended reference. Views seen through columns or over cornices had status value in the Hellenistic world, connoting tourism and dominance through the appropriation of a chosen space. Similarly, portable panels depicting landscapes attained considerable value as gifts, as collectors' items, and as votive offerings and were often dedicated and hung in shrines of gods or in *pinacothecae*, buildings erected specifically for their display. The ambiguous monochromatic surfaces of yellow, black, and red recall materials such as parchment, marble, and metal rather than the atmosphere and transitory effects of natural landscape.[27]

On Roman walls, however, each form of the grove presents the viewer with a paradox by revealing features that negate its own illusion. Herein lies the fundamental difference between the ancient images and the European easel paintings of pastoral. Within the intricate constructs of wall designs, pastoral conflicts occur on a number of levels. The dialogue between nature and monument described in the individual pictorial structure classifies the single scene as pastoral. Yet through its very representation the grove becomes divorced from its original nature as a sphere of growth and change. Abstracted, codified, and transposed into two dimensions, the painted images embody an opposition of nature and artifice. When perceived within a new decorative framework, this conflict is amplified into a clash between the natural scene and the overt materialism of the setting, an antithesis that is modified by the consistent color and lighting that join the parts into a coherent whole. Once again the grove is bounded by artifice—now together with its wider domain—and it assumes a new status among other signs of civilization and nature. As a result the viewer, who is centered within a fictive structural space and pulled between sensations of access and denial, perceives images of the grove in which others participate and witness the sacred, but the viewer has no pure experience of the idyllic moment. Visually inviting, the grove allows little rapport with its viewer, leaving the sense of a spiritual gap.

17. Drawing of two sections of black walls from corridor C (now faded), Villa Farnesina, Rome, third style, c. 20 B.C. Museo Nazionale, Rome. From A. Reinach, *Repertoire de peintures grecques et romaines* (Paris, 1922), pl. 62

18. Section of yellow panel, antechamber of room 14, Villa at Oplontis, second style, third quarter of first century B.C. Author photograph

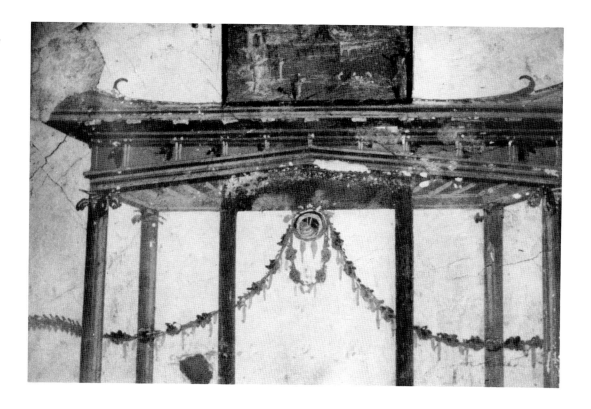

19. Wall fragment from
Herculaneum, fourth style,
mid-first century A.D.
Museo Archeologico Nazionale,
Naples, 8583. Author photograph

20. View of corner of room 78,
Domus Aurea, Rome, fourth
style, c. A.D. 64–68
From R. Bianchi Bandinelli, *Rome:
The Center of Power* (New York 1970),
fig. 368

Domestic Groves

The transformation in meaning of sacred space on interior walls parallels widespread changes in the domestic sphere in the first centuries B.C and A.D. Images of groves—made accessible through inviting spatial structures, yet detached and removed by a series of competing frames—make sense when considered in the wider architectural context, and particularly in the way actual groves were incorporated into and evoked by that context. The pastoral conflicts evident in single images and in their relation to larger wall designs unfold in the overlapping spaces of the *domus*, where the viewer's experience of inside and outside, art and nature, old and new, provides resolution. Indeed, Roman images of groves can only be understood as part of a shifting attitude toward the landscape that reshaped domestic design.[28]

The current taste in building and painting can be detected in Vitruvius' handbook of architecture written for the educated man of his time. According to Vitruvius, architecture should express the status of the patron or god for whom it was built. Just as the shrine conveyed the nature of the deity, the arrangement of the rooms of a house should correspond to the rank of each occupant.[29] Essential to maintaining decorum and a sense of hierarchy was the orientation of the viewer. Rooms should be sited with respect to the corners of the world, the times of day, the seasons, and the winds. The proportions of architectural elements should be adjusted for the host or guest of honor positioned at a certain spot. Archaeological evidence corroborates the priority given to the view in domestic design. While the person standing at the threshold or lying on his *kline* was presented with an overwhelming image that could be explored piecemeal, the moving viewer could enjoy multiple perspectives in porticoes designed both for the fleeting glance and protracted contemplation.[30]

In short, the geometric frames of doors, windows, and columns functioned like the painted frames on walls, enhancing the continuum of experience by expanding architecture, admitting light and air, and leading the eye into deep shafts of space.

21. View from entrance through atrium to peristyle, House of the Vettii, Pompeii (VI,15,1), 79 A.D.
Postcard photograph

When one looked through a house along its central axis, solid walls and columns limited the view, directing the gaze into the illuminated open space of the peristyle (fig. 21). Thus also in mural decoration the apparently real columns and podia of the foreground led into fictive apertures and depicted landscapes (figs. 15, 16, 17). In each case architecture framed and isolated a spatial dimension, objectifying the external world for the chosen witness.

Remarks by homeowners illuminate the artistry of view-making from the late republic on. One *topos* that can be corrob-

orated by extant remains describes the views seen through windows of a room as distinct landscapes. Pliny the Younger enjoyed the "three seas" captured in three windows of a room in his villa, while another room incorporated the contrasting spheres of sea, forest, and sky. The arrangement of windows in houses and villas built on the Bay of Naples in the first century A.D. reveals the popularity of multiple views in one space, where the spectators would have rotated their heads from one lively picture to another (fig. 22). If the large-scale painted architecture on walls corresponds to views within and outside the built interior, the individual landscapes set within the painted architecture are like outdoor prospects progressing from order to wilderness, materiality to atmosphere. Ancient viewers reported that in looking into the distance the eye jumped over separate buildings on hills and along waterways, just as it does over the spatial units in scattered landscape compositions.[31]

The desire to blur the line between vision and representation, an impulse that shapes much of Roman painting, is clearest when real views become part of the decorative scheme. In the villa at Boscotrecase, painted landscapes were linked to the space of the room by a common light source, a door offering a view of the Bay of Naples, so that actual and depicted vistas formed pendants in the unified design. The implication of this decor—that an actual view is as much a translation of reality as a representation—was expressly stated by Romans, who noted that views through windows and reflections on water or on marble panels produce similar images in which objects emerge only indistinctly through diffused light. Again, such observations of optical effects must have influenced the creation of paintings, for in many landscapes colors shift or fall back into the distance, fading into a light-gray, filmy mist where figures and objects appear as translucent shadows (figs. 7, 12, 14).[32]

Pastoral, as we have defined it, involves a meaningful and harmonious representation of a confused or conflict-ridden reality. The simple scenes of nature painted on walls and captured in windows and colonnades manifest that conflict on a basic

22. View through windows of apse, second floor room, Mansion of Fabius Rufus, Pompeii (VII Insula Occidentalis 16–19), mid-first century A.D.
Author photograph

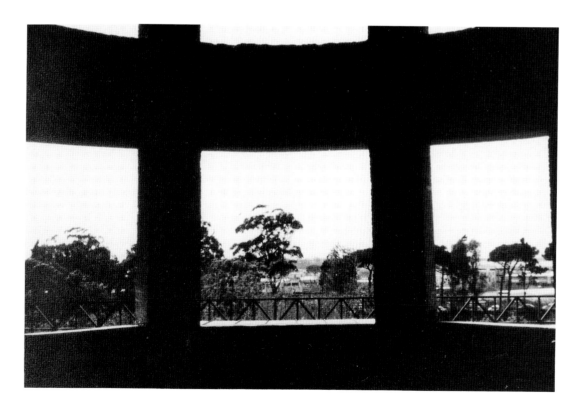

level of cognition. The initial perception of the landscape, its subsequent depiction, and its reception all involve mere images, reflections, or substitutes for the place, whose essence cannot be purely or directly grasped. This assumption underlies Pliny's comparison of a painting with a beautiful prospect seen from his villa. By equating a painting with a view, Pliny acknowledged the power and the artifice of vision and affirmed the status of appearance, thereby calling reality into question.[33]

The duality or tension apparent in the combined perspectives of Roman walls not only reveals an understanding of the nuances of optical activity but manifests a creative use of the shortcomings or deceptions of vision. A debate in the first century B.C. focused on whether visual rays issued from the eye or from the object seen. Both theories assumed that vision involves an intersection between the eye and the external world. The form of this juncture was variously interpreted. Lucretius explained that our ability to perceive distance resulted from a series of films, or *diaphanes*, between the object and the eye. The more air that intervened, and the longer the air flowed through our eyeballs, the more remote was the object.[34] Such an explanation elucidates the basic principle of Roman architectural and pictorial design, in which layers of overlapping planes convey depth. Indeed, the play of space and surface on Roman walls articulates distinct *diaphanes*, each of which is isolated and must be perceived separately in a process that expands space and, as Lucretius tells us, time as well. The activated wall with its projecting colors, receding forms, and landscapes oscillating between ambivalent planes taps the potential energy both in the object seen and in the viewing eye.

By exploiting the gullible character of sight, an architect or painter could create illusions that placed viewers in the center of an ideal sphere, thereby empowering them. Cicero, in the midst of designing his villa, joked in a letter to Atticus about whether the source of the rays of vision should determine the size of his windows. Only in cases in which the rays emanate from the object, he argued, would it be necessary to enlarge the windows to accommodate the images entering from outside. In Roman houses, however, things outside did not have a life of their own; they existed only in the act of being seen. The spectator defined and oriented his world. Indeed, viewing became an act of fundamental social significance, and views, like the artistic luxuries displayed in the home, lent the owner status.[35]

One popular focus of painted and contrived prospects in Roman homes was the grove. At the same time that Varro began documenting vanishing sites, proud owners boasted their own sacred trees, shrines, and cultic objects. Although the objects were robbed of their intended function, the votive flavor of the artifact, with its own history, increased its value. Single trees became as expensive as marble columns, and rural sanctuaries were recreated in peristyles and backyards, as in the small House of the Moralist in Pompeii where a grove of Diana, the familiar setting in paintings identifiable by its tree, shrine, and statue of the goddess, formed a focal point for reclining diners. Even the pious dedications of epigrams and votive *pinakes* resonated throughout house interiors; on one Pompeian wall an echo of a Hellenistic epigram accompanies a painted scene of a fisherman, hunter, and fowler making a dedication to Pan.[36]

The closest three-dimensional counterpart to the unified and expansive landscapes painted on interior walls was the luxury villa, a new phenomenon in the late republic and an arena charged with pastoral moments. In instances in which entire sanctuaries were absorbed into private estates, as with the archaic *lucus Feroniae* attached to the great villa of the Volusii, the possession of a space that by its very nature was immune to worldly values must have given the owner an elevated sense of power and grandeur. The sacred center became one focal point among many in his domain. Like the paintings, villas displayed a new kind of landscape both within their confines and in the views they "possessed."[37]

The popularity of variegated views must be understood as part of a changing attitude toward the land, its parceling, its ownership, and its new historical and religious

value. On the one hand, houses and villas connoted new wealth; on the other, they became symbols of regional and ancestral ties, which, like sacred groves, were cherished as the vanishing sites of ancient tradition.[38] An agricultural owner himself, Varro articulated the current confusion of status with regard to private land: "Isn't this villa, which our ancestors built, simpler and better than that elaborate villa of yours?" To him the pastoral way of life with its vital connection to the land offered a link to the venerable past:

How can that be a villa, if it has neither the furnishings of the city nor the appurtenances of the country? . . . if your place is to be commended for its pasturage, and is rightly called a villa because cattle are fed and stabled there, for a like reason that also should have the name in which a large revenue is derived from pasturing.[39]

In singling out herdsmen, cattle, and other signs of agriculture as the necessary elements of a villa, Varro emphasized their current value. Ownership of ancient farm buildings, herds, and the lands that were grazed in different seasons was as desirable in the middle of the first century B.C. as were Hellenistic royal parks and palaces. Inland, Italians were called "rich in flocks," "rich in sheep," or simply "rich in herds"; at the seaside their fisheries provided them with exotic fish. Agricultural and defensive buildings no longer in use became attractive garden structures. A villa's resident shepherds and fisherman bred small species solely for the luxury of the dinner table.[40]

The new status of the rustic explains its popularity as a subject of representation. The possession of trees, shepherds, and antiquated wooden statues of nature deities affirmed the owner's nationalism and *pietas*. Varro claimed: "Why, your villa is plastered with paintings, not to speak of statues; while mine, though there is no trace of Lysippus or Antiphilus, has many a trace of the hoer and the shepherd," and Martial, in a kind of reverse snobbery, called the Priapus of an extremely wealthy owner on his little farm a "nobile . . . opus."[41] Again, the landscape paintings visualize these topical contrasts, combining fashionable classical statues with simple rustic forms; while Priapus guards the grove, glittering statues are propped on pedestals and framed by wooden structures (fig. 1).

The elevated views in paintings recall the landowners' privileged perspectives, in which the sight of family tombs and honored old trees were a reminder of the owners' genetic ties, privately employed fishermen and shepherds of their self-sufficiency, and shrines and votives of the gods' protection of their proud possessions. Horace said that the happy man spent his days surveying his grazing herd and pruning his trees. And Pliny left the upper part of his villa open in order to survey his *domus* and watch the fishermen going about their duties. To some, the sight of sailors, shepherds, and fishermen at work conjured up an ideal of breeding and tradition. Varro claimed that getting along with them was a sign of an owner's *humanitas*.[42]

Descriptions of villa views repeatedly stress their *amoenitas*. Especially pleasing to look at and energizing for the senses was the sacred grove.[43] Roman owners clearly delighted in the structured, progressive vistas that imposed regularity on the landscape. The same aesthetic informs Roman paintings, which counteract the transitory effects of nature and compensate for optical weakness by bringing the distant and imperceptible into view. In regarding the harmonious scenes, the ancient spectator's status as a privileged, ordering agent was affirmed.

The ideal landscape or "complete" villa could be created *ex novo*, as in the Domus Aurea of Nero, a country villa in the city. Here villages, woods, fields, and shepherds and their flocks were set on the shores of an artificial lake as a pendant to the monumental colonnades of the city. From his *domus* Nero enjoyed viewing the familiar *topia* of poetry and painting. One particularly potent Roman image of goats (*pecora*) scattered across a hillside betrays literary inspiration (figs. 1, 5, 13, 14). In an eclogue written in 41 B.C., the year of land assignment, Virgil describes the farm restored by Tityrus. The farmer sits in the shade among his streams, and gazes at goats that

from a distance appear to hang on a hillside. For Lucretius the same image served as a metaphor for the atomistic structure of the visible world.[44]

The domestic setting, in sum, was a sphere of dialectical reconciliation, combining signs of old and new, foreign and indigenous, piety and luxury. In paintings, sacred groves adjoined palatial porticoes. In gardens, urban, rural, and exotic emblems combined in picturesque arrangements. And on expansive villa estates, as far as the eye could see, the visible landscape with its various constellations was unified by the privileged view. Thematically and visually the grove pervaded the *domus*, invested, Varro informs us, with new values of ancient purity and modern wealth at a time of intense political and cultural upheaval. Contrived appearance and symbolic association provided pastoral resolution for the private owner, who was both witness to and agent of new formations in the landscape.

Roman images of the grove have been considered in light of broadening definitions of the pastoral. The impact of modern art and changes in art historical methodology have caused an erosion of old categories and criteria so that specific formats and representational motifs have given way to more general principles. Thus an abstract painting evoking a certain space and mood can be defined as pastoral. Furthermore, painting must be recognized as one of many possible forms of pastoral expression, which, along with music and literature, arises from a cultural movement called pastoralism. Essential to each mode of pastoral is a perceptible conflict between nature and civilization. That conflict finds resolution through representation and reception.

In its pictorial structures, which focus on a human-made form in nature, the Roman grove appears as a realm of harmony and contrast. Within the design of a room as a whole the opposition between the sacred spot and the overt materialism of its architectural framework is modified by such formal means as symmetry and color. Roman wall paintings indeed present compelling ensembles of nature and artifice, extending the pastoral conflict to the act of viewing itself.

It should not come as a surprise that intense upheaval in Roman society of the late republic and early empire stimulated the creation of images embodying the basic pastoral conflict. At a time when its old meaning was in danger of being lost, the grove was one aspect of the visual world to be singled out by Romans and invested with new meaning. Its representation registers an aesthetic response to dramatic changes in the ownership and structure of the land. Seen in isolation, the pious scene recalls a previous existence, stirring recognition of the inner meanings of Roman culture and its religious core values. Within the design of the house the sacred node becomes secularized and peripheral. In viewing the painted walls, the Roman spectator glimpsed sweeping surveys of an ideal terrain where opposites were brought into concord, space was bounded, and time contained. Architecture mediated between the spectator's own mobility and a captured, static image of the world, challenging one to assess status—of the present, the past, the luxury object, sacred space, and ultimately of one's own relationship to nature.

NOTES

I am grateful to B. Conticello and A. Varone of the Soprintendenza Archeologica di Pompei and to E. Pozzi of the Soprintendenza Archeologica di Napoli for permission to work on the landscape paintings, to the Getty Grant Program for its support, and to John Dixon Hunt, Richard Brilliant, and Michael T. Davis for their incisive comments.

Dimensions of paintings, which are approximate, are given in inches, height preceding width:

Fig. 3. 37 x 26	Fig. 7. 32 x 33	Fig. 11. 22 x 29
Fig. 4. 15 x 33	Fig. 8. 39 x 39	Fig. 14. 50 x 49
Fig. 5. 28 x 38	Fig. 9. 8 x 21	Fig. 19. 9 x 20
Fig. 6. 21 x 33	Fig. 10. 30 x 30	

1. For sources on the invention of the pastoral see Robert C. Cafritz, Lawrence Gowing, and David Rosand, *Places of Delight: The Pastoral Landscape* [exh. cat., Phillips Collection and National Gallery of Art] (Washington, 1988), with its extensive bibliography. Although the Roman paintings make up the earliest corpus of landscape representations, there are numerous isolated examples from earlier periods. The West House frescoes from Thera, the Tomb of Hunting and Fishing at Tarquinia, the Hunt Scene on the Tomb of Philip at Vergina, and various Hellenistic reliefs show that the depiction of a unified landscape setting was thought appropriate in certain contexts from the time of the Bronze Age.

2. David Rosand, "Giorgione, Venice, and the Pastoral Vision," and Lawrence Gowing, "The Modern Vision," in Cafritz et al. 1988, 21–81, 183–248.

3. Leo Marx, "Does Pastoralism Have a Future?" in this volume; Denis Cosgrove, *Social Formation and Symbolic Landscape* (Sydney, 1984); Denis Cosgrove and Stephen Daniels, eds., *The Iconography of Landscape* (New York, 1988).

4. Although similarities between selected literary passages and landscape paintings have been amply demonstrated, there has been no evaluation of the paintings in relation to the art historical genre. For parallels see Eleanor Winsor Leach, *Vergil's "Eclogues": Landscapes of Experience* (Ithaca, 1974); Leach, "Sacral-Idyllic Painting and the Poems of Tibullus' First Book," *Collection Latomus*, vol. 39 (Brussels, 1980), 47–79; and Leach, *The Rhetoric of Space* (Princeton, 1988). See also J. M. Croisille, "Poésie et art figuré de Neron aux Flaviens: Recherches sur l'iconographie et la correspondance des arts à l'époque impériale," *Collection Latomus*, vol. 179 (Brussels, 1982); the attempt to relate the landscapes to contemporary political issues by Susan Silberberg-Peirce, "Politics and Private Imagery: Sacral-Idyllic Landscapes in Augustan Art," *Art History* 3 (1980), 241–251, is based on a problematic identification of patrons; more convincing is the short discussion by Paul Zanker, "Bukolische Projektionen," in *Augustus und die Macht der Bilder* (Munich, 1987), 284–290. The classic study of bucolic themes is Nikolaus Himmelmann, *Uber Hirten-Genre in der antiken Kunst* (Opladen, 1980); subsequent works on bucolic figures are Eva Bauer, *Fischerbilder in der hellenistischen Plastik* (Bonn, 1983); H. P. Laubscher, *Fischer und Landleute* (Mainz, 1982); on precedents see Phyllis Maureen Carroll, *Greek Classical and Hellenistic Stone Relief Sculpture with Landscape Motifs* (Ann Arbor, University Microfilms, 1983); an insightful discussion of the bucolic theme in sculptural reliefs is Henner von Hesberg, "Das Münchner Bauernrelief: Bukolische Utopie oder Allegorie individuellen Glücks?" *Münchner Jahrbuch der bildenden Kunst* 37 (1986), 7–32. Luba Freedman, *The Classical Pastoral in the Visual Arts* (New York, 1989), provides a list of bucolic motifs.

5. David M. Halperin, *Before Pastoral: Theocritus and the Ancient Tradition of Bucolic Poetry* (New Haven, 1983), 70–71.

6. The ancient distinction between a sacred tree and a grove is difficult to discern in the paintings, where a single tree may signify a larger wooded area. On ancient groves see D. E. Birge, *Sacred Groves in the Ancient Greek World* (Ann Arbor, University Microfilms, 1982); Ingrid Edlund, *Location and Function of Sanctuaries in the Countryside of Etruria and Magna Graecia (700–400 B.C.)* (Rome, 1987); on sacred trees see Carl Bötticher, *Der Baumkultus der Hellenen* (Berlin, 1856).

7. Bettina Bergmann, *Sacred Groves and Sunlit Shores: The Roman Art of Landscape* (Princeton, forthcoming). The traditional categories of the "sacral-idyllic," "villascape," and "mythological landscape" are misleading. The fact that they are often combined in a single composition warns against the use of such artificial distinctions.

8. This interpretation is substantiated by contemporary comments. Cicero, *Tusculanae disputationes*, 5.65, and Martial, *Epigrams*, 1.88, among others, note the ruinous state of ancient tombs, while Strabo, *Geography*, 17.3.12, regards the ruined watchtowers in the Mediterranean as proof of Augustan peace. For an interpretation of the crumbling sacred enclosure in the Munich Peasant Relief see Von Hesberg 1986, 23.

9. For a discussion of this painting as a continuous narrative based on a Euripidean tragedy see Eleanor Winsor Leach, "The Punishment of Dirce: A Newly Discovered Continuous Narrative in the Casa di Giulio Polibio and Its Significance Within the Visual Tradition," *Römische Mitteilungen* 93 (1986), 118–138; and Leach 1988, 333–339. That many mythological landscapes are structured with the same schemes as non-narrative ones has not been fully acknowledged; on this category see Christopher M. Dawson, *Romano-Campanian Mythological Landscape Painting*, Yale Classical Studies 9 (New Haven, 1944).

10. On liminality see Victor Turner, *Dramas, Fields, and Metaphors* (Ithaca, 1974), 197–259; on boundaries and the demarcation of sacred space see Birge 1982; Edlund 1987; Georges Dumezil, *Archaic Roman Religion*, vol. 1 (Chicago, 1966), 340–353.

11. On the augural process see Hubert Cancik, "Rome as a Sacred Landscape: Varro and the End of Republican Religion in Rome," *Visible Religion* 4-5 (1985-1986), 250-263. On private dedications see Henner von Hesberg, "Bemerkungen zu Architekturepigrammen des 3. Jahrhunderts v. Chr.," *Jahrbuch des deutschen archäologischen Instituts* 96 (1981), 55-119. In Pompeii several inscribed slabs record the building of colonnades, temples, and other buildings; one tells how a citizen rebuilt the Temple of Isis at his own expense (*Corpus inscriptionum Latinarum*, 10.846).

12. On inscribed paintings see A. F. Gow, ed., *The Greek Anthology: Hellenistic Epigrams* 2 (Cambridge, 1965), 52; for the themes see W. Elliger, *Die Darstellung der Landschaft in der griechischen Dichtung* (Berlin, 1975), 380-390; Von Hesberg 1981, 55-119.

13. Vitruvius, *De architectura*, 7.5.2. On this passage in relation to the categories of Roman landscape see Roger Ling, "Studius and the Beginnings of Roman Landscape Painting," *Journal of Roman Studies* 67 (1977), 1-16.

14. For the slaughter of a goat see Philip 15, *Anthologia palatina*, 6.99; for the dedication of a goat's image see Leonidas of Tarentum 82, *Anthologia palatina*, 9.744. For other offerings of shepherds, fishermen, and travelers see Gow 1965; A. F. Gow, ed., *The Greek Anthology: The Garland of Philip and Some Contemporary Epigrams*, 2 vols. (Cambridge, 1968).

15. Virgil, *Georgics*, 3.322-338; Gerhard Schönbeck, *Der Locus Amoenus von Homer bis Horaz* (Heidelberg, 1962). For other comments on the pleasure of the grove—a poet finding shelter from the heat under an oak, for instance—see Antiphilus 33, *Anthologia palatina*, 9.75; Lucretius, *De rerum natura*, 2.29; Horace, *Carmina*, 23.9; Tibullus, *Elegies*, 1.1; on parallels between Tibullus' rustic landscapes and third-style vignettes see Leach 1980, 47-60.

16. *Anthologia palatina*, 9.282; 9.312; 9.706.

17. On the religious constraints on felling trees see Russell Meiggs, *Trees and Timber in the Ancient Mediterranean World* (Oxford, 1982), 378; on the archaic Roman laws protecting trees see Pliny, *Naturalis historia*, 17.1.7-8; on Actium and Nicopolis see Strabo, *Geography*, 7.7.6; on triple Hecate see Virgil, *Aeneid*, 6.13. For other sacred trees and groves see Pliny, *Naturalis historia*, 16.85-91; Giorgio Stara-Tedde, "I boschi sacri dell'antica Roma," *Bollettino della Commissione Archeologica Communale di Roma* 33 (1905), 187-232.

18. On the emotion felt in groves see Seneca, *Epistulae*, 41.3; Ovid, *Metamorphoses*, 8.741; Quintilian, *Institutio oratoria*, 10.1.88; Virgil, *Aeneid*, 8.597-598. On signs of antiquity see Ovid, *Metamorphoses*, 8.741. On Cerveteri see Virgil, *Aeneid*, 8.597-598. On Falisci see Ovid, *Fasti*, 3.13. On Arician grove see Ovid, *Fasti*, 3.267, 3.269; Athenaeus 15.13.41.

19. Lucan, *Pharsalia*, 1.143-163. Propertius, *Elegies*, 3.13.47, trans. H. E. Butler (Cambridge, Mass., 1939), 225; on an infrequently visited shrine see Propertius, *Elegies*, 2.19.13; Martial, *Epigrams*, 1.88; Pliny, *Naturalis historia*, 2.63, trans. H. Rackham (Cambridge,

Mass., 1938), 291. On the diminishing number of sacred groves due to urban development see Pierre Grimal, *Les jardins romains* (Paris, 1969), 166-168.

20. On the fall of Roman religion in the republic see Cicero, *De natura deorum*, 2.9; Cicero, *De legibus*, 2.33; Cicero, *De republica*, 5.1.2; on recovering the past see Varro, *De lingua Latina*, 5.49; Cicero, *Academica posteriora* 9 (test.1); J. A. North, "Religion and Politics, from Republic to Principate," *Journal of Roman Studies* 76 (1986), 251-258; Arnaldo Momigliano, "The Theological Efforts of the Roman Upper Classes in the First Century B.C.," *Classical Philology* 79 (1984), 199-211.

21. Burkhardt Cardauns, *M. Terentius Varro. Antiquitates rerum Divinarum* (Wiesbaden, 1976), 147-148; Lucretius, *De rerum natura*, 5.47; Quintilian, *Institutio oratoria*, 10.1.88; Pliny, *Naturalis historia*, 12.1-2, trans. H. Rackman (Cambridge, Mass., 1945), 5. For strains of primitivism and antiprimitivism in the first centuries B.C. and A.D. see Arthur O. Lovejoy and George Boas, *Primitivism and Related Ideas in Antiquity* (New York, 1973), 222-388.

22. For the building types in the landscapes see M. Rostovtzeff, "Die hellenistisch-römische Architekturlandschaft," *Römische Mitteilungen* 26 (1911), 1-185. Ancient wooden shrines became evocative symbols in public art of the Augustan period. Thus Salvatore Settis interprets the interior of the enclosure wall of the Ara Pacis, which is a translation into marble of a wooden countryside enclosure such as those seen in the paintings, as an allusion to the emperor's religious revival: "Die Ara Pacis" in *Kaiser Augustus und die Verlorene Republik* [exh. cat., Martin-Gropius Bau] (Berlin, 1988), 400-425. The earliest surviving representation of a grove is part of a continuous frieze running around the upper part of the atrium wall in the Villa of the Mysteries in Pompeii, identified as a representation of the Nile: Amadeo Maiuri, *La Villa dei Misteri* (Rome, 1931), 47, 200, 235; figs. 11, 83-84. On the aniconic monuments in the scenographic vistas of the House of Augustus on the Palatine see Gianfilippo Carettoni, "La decorazione pittorica della Casa di Augusto sul Palatino," *Römische Mitteilungen* 90 (1983), 373-419; M.-Th. Picard-Schmitter, "Bétyles Hellénistiques," *Monuments et mémoires publiés par l'académie des inscriptions et belles-lettres* 57 (1971), 43-88. On the *porta sacra* see Laura Dall'Olio, "Il motivo della 'porta sacra' nella pittura romana di paesaggio," *Collection Latomus*, vol. 48 (Brussels, 1989), 513-531.

23. At this time pasturage was conducted on private estates, in different parts of Italy under the supervision of Rome, and by nomads living on the margins of society. Carmine Ampolo, "Rome archaïque: une société pastorale?" in *Pastoral Economies in Classical Antiquity*, Cambridge Philological Society, suppl. 14 (Cambridge, 1988), 120-133.

24. Most research on Roman landscapes has concentrated on their place within the four chronological styles of wall painting proposed by August Mau a century ago, *Geschichte der dekorativen Malerei in Pompeji* (Berlin, 1882). Although a firm date is essential to

any interpretation of historical material, this analysis considers groves on walls painted between 60 B.C. and A.D. 79 as a representative group. Interestingly, the basic schemes persist throughout this period despite major changes in overall wall design.

25. On the ambiguity of illusionistic apertures see August Mau, "Tafelbild oder Prospekt," *Römische Mitteilungen* 18 (1903), 222–273.

26. The classic example of this format is the third-style frescoes from the Villa at Boscotrecase, which have been eloquently described by Peter von Blanckenhagen and Christine Alexander, *The Augustan Villa at Boscotrecase*, with contributions by Joan R. Mertens and Christel Faltermeier (Mainz, 1990). Several panels have been restored at the Metropolitan Museum of Art in New York: Maxwell L. Anderson, "Pompeian Frescoes in the Metropolitan Museum of Art," *Metropolitan Museum of Art Bulletin* (Winter 1987–1988), 37–54.

27. On the frieze as a view see Klaus Fittschen, "Zur Herkunft und Entstehung des zweiten Stils: Probleme und Argumente," in *Hellenismus im Mittelitalien. Kolloquium in Göttingen vom 5. bis 9 Juni 1974*, ed. Paul Zanker (*Abhandlungen der Akademie der Wissenschaften in Göttingen, Philologisch-Historische Klasse*, 3d ser., 97 [1976]), 539–563. On *pinakes* see A. W. Van Buren, "Pinacothecae: With Especial Reference to Pompeii," *Memoirs of the American Academy in Rome* 15 (1938), 70–81. Actual votive tablets were in use at the time the walls were painted: Horace, *Carmina*, 1.5.13–16. On the secularization of votive *pinakes* in the private house of the first century B.C. see Heidi Froning, *Marmor-Schmuckreliefs mit griechischen Mythen im 1. Jh. v. Chr.* (Mainz, 1981), 33–47; on their translation into paint on Roman walls see Eric M. Moormann, *La pittura parietale romana come fonte di conoscenza per la scultura antica* (Assen/Maastricht, 1988), 36–39. On the fashion of cutting marble into thin slabs see Heinrich Drerup, *Zum Ausstattungsluxus in der römischen Architektur* (Münster, Westfalen, 1957); Pliny mentions that it was introduced into Rome in the first century B.C.: *Naturalis historia* 36.48–50. Clearly an important influence on the depicted spatial relationships was the function of the room, an aspect which has only recently begun to receive attention. See Strocka 1984; Alix Barbet, *La peinture romaine* (Paris, 1985); Andrew Wallace-Hadrill, "The Social Structure of the Roman House," *Papers of the British School at Rome* 51 (1988), 43–97.

28. On the new status of the *domus* in these years see Wallace-Hadrill 1988; Timothy Peter Wiseman, "Conspicui Postes Tectaque Digna Deo: The Public Image of Aristocratic and Imperial Houses in the Late Republic and Early Empire," in *L'Urbs: Espace urbain et histoire (Ier siècle av. J. C. - IIIe siècle ap. J. C.)* (Rome, 1987), 393–413; Richard Saller, "Familia, Domus, and the Roman Conception of the Family," *Phoenix* 38 (1984), 336–355; Elaine K. Gazda, ed., *Roman Art in the Private Sphere* (Ann Arbor, 1991).

29. Vitruvius, *De architectura*, 6.5.1–3. On the concept of *natura* for the choice of a proper site and building

for the intended god see *Vitruvio, dei libri I-VII*, ed. and trans. Silvio Ferri (Rome, 1960), 228–229; Alster Horn-Olcken, *Über das Schickliche: Studien zur Geschichte der Architekturtheorie. Abhandlungen der Akademie der Wissenschaften in Göttingen, Philologisch-Historische Klasse*, 3d ser., 70 (1967), 33–35. F. W. Schlikker, *Hellenistische Vorstellungen von der Schönheit des Bauwerks nach Vitruvius* (Berlin, 1940); Lise Bek, *Towards Paradise on Earth: Modern Space Conception in Architecture: A Creation of Renaissance Humanism*, Analecta Romana 11 (Copenhagen, 1979), 164–203.

30. Heinrich Drerup, "Bildraum und Realraum in der römischen Architektur," *Römische Mitteilungen* 66 (1957), 147–174; Bek 1979. On the different structures of views created within the house see Franz Jung, "Gebaute Bilder," *Antike Kunst* 27 (1984), 71–122.

31. Pliny, 2.17.13. For other passages on rooms with separate views see H. J. Van Dam, *P. Papinius Statius: Silvae Book 2, A Commentary* (Leiden, 1984), 239–240. From Cicero's Formianum, a "superior villa," one could see Ischia, Vesuvius, and Misenum over the porticoes stretching down the mountain slope to the beach of Baiae: O. E. Schmidt, *Ciceros Villen* (1899; Darmstadt, 1972), 28. Pliny's estates offered a number of staggered views over meadows or porticoes to the sea: E. Lefevre, "Plinius-Studien. Römische Baugesinnung in der Landschaftsaffassung in den Villenbriefen (2, 17; 5, 6)," *Gymnasium* 84 (1977), 519–541. The orientation of extant villa remains shows similar visual goals; from the Villa dei Misteri in Pompeii one looked first to the gulf of Castellammare, then to the peninsula of Sorrento, ending at the isle of Capri. For a collection of these sources and others see Jutta Römer, *Naturästhetik der frühen römischen Kaiserzeit* (Frankfurt, 1981).

32. For an isometric plan showing the series of painted rooms containing landscapes in Boscotrecase see Anderson 1987, 36. Lucretius, *De rerum natura*, 4.130–139, trans. R. E. Latham (New York, 1979), 133: "the reflections that we see in mirrors or in water or any polished surface have the same appearance as actual objects. They must therefore be composed of films given off by those objects." Statius compares the encrusted marbles to the views through windows in a Sorrentine villa: Statius, *Silvae*, 2.2.75–97.

33. Pliny the Younger, *Epistulae*, 5.6.13. An object and its representation were often regarded as indistinguishable: Raimund Daut, *Imago: Untersuchungen zum Bildbegriff der Römer* (Heidelberg, 1975). On the platonic metaphor of painting for appearance see Eva Keuls, *Plato and Greek Painting* (Leiden, 1978). On the confusion of view and prospect in painting see Mau 1903.

34. Lucretius, *De rerum natura*, 4.1.–322. On *diaphanes* see Drerup 1959, 147–174; Burckhardt Fehr, "Plattform und Blickbasis," *Marburger Winckelmannsprogramm* (1969), 56–58.

35. Cicero, *Epistulae ad Atticum*, 2.3.2; Drerup 1957, 150. A. Rodger, *Owners and Neighbors in Roman Law* (Oxford, 1972), 124–140.

36. On the absorption into the private context of sacred places see Filippo Coarelli, "Architettura sacra e architettura privata nella tarda repubblica," in *Architecture et société de l'archaïsme grec à la fin de la république romaine*. Collection de l'Ecole française de Rome, 66, ed. Pierre Gros (Rome, 1983), 191-217. On trees as luxury items see Pliny, *Naturalis historia*, 17.1. For a venerable old plane tree in an estate as a metaphor for the elemental *agon* between earth and water see Statius, *Silvae*, 1.3.61-64. For a tree that symbolizes family tradition and continuity see Statius, *Silvae*, 5.3.50. Remains of trees within houses have been found; note especially the old chestnut tree that shaded the peristyle of the villa at Oplontis: Jashemski 1979, 290. On the grove of Diana in the House of the Moralist in Pompeii (III.4.2-3) see Paul Zanker, "Die Villa als Vorbild des spätpompejanischen Wohngeschmacks," *Jahrbuch des deutschen archäologischen Instituts* 94 (1979), 488-489. On bucolic motifs in sculptural programs of Roman villas see R. Neudecker, *Die Skulpturenausstattung der römischen Villen in Italien* (Mainz, 1988), 54-59; Henner von Hesberg, "Einige Statuen mit bukolischer Bedeutung in Rom," *Römische Mitteilungen* 86 (1979), 297-317. On epigrams see Karl Lithey, "Dipinti pompeiani accompagnati di epigrammi greci," *Annali dell'Instituto di corrispondenza archeologica* 48 (1876), 294-314; Leach 1988, 220-222; Cicero, *Epistulae ad Atticum*, 1.13.1. The graffiti in Pompeii reflect the popularity of certain literary works such as Virgil's *Bucolica*: M. Gigante, "La cultura letteraria a Pompei," *Pompeiana* (1950), III-143; R. Etienne, *La vie quotidienne à Pompei* (Munich, 1966), 377-402; P. Ciprotti, "Brevi note su alcune scritti pompeiane," in Andreae and Kyrieleis 1975, 276.

37. On the *lucus Feroniae* see Filippo Coarelli, *I Santuari del Lazio in eta repubblicana* (Rome, 1987), 183. For a recent brief survey of the Roman villa with literature see Harald Mielsch, *Die römische Villa: Architektur und Lebensform* (Munich, 1987); Nicholas Purcell, "Town in Country and Country in Town," in *Ancient Roman Villa Gardens*, Dumbarton Oaks Colloquium on the History of Landscape Architecture, ed. Wilhelmina F. Jashemski, 10 (1984), 185-204.

38. John D'Arms, *Romans on the Bay of Naples: A Social and Cultural Study of the Villas and Their Owners from 150 B.C. to A.D. 400* (Cambridge, Mass., 1970), 29-33; D'Arms, "Proprietari e ville nel golfo di Napoli," in *Convegno: I Campi Flegrei nell'archeologia e nella storia, 4-7 Maggio 1976* (Rome, 1977), 347-364; G. A. Mansuelli, *Le ville del mondo romano* (Milan, 1958), II-17, on the roots of the villa in old Roman society; Susan Treggiari, "Sentiments and Property: Some Roman Attitudes," in *Theories of Property: Aristotle to the Present*, ed. A. Parel and T. Flanagan (Ontario, 1979), 53-85.

39. Varro, *De re rustica*, 3.2.3.; 3.2.10, trans. William D. Hooper (Cambridge, Mass., 1979), 431-435.

40. Horace, *Epistulae*, 1.14.1; 1.16.1; Horace, *Carmina*, 3.16.25; Horace, *Satirae*, 2.7.118. Helmut Dohr, *Die italienischen Gutshöfe nach den Schriften Catos und Varros* (Cologne, 1965), 38; Varro and his companions were such owners of large herds: *De re rustica*, 1.18.3; 2.4.3; discussing the suitable place for rearing animals, Virgil took his homeland as a model: *Georgics*, 2.195-202. Nicolaus Purcell, "The Roman Villa and the Landscape of Production" (forthcoming).

41. Varro, *De re rustica*, 3.2.6, Hooper (trans.) 1979, 431; Martial, *Epigrams*, 6.73, quoted in G. Steiner, "Columella and Martial on Living in the Country," *Classical Journal* 50 (1954-1955), 86. In an epigram Priapus warns the potential trespasser to stay away from a domestic sphere: "Farm-guardian I stand in wealthy fields, protecting the hut and plants," Antistus IV, Gow 1965, 127. On the appreciation of images in wood as symbols of a lost age of innocence see Meiggs 1982, 322-324. On rusticity as an element of *otium* see J. M. Andre, *L'otium dans la vie morale et intellectuelle romaine* (Paris, 1966), 36-482.

42. Horace, *Epodi*, 2.9-22; Pliny the Younger, *Epistulae*, 9.7.4; Varro, *De re rustica*, 1.17.4. See also Cicero, *Epistulae ad Atticum*, 2.13; Schmidt 1972, 28. On the significance of the bird's-eye view see D. Fehling, "Ethologische Überlegungen auf dem Gebiet der Altertumskunde," *Zetemata* 61 (1974), 39-58.

43. D'Arms 1970, 45, writes: "unlike the adjectives *iucundus*, *suavis*, or *dulcis*, *amoenus* is properly applied only to things affecting the sense of sight"; Bek 1979, 179, 180, 188; Römer 1981, 55, 70.

44. On the Domus Aurea see Suetonius *Nero*, 313.1-2; Tacitus, *Annales*, 15.40-43; Axel Boethius, *The Golden House of Nero* (Ann Arbor, 1960), 94-128; Laubscher 1982, 91, suggests that the figures around the lake were garden statues. On the image of distant goats on a hillside see Elliger 1967, 360; Virgil, *Eclogues*, 1.46-58; Klaus Garber, *Der locus amoenus und der locus terribilis: Bild und Funktion der Natur in der deutschen Schäfer- und Landlebendichtung* (Cologne, 1974), 93. On the relationship between landscape painting and literature in the Neronian and Flavian periods see Croisille 1978. On the new panegyrical meaning of the shepherd in the Neronian period see R. Vischer, *Das einfache Leben. Wort und motivgeschichtliche Untersuchungen zu einem Wertbegriff der antiken Literatur* (Göttingen, 1965), 126-147; G. Scheda, *Studien zur bukolischen Dichtung der neronischen Epoche* (Bonn, 1969).

Frontispiece: color reproduction courtesy of Deutsches Archäologisches Institut, Rome

ALFRED FRAZER
Columbia University

The Roman Villa and the Pastoral Ideal

Instinctively one turns to the villa when seeking an expression of the pastoral ideal in the repertory of Roman architectural forms. Not, of course, to the *villa rustica*, the working farmstead of a simple country-man citizen, or to the edifice built or acquired by a more prosperous Roman as an investment, but to the *villa urbana*, the villa *de luxe*, which, as its name implies, contained amenities and representational spaces appropriate to the city mansions of the elite. It also possessed certain elements more difficult to construct in—or not entirely suitable to—city dwellings: extensive porticoes and pavilions, water displays, landscaped gardens, and parklands, where pastoral sentiments might find apt expression. As a setting for country life artistically considered, which is, in part the subject of pastoral poetry, the *villa urbana* was a defining feature of the material and social culture of the Roman ruling class in the late Republican and Imperial periods.[1] This paper will explore a few ways in which one may perceive the effect of Graeco-Roman pastoral poetry and the ethos it evoked on the physical form and embellishment of Roman villas.

The pastoral ideal of unfettered, free-spirited shepherds, herdsmen, and fishermen, earthy by nature yet capable of nymph-inspired song—as originally expressed by Theocritus and later by Virgil and his contemporaries—and the phenomenon of *villeggiatura*, of sojourning in the countryside, are perhaps not naturally complementary if the two are rigidly construed. In the creation of the large villa *de luxe* the individual human staffage of the pastoral landscape was banished to make way for large crews of servile laborers whose working conditions were antithetical to poetic elaboration and reflection on the freedom and spontaneity of country life.[2] Indeed, it has been argued that Horace's nature poetry cannot be called truly idyllic because almost all of his poems ascribed to that genre contain, at their core, a villa.[3] The man-made artifact obtrudes on the landscape of the *locus amoenus*, and as the *villa rustica*, the simple farm, evermore ceded primacy to the *villa urbana* in the rural landscape of central Italy in the last two centuries B.C., so the *villa urbana* increasingly dominated and compromised the natural grove, glade, and grotto so central to the pastoral sensibility.

This view, however, is too rigid and unrealistic. The Roman ruling class of the Republic apparently originated the concepts of rural *otium* and *villeggiatura*.[4] Theocritus was read and appreciated and pastoral poetry did flow from Latin pens. The paradox of the shepherd's untrammeled nature and the villa owner's well-tended gardens is more apparent than real, for if the villa was an artifact of pretense imposing a self-conscious interpretation by a cultivated elite on a natural world and its rustic

inhabitants, so the essence of pastoral poetry is equally artificial.[5] Both were conceived *de haut en bas*. If, in fact, Theocritus was the poetically inclined city man wayfaring in rustic climes in the guise of Simichidas in idyll 7 so, too, was the Roman villa's *dominus* or master vicariously a Simichidas viewed through the roseate, distorting lens of Theocritus. Through such a transference the entire world of the pastoral became available to the Roman ruling elite in its larger expropriation of Hellenistic culture.[6] To Romans the presence in the Hellenistic world of a culturally sanctioned pastoral ideal must have seemed an especially attractive *objet trouvé*, given the ideological mystique of the agrarian life characterized by tough farming and hard fighting already existing in Italy prior to the Roman conquest of the Greek East and so well subsumed in retrospect by Virgil:

His [the farmer's] unstained home guards its purity; the cows droop milk-laden udders, and on the happy turf, horn to horn, the fat kids wrestle. The master himself keeps holiday, and stretched on the grass, with a fire in the midst and his companion wreathing the bowl, offers to thee, O god of the wine-press, and for the keepers of the flock sets up a mark on an elm for the contest with the winged javelin, or they bare their hardy limbs for the rustic wrestling match. Such a life the old Sabines once lived, such Remus and his brother. Thus, surely, Etruria waxed strong, thus Rome became fairest of all.[7]

This moralistic nativist cast was, however, foreign to the development of *villeggiatura*, with its strongly Hellenistic coloring. What might be admirable in programmatic poetry was not necessarily serviceable to the ideology of the Roman nobility and the architecture constructed for its rural setting. The question is how the Romans in their seats of *otium* manifested, in concrete architectural form and decor, an appreciation and acceptance of the pastoral ideal. The answer is, perhaps, to be more easily found in the paintings with which they chose to embellish the walls of their villas than in the fabric of the villas themselves.[8] In architectural terms the available areas of expression were limited, owing to the heterodox nature of the villa

de luxe and the different functions—physical, social, and ideological—that it had to serve. For an exploitation of the pastoral ideal, a great villa's *pars rustica* and *pars fructuaria*, those zones given over to agricultural production, were excluded, for they were for serious business. They were devoted to maximizing the profits from plough agriculture, orti- and viniculture, stock rearing, and, if the villa lay close enough to an urban market, to market gardening. This aspect of villa life left no room for rustic attitudinizing.[9]

The *pars urbana*, the living quarters of the master and mistress of the villa, offered greater opportunities, but even here they were limited. The residence itself was large and elaborate. It was the locus of representation and *luxuria*, its atrium serving much the same purpose with respect to the villa owner's local clientele as did its counterpart in the city mansion with regard to his urban following. The same could be said for its elaborate triclinia. Even its peristyles, *ambulationes*, and *gestationes* were sophisticated, not rustic. We would be wrong to see anything pastoral in Cicero's evocation of his brother Quintus' improved villa near Laterium, of which Cicero writes after inspecting the property:

The proposed additions will be charming. Your gardener won my praise. He has covered everything with ivy, not only the foundation walls, but also the intercolumniations of the ambulationes that the Greek statues seem to be hedge cutters and to be selling their wares.[10]

Suggestive as ivy and hedge cutters may be of things rustic, the latter are marmoreal members of the villa's domestic *familia*, trimming the vines into artificial shapes conforming to the architectural configuration of the structure.

At the truly rustic level, we read of the existence in some villas of a *cella pauperis*,[11] "which was apparently an austere room or suite standing in apposition to the luxury of the remainder of the villa, perhaps as Marie Antoinette's *hameau* did to Versailles, or the Emperor Francis Joseph's Spartan bedroom to the rest of the Hofburg. This feature may have functioned somewhat like a hermitage in an eighteenth-century English park. But it did not form a conspicuous element in the villa repertory.

We are essentially left with only the more extended grounds of the villa as the best locus for pastoral expressions. Paradoxically, we find this fact best documented in Nero's Golden House, the famous site of *rus in urbe*. Among its features, Suetonius lists "a landscape garden consisting of ploughed fields, vineyards, pastures, and woodlands—where every variety of domestic and wild animals roamed about."[12] I would take wild animals to mean not feral beasts appropriate to a menagerie, although some villa parks apparently possessed these, but woodland animals such a boar, deer, and hares, the normal inhabitants of *leporaria*.[13] The domestic animals were those pastoral favorites: goats, sheep, and perhaps even cattle—the livestock of the bucolic idiom. Ploughed land implies ploughmen to till the soil, vineyards called for vine-dressers, and the animals required shepherds, goatherds, and gamekeepers—a kind of living staffage drawn from the *dramatis personae* of pastoral and bucolic poetry.[14] No matter that these were imperial slaves; they were slaves playing parts in an idyllic landscape.

The scene evoked by Suetonius is both like and quite different from one pictured by Virgil:

Yet theirs is repose without care, a life that knows no burden but rich in treasures manifold. Indeed the ease of broad lands, caves and natural lakes and cool valleys, the lowing herd, and soft slumbers beneath the trees—all are theirs. They have woodland glades and haunts of game.[15]

Despite the similarity of meadows, glades, and game, Virgil's and Nero's landscapes are worlds apart. Virgil projects a picture, however idealized, of nature inhabited and experienced by real country folk, freeborn farmers. The setting is evoked in their terms. Nero's image, as interpreted by Suetonius, is voyeuristic. The park is inhabited by servile laborers who, like the crops, vines, and animals they tend, are elements in a picture to be viewed and read from a distance—in this case from the terraces and the halls of the Golden House.[16] Virgil's and Nero's views, one in words and the other in turf, illustrate what happened to the pastoral ideal in Roman thought and practice from the age of Octavian to that of

the last of the Julio-Claudians. Increasing distance from the initial poetic impulse led to a hardening and codification of garden and architectural conceit and category. Inspiration was transformed into topos.

If Virgil's lowing herd is basically functional and Nero's animals are play actors, at least the latter were relatively free to move about in their park. And yet European museums are filled with sculptural representations of deer, sheep, goats in abundance, hounds, hares, and boars—in short, all manner of pastureland and woodland creatures—excavated at ancient Roman sites. Most of these are heavily restored, some even seem to be wholly cobbled up out of eighteenth-century cloth. The authentic works seldom have a provenance, but those few that do appear to have been found predominantly at villa sites, in the *horti*, or gardens, just beyond the walls of Rome or else in Romano-Campanian dwellings whose features replicated in miniature those of villas.[17]

Not unlike the cast-iron cervine herds that populated the nineteenth-century gardens of American suburban villas and country seats, these sculptures must have served as features in the parks and gardens of Roman villas—more tractable, certainly more static, and less troublesome than their real-life models. Some, such as stags and hounds, must have conjured up ideas of the hunt, not an idyllic pursuit but one important to *villeggiatura*.[18] Leaving aside these animals and the ones patently related to Dionysiac imagery, there remains an enormous population of sheep and goats, especially goats, the pastoral animal par excellence so frequently found in Theocritus and in sacro-idyllic landscape paintings (fig. 1). Many such animals, all horns and hair, are reminiscent of Theocritus' lines:

I go to serenade my Amyrillis.
My goats are grazing on the mountainside,
Tityrus in charge. Tityrus, my darling,
watch the goats, then drive them to the spring.
Watch the Libyan, Mustard, or he'll butt you.[19]

The world of artificial inhabitants of villa grounds was not restricted to animals. The entire sculptural genre of farmers, farm women, and fishermen ap-

pears to have been deployed by Romans in natural or naturalized settings, no matter how these figures may have been displayed in the Hellenistic era. The well-known headless figure in the Museo Palazzo dei Conservatori, Rome, of an elderly person, now identified as an old shepherd, dressed partly in an animal-skin mantle and carrying a lamb, was found on the site of a *hortus* in Rome (fig. 2).[20] Shepherd, mantle, and lamb are outspokenly pastoral. Given the figure's villa provenance, other less well-located figures of the type may be ascribed to a similar milieu. Whether this figure and those like it represented humble farm folk on their way to market or en route to a rustic sacrifice cannot be determined on the basis of present evidence.[21] Comparison with parallels in sacro-idyllic paintings and stone reliefs indicates that either destination is possible, and both are equally pastoral in nature.[22]

Sculptures of fishermen abound; some fourteen examples of a well-known figure in dark stone of the so-called Seneca type are in the Musée du Louvre (fig. 3).[23] We know the provenance of only three of them—a bath, a nymphaeum, and a villa—all three from aqueous settings.[24] In the first century B.C. ichthyomania reached a fever pitch among the Roman elite, *piscinae* or fish ponds of elaborate forms were features of maritime villas on the coasts of Latium and Campania, and stories featuring fish proliferated. We may well restore the Louvre fisherman and his brethren to the sides of villa pools filled with oratas, triglie, seppie, and all of the species documented in Apicius and in Roman fish mosaics.[25] In such a setting these petrified piscators may have recalled to the master of the villa and his guests the moral in the Theocritean idyll 21: "Hunt real fish, or you'll perish of hunger and your golden dreams."[26] Indeed, seek not only illusionary fish of gold, a point in the poem, but real oratas, a species whose name may have been shared with the great Republican fish fancier and villa owner C. Sergius Orata.[27]

Even figures not normally related to a villa and its gardens may originally have been situated in such settings. A possible candidate is the famous seated figure of a bronze boxer in the Museo Nazionale delle Terme in Rome (fig. 4).[28] Found in 1884 in an area near the site of the Baths of Constantine, it has been reasonably associated with the decoration of a *palaestra*, or exercise ground, in the baths, but the figure is, of course, much earlier in date, perhaps mid-first century B.C. Is it possible that it came to the baths from one of the not-too-distant *horti*, all of which had long before been absorbed into the imperial patrimony? The boxer's identification continues to be a subject of dispute. One identification, first proposed some forty years ago by Phyllis Lehmann, would see in the figure a representation of Amykos, on the basis of its correspondence to the description in Theocritus' idyll 22 of the legendary inventor of boxing with leather thongs.[29]

In it the Dioskouroi, embarking on the Berbrycian shore, came upon a monstrous figure:

And there sat basking a man of prodigious size and aspect, his ears scarred over with welts that fists had raised, his chest rounded monstrously and his back a broad expanse of forged flesh— for all like an armor-plated colossus. The muscles stood out sharply at the head of his brawny arms like the rounded stones which a winter torrent rolls and grinds smooth with its powerful eddies.[30]

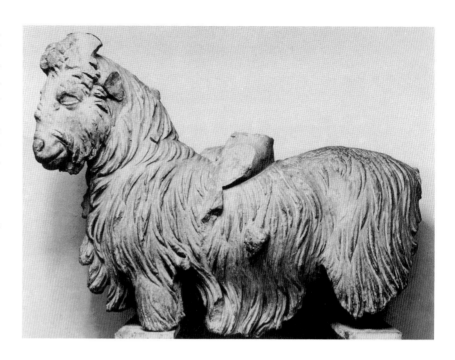

1. Ram with fragmentary rider, marble
Museo Palazzo dei Conservatori, Rome

But Lehmann did not cite the lines immediately preceding these:

And Castor, the swift horseman, and swart Polydeukes sought solitude together, and wandered away from their comrades to inspect the wild wood of every kind on the mountainside. Under the smooth rock they found a living spring, brimming with water; the pebbles gleamed from its depths like crystal or silver; nearby grew lofty pines, poplars, planes, and the pointed crests of cypresses, and as many scented flowers—work beloved of the furry bees—as carpet the meadows when spring is ending. And there sat basking a man of prodigious size. . . .[31]

These lines are the definition of a *locus amoenus*, central to the pastoral ideal, but here we find "a man of prodigious size and aspect," like a brutish fly captured in idyllic amber, an aberrant version of the theme of *et in Arcadia ego*. Strictly speaking, Theocritus' idyll 22 is not a pastoral poem, but how carefully would a Roman villa owner observe the confines of the genre if he found in the Theocritean canon a subject so well suited to serve as a conversation piece in the *locus amoenus* of his garden?

The taking of a simple out-of-doors meal is a recurring theme in pastoral poetry, and actual *al fresco* dining was a frequent practice in Roman *villeggiatura*. In the garden of the house of D. Octavius Quartio in one of the less built-up quarters of Pompeii we find even today a small, artificial watercourse, covered by an arbor, which begins in a little fountain set in an artificial, pumice-clad grotto flanked by a *biclinium* for informal dining (fig. 5).[32] This modest feature of a Pompeian house may remind one of lines from Theocritus' idyll 7, the harvest festival:

Eucritus and I and pretty Amyntas turned toward Phrasidimas' farm, and laid us down on soft beds of scented rushes and new-stripped vine leaves, while overhead rustled many a poplar and elm, and near at hand from the nymphs' cave splashed sacred water. On the shady boughs, the scorched cicadas carried on the chirping labor, and the tree frog croaked far off in the dense thorn brake. Larks and linnets sang and the turtledove made moan, and the bees zoomed around and about the fountain.[33]

Mutatis mutandis, what Theocritus' lines and the modest eating arrangement at Pompeii have in common are simple out-

2. Old man carrying a lamb, marble
Museo Palazzo dei Conservatori, Rome

3. Old fisherman
Musée du Louvre, Paris

door dining, a grotto or cave—that is to say, an abode of the nymphs—a spring or fountain and a watercourse, and a chorus of birds and insects providing dinner music. Despite these similarities in the imagery of the poem and the architectural setting, it may be doubted whether the bourgeois householder was consciously attempting to replicate the mood of the Hellenistic poet in his idyll. This little construction, as Paul Zanker has shown in his discussion of it and other Pompeian *comparanda*, was a topos derived from more elaborate manifestations of art imitating poetry to be found in contemporary and earlier villas of the cultivated Roman upper classes.[34] The Pompeian *plaisance* is an example of both pastoral trickle-down and trickle-in.

From this simple dining arrangement and its Theocritean parallel two features representative of the effect of the pastoral sensibility on features of the Roman villa are clear: the actual provisions for dining and their setting. I will review these in reverse order. At Pompeii the diners took their meal before a grotto in miniature, but not all Roman grottos were so small. Let us consider only one, the Smaller Grotto in the so-called seaside Villa of Cicero at Formia.[35] Basilican in form, it is quite sophisticated in comparison to many grottos, its articulation by a classical order overgrown by a primitive accretion of pebbles, shells, and pumice stone. It seems a proleptic illustration of the Abbé Laugier's evolutionary theory of architecture.[36] The grotto, illuminated by reflections from the sea, is an enchanted space of earthly delight. And, if we take into consideration Theocritus, idyll 2, it is an erotic vessel imploring to be penetrated. Thus his goatherd's serenade:

Amyrillis, my sweet, why don't you peek out
and invite me into your cave these days?
Am I not your sweetheart? Do you hate me?
Could it be that at close quarters,
girl, you find me snub-nosed,
or stub-hearted? You make me go swing!
Here—I've brought you apples, ten,
picked from the spot you told me yourself.
Tomorrow I'll go to fetch you more.
Look at me, won't you—stricken with this
 love ache!
I'd have entrée then to your cave—
zoom through your ivy and fern-leaf screen![37]

4. Seated boxer, bronze
Museo Nazionale delle Terme, Rome

The grotto in the so-called Villa of Cicero at Formia is part of the villa's *basis villae*. We recall that the same feature in Cicero's brother's villa was ivy clad. But could ivy have grown at the seaside? Theocritus' idyll 3 suggests that it could:

In a moment you'll make me tear this garland
in shreds—and I was bringing it to you.
Amyrillis! Dear one! It's ivy,
twined with buds and celery.
Alas, poor devil that I am!
This is unbearable. Won't you hear me?
I'll take off my cloak and jump into the sea
from the point where Olpis the fisherman keeps
watch for tuna. Either I'll drown,
or at least your vanity will be tickled.[38]

As to the actual arrangements for out-door dining, we find the original simple semicircle of diners in a painted scene from a *columbarium* of the Augustan period in Rome (fig. 6).[39] Although the context is funerary, the scene must have been sufficiently familiar in everyday life to carry recognition and conviction. The diners recline on a mattress called a *stibadium*, a term derived from the Greek verb meaning to strew—that is, to strew rushes and branches for a rustic couch of the sort encountered in Theocritus' idyll 7.[40] A somewhat more elegant version of this is found in a scene from the famous Nile Mosaic at Praeneste, which is dependent on a Hellenistic model (fig. 7).[41] Although in it the diners repose on couches laid on rectangular benches, these too appear to be arranged in a curve.

In the course of the first century A.D. the simple *al fresco* semicircle seems to have become a fixed, concrete form in villa architecture. A number of semicircular rooms opening onto villa gardens have been variously identified as *scholae*, *exedrae*, and *diaetae*. Probably they were all shaped to conform to a semicircular *stiba-*

5. View toward the *nymphaeum* and *biclinium* in garden
House of D. Octavius Quartio, Pompeii

6. Outdoor dining party, *columbarium*
Villa Pamphili, Rome

7. Detail of the Nile Mosaic
Museo Archeologico Nazionale,
Palestrina

8. Detail of the Small Hunt
Mosaic, Piazza Armerina
From Gentili

dium or *sigma*. As evidence that the curved form persisted in Roman outdoor dining for a long time, witness the Little Hunt mosaic from the fourth-century A.D. villa at Piazza Armerina (fig. 8).[42]

At the San Marco Villa above Stabiae on the Sorrentine Peninsula there are two rooms facing one another across a garden (fig. 9).[43] At the southeastern end of the garden's axis there is a grotto-nymphaeum whose waters flowed into a stream— a Euripus—running down the center of the garden, which is planted with plane trees.[44] It appears that the basic elements of the simple dining layout at the House of D. Octavius Quartio have here been pulled apart, and the *disiecta membra* rearranged in a larger and more imaginative fashion. The right-hand room faced northeast and thus would have been ideal for shaded summer use, while the left-hand chamber facing southwest could have been used in comfort in the cooler months.[45]

A room of similar form is found in the easternmost and latest wing of the great villa at Oplontis (Torre Annunziata, room 78), probably of Neronian date (fig. 10).[46] It lacks a grotto, but the deep recess at its rear may have contained some appropriately evocative sculpture. The room faced a fountain in the form of a marble neo-attic bell crater, placed at the end and on axis with a large *natatio* whose adjacent border was embellished with a sculpture representing an aggressive satyr and a no-less-resolute hermaphrodite. Beyond these and on axis with room 78 were two additional sculptures of unknown subjects set against a planted background.[47] A chamber of similar form appears in Domitian's villa at Sabaudia (modern San Felice Circeo) where the view is of the sea (fig. 11).[48]

Even more significant in the transformation into a rigidly codified architectural construct of an originally simple semicircle of outdoor conviviality, shaded by poplars and sung to by cicadas in their noontime concert, is the Canopus in Hadrian's Villa near Tivoli (fig. 12).[49] Here the semicircular *kline* or *stibadium*, literally cast in concrete, is set within a vast vaulted grotto-hemicycle once sheathed in marble and mosaic. Behind and above it was a grottolike *nymphaeum*, mysteriously illuminated, that was fed by its own aqueduct, whose waters gushed forth from

9. Plan of the San Marco Villa, Stabia
From Mielsch

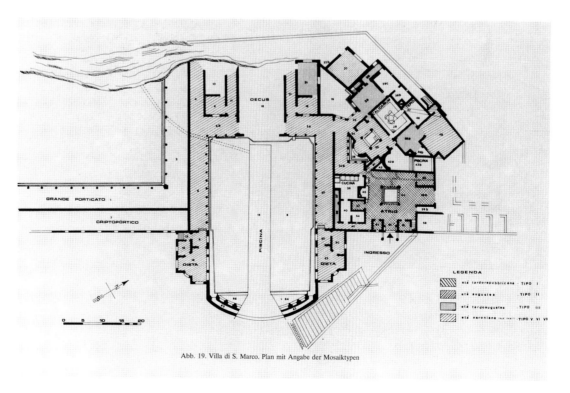

Abb. 19. Villa di S. Marco. Plan mit Angabe der Mosaiktypen

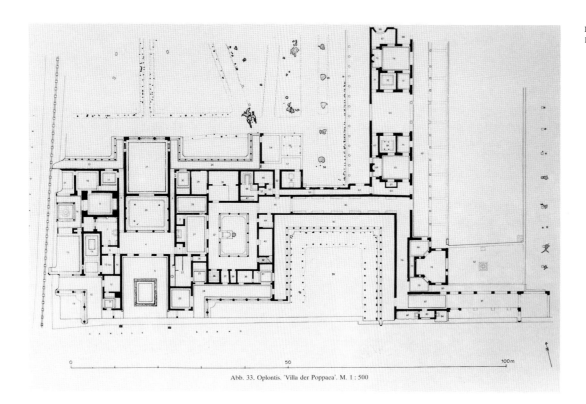

10. Plan of the Villa at Oplontis
From Mielsch

Abb. 33. Oplontis. 'Villa der Poppaea'. M. 1 : 500

11. Plan of the bath complex
and adjoining room,
Domitian's Villa, Sabaudia
(San Felice Circeo)
From Mielsch

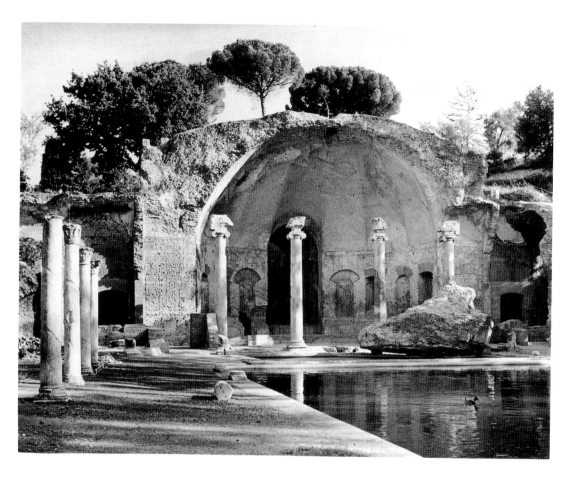

the semicircular wall behind the *stibadium* to reappear in the watercourse that was surely more a Nilus than a Euripus. In the Canopus we are a long way from the site of Simichidas' simple, locust-serenaded repast of Theocritus' idyll 7, but somehow the memory lingers on. That this is so is characteristic of the design approach in Hadrian's Villa, the acme of Roman architecture, whose architects were armed with a unique and sovereign knowledge of prior Roman building and its history. Old forms were rearranged and reinterpreted in a new and imaginative whole, whose ultimate appeal stems from the recognition by the cognoscenti of their humble, remote, and at the same time, poetic origins.

NOTES

1. Harald Mielsch, *Die römische Villa: Architektur und Lebensform* (Munich, 1987), esp. 95-140.

2. M. I. Finley, *The Ancient Economy* (Berkeley and Los Angeles, 1973); *Società romana e produzione schiavistica*, ed. A. Giardina, A. Schiavone, 3 vols. (Rome, 1981), esp. vol. 1, *L'Italia, insediamenti e forme economiche*.

3. Thomas G. Rosenmeyer, *The Green Cabinet: Theocritus and the European Pastoral Lyric* (Berkeley, Los Angeles, and London, 1969), 182-183.

4. J. André, *L'otium dans la vie morale et intellectuelle romaine* (Paris, 1966).

5. David Lodge, *Working with Structuralism* (London, 1981), 177: "the conventions of . . . pastoral poetry are already artificial and understood as such by author and audience." See also Frank Kermode, ed., *English Pastoral Poetry from the Beginnings to Marvel* (London, 1952), 1 ("to us it probably suggests the word 'artifice' rather than the word 'natural'"), and 14.

6. Paul Veyne, "The Hellenization of Rome and the Question of Acculturations," *Diogenes* 106 (Summer, 1974), 1-27.

7. Virgil, *Eclogues* 10: 42-48.

8. Eleanor Winsor Leach, *The Rhetoric of Space: Literary and Artistic Representations of Landscape in Republican and Augustan Rome* (Princeton, 1988), 197-306, with previous literature; see also the article by Bettina Bergmann in this volume.

9. Columella, *De re rustica*, 1,2,1, trans. H. B. Ash, vol. 1 (Cambridge, Mass., 1941): "whenever the chance offers, [the villa owner] should stay in the country; his stay should not be an idle one nor one *spent in the shade*."

10. Cicero, *Epistulae ad Quintum, fratrem*, 3,1,5, trans. W. Glynn Williams, *Letters to His Brother Quintus* (Cambridge, Mass., 1953).

11. Seneca, *Epistulae Morales*, 18,7; 100,6; Martial, 3,48. The term is defined in *The Oxford Latin Dictionary*, s.v., as "a bare room affected by the rich."

12. Suetonius, *Nero*, 31,1, trans. Robert Graves, *The Twelve Caesars* (Baltimore, 1957).

13. Varro, *De re rustica*, 3,3,3, specifying the boar, the deer, and the hare; Mielsch 1987, 21-22.

14. Varro, *De re rustica*, 3,3,4, lists fowlers, hunters, and fishermen.

15. Virgil, *Georgics*, 2,467-471.

16. Heinrich Drerup, "Bildraum und Realraum in der römischen Architektur," *Römische Mitteilungen* 66 (1959), 147-174.

17. Richard Neudecker, *Die Skulpturen-ausstattung römischer Villen in Italien* (Mainz, 1988), 54-60, esp. 57-60; Eugene J. Dwyer, *Pompeian Sculpture in Its Domestic Context: A Study of Five Pompeian Houses and Their Contents* (Ann Arbor and London, 1977), 266-267; Wilhelmina F. Jashemski, *The Gardens of Pompeii, Herculaneum and the Villas Destroyed by Vesuvius* (New Rochelle, N.Y., 1979), 67, for the Casa dei Cervi, Herculaneum (VI, 21).

18. Jacques Aymard, *Les chasses romaines des origines à la fin du siècle des Antonins* (Paris, 1951), 159-198, esp. 185-198.

19. Theocritus, idyll, 3, 1-5, trans. Anna Rist, *The Poems of Theocritus* (Chapel Hill, 1978).

20. Christine Häuber in *Le tranquille dimore degli dei: La residenza imperiale degli horti Lamiani*, ed. Maddalena Cima and Eugenio La Rocca (Rome, 1986), 100-102, with previous literature.

21. Neudecker 1988, n. 58; Nikolaus Himmelmann, *Über Hirten-Genre in der antiken Kunst* (Opladen, 1980), 87-91; Eva Bayer, *Fischerbilder in der hellenistischen Plastik* (Bonn, 1983), 189-190; differently, Hans-Peter Laubscher, *Fischer und Landleute; Studien zur hellenistischen Genreplastik* (Mainz, 1982), 47-48.

22. Henner von Hesberg, "*Das Münchner Bauernrelief: Bukolische* Utopie oder Allegorie individuellen Glucks?" *Münchner Jahrbuch für Kunstgeschichte* 37 (1986), 7-32.

23. Laubscher 1982, 85-86.

24. Laubscher 1982, 85-86; a bath at Aphrodisias, a nymphaeum at Bibylos, and the great villa at Chiragan near Toulouse.

25. Mielsch 1987, 23-32; John H. D'Arms, *Romans on the Bay of Naples: A Social and Cultural Study of the Villas and Their Owners from 150 B.C. to A.D. 400* (Cambridge, Mass., 1970); Gioia Daniela Conta in Guilio Schmiedt, *Il livello antico del Mar Tirreno: Testimonianze dei resti archeologici* (Florence, 1972), 5-214, 236.

26. Theocritus, idyll 21, 66-67, trans. Thelma Sargent, *The Idylls of Theocritus: A Verse Translation* (New York, 1982). Modern critics have excluded it from the Theocritean canon; see A. S. F. Gow, *Theocritus*, 2 vols. (Cambridge, 1950), 2: 369-370.

27. Münzer, "C. Sergius Orata," in *Paulys Real-Encyclopedie der klassischen Altertums*, 2 A (1923), 1713-1714.

28. Werner Fuchs in Wolfgang Helbig, *Führer durch die öffentlichen Sammlungen klassischer Altertümer in Rom*, 4th rev. ed., vol. 3 (Tübingen, 1969): 184-185.

29. Phyllis L. Williams [Lehmann], "Amykos and the Dioskouroi," *American Journal of Archaeology* 49 (1945), 330-352. Her attribution has not found general acceptance, perhaps because it is part of a broader hypothesis that would see the boxer as part of a triadic composition, the other two figures being the so-called Hellenistic Ruler, found in association with the boxer and now in the same museum, and a hypothetical near mirror image of the boxer that represented the second of the Dioskouroi. One need not accept Lehmann's identification of the Hellenistic Ruler with one of the Dioskouroi to agree with her comparison of

the boxer with Theocritus' description of Amykos. For the attribution, but rejecting a third figure, see Martin Robertson, *A History of Greek Art*, 2 vols. (Cambridge, 1975), 1: 520; noncommittal, J. J. Pollitt, *Art in the Hellenistic Age* (Cambridge, 1986), 145–146; contra, Werner Fuchs in Helbig 1969, 185.

30. Theocritus, idyll 21, 42–48, trans. Anna Rist.

31. Theocritus, idyll 21, 33–41, trans. Anna Rist. On the basis of the fresh wounds that appeared during recent conservation of the statue, the identification as Amykos has been rejected by Nikolaus Himmelmann, *Herrscher und Athlet. Die Bronzen rom Quirinal* (Milan, 1989), 152.

32. V. Spinazzola, *Pompei alla luce degli scavi nuovi di Via dell' Abbondanza*, 2 vols. (Rome, 1953), 2: 404; Norman Neuerberg, *L'architettura delle fontane e dei ninfei nell'Italia antica: Accademia di archeologia, lettere e belle arti; Memorie*, n.s., 5 (Naples, 1965), 118–119; Eugenio La Rocca and Mariette and Arnold de Vos, *Guida archeologica di Pompei* (Verona, 1976), 243; Arnold and Mariette de Vos, *Pompei, Ercolano, Stabia* (Rome and Bari, 1982), 140–141; Baldassare Conticello, *Pompeii: Archaeological Guide* (Novara, 1987), 96. Since the first publication of the house of D. Octavius Quartio by Spinazzola, there has been a dispute concerning the name of the house's owner. Although of no importance to this discussion, the question can lead to confusion when one is reviewing the literature. Spinazzola 1953, 367, ascribed the ownership to D. Octavius Quartio, but in Amadeo Mauri, *La casa di Loreio Tiburtino e la Villa di Diomede in Pompei: I monumenti italiani*, ser. 2, fasc. 1 (Rome, 1947), 3–4, Roberto Pane ascribed it to one Loreius Tiburtinus. The latter attribution entered the literature as the common name of the house. Paavo Castrén, *Ordo Populusque Pompeianus: Polity and Society in Roman Pompeii. Acta Instituti Romani Finlandiae* 8 (Rome, 1975), 184, has demonstrated that there was never a Loreius Tiburtinus, and thus in the current literature the house appears under the name of D. Octavius Quartio on the basis of a bronze seal bearing that name found in the house. Lawrence Richardson, Jr., *Pompeii: An Architectural History* (Baltimore and London, 1988), 337–343, retains the traditional name and rejects the use of the *biclinium* for dining (340–341) owing to the lack of a table or space for it; the argument is unconvincing.

33. Theocritus, idyll 7, 140–148.

34. Paul Zanker, "Die Villa als Vorbild des späten pompeianischen Whongeschmacks," *Jahrbuch des Deutschen Archäologischen Instituts* 94 (1979), 473.

35. Neuerberg 1965, 145–147; G. F. Giuliani and M. Guaitoli, "Il ninfeo minore della villa detta Cicerone a Formia," *Römische Mitteilungen* 72 (1972), 191–219.

36. Marc Antoine Laugier, *Essai sur l'architecture* (Paris, 1753), frontispiece, 8–10.

37. Theocritus, idyll 2, 6–18.

38. Theocritus, idyll 3, 27–36.

39. Goffredo Bendinelli, *Le pitture del columbario di villa Pamphili* (Rome, 1941), 7, pl. 2, the earliest known representation of a *stibadium* in Roman painting.

40. L. B. van der Meer, "Eine Sigmamahlzeit in Leiden," *Bulletin Antike Beshaving* 59 (1983), 107–108, with previous literature.

41. Salvatore Aurigemma, "Il restauro di consolidamento del mosaico Barberini, condotto nel 1952," *Atti della Pontificia Accademia Romana di Archeologia, Rendiconti*, ser. 3, 30–31 (1957–1959), 59–62, demonstrates that the entire scene was remade in 1640 in the restoration following the damage to the mosaic in transport from Rome to Palestrina. The scene, like its duplicate in Berlin, must have been based on Cassiano Dal Pozzo's colored drawings of the undamaged mosaic made around 1614. Aurigemma supercedes Eva Schmidt, *Studien zum Barberinischen Mosaik in Palestrina* (Strasbourg, 1929), 56–60, and Giorgio Gullini, *I mosaici di Palestrina* (Rome, 1956), 39–40.

42. G. V. Gentili, *La villa Erculia di Piazza Armerina: I mosaici figurativi* (Rome, 1959), pl. XXI.

43. Olga Elia, "La villa stabiana di S. Marco," *Napoli Nobilissima* 2 (1962), 43–51; de Vos 1982, 322–326; Valentin Kockel, "Funde und Forschungen in den Vesüvstadten, I," *Archäologischer Anzeiger* (1985), 3: 531–536.

44. Jashemski 1979, 330–331

45. Vitruvius, 6, 4, 2.

46. Alfonso de Franciscis, "La villa romana di Oplontis," in *Neue Forschungen in Pompeji*, ed. Bernard Andreae and Helmut Kyrieleis (Recklinghausen, 1975), 9–36; Jashemski 1979, 314; de Vos 1982, 250; Kockel 1985, 550, who compares the chamber to the rooms in the San Marco villa.

47. Jashemski 1979, fig. 80; Stefano de Caro, "The Sculptures of the Villa of Poppea at Oplontis: A Preliminary Report," in Wilhelmina F. Jashemski, ed., *Ancient Roman Villa Gardens* (Washington, 1987), 96–100.

48. Giuseppe Lugli, "Circei," in *Forma Italiae: Latium et Campania, 1. Ager Pomtinus*, part 2 (Rome, 1928), 65–76; R. Righi, "La villa di Domiziano in località Palazzo sul lago di Sabaudia: Pavimenti in *opus sectile* dell'edificio balneare ad esedre," *Archeologia laziale* 3 (1980), 97.

49. Salvatore Aurigemma, *Villa Adriana* (Rome, 1962), 100–107; Eugenia Salza Prina Ricotti, "Water in Roman Garden Triclinia," *Ancient Roman Villa Gardens: Dumbarton Oaks Colloquium on the History of Landscape Architecture* 10 (1987), 175–177.

ELEANOR WINSOR LEACH
Indiana University

Polyphemus in a Landscape:
Traditions of Pastoral Courtship

Poussin's *Landscape with Polyphemus* of 1648 belongs to a group of the artist's later paintings that populate rich, expansive landscapes with figures whose full significance is often to be understood in relation to topographical complexity and atmospheric tone (fig. 1). As Anthony Blunt characterizes them, these landscapes represent the painter's expression of "a parallel between two productions of the supreme reason: the harmony of nature and the virtues of man."[1] In the Polyphemus landscape a luxuriously fertile countryside pre-empts the viewer's attention, which is further solicited by the sideways gaze of a nymph. Whether she is looking obliquely toward us or turning her eyes coyly toward the ground, her self-conscious posturing is evident. It is emphasized by the backward glance that one of her two companion figures casts toward a satyr leering in the shrubbery. In the middle distance a number of human figures, variously grouped, engage in a variety of rural occupations, some digging or plowing, some tending flocks, one kneeling to drink from an upraised vessel. The fertile landscape unites the two separate groups of demigods and agriculturalists, bridging the obvious difference between work and play so that each appears appropriate to its setting.

Because the composition grasps our attention in so directed a manner, the spectator may not instantly perceive, at the summit of a second craggy mountain rising above the leafy forests, the upper torso of a gigantic Polyphemus playing a pipe. So closely do his shaggy head and shoulders resemble the irregular outlines of the mountain that he appears as a second peak. The oblique turn of his figure conceals the greater part of his features, allowing just enough detail for him to be identified by the spectator. The starkness of the rocks and the isolation of the mountain enforce our impression of his solitude, which the fading aerial perspective dramatizes in an almost mystical way. The spectator should recognize that Polyphemus is serenading the sea nymph Galatea: an unseen audience. We may imagine her resting on the sea beyond the mountain range, and this inference adds a further imaginary dimension to the scene. Or is Galatea really not in Polyphemus' line of vision; is she instead that ambiguously flirtatious nymph in the foreground? Is it Polyphemus or the lurking satyrs who make her smile? This uncertainty calls into question the apparent divisions between the foreground and background areas of the landscape, making the composition immediately more complex.

Blunt calls attention to the visual difference between the verdant plain and barren mountains, by which he believes Poussin approximated contrasts typical of the real Sicilian landscape.[2] He explains this division by a reference to mythological history, recalling how "the Cyclopes stand for the

1. Nicholas Poussin,
Landscape with Polyphemus,
1648, oil on canvas
The Hermitage, St. Petersburg

Golden Age before the invention of agriculture when men lived off the fruits of the earth." By the terms of this reading the figures in the middle ground who practice the arts of agriculture embody the forces of change, while the isolated Polyphemus "symbolizes an age disappearing before the advance of man."[3] Although this explanation makes the visible structuring of the landscape readily legible, it still seems necessary to inquire how the Cyclops' preoccupation with Galatea might belong to this moment of transition.

Homer mentions the divinely favored community of the Cyclopes and also suggests Polyphemus' isolation even from his own kind. Odysseus describes the savage giant as "a man like a wooded peak of the high mountains standing away from the others."[4] All the same, the figure of the lonely, musical Cyclops whom we see here is scarcely Homeric. Two intermediary sources must be understood in the transmission of this image. One is the *Imagines* of Philostratus, a collection of mythologi-

cal *ekphraseis* of the second century A.D. to which Renaissance painters often alluded visually in order to lend classical authority to their paintings.[5] Philostratus' description shows us a landscape inhabited by Cyclopes who are harvesting the spontaneous produce of earth and vine.[6] Among them he points out an ugly Polyphemus singing beneath an ilex while his animals stray untended. His appearance is shaggy like the wild mountains, with jagged teeth and an arboreal mat of hair. Galatea, holding a sea-purple scarf arched over her head like a sail, sports on the waves in a chariot drawn by four dolphins. She faces the spectator "with a distant look in her eyes that seems to reach the boundaries of the sea."[7]

Behind both Poussin's and Philostratus' depictions of Polyphemus, however, we must also recognize the bucolic *Idylls* of Theocritus, our first extant treatment of the Cyclops' unrequited passion. As we shall see, Poussin's landscape does not precisely conform to either Greek source; nonetheless, the sources reinforce our

questions concerning the interassociation of foreground and background and the location of Galatea. They should also serve to remind us of the larger context of ancient pastoral to which this subject belongs. Since the painting clearly embodies attitudes toward a complex of classical images, it raises questions germane to the definition of pastoral and its landscape.

Within the dialogue of contemporary pastoral theory or criticism the status of landscape is currently a controversial topic, and often invoked as a means of differentiation among pastoral ideologies.[8] Within a broad Empsonian conception of pastoral as a mode of dialogical clarification achieved by "putting the complex into the simple," the presence of a rural landscape is no longer a canonical requirement of the mode. Urban lowlife can also offer a stage for pageants of innocence. Granted this, the Empsonian critic nonetheless recognizes the importance of landscape or landscape elements as signifiers to designate a frame of reference for the particular complexities involved.[9] A long-range historical view of pastoral landscapes shows how thoroughly their function and emphases are affected by contemporaneous definitions of the mode. These definitions specify conditions of inclusivity or exclusivity. What manner of furnishings can the pastoral landscape admit without violating its generic integrity, or what kind of activities can legitimately be pursued there? Is labor permissible or desirable? Beyond this are a host of considerations that may vaguely be called stylistic, although they generally carry ideological implications. Should pastoral settings be rustic or idealized, natural or artificial? Are they necessarily opposed to the urban scene? Should their climate be called "Arcadian" or viewed as a renaissance of the mythical Golden Age?

Depending upon the historical period in which we base our inquiry, answers to these questions will greatly vary. Ultimately they hinge upon the large question at the root of modern theory, namely, whether pastoral itself is confrontational or escapist. Although many of these questions have been generated by readers of postclassical pastoral with reference to

works of their respective periods, they can easily become a concern to classicists because of the tacit assumptions about the nature of ancient pastoral they so often incorporate.[10] Inevitably entrusted with the custodianship of pastoral origins, classicists are often expected to explain their postclassical mutations as if they were essential elements of pastoral identity. An ideal definition may aim to balance a culturally responsible view of pastoral origins against a view that has been sufficiently informed by the history of the reception of pastoral for a meaningful application to later forms.[11] The balance of views becomes especially tricky if we decide to extend our quest for origins all the way back to Theocritus, whose relationship to the mainstream tradition is filtered through the multifold screens of Virgilian pastoral, imitation of Virgilian pastoral, and Virgilian commentary.[12]

These issues of reception and transformation are too various and complex to be encompassed within any brief, abstract discussion. In this paper I shall approach them indirectly by focusing upon certain vicissitudes in the courtship of Polyphemus as a recurrent subject in Graeco-Roman literature and painting. The discourse of courtship serves the definition of pastoral landscape because of its tendency to foreground an interassociation of speaker and environment. The protagonist in a courtship poem seeks acceptance. Frequently he strives to open a communicative exchange with someone beyond the confines of his immediate milieu. To this end he may either set up his own figure as an epitome of pastoral beatitude or else, in compensation for some personal deficiency, he may advertise the attractions of a pastoral ambience along with whatever products of natural or material culture it embraces. Although courtship monologues habitually create imaginative spaces whose topography and furnishings can often be seen as transformations of desire, it is a mistake to regard these "interior landscapes"—as some readers like to call them—as pure emanations of a pastoral psychology. Visual representations of Polyphemus in Roman painting provide a useful corrective to such interpretive tendencies by showing the

practical manner in which such imaginative spaces acquire their landscape imagery and the traditions from which this imagery derives. For this reason the history of Polyphemus and Galatea brings out some interesting interchanges in an oblique dialogue between literature and the visual arts, which also may serve to illustrate their possibilities of mutual illumination.

Within Theocritus' collection of *Idylls* the courtship of Polyphemus serves as an internal mirror to enable the self-contemplation of pastoral artistry.[13] Recognition of background is essential to consideration of this artistry since Theocritus himself plays with his reader's literary awareness. His transformation of the primitive Cyclops into a yearning lover exemplifies that fusion of elevated and humble themes characteristic of his approach to literary tradition. The two sources from which Theocritus draws his personage are Homer's *Odyssey* and writings for the Hellenistic stage. Although the two genres of *epos* and drama are the sources upon which Theocritus commonly draws for the personages and themes of his *Idylls*, the relationship in this case is a special one since drama had recently created precedents for revising the myth. In drama the Cyclops' primitive savagery is controlled by comical contexts. Ancient *scholia* attribute the first amorous Polyphemus to Philoxenus, a poet at the court of Dionysius of Syracuse.[14] When the poet found himself a prisoner in the stone quarries for intriguing with a certain Galatea, who was Dionysius' mistress, he took revenge in a satirical dithyramb that allowed him to play the role of Odysseus in opposition to the tyrant's Polyphemus. The connection with the legendary sea nymph rested upon the legend that Polyphemus had built a shrine to her on the Sicilian shore to court her protection for his flock.[15] Although Philoxenus' characterization of Polyphemus may have been closer to that of the Euripidean comic satyr play than to the pastoral lover whom we know, later Alexandrian comedies on the subject bear the name *Galatea*.[16] Any of these may have furnished suggestions for the two versions in Theocritus.

The Polyphemus *Idylls* are of two forms: idyll 6 is a dialogue approximating the mimic form, and idyll 11 is a monody. I stress these structural characteristics because they are important not merely as a reflection of background but also as pointers to the Roman development of the myth. Of the two poems, the romantic idyll 11 is the better known within the pastoral canon because it underlies the tradition of courtship songs in Virgil and later literature. Paradoxically, however, a look at the lesser known and less intensely emotional idyll 6 may give a better indication of the attitudes in which Polyphemus and Galatea appealed most strongly to ancient audiences. Let me begin with what the poems show about Theocritus.

Idyll 11 dramatizes the Cyclops' frustrated passion, showing his vision of Galatea as little more than a delusion or mirage. He believes that the nymph approaches him when he is sleeping and runs away whenever he awakens (lines 22–24). This absolute naïveté symptomizes the underdeveloped state of intellect in which Polyphemus succumbs to love. In the lines that frame the idyll, the poet explains the hopelessness of this love: addressing himself to a friend, Aratus, a physician, he defines the significance of the poem as the discovery of a *pharmakon* for love (lines 1–6). This charm does not procure love, but eases the pain of frustration. Although it is hard to find, Theocritus' fellow countryman Polyphemus discovered it, "finding relief easily" when he sang to Galatea about his passion.

For the reader the *pharmakon* must be discovered within a dialogue of literary genres representing a cultural exchange across time. By calling Polyphemus his "fellow countryman," Theocritus fixes the representational aspect of the poem as a "Sicilian story." This regional affiliation provides a practicable basis for Theocritus' rewriting of Homeric character in accessible human terms. But the meaning of this representation is only validated when we refer it to its context in Alexandrian literature.

This symbolic interchange of cultural perspectives has its counterpart in a complex structure of dramatic, poetic, and mythological time. Within the framework of the song Polyphemus himself experi-

ences a present time corresponding to the narrative time within which Theocritus has placed him. For the Cyclops this immediate moment distinguished by the pain of love is attached also to a dimension of memory. The emotions that drive him to his self-expressive song originated in a well-defined past moment when he first glimpsed Galatea gathering hyacinths on land in the company of his mother (idyll 11, 25–29). Looking beyond the present moment, the Cyclops can envision several alternative solutions to his dilemma. All are hypothetical and untested: that he should learn to swim and enter Galatea's own world (lines 54–62); that she should abandon the sea to join him (lines 63–64); or that he should find another beloved (lines 76–78). Within this triad of hypotheses, however, is contained a reference to the arrival of a stranger. For the reader this reference provides important chronological information, since it locates Polyphemus' singing before the moment of the *Odyssey*. By this token Theocritus' Sicilian time is itself moved backward from contemporaneity into a pre-Homeric sphere. This reference to the *Odyssey*, which is inevitably ironic in its foreshadowing, indicates a distance between Theocritean bucolic and its epic background; the difference of fictional time serves to underline the thematic differences of characters, which are the essence of Theocritean bucolic. This is the only one of Theocritus' poems that does in fact spell out the mytho-literary time scheme that encompasses the poet's transformation of heroic poetry.[17]

Within this time scheme are two further ways to consider Polyphemus. In the *Odyssey* he was an uncivilized creature whose pastoral environment remained still on the fringes of Saturnian spontaneity. His meeting with civilized men at once revealed his position outside the bonds of community and exposed that situation as pernicious. In idyll 11 love tempers this inherent savagery, but Theocritus' literary context actually displays this tempering as a consequence of the Cyclops' unconscious imitation of a Theocritean courtship serenade such as that sung by the "snubnosed goatherd" in idyll 3. Consequently, the reader should see Polyphemus first as an imitator of Theocritean *personae* and secondly as an imitator of Theocritus, his own creator, who is ostensibly claiming him as a precedent. This circularity privileges a pastoral art that extends into immemorial time.

In this situation the Cyclops particularly focuses Theocritus' foregrounding of love in the *Idylls*. His monologue exemplifies two aspects of love: its unbalancing effect and its power as transformational fantasy. Theocritus clearly gives us to understand that the lack of fulfillment makes Polyphemus suffer, thus generating the restless obsession that provokes his song. Acknowledging his physical ugliness as the cause of failure, the Cyclops attempts to compensate for his deficiencies. Here we see how desire leads him to define his personal identity in close association with the features of his pastoral environment. Like other enamored herdsmen, he promises to lavish on his loved one all his pastoral wealth in love gifts. Accordingly the basic symbiosis of place and person that Homer presents in the *Odyssey* is cast in a new light.

Theocritus gives the backdrop for Polyphemus' song as a barren crag at the edge of the sea, the place where land meets Galatea's mysterious undersea realms.[18] This is at once a recognizable allusion to the coastline of western Sicily and to the inhospitable Homeric country of the Cyclops. Although Polyphemus remains a primitive herdsman within an economy based upon flocks and cheese, love expands his appreciation to encompass a variety of more delicate items calculated to appeal to a feminine taste. He raises little pet animals for Galatea (idyll 11, lines 40–41); he pictures invitingly the laurel and cypress, the ivy and grapevines surrounding his cave (lines 45–46). This alteration of sensibility is, of course, what makes him both sympathetic and pathetic. In spite of his deformed nature and impulses, the Cyclops responds to a perception of the beautiful that revises his habitual perceptions. By this token he becomes a central figure in the self-definition of Theocritean pastoral art. He has found the charm belonging to the Muses; its practical simplicity makes it superior to cash. And, in fact, the

practical and the aesthetic values of the charm are wholly congruent, since the alleviation of pain through singing valorizes the life of emotion. Theocritus leaves us with the summation that Polyphemus "shepherded" his love by singing.[19] The metaphor domesticates passion within the fabric of an accustomed life. In this manner the Cyclops is a model for any and all lovers who find the mirror of their emotion or their fantasy in pastoral.

There are two categories of interpretive response to this idyll, one stressing the comic grotesque and one the romantic fantasy.[20] According to the former point of view, Polyphemus seems eventually a trivializer of the pastoral ambience and its sensibilities. Those who maintain this view are eager to stress the transience also of his passion for Galatea. Thus Charles Segal speaks derogatorily of the pastoral capitalist whose unintellectual involvement with "the material comfort and physical wealth of the locus . . . cancels out its more refined attractions."[21] To a more romantic interpretation, however, it is not product but process that is important, and the essence of the song is its perpetuation of the fantasy of love through singing. This reading, which stresses a continual magic of transformation, is more relevant to the role of the poem within the *Idylls*. But idyll 6 also valorizes the transformative processes of pastoral.

Segal favors idyll 6 over idyll 11 ostensibly because of the higher tone achieved through its focus on normal pastoral inhabitants rather than on the grotesque pariah.[22] Other critics also have commented on the unity, harmony, and symmetry of the poem, but essentially without perceiving the real nature of the interchange that transpires within it.

Idyll 6, like idyll 11, consists of frame and demonstration. Its miniature drama takes the form of a dialogue between two herdsmen, Daphnis and Damoetas, who agree to the impromptu staging of a singing match. The poet's introductory words picture the two, with details that establish a distinction between their ages. By token of his ruddy beard Damoetas must be the elder; Daphnis' beard is only half-grown. Although this description might seem pri-

marily intended to confer a touch of reality upon the singers, it is actually very important to the subject of the dialogue, which is amorous flirtation. Daphnis, the younger, sings first as challenger in the contest and determines both subject and form.

In idyll 6, unlike in idyll 11, the dialogue does not reproduce the contents of the Cyclops' monody but rather presupposes such a song, which it proceeds to discuss and analyze. Making the first move in the contest, Daphnis creates a vicarious persona for Damoetas, whom he casts in the role of Polyphemus and teases about his laggard performance as a lover. The aggressively flirtatious Galatea whom he pictures bombards the Cyclops' flock and his dog with apples. Responding to this approach with apparent indifference, Damoetas/Polyphemus does not look at the nymph but sits absorbed in his piping. Only his dog barks at Galatea as she emerges from the waves. Daphnis advises Damoetas to restrain the animal lest it do harm to the coquettish maiden. As capricious as dry thistledown, she flees the wooer and pursues the indifferent. This final line is ambiguous: "To a lover, Polyphemus, many a time has the not beautiful seemed beautiful."

But who, in this case, is the lover? Is Daphnis' declaration actually mocking or encouraging Polyphemus? His teasing language suggests emotional stirrings beneath the surface of the Cyclops' unconcern. These ironies are underscored by a strong emphasis on the faculty or action of sight. While Polyphemus himself does not look at Galatea (line 8), his dog is a watcher (σκοπός) who looks toward the sea. The waves show (φαίνει) Galatea as she moves toward the shore. Polyphemus must watch that (φράζεο) his dog does not injure her. Finally we hear that the unlovely appears (πέφανται) lovely in love. Such words suggest that Polyphemus is, so to speak, all eyes in spite of his feigned unconcern. His erotic feelings are betrayed by the barking dog, whose aggressiveness implies the difficulty he finds in restraining himself. Still, as Daphnis intimates, this Polyphemus is too inept to capitalize upon his own advantage. His scenario may remind us of the figures on the goatherd's carved bowl in the first idyll: the static lovers endlessly

contending beneath the dispassionate eyes of their mistress, or the young boy who weaves a cricket cage oblivious of the predatory foxes eyeing both his vineyard and his lunch.[23]

An equal emphasis on sight is found in Damoetas' answering song, performed in the persona of Polyphemus. By his first word, εἶδον, Polyphemus claims to have seen all, and then he swears by an eye that sees "to the finish" (ἐς τέλος) that the girl has not escaped his sight. Daphnis does not realize that Polyphemus' pretense of not seeing Galatea (οὐ ποθόρημι) is a calculated response to the nymph's flirtatious teasing. That Galatea has gone so far as to set her foot on shore is proof, from this point of view, that Polyphemus is playing his game well. He has stirred up the jealousy of the capricious woman by pretending already to have a wife. This strategically devised enticement has provoked the nymph to a frenzy of increased spying on the flock and shepherd. Claiming total control over the situation, Damoetas argues that not even the barking dog should be taken as a sign of negligence, since the creature used to approach much nearer and to behave as a pleading lover before the Cyclops taught him to keep his distance. So far Polyphemus claims that his strategies are succeeding. All the same, responsive flirtation is not the end of his game. He is waiting for Galatea to see much more (ἐσορεῦσα). He wants to receive a message, but he will accept only one message from the nymph: a promise to leave her watery element and share his island habitation. So, he answers, he has been playing his game masterfully. In answer to Daphnis' challenge of his skill in flirtation, Damoetas professes a far superior knowledge based on an instinct for feminine psychology. Furthermore, he does not accept his teaser's backhanded remarks about his appearance but insists that he is a worthy object of love.

To consider the significance of this interchange we must give full emphasis to the narrator's conclusion, which stresses the success of both speakers. Neither was a victor; both proved invincible (idyll 6, line 46), which is to say, that with attention to their creation of persona both conducted their roles well. After an exchange of musical instruments the singers perform an epilogue that brings the contest to a harmonious close. We see their recreational spirit taken up by their animals as the calves begin to dance in the grass, representing in pantomime exactly what the speakers themselves have been doing. This pantomime indicates the manner in which the song contest should be related to the poet's frame. Gilbert Lawall, who proposes that the singers are homosexual lovers, thinks that the song should be interpreted as a warning against the vagaries of heterosexual love.[24] On the basis of the song's several planes of imitation I do not think that warning is the message. Rather we see the capacity of pastoral fiction to negotiate with real experience.

By his introductory address to Aratus the speaker in idyll 6 positions himself in an everyday world, which becomes our own field of reference for judging the imaginary world of the poem. The details that characterize the two pastoral speakers, however, also constitute a frame of reference to which their prosopopoeia must be related. Being both on the verge of adulthood, the two are old enough to be taking a serious interest in love, but the slight difference in their ages reflects a degree of difference in their respective understanding. Daphnis, the younger, teases his friend from the position of an uninvolved spectator, thinking that his criticism of the lover's passivity reflects superior insight. Damoetas' responses imply that Daphnis' self-proclaimed superiority is nothing but the naïveté of the uninitiated. Reading only the face value of behavioral strategies, he wholly underestimates their calculated design. Especially, Daphnis lacks Damoetas' own comprehension of feminine conduct. Thus, by means of prosopopoeia, the singers proleptically enact their perceptions of the fascinating mysteries of an adult erotic world they are about to enter. The imitation is an initiation, and by this function it is empowered to transmute all the negative and futile reverberations of the Cyclops' courtship into normative patterns of human behavior so that the song ends with promises of harmony. The immediate re-

play of the drama by the impressionable young animals constitutes a third recapitulation of the initiatory prolepsis, since the calves, like their keepers, must also anticipate entry into a mature sexual stage. In concert these figures play out a practical drama of human experience that draws both information and inspiration from love on a high plane of poetic fantasy. Thus, in this poem, the imaginative sphere of pastoral is a liminal or mediating realm between the everyday world and literary models for that experience. Such a world coordinates fully with the world of make-believe exemplified in mime.

The element in this poem most important for our consideration of Roman versions of the myth is Galatea's response to Polyphemus. In idyll 11 this is purely a figment of the Cyclops' wishful imagination, showing the totality of his naïveté and enforcing the poignancy of his fantasy. Although the response described in idyll 6 may also be given a purely fictive status, the more fully articulated treatment of the idea confers greater substantiality on it. Whether this hypothetical response reflects exchanges or confrontations that would actually have taken place between actors in a dramatic tradition of the myth cannot be ascertained, but there are strong suggestions that such is the case. From this point it is an easy step for the myth to transform itself into a testimony to the persuasive powers of art. The process is one of reception and interpretation. I will approach it first by examining that part of the Roman corpus that has often been thought to emanate most directly from Theocritean influence, namely painting.

In art historical terms the background for the Roman Polyphemus and Galatea tradition is actually somewhat mysterious and lacunate. The corpus of paintings contains two examples whose provenance alone seems sufficient to place them at the beginning of the Italian development. Of these examples one, located in the Palatine house associated with Livia, has no apparent descendents (fig. 2).[25] It is a large-scale painting that shows Polyphemus under the guidance of an Eros who drives him in harness, wading far out from shore, while Galatea and her fellow nymphs drift on the waves. Their gestures mock the love-crazed Cyclops. As for his presence in the sea, it is hard to say whether this is the painter's own clever invention or whether it is extrapolated from the Theocritean Cyclops' fantasies of entering Galatea's realm.

Galatea's response is less clear in the best-known version of the subject: a panel from the Roman villa at Boscotrecase on the slopes of Mount Vesuvius, whose decorative context has generally been accepted as third style (fig. 3).[26] Contrary to the usual assumption that Roman mythological paintings must be derived from Greek or Hellenistic originals, Peter von Blanckenhagen has proposed that this painting itself represents the model, or at least a replica of the model for the Roman tradition.[27] Certain features of Philostratus' description do seem to persist, even three centuries later—most notably the shaggy Polyphemus with his straying flocks whose precinct is defined by a single tree. Here also, as in Philostratus,

2. Mythological landscape: Polyphemus and Galatea, "Casa de Livia," Palatine, Rome, late first century B.C. Deutsches Archaeologisches Institut, Rome

3. Mythological landscape with Polyphemus and Galatea from the Roman villa at Boscotrecase, late first century B.C.
Metropolitan Museum of Art, New York

Galatea faces the spectator, holding her arched purple veil with a distant look in her eyes. Since she is actually floating behind the Cyclops' line of vision, the spectator may question whether she is literally present as an audience or merely intended as a figure of the Cyclops' imagination, as is so clearly the case in Theocritus.

Along with his belief in the innovative status of the Boscotrecase painting, von Blanckenhagen thinks that the work derives directly from Theocritus. His judg-

ment is based primarily on details in the landscape background that invest it with a Theocritean atmosphere: the lonely seaside crag, the steeply wooded slopes of Mount Aetna.[28] In fact, the most Theocritean aspect of the painting is the generic collocation of epic and idyll. The double image of the Cyclops, which, as von Blanckenhagen rightly observes, is not a strictly narrative construction, brings together heroic and pastoral resonances of the myth in a manner approximating Theocritus' transformation of Homer's savage creature into a pastoral lover and back again. This is thematic narrative, more discourse than story, which points to a sense of self-conscious pastoral definition in the painting akin to that in Theocritus' idyll.[29]

But before one becomes too confident about the specific indebtedness of the Boscotrecase painting to Theocritus, the interrelationship of action and rustic setting needs further comment. Recent cleaning of the painting has brought out a previously concealed feature in the background: the mouth of a large cavern located on a plane behind that of the crag comprising the center of the painting, but nonetheless so closely resembling the rock formation as to appear as a part of the same structural mass.[30] Cavern motifs are by no means rare in Campanian mythological painting, but the most interesting aspect of this example is its structural similarity to the background imagery of another continuous narrative painting excavated only a few years ago in Pompeii, which shows scenes from the myths of Dirce and Antiope so selected and arranged as to indicate a direct reference to Euripides' tragic drama *Antiope* (figs. 4, 5).[31] The cavern is a telling feature in this panel because we know that the final action of the drama centered on a cavern that was physically present on stage.

The coincident features of the two panels may put us in mind of Vitruvius' specification of caverns and mountains as elements of the setting appropriate to satyr plays.[32] In both examples the cavern adjoins a sacred precinct marked by a shrine; such shrines often figured in stage settings and they are specifically appropriate to each of the actions here. In the *Antiope*

painting the shrine is to Dionysus Bassareus on Mount Cithaeron, where Dirce arrives with her maenads to celebrate the rites of the god; in the Polyphemus scene it is a column with a sacred tree, which might be interpreted as a precinct sacred to the nymph herself.[33] Thus the two landscapes, while not to be taken as exact replicas of stage settings, may nonetheless give some idea of how these affairs were constructed. At the same time we may see that the Polyphemus landscape does not necessarily represent a generically conceived pastoral landscape, but a setting that becomes pastoral by association. Probably its furnishings were carried over from the Euripidean *Cyclops*, a genuine satyr play, in order to supply a suitable background for the comic versions of Polyphemus. Also we may take this landscape as evidence of the popularity of this drama in Roman performance.

Two additional pieces of visual evidence document this popularity. One is a marble plaque of the first century found at Nemi, showing Polyphemus and Galatea as disembodied masks, or *personae*, placed in a vestigial seacoast setting (fig. 6).[34] This species of decorative relief was quite common in the Roman world; perhaps it functioned as a theatrical billboard.[35] The plaque is useful in interpreting a painted panel in the corridor of a Roman house at Assisi: a kind of *pinacotheca* collection of subjects accompanied by lines of explanatory verse. Here Polyphemus and Galatea are also represented as disembodied masks in a seacoast setting, to which a few of Polyphemus' animals have been added along with a lyre resting on the rock.[36] The painting is accompanied by an epigram that reads:

ποιμαίν[ε]ι Πολύφημος ἀΐδων, καὶ Γαλάτεια
κυρτ[ὸ]ν ὑπὲρ σειμοῦ νῶτον ἀγαλλομένη

(Polyphemus shepherded, singing, and Galatea paid him homage on the humped back of her sea beast.)

Certainly the word for "shepherd," ποιμαινει, suggests the final line of Theocritus' idyll, but the ἀγαλλομένη, "paid homage," referring to Galatea, intimates a situation very different from the absence of Theocritus' unresponsive nymph. Believ-

4. Mythological landscape showing scenes from the myth of Antiope and Dirce, c. A.D. I, fresco, Casa di Giulio Polibio, Pompeii
Istituto centrale per il catalogo e la documentazione, Rome

5. Dirce and the bull, detail of fig. 4

ing that this collocation of words and picture represents the first instance of rapprochment between the two figures in the history of their myth, Margherita Guarducci, who published the painting and epigram, attributes this innovation to her hypothetical owner of the house, the Roman poet Propertius. A couplet in his *Elegies* provides a parallel to this representation:

*quin etiam, Polypheme, fera Galatea sub Aetna
ad tua rorantis carmina flexit equos.*

(And indeed, Polyphemus, did not untamed Galatea turn her sea-dewed steeds beneath Aetna to face your songs?)[37]

But Guarducci's interpretation does not take account of the theatrical code of representation signified by the *personae*, which she interprets as a conventional metonymic substitution for full figures, referring the practice to Alexandrian art. If, however, we recognize the direct allusion to the theater, the evidence of the figures is sufficient to suggest that Propertius' new construction of the story line, as well as the modifications in the Assisi panel, should be ascribed to a dramatic tradition.

This twist that occurs in Propertius also characterizes the subsequent development of the Roman visual tradition. A painting in the late third style *pinacotheca* ensemble of the Casa del'Amando Sacerdote, whose design indicates derivation from the Boscotrecase model, shows a Galatea who has turned her attention toward the singer, just as Propertius specifies (figs. 7, 8). Otherwise the painter has simplified the components of his story line, omitting the figure of the angry Polyphemus but not Odysseus' arriving ship. This altered composition emphasizes the hero's intrusion into the Cyclops' brief fantasy. Thus the picture takes a far more romantic turn than its predecessors, since Galatea's responsive gesture establishes an ideal atmosphere that will be dissolved by contact with the heroic world. A series of later paintings in the Campanian third and fourth style even further narrows the range of the myth to settle upon this reciprocal communication as the central point of the story (figs. 9, 10).[38]

Many of these paintings show a significant change in background, from the sym-

6. Plaque with theatrical masks of Polyphemus and Galatea found at Nemi, first century A.D., marble
From *Notizie degli Scavi*, 1931

metrically ordered sacral-idyllic precinct of the third-style paintings to a form of coastal landscape more closely resembling the villa type that became popular in later third- and fourth-style wall decorations (figs. 10, 11). In the most extensive such composition, a large-scale painting that occupied an entire wall in the peristyle of the Casa della Caccia Antica, the villa prospect has assumed a panoramic dimension that virtually overshadows the actors in the mythological drama (fig. 11). Temples and porticoes, even a vineyard, appear on the further shore, and Polyphemus' own precinct has become so elaborate that its architecture almost conceals the ilex trees. While the visual arrangement appears to bring Polyphemus into the confines of a civilized sphere, the location of the painting in combination with a *venatio* on the adjoining wall of the peristyle might also suggest an allusion to staged performance.[39]

Thus, under the influence of popular mimic performances, these images have departed further and further from literary sources and assumed their own independent shape, whose direction answers to the culture in which it participates. While we may assume that the mime always exploited the grotesque incongruity of the lovers, the landscape versions mitigated the disparity between Polyphemus and Galatea and focused upon the power of the Cyclops' song, which it established within civilized surroundings. While this change may owe much to a contemporary aesthetics of landscape, it also reflects something much larger. That Galatea should respond to the piping or singing of Polyphemus typifies an endemic Roman insistence upon the capacity of art to produce an effect on its audience: of oratory to persuade, of painters to imitate with deceptive realism, of governments to organize—and thus of poets or singers to command attention and inspire order. The perpetual frustration of a rejected Polyphemus was unsympathetic to the popular Roman imagination, no matter how indecorous the resultant alliance might be. In one fourth-style painting Polyphemus cocks a triumphant eye at the spectator as he reaches out to receive his long-desired let-

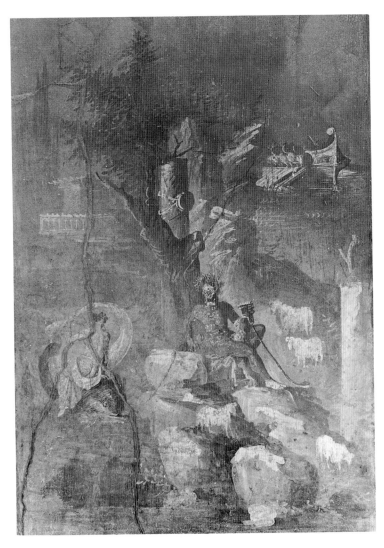

7. Mythological landscape with Polyphemus and Galatea, early first century A.D., fresco, Casa del Sacerdote Amando, Pompeii
Deutsches Archaeologisches Institut, Rome

8. Detail of fig. 7

9. Drawing of a mythological panel showing Polyphemus and Galatea, early first century A.D., House 9. 6. 17, Pompeii
Deutsches Archaeologisches Institut, Rome

10. Mythological landscape with Polyphemus and Galatea, discovered in the second complex of the Villa Varanno, first century A.D., fresco, Antiquarium Stabiae
Author photograph

ter delivered by Eros on the back of a dolphin (fig. 12).[40]

It remains at this juncture to consider whether a similar emphasis on persuasion characterizes the Roman literary versions of pastoral courtship derived from Polyphemus' song. In fact we can distinguish these revisions from their Theocritean precedent in two major respects: by a shift in their emphasis from the expressive to the performatory aspects of singing and by their deliberate concretization of the pastoral environment as something to sell. Both changes involve a new and characteristically Roman emphasis on the persuasive role of rhetoric. Thus while Theocritus surrounds Polyphemus, as an unselfconscious artist, by a poetically self-conscious frame, the Cyclops' Roman imitators are themselves self-conscious pastoral chauvinists. At the same time, the absence or presence of an implied audience is a critical factor in the conduct of these rewritings, each of which incorporates a model of literary reception. This point can be illustrated by three very different examples: in Virgil's *Eclogues* the song of Corydon, a framed monologue performed by another unsuccessful lover; in Horace's *Odes*, book I, ode 17, a poetic self-introduction in the guise of an invitation for a country weekend to a lyre player named Tyndaris who comes out of the background of the symposium; and finally in Ovid's *Metamorphoses*, a direct reprise of Theocritus' poem in the narrative account of Polyphemus' courtship related by Galatea herself. This is the first time, at least in extant literature, that we hear an account of the courtship from the sea nymph's point of view, and likewise the first time that we learn of her rival lover Acis.

Like the song of Polyphemus, Corydon's courtship song reflects an image of the singer within his environment. Most scholars comparing the two will pronounce Virgil's poem the more serious and more sensitive.[41] This is primarily because Corydon is no grotesque Cyclops but a simple herdsman who directs his courtship toward an anonymous fellow mortal rather than an inaccessible nymph. By this token the song also should appear more accessible, but in fact the eclogue undercuts this pos-

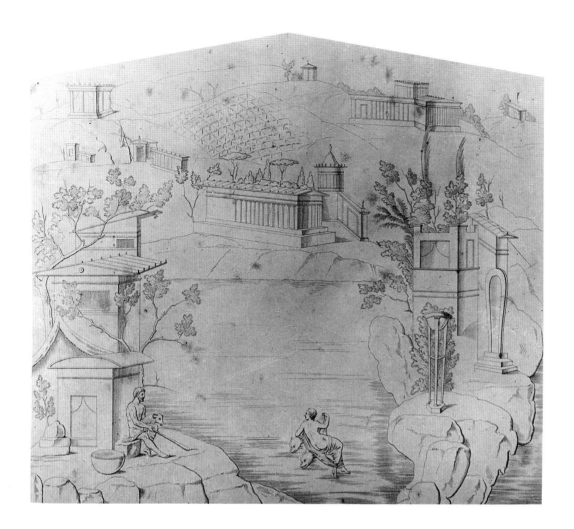

II. Drawing of a large mythological landscape with Polyphemus and Galatea, late first century A.D., peristyle, Casa della Caccia Antiqua, Pompeii
Deutsches Archaeologisches Institut, Rome

sibility by the structure of poem and frame.⁴² The eclogue poet reinforces his analogy with Theocritus' Cyclops by making Corydon address an absent and seemingly unattainable love object: "formosus Alexis, delicias domini." Since the song is poured out to the woods and mountain, the desire expressed is a *studium inane*. Furthermore, the eclogue supplies the information that Corydon has sung this song repeatedly ("adsidue veniebat"). If we thus compare Theocritus' introduction, several major differences appear. Unlike Theocritus, who addresses his framing remarks to Nicias, the eclogue poet speaks to his hearers without intermediary. This directness has the effect of making us also an anonymous audience. But in place of the interpretive assurance that the song is of value to its singer, we are confronted with a curious emptiness.

The song itself does little to dispel this emptiness. While Polyphemus uses pastoral landscape to compensate for his personal deficiency, Corydon depends entirely upon it to represent an otherwise vacant character. His song, which is composed of Theocritean imitations, reveals no personality independent of his picturing of the pastoral world. With little guidance from the poet, the reader must rely entirely upon his or her own critical instincts to interpret this picture, and it is precisely for this reason that the piece has provoked sharply conflicting assessments. While some readers place Corydon at the very center of pastoral aesthetics, others consider him a pretentious poetic hack.⁴³ The question of value is focused by the passage in which the singer himself introduces a double perspective upon his performance by adopting a self-deprecating view of his "rustic" identity:

rusticus es, Corydon; nec munera curat Alexis,
nec, si muneribus certes, concedat Iollas.
heu heu, quid volui misero mihi? floribus
 Austrum
perditus et liquidis immisi fontibus apros.
quem fugis, a! demens? habitarunt di quoque
 silvas
Dardaniusque Paris. Pallas quas condidit arces
ipsa colat; nobis placeant ante omnia silvae.

(Corydon, you are countrified; and Alexis does
not fancy your offerings, nor should you con-
tend with offerings, would Iollas concede. Alas,
alas, what have I done to my sad self; I have let
the south wind into my flowers and boars into
clear springs. Whom are you escaping, o, sense-
less one? Gods have also dwelt in the wood-
lands, and Trojan Paris. Let Pallas cherish the
cities she has founded; let the woodlands please
me before all.)[44]

This internal dialogue of moods, reveal-
ing the speaker's apparent readiness to
separate song from emotion, constitutes
a further manifestation of the self-con-
sciousness that distances Virgil's protagon-
ist from Polyphemus. The eclogue closes
with an ambiguous consolation: "Invenies
alium, si te hic fastidit, Alexin" (You will
find another Alexis if this one spurns you).
The words reflect the poet's initial declara-

12. Polyphemus receiving a
letter from Galatea, first cen-
tury A.D., fresco, Herculaneum
Museo Archeologico Nazionale,
Naples

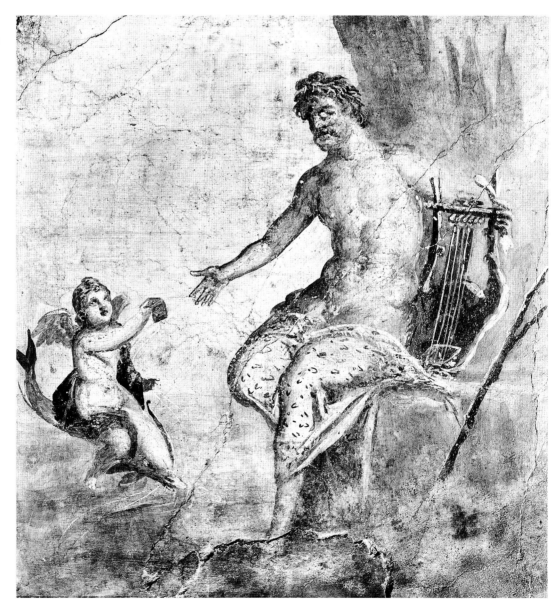

tion that Corydon's passion is destined to go unrewarded, but the open-ended closure once more places emphasis upon the interaction of performer and audience. The continuity it envisions is not a stabilizing emotional function like that of Polyphemus' eternally shepherded passion, but rather an endless repetition of poses, of imitations and revisions, a prospect of limitless pastoralizing. Whatever the clues to interpretation that Virgil himself may have extended to his contemporary reader, literary tradition has effectively adopted Corydon rather than Polyphemus as the prototype of the dejected lover. His influence within the pastoral canon touches not merely the formalization of rusticity as a characteristic of assumed persona but also the critical opposition of country and city.

That Horace's invitational ode 1.17 might also be counted as a version of Polyphemus' monologue has not occurred to most readers, yet the formulas of pastoral courtship make up the substance of its address.[45] Unlike Theocritus and Virgil, Horace does not frame the performance of another speaker but presents his invitation directly in his own voice. The "frame" that enables interpretation is provided by the reader's recognition of the relationship of the poem to its antecedents. At the outset this relationship is not clear, since the invitational format has not yet been made explicit. The opening stanzas focus in a significant manner upon setting rather than invitee:

Velox amoenum saepe Lucretilem
mutat Lycaeo Faunus et igneam
* defendit aestatem capellis*
* usque meae pluviosque ventos.*

Impune tutum per nemus arbutos
quaerunt latentis et thyma deviae
* olentis uxores mariti*
* nec viridis metuunt colubras*

nec Martialis haediliae lupos,
utcumque dulci, Tyndari, fistula
* valles et Usticae cubantis*
* levia personuere saxa.*

(Often swift Faunus exchanges pleasing Lucretilis for Lycaeus and wards off fiery summer and even rain-laden winds from my flocks.

Fearing no danger throughout the safe woods, the straying wives of the stinking he-goat seek hidden strawberries and thyme.

Nor do their kids fear green colubers or Martian wolves whensoever, Tyndaris, the valleys and light rocks of low-lying Ustica resound to the pipe.)[46]

The poet speaks as the resident of his Sabine property in the shadow of Mount Lucretilis. He claims the favored patronage of Lycaean Pan, who often visits in the guise of Italian Faunus, exerting, by his presence, a certain magical protection that shades the flock from the ravages of sun and rainstorms. Likewise, musical resonance banishes fear of green serpents and Martian wolves. Now the poet addresses a certain Tyndaris whom he hopes to lure to this setting, promising all the abundance of the rural world:

* hic tibi copia*
manabit ad plenum benigno

* ruris honorum opulenta cornu.*

(Here an abundance of country tributes will pour forth to the fullest for you from a generous horn.)

These few words efficiently paraphrase the fulsome promises made by other pastoral chauvinists. By concentrating rural largess within a cornucopia, Horace adds a further touch of wit to his topos. Contextual overtones of seduction reveal sexual implications lurking within one of the symbols Augustus had adopted to represent the peace and abundance of his reign.

As for Tyndaris herself, she is being summoned not merely as a passive recipient of rural hospitality but rather in the capacity of a performer. The topics of her songs are defined with a curious reference to epic: Penelope and Circe "contending for the love of one man" (ode 1.17.19–20). While her own name has epic resonance, her literary context is that of the symposium. Although Horace does not spell out the exact terms on which she is to visit the Sabine farm, either for a symposium that he is himself sponsoring or for a private tête-à-tête, still he promises that her visit will be free from jealous brawling that would threaten damage either to her person or to her ornaments.

This promise is significant as one of a series of transformations emanating from the magic of locale. Indeed it is not so much the specific features of the landscape here that form a meaningful link with pastoral, but rather a transformative capacity first signaled by the elevation of rustic Italian Faunus to the literary status of Lycean Pan. This merging significantly parallels Horace's own readaptation of Greek lyric meters in Roman form. His hospitality to the Greek-named Tyndaris also enfigures this revision. One should notice that Horace does not set his place in opposition to the city, nor should it be considered as a refuge from that world. Rather, it is a center of resonance whose influence may extend as far as its reach. Himself partaking of the same magic, the host presents himself as a patron dedicated to high artistic ideals, who can guarantee an atmosphere free of violence. Unlike the other courtship poems, this one seeks no practical answer, for the response is implicit in the assurance of its own self-definition. It is neither the charms of his rural ambience nor his own erotic sufficiency that our speaker needs to impress upon us, but rather his own dedication to art. In the guise of artistic patronage he is introducing his own poetic credo as the creator of the books of *Odes*, and his persuasion of Tyndaris to join him is far less important than his courtship of us as readers.

The wicked wit that enlivens Ovid's version of Polyphemus' song in the *Metamorphoses* comes not only from its parodic approach to Theocritus but also from its burlesque of Roman poets who imitate Theocritus. Imitation in this piece appears on multiple levels. Reconstructing the song as a substantial portion of her narrative, Galatea ostensibly imitates the Cyclops, who is, from the Ovidian reader's point of view, imitating his Theocritean prototype. In this capacity he may also be seen to compete with such intermediary Roman imitators as Corydon, whose practice is that of going the original one better. Expansion is also the keynote of this imitation, more notable here because we are challenged to measure it directly against Theocritus. For every single item in the earlier song we find multiples: thus, in place of four similes praising qualities of Galatea's charm, we have thirteen; the Cyclops' count of his wealth also reaches a total of thirteen items. The manner in which he catalogues his possessions would be more appropriate to agricultural discussion than courtship. But not only does Polyphemus outdo his Roman competitors in commercialization, he even formulates a principle of vulgarity ("pauperis est numerare credideris" [It is a poor man's occupation to count over his flock][47]). If the hearers doubt the remarkable nature of these animals, they should see them face to face. His goats can scarcely stagger home above the burden of their udders.

This overdressed imitation, which vitiates all the natural charms of its original, is the predictable offering of a monster. From her spectator's point of view Galatea emphasizes the uncouth appearance of her suitor, while mocking his efforts to make his personal appearance pleasing. He has dragged a rake through his hair and trimmed his beard with a pruning hook (964–967). These preparations lead to the calculated theatricality displayed in his choice of a *cuneatus collis* (779), a slope shaped and divided like an auditorium, as the setting for his performance. Here we see him assume center stage amid his sheep, which are not straying because of his absent-minded neglect (as Theocritus has it) but rather clustering around without coercion, as if they were listening to Orpheus. Placing his huge staff at his feet he takes up his shepherd's pipe, whose normal seven reeds have somehow increased to a hundred. Mountains and waves reverberate from the sound blast (784–786). With its inflated pastoral catalogues the language of his song transmutes sound volume into verbal excess.

But this Cyclopean rhetoric does not consist simply of accretive expansion. The Cyclops' imitations are vulgarized not only in their enumerations but also in the artificiality of their invention. Of the four items in Theocritus' opening recital of similes praising Galatea, not one is exactly reproduced, but the terms are, all the same, conspicuously enough embedded in the new catalogue for the reader comparing the versions to find them. The Galatea

whom Theocritus' Polyphemus praises is whiter than curd, more playful than a lamb, sleeker than the grape, and more skittish than a calf. Here she is whiter than a leaf, sweeter than a ripe grape, and softer than swansdown or curd. Overtones of sensuousness insolently characterize these deformations, the more to remind us of the great repugnance that the Cyclops inspires in the nymph. Even so, these inventions, along with several others, observe the guidelines of pastoral decorum. Such comparisons as "floridior prato" (more colorful than a meadow in flower) and "longa procerior alno"(taller than the lofty alder) are clear borrowings from Virgilian pastoral vocabulary, obeying the principle of using natural objects for comparison. Another item, "splendidior vitro" (more sparkling than glass), abruptly violates this rule by intruding art into nature. Here the listener can recognize an echo of Horace's ode to the *Fons Bandusiae* (3.13). Has the Cyclops unwittingly confused his genres? Is this invention or pastiche? In fact it would seem that the items and the awkwardness caused by their inappropriateness both to Galatea and to the pastoral context are such that only an inept Cyclops could have composed such a song.

The reader must remember that this is only a second-hand impression of the story. The narrative context established by the *Metamorphoses* constitutes the most elaborate of all literary frames for versions of Polyphemus courtship.[48] The tale forms part of a sequence of stories clustered around the arrival of Aeneas in Latium. The sequence constitutes a transition in the poem from the Greek world to the Roman and is notable for presenting refracted views of familiar heroic episodes. For the most part these retellings are altered by compression. The expansion of this story over its Theocritean source forms an exception. The audience of Galatea's story is clearly defined; she tells her tale to Scylla in return for that nymph's diverting accounts of her dexterity in evading the advances of lovers. It is of no small consequence to this story that sea nymphs should have the reputation for habitually fleeing from love as Scylla claims to have done.

The Theocritean Galatea was, likewise, a typically elusive sea nymph, but her Ovidian incarnation shows a different disposition toward men. Explaining, *in propria persona*, her avoidance of Polyphemus, she reveals that it was motivated by her preference for a more attractive lover. Seemingly unbeknownst to her savage suitor, she listened to his song in the arms of the handsome young Acis. Her motivation for telling the story is to depict Polyphemus' cruel destruction of his rival. Self-justification is her hidden agenda, for which reason we may understand that every aspect of the story will explain Galatea's loathing. So effectively does it do this that the reader is unquestioningly led to accept Galatea's reliability as a witness. She insists upon this reliability, because she took notes on the performance ("procul auribus hausi/talia dicta meis audita verba notavi" [From a safe distance I drank in what he said, and I jotted down the words I heard], 787–788). By this very detail, however, Ovid introduces an intertextual dimension that invites comparison of his expanded monologue with its original. The Cyclops himself recognizes the semantic status of this latter-day revision of his story and regrets being a character in it. Primarily he blames Galatea for her change of character and habits. Without the intrusive Acis he could patiently have endured rejection and gone on loving and singing, but real competition has wounded his vanity. Being scorned in favor of a rival gives rise to physical vengeance. From this point of view it is hard to overlook the implication that Galatea, by violating codes of conduct both generic and natural, has provoked Polyphemus' anger and thus the destruction of Acis.

If we should finally come to see it this way, if we should retrospectively acknowledge the self-defensive bias of Galatea's narrative and begin to sympathize with Polyphemus' complaint about violated codes of conduct, then we will also be likely to look more impartially at the rhetoric and structure of the song. Accordingly we might come to suspect that Galatea's narration is not the faithful record of a debased performance, but rather a parodic deformation. No matter whether we do or do

13. Raphael, *Triumph of Galatea*, c. 1498, fresco, Villa Farnesina, Rome
Alinari/Art Resource, New York

the forward momentum of epic.[49]

This descent into violence clouded Polyphemus' reputation in the Renaissance. As precursors to Poussin's *Landscape with Polyphemus*, two pictorial mutations of the myth in Rome may be considered. At the Villa Farnesina, Agostino Chigi commissioned paintings of the two figures by different artists. Sebastiano del Piombo's Polyphemus follows the Ovidian model for the ridiculous musician as it had been transmitted by Poliziano; but Raphael's celebrated *Triumph of Galatea* brings new pageantry to surround Philostratus' graceful nymph.[50] Amid a cortege of sea deities a glamorous Galatea rides in full glory while three Erotes with drawn bows hover above her head. She looks obliquely upward with a rapt expression. If the glance seems in some manner passionate, it is, all the same, not turned toward Polyphemus but fixed on some indefinite, far-off point (fig. 13). With reference to Renaissance interpretations of the myth, such as Poliziano's, this ambiguously remote glance might be explained by Galatea's accrued significance as an embodiment of chastity. And it answers ideally to Philostratus' description of the nymph's "marvelous eyes . . . which look all the way to the limits of the sea."[51] But two scenes in Annibale Carracci's ceiling for the Farnese Gallery revert to the Ovidian story line to show the Cyclops as a negative extreme of passion (figs. 14, 15).[52] At one end of the room the singer serenades a Galatea who appears to listen attentively while resting a possessive arm comfortably on the shoulder of a youthful, demure Acis.[53] The opposite panel converts the Cyclops to fury and the lovers to fugitives. Context has a bearing upon presentation. Within an ensemble juxtaposing many permutations of divine love, this narrative sequence serves as the chief example of unwelcome passion, yet the point is touched by the painter's characteristic humor. Looking beneath the surface of Ovid's narrative with a visual wit that approximates the poet's verbal subtlety, Annibale gives Galatea a complacent expression to indicate her awareness of the flattery. Like the Ovidian nymph who "took notes" on her despised lover's address, she is not wholly averse to homage.[54]

not subscribe to this interpretation, however, the fact remains that the Cyclops' song has fallen short of its purpose by any standard of measure, neither persuading the beloved nor consoling the lover. Rather it has become a preface to violence and to a disturbance of the order in which it takes place. For Galatea the consequences are not grave; since her crushed lover is of immortal origin she is able to revive him in the form of a spring god. Indeed things turn out worse for the Cyclops, who has ended the pacific moment of his courtship by this violence and once more become the figure who will, to his own sorrow, attempt the entrapment of Odysseus. The enchanted moment of Theocritus' pastoral yields to

In light of this distinctly Ovidian representation Poussin's choice seems very deliberate. At the time when he painted his picture he was developing a system for conceptualizing pictorial styles modeled on those affective qualities attributed to Greek musical modes.[55] By reviving Greek sources to recontextualize the myth, he would seem to be restoring the Cyclops' Theocritean dignity as lover and musician alike.[56]

This gesture of restoring lost dignity is also achieved by the reestablishment of Polyphemus within a fully articulated pastoral landscape. Behind it lies Poussin's direct interpretation of Philostratus' description by which he follows the rhetorician's own practice of employing details from literary texts to amplify and animate a visual image.[57] As Philostratus explains how love has set the Cyclops apart even from his own kind, he paraphrases the praises of Galatea from Theocritus' idyll to illustrate the song Polyphemus is singing.[58] This is typical of Philostratus' practice of combining features of real paintings with fictive or literary additions.[59] In summoning these allusions, he uses his role as rhetorical interpreter to fix a meaning for the visual rubric; his animation rejects the comic stage tradition, which has influenced the visual history of the subject. This *ekphrasis* resembles the Boscotrecase painting in its description of the central figures but differs in such significant details as the addition of Polyphemus' fellow Cyclopes harvesting grapes in the vineyard.

Naturally Poussin had no access to the still unexcavated Campanian frescoes underlying the ancient *ekphrasis*. Also his employment of Philostratus was in many ways indirect. Within the compositional framework that he adopted from the description, he has substituted new images in such a manner as to engage the learned spectator in a form of negative intertextuality. Although his landscape contains

subordinate figures at work in the fields, they cannot be the Cyclopes harvesting but are clearly human figures planting. Likewise his nymph is not carried on a dolphin; a pool of water stands before her at the margin of the foreground. Two urns by her side are of the kind usually associated with river or spring nymphs. Poussin has fol-

14. Annibale Carracci, *Polyphemus and Galatea*, c. 1600, fresco, Palazzo Farnese, Rome
Alinari/Art Resource, New York

lowed Philostratus in arranging groups of figures without visible intercommunication. The effect of this is to make the psychological remoteness of Polyphemus literal within the physical structure of his landscape, while his passion is left to the viewer's imagination. Likewise the viewer must extrapolate the effects of his music. Conceivably the viewer will compare this endless passion that music makes ideal with the implied erotic interplay of the nymphs and satyrs in the foreground. If these nymphs belong to that same post-Saturnian nature that the middle-ground figures are cultivating, an ideal and imaginary Galatea remains, out of sight beyond the horizon as a sign of permanent renewal of fantasy.

15. Annibale Carracci, *Polyphemus and Acis*, c. 1600, fresco, Palazzo Farnese, Rome
Alinari/Art Resource, New York

NOTES

1. Anthony Blunt, *Nicholas Poussin* (Princeton, 1958), 285.

2. Blunt 1958, 299.

3. Blunt 1958, 299.

4. Homer, *Odyssey* IX.105–III, 191–192. For discussion of the passage with its curious contradictions and double view of nature and culture see G. S. Kirk, *Myth: Its Meaning and Functions in Ancient and Other Cultures* (Berkeley, 1970), 163–171. The need to make Polyphemus more savage than the rest of the Cyclopes is surely the beginning of the isolation that ends with his pastoral domestication.

5. *Philostratus' Imagines*, trans. Arthur Fairbanks (Cambridge, Mass., 1931), II.18.211.

6. Karl Lehmann, "The *Imagines* of the Elder Philostratus," *Art Bulletin* 23 (1941), 25, suggests that this composition laid deliberate stress upon the concept of primitivism in the myth, which was located within a room generally dedicated to paintings with a thematic emphasis upon aspects of primitivism.

7. *Philostratus' Imagines* 1931, II.18,371K: Θαῦμα οἱ ὀφθαλμοί. βλέπουσι γὰρ ὑπερόριόν τι καὶ συναπιὸν τῷ μήκει τοῦ πελάγους.

8. Paul Alpers, "What Is Pastoral?" *Critical Inquiry* 8 (Spring 1982), 437–460, reviews and summarizes many positions. Observing that "many critics and readers seem to know what they mean by pastoral," he nonetheless points out that "there are as many versions of pastoral as there are critics who write about it."

9. William Empson, *Some Versions of Pastoral: A Study of the Pastoral Form in Literature* (London, 1950), 253–294, himself recognizes a topography for the urban pastoral of *The Beggar's Opera*. The point is not that landscape is superfluous, but rather that the significance of pastoral landscape must be determined by its specific contextual function. The idea is well demonstrated by Raymond Williams, *The City and the Country: A Study of the Pastoral Form in Literature* (Oxford, 1973), whose appraisals cut through the conventional "idealization" of pastoral art to the social realities beneath its veneer.

10. Paul Alpers, "Pastoral and the Domain of Lyric in Spenser's *Shepheardes' Calendar*," *Representations* 12 (1985), 83–100, is concerned to define a concept of "aesthetic space" that takes cultural and ideological elements into account, a consideration whose importance he, paradoxically, disallows in reading classical pastoral. His essay, "Community and Convention in Vergilian Pastoral," in J. D. Bernard, ed., *Vergil at 2000: Essays on the Poet and His Influence* (New York, 1986), 43–66, approaches these questions from the point of view of a Renaissance scholar seeking the light that later poems shed on their Virgilian models. He shows the *conventus* of shepherds for singing as the genesis of what is familiarly called "pastoral convention." Additionally (54–55) he speaks of the convention of a mourning nature as the creation of Theocritus and Virgil, but this is a necessarily retro- spective view of a phenomenon whose specific contexts may characterize its occurrences quite differently, even treating them from a critical or skeptical point of view. Retrospective interpretation necessarily drains off this cultural subtext with all its contemporary ambiguities. This has been demonstrated by Annabel Patterson, *Pastoral and Ideology: Virgil to Valéry* (Berkeley and Los Angeles, 1987), 106–132, when she explains Spenser's "green cabinet" as a repository of secrets signifying a rediscovery of the commentator Servius' conception of ideological awareness in pastoral.

11. David M. Halperin, *Before Pastoral: Theocritus and the Ancient Tradition of Bucolic Poetry* (New Haven, 1983), conducts a searching reexamination of the relation of canonical features of pastoral to the classical origins of the form. His discussion marks the influences of Schiller's essay, *Naive and Sentimental Poetry*, in determining the attitudes toward nature that critics have brought to their reading of pastoral.

12. The predominance of Virgil as a model for European pastoral is generally acknowledged. See, for example, Frank Kermode, ed., *English Pastoral Poetry from the Beginnings to Marvell* (1952; New York, 1972), 15–22. As Halperin 1983, 2–4, observes, Theocritus has enjoyed his reputation in recognition for his services to Virgil. But the real problem for perceiving either continuity or discontinuity among the sequence of pastoral texts themselves is not so much Virgil's identifiable influence upon the later tradition as his influence upon the expectations that readers bring to Theocritus. Many aspects of the reception of Virgilian pastoral are now clarified by Patterson 1987, who shows how Virgil's adoption by later readers as a paradigm for the intellectual's dilemma fostered his reputation for complexity as against Theocritean simplicity.

13. In such a consideration it is important to take account of the distinction that Halperin 1983 makes between modern conceptions of pastoral and "Theocritean bucolic," an innovative kind of poetry created within the genre of *epos* by engrafting heroic themes into everyday settings, sometimes, but not necessarily, rustic or pastoral. In this sense the poems do not elevate or idealize their topics, but rather supply the everyday perspective by which large concerns are scaled down to human size. Theocritus' pastoral settings contribute to this everyday perspective; they themselves are often adapted from heroic locations. While the poet, as Halperin sees him, did not sentimentalize these natural settings, he did celebrate the artistry by which he imported his themes into rustic contexts. In this sense he should be seen as a highly self-conscious pastoralist.

14. *Theocritus with a Translation and Commentary*, ed. A. S. F. Gow, 2 vols. (Cambridge, 1952), 2:118.

15. Gow 1952, 2:118.

16. Gow 1952, 2:118.

17. Other allusions and reworkings, such as the encounter with Lycidas in idyll 7, modeled on that of Odysseus and Eumaeus, are both anonymous and timeless. Halperin 1983, 224–227, discusses this temporal transformation. While the landscape centered on a spring, and also elements of mockery in the dialogue are clear clues to what Halperin calls "Theocritus' expansion of the anti-heroic material in the Homeric epic," the contemporary time frame prevails.

18. Anne Brooke, "Theocritus' *Idyll* 11: A Study in Pastoral," *Arethusa* 4 (1971), 73–82, emphasizes the significance of this further realm that the Cyclops idealizes as a world more desirable than his own pastoral.

19. Idyll 11, lines 80–81: ἐποίμαινεν τὸν ἔρωτα μουσίσδων. E. W. Spofford, "Theocritus and Polyphemus," *American Journal of Philology* 90 (1969), 22–35, comments on the significance of this word.

20. For the first see Charles P. Segal, "Landscape into Myth: Theocritus' Bucolic Poetry," in *Poetry and Myth in Ancient Pastoral: Essays on Theocritus and Vergil* (Princeton, 1981); for the latter, Spofford 1969, 22–35; Brooke 1971, 73–82.

21. Charles P. Segal, "Thematic Coherence in Theocritus' Bucolic Idylls," in *Poetry and Myth in Ancient Pastoral: Essays on Theocritus and Vergil* (Princeton, 1981), 188–190, reprint from *Wiener Studien*, n.s., 11 (1977), 35–68.

22. Segal, "Bucolic Idylls," 1981, 188–190, does not perceive here the difference between the spectator's characterizations of Polyphemus and the giant's self-characterizations in idyll 11. Thus he remarks that in 6, unlike 11, Galatea appears to be "the more active partner in an unequal and improbable relationship."

23. Halperin 1983, 161–189, discusses the centrality of this image to his conception of Theocritus' bucolic poetics.

24. Gilbert Lawall, *Theocritus' Coan Pastorals: A Poetry Book* (Cambridge, Mass., 1967), 70–73, proposes that the songs actually represent a realistic lovers' quarrel that the poet has projected backward with mythological costumes into mythical time. Thus "the songs give no hope that either will ever yield; it is the nature of male and female to be ever separated." The harmony of the frame involves a total inversion of these standoff relationships.

25. G. E. Rizzo, *Monumenti della pittura antica scoperti in Italia*, sec. 3, vol. 3, *Le pitture della casa di Livia* (Rome, 1936), 35, figs. 24–29, pls. 2–3.

26. Peter H. von Blanckenhagen and Christine Alexander, "The Paintings from Boscotrecase," *Mitteilungen des deutschen archaeologischen Instituts römische Abteilung*, supp. 6 (1962), 9–11. This dating, based on a hypothesis of ownership, represents the conventionally accepted view but has recently been challenged on stylistic grounds by F. L. Bastet and M. de Vos, *Proposta per una classificazione del terzo stile pompeiano*, Archeologisch studien van het Nederlands Institut de Rom 4 (The Hague, 1979), 9–10.

27. Von Blanckenhagen 1962, 47; P. H. von Blanckenhagen, "Daedalus and Icarus on Pompeian Walls," *Mitteilungen des deutschen archaeologischen Instituts römische Abteilung* 75 (1968), 140.

28. Von Blanckenhagen 1962, 42.

29. The issue is discussed more extensively in Eleanor Winsor Leach, *The Rhetoric of Space: Literary and Artistic Representations of Landscape in Republican and Augustan Rome* (Princeton, 1988), 339–344.

30. Maxwell Anderson, "Pompeian Frescoes in the Metropolitan Museum of Art," *Metropolitan Museum of Art Bulletin* 83 (1987/88), 50–51, pl. 54. See also Peter von Blanckenhagen and Christine Alexander, *The Augustan Villa at Boscotrecase*, with contributions by Joan R. Mertens and Christel Faltermeier (Mainz, 1990), 28–35.

31. E. W. Leach, "The Punishment of Dirce: A Newly Discovered Painting in the Casa di Giulio Polibio and Its Significance in the Visual Tradition," *Mitteilungen des deutschen archaeologischen Instituts römische Abteilung* 93 (1986), 160–176.

32. Vitruvius, *De architectura* v.6.9. When discussing stage decorations appropriate to the various dramatic genres, he describes the background for satyr drama as having "trees, caverns, mountains and other rustic objects delineated in a landscape style." A further piece of evidence can be adduced from Virgil's use of the word *scena* with reference to a landscape topography that centers on a cavern beneath a forested cliff at the site of Aeneus' landing near Carthage (*Aeneid*, 1.164–166).

33. Gow 1952, 118, gives this reference. The iconography of the shrine is discussed in Leach 1986, 175 n. 72.

34. Mario Bosio in *Notizie degli Scavi* 7 (1931), 269, fig. 29; also J. M. Pailler, "Attis, Polypheme et le Thiase Bachique: Quelques représentations méconnues," *Mélanges de l'Ecole Française de Rome* 83 (1971), 126–139. The plaque is in room 23 of the Museo Nazionale delle Terme, Rome.

35. A group of these plaques is described and pictured in Margareta Bieber, *History of the Greek and Roman Theatre*, 2d ed. (Princeton, 1961), 155–159. They existed both for comedy and tragedy and occurred in contexts as diverse as the Capitoline Hill and the peristyle of a Pompeian house.

36. Margherita Guarducci, "Epigrammi greci in una casa Romana di Assisi," in *Colloquium Propertianum*, Assisi, 26–28 March 1976, Accademia Properziana del Subasio (Assisi, 1977), 123–129, with an epigraphical appendix; "Domus Musae: epigrafi greche e latine in un'antica casa di Assisi," *Memorie. Atti dell'Accademia Nazionale dei Lincei. Classe di scienze morali, storiche e filologiche*, 8th ser., 23 (1979), 269–297. "La Casa di Properzio: Nuove riflessioni sulla Domus Musae di Assisi e sulle sue epigrafi," *MemLinc*, 8th ser., 29 (1985), 163–181. Bieber 1961, 154, fig. 571, shows a painted Perseus and Andromeda panel with three masks.

37. E. A. Barker, ed., *Sexti Properti Carmina*, 2d ed. (Oxford, 1960), 3.2.7–8.

38. C. M. Dawson, *Romano-Campanian Mythological Landscape Painting*, Yale Classical Studies 9 (1944; reprint, Rome 1965), 123–125, counts eleven examples of the subject in which he notices a gradual change from sacral-idyllic to villa style. W. J. T. Peters, *Landscape in Romano Campanian Mural Painting* (Assen, 1963), 133, fig. 113. This painting has a single villa in the background. It is combined with a subject suggesting Greek tragedy: Hercules freeing Prometheus.

39. Dawson 1944, 111, no. 64, sees the subject in this case "overloaded with inappropriate architecture." Peters 1963, 177, treats this as a villa landscape with staffage; the peristyle, which was repainted at a late date, contains a *venatio*, the only example in Pompeii in which hunters are shown pursuing the beasts. While that subject was appropriate to the amphitheater, this belongs to the stage and one might think that the owners of the house had sponsored both. Paavo Castrén, *Ordo populusque Pompeianus: Polity and Society in Roman Pompeii* (Rome, 1975), 189, identifies the Marii, owners of the house, as magistrates in the final years of the town—thus their sponsorship of games is highly probable.

40. Peters 1963, 141, fig. 127, describes the painting commonly called "Polyphemus receiving a letter," in which Eros on a dolphin serves as messenger and Polyphemus with a lyre eyes the spectator with a complicitous wink. Here, beyond doubt, there is evidence for reflections of a stage tradition. Much is left to the imagination, which is not the case in the Polyphemus embracing Galatea from the Casa della Caccia Antica (Peters 1963, 141; illustrated by Michael Grant, *Eros in Pompeii* [New York, 1975]). In this painting, nothing but a staff and a ram distinguishes the lovers from the copulating pairs in any erotic representation.

At this point it is also appropriate to mention Lucian's comic conversation in the *Dialogues of the Seagods* between Galatea and her sister Doris, which trades upon the grotesque implications of Galatea's response. Here a dizzily infatuated Galatea defends her flattering lover against her sister nymph's realistically disparaging remarks.

41. Brooks Otis, *Vergil: A Study in Civilized Poetry* (Oxford, 1963), 121, establishes the precedent with his estimate of Corydon as "a rustic who can be taken seriously as a man who understands and appreciates the countryside he is in." His judgment rests upon a contrast with Polyphemus' hapless grotesquerie. Paul Alpers, *The Singer of the Eclogues: A Study of Virgilian Pastoral* (Berkeley, Los Angeles, and London, 1979), 120–125, carries the notion much further, describing the difference as a transition "from Theocritean naive to Vergilian sentimental poetry." In Theocritus, he argues, the representation of a shepherd is never felt to be self-representation.

42. W. Ralph Johnson, *The Idea of Lyric: Lyric Modes in Ancient and Modern Poetry* (Berkeley, 1982), 163–164, notes that this framing is far more artificial in its effect than that of Theocritus.

43. As Otis 1963 sees it, pastoral outranked love here as a pole of loyalty and emotion inspiring a vision of pastoral that lingers after erotic disillusionment. To follow this line to its logical end is to see Corydon as the unfolder of a pastoral program essentially the same as that of the eclogue poet. This step is taken by Michael Putnam, *Vergil's Pastoral Art* (Princeton, 1969), 112: "What really mattered in Corydon's life, pastoral practice, which here is a metaphor for poetry and its composition, lies neglected." Real difficulties result from readers' attempts to uncover a personal narrative hidden behind the performance. Thus Johnson 1982, 164–166, calls the poem as far from Theocritus as one can get, a systematic rejection. This is a contradictory observation on Corydon, whom he calls "not conscious of Alexis who is only material for the artist," but also "hopelessly neurotic and a prey to hideous emotions."

44. R. A. B. Mynors, ed., *P. Vergili Maronis Opera* (Oxford, 1969), eclogue II, 56–62.

45. R. M. G. Nisbet and Margaret Hubbard, *A Commentary on Horace's Odes: Book I* (Oxford, 1970), 216, use the idea to deflect biographical speculations, observing that Tyndaris is "a dream figure belonging to the world of Alexandrian pastoral whose prototype is Theocritus' Galatea." Nonetheless they do not consider the relevance of the allusion to the actual form of the poem.

46. D. R. Shackleton Bailey, ed., *Q. Horatii Flacci Opera* (Stuttgart, 1985), ode I. 17. 1–8.

47. W. S. Anderson, ed., *P. Ovidii Nasonis Metamorphoses* (Leipzig, 1982), XIII. 824.

48. For general discussion of the manner in which these Ovidian narratives challenge their epic models see Betty Rose Nagle, "A Trio of Love Triangles in Ovid's *Metamorphoses*," *Arethusa* 21 (1988), 75–98.

49. Nagle 1988, 96, stresses the relationship of Roman to Greek poetry in this context. The same also is true for Galatea's audience, the sea nymph Scylla who goes on from this point to reject the love of Glaucus and thus, by a perverse application of Circean vengeance, to become the monster who lies in wait for Odysseus. When she exercises reciprocal vengeance on Circe by despoiling six comrades of Odysseus, she has come to play a role parallel to that of the Homeric Cyclops.

50. Christof Thoenes, "Galatea: tentativi di avvicinamento," in Konrad Oberhuber, ed., *Raffaello a Roma: Il convegno di 1983* (Rome, 1986), 59–73, discusses the complexities of the relationship between the image and its Renaissance sources, both artistic and literary, as well as probable ancient models. Poliziano's descriptions in the "Giostra," as he sees it, marked a turn from the medieval Ovidian tradition back to Philostratus as a prime source.

51. *Philostratus' Imagines* 1931, II. 18.4.

52. Charles Dempsey, "*Et nos cedamus amori*: Observations on the Farnese Gallery," *Art Bulletin* 50 (1968), 363–374, emphasizes the comic aspect of this erotic

heaven, closely related to the loggia of Psyche at the Villa Farnesina.

53. Dempsey 1968, 371, calls the Polyphemus and Galatea an "astonishingly literal copy of an ancient painting described by Philostratus." This is not quite so; in fact the version by Raphael, which does not contain the figure of Acis, is much closer. Annibale Carracci's comic vision renders Acis as a passive, androgynous figure and Galatea as a self-satisfied recipient of flattery. Within the complete ceiling Annibale alludes indirectly to Raphael's Galatea in the panel that Dempsey has called "Peleus and Thetis" by imitating a subordinate pair of embracing sea deities from the earlier painting.

54. John Rupert Martin, *The Farnese Gallery* (Princeton, 1965), 109–112, quotes Bellori's characterization of the power of music to transform the savage beast, calling it "inadequate" here because of Polyphemus' reversion to savagery. But this is the point.

55. Poussin explains this theory in a letter of November 1647 to his friend and patron Chantelou (Blunt 1958, 367–370). The Polyphemus painting surely exemplifies the "Hypolidian," which is characterized by elegant sweetness "qui remplit l'ame des regardans de joye." The frame of reference is also accommodated to this painting: "Il s'accommode aux matières divines gloire et Paradis."

56. The subject of Acis and Galatea had figured among Poussin's early works, both in a painting and also in a set of drawings made for the poet Marino as illustrations to the *Metamorphoses* (Blunt 1958, 39–49, pl. 31). All of these, however, might be said to treat Polyphemus more kindly than does Annibale. The painting shows the Cyclops playing his reed pipe amid frolicking sea deities almost like a village musician piping for a rustic festival.

57. John Onians, "Abstraction and Imagination in Late Antiquity," *Art History* 3 (1980), 15–18, discusses these descriptive practices and their roots in Quintilian. The encomium represents an imaginary "filling in" of a pictorial script, a practice whose complexity increases with the increasing popularity of the form. Since the description is a species of rhetorical display piece, the speaker naturally wants to parade his learning.

58. *Philostratus' Imagines* 1931, II.18.4.370k. He differs only in writing ἡδίων (sweeter) than an unripe grape in place of the poet's φιαρωτέρα (brighter), an Alexandrian word.

59. Lehmann 1941, 16–44, argues that, given the concealed thematic links he finds among pictures, they are based upon a collection that the writer actually saw in a real Neapolitan gallery. This view implies that Philostratus himself completely missed the programmatic interconnections of the images, yet the implications of this oversight for the structuring of the descriptions are purely neutral. As Lehmann also points out, the subjects of the paintings are in great part identical with earlier subjects, but scenes exist in this collection that are not to be found in earlier periods.

HOWARD M. BROWN
University of Chicago

The Madrigalian and the Formulaic in Andrea Gabrieli's Pastoral Madrigals

As David Rosand has pointed out, the pastoral tradition of the sixteenth century did not celebrate workaday shepherds and shepherdesses tending their flocks, but rather offered a specifically classicizing view of the rustic life, derived ultimately from Theocritus and Virgil.[1] If poets and painters called on ancient models for their inspiration in portraying an idyllic and carefree existence independent of the problems and tensions of the normal world, would not composers as well have alluded in some way to ancient Greece and Rome and their lost musical traditions in settings of pastoral poetry? Or was the classicizing element in pastoral madrigals limited merely to the choice of the poem to be set, with the music written in "normal" sixteenth-century madrigalian style (or rather, one of the acceptable styles in which madrigals were written)? In short, what constitutes a "pastoral style" in the sixteenth-century madrigal, and how does it compare with the styles and themes adopted by painters, poets, and intellectuals of the time in their own work?

These questions are not easy to answer, in spite of Alfred Einstein's magisterial study of the Italian madrigal of the sixteenth century, for scholars have not devoted much effort to the task of defining or explaining the nature of pastoral music.[2] We must begin to construct a view of what constitutes musical pastoralism by studying individual pieces or the works of particular composers, to see what kinds of musical responses shepherds and shepherdesses elicited from sixteenth-century musicians. Almost any composer of sixteenth-century madrigals would be appropriate for such a study (especially anyone working in the second half of the century, once pastoral themes became widespread)— the madrigal, after all, might fairly be described as a quintessentially pastoral genre. But Andrea Gabrieli seems a particularly germane figure for our purposes for two reasons: we now have a modern edition of all his madrigals;[3] and more important, he seems to have been one of the most influential musicians creating and disseminating a kind of madrigal attuned to the pastoral spirit (whatever that may be taken to mean) rather than the florid, virtuoso madrigal that has heretofore drawn the most scholarly attention.

Einstein calls Gabrieli the Veronese of music and describes him as the archetypical creator of a particular kind of madrigal associated especially with the musical culture of Venice, "a lighter, more fanciful, socially more adaptable variety" than that composed by his predecessors.[4] He explains Gabrieli as a worthy pupil and successor of Adrian Willaert, the chapel master at Saint Mark's from 1527 until his death in 1562 and the *fons et origo* of Venice's preeminence as a pan-European musical capital in the sixteenth century. In identifying Gabrieli so closely with the

Venetian tradition and with Willaert, Einstein presumably intends to clarify his stylistic orientation: Andrea wrote a kind of music that closely and sensitively translates into musical terms not only the form and syntax of the poems he chose to set to music but also their meaning and their rhetoric. He offered, in short, a reading of a poem that took into account its form, its figures of speech, its arrangements of ideas, and where and how individual words and phrases should be emphasized so that the text could be effectively declaimed. As Andrea's nephew Giovanni Gabrieli declared, "it can clearly be seen from his compositions how unique an imitator he was in finding sounds to express the force of words and of ideas."[5]

The first of Andrea Gabrieli's three books of madrigals for five voices, published in 1566, contains only one composition that can be described as pastoral, his setting of the anonymous sestina *Per monti e poggi, per campagne e piagge*, the longest poem and the only cycle in the volume.[6] In musical technique it resembles most of Gabrieli's other high-style compositions, save perhaps that it is more homophonic, a consequence, as we shall see, of the fact that it was almost certainly conceived as a celebratory composition for a specific occasion, when it would have been especially important for the audience to understand the words:[7]

1

Per monti e poggi, per campagne e piagge,
Per vaghi aprici ameni e verdi colli,
Per strani rupi, valli, selve e boschi,
Per rivi, fonti, per torrenti e fiumi,
Per prati herbosi, per fiorite rive,
Vo cercando riposo alla mia gregge.

(Over mountains and knolls, over fields and slopes, over charming sunny pleasant and green hills, by uncouth cliffs, valleys, forests and woods, by streams, springs, by torrents and rivers, through grassy meadows, by flowing banks, I go seeking a resting place for my flock.)

2

Chi sei tu che procacci alla tua gregge
Trovar riposo in qualche liete piagge,
Pastor novello, gionto in queste rive,
Sceso da gl'alti et honorati colli?

Ecco'l Tesin, tra li più chiari fiumi,
T'invita a meriggiar in questi boschi.

(Who are you who are trying to find a resting place for your flock on some cheerful slopes, new shepherd, having come to these banks, having descended from the high and venerable hills? Here the Ticino, among the clearest of rivers, invites you to pass the afternoon in these woods.)

3

Dolce mia pastorella, in questi boschi
S'amor mi fece degno unir mio gregge
Con le tue peccorelle, i duo miei fiumi,
Secchia e Scultena, fin in queste piagge,
Largarebbon le braccia a far i colli
Gir in diporto e festeggiar le rive.

(My sweet shepherdess, if in these woods love made me worthy to unite my flock with your sheep, my two rivers, the Secchia and the Scoltenna, would spread their arms as far as these slopes, to cause the hills to spin with pleasure and the banks to celebrate.)

4

Amorosette e ben fiorite rive,
Et voi ombrosi et celebrati boschi,
Felici voi, et voi beati colli;
Sarete ben se di sì nobil gregge
Vi fesse degno amore. O quante piagge
Invidiarebbon voi, et quanti fiumu!

(Amorous and well-flowered banks, and you shady and celebrated woods, happy you, and you blessed hills, will be lucky if love should make you worthy of such a noble flock. Oh, how many slopes would envy you, and how many rivers!)

5

Quando sarà giamai che i nostri fiumi
Vengano insieme per le fresche rive,
Spargendo per campagne e per le piagge,
A rinfrescar le selve e questi boschi,
E spinger de la mandra fuor il gregge
E unirla insieme ai desiati colli?

(When will it ever be that our rivers come together by the fresh banks, spreading through the fields and slopes, to refresh the forests and these woods, to drive the flock from the sheepfold and unite it on the longed-for hills?)

6

Vengo, caro pastor, a quei bei colli,
E mi seguon'a dietro i cari fiumi,
Lambri'e'l Tesin, che de la tolta gregge
Senton'un dolce duol; e per le rive

Del Po che seco vien, lasciando i boschi
Per honorar queste honorate piagge,

Rallegratevi dunque, piagge e colli,
Et voi boschi, e miei cari e dolci fiumi,
Voi rive, ai fausti de l'unita gregge.

(I come, dear shepherd, to these beautiful hills,
and behind me follow the beloved rivers, the
Lambro and the Ticino, that hear a sweet la-
ment from the captured flock; and by the banks
of the Po, which comes along leaving the woods
to honor the venerable slopes,
Rejoice then, slopes and hills, and you woods,
and my dear sweet rivers, you banks, at the
celebration of the united flock.)

These six strophes form a dialogue be-
tween a shepherd and a shepherdess. In pe-
destrian and cliché-ridden verse the shep-
herd, from somewhere in Emilia Romagna,
near the rivers Secchia and Scultena (or, as
it is spelled today, Scoltenna), hopes that
the shepherdess will accept him and his
flocks and love him. She eventually wel-
comes him as a newcomer to her home,
somewhere in the territory of Milan, fed by
the rivers Po, Ticino, and Lambro.[8] By the
sixth strophe the shepherdess rejoices at
their union and hopes their respective
rivers can now unite.

The awkwardness of the poetic concept
can only be explained by supposing that
the madrigal was conceived for some par-
ticular festive occasion. We know alto-
gether too little about celebratory and
theatrical music written by Venetian com-
posers in the sixteenth century, a subject
sadly neglected by musical scholars, but it
is, of course, clear in a general way that
such celebrations were often accompanied
by great pomp and circumstance, including
festive music.[9] Not the least interesting as-
pect of *Per monti e poggi*, in fact, is that
the pastoral mode was fashionable enough
by the early 1560s, considerably before Tor-
quato Tasso's *Aminta* and Batista Guarini's
Il pastor fido were written, to inspire some
doubtless local poet to frame his political
encomium as a dialogue between rustics.
We can imagine, I think, the cycle being
performed by a single group of singers, pos-
sibly accompanied by instruments, and
even conceivably embellished with some
simple dramatic action.

Martin Morell has made the convincing

argument that Gabrieli's cycle was written
for performance at one of the celebrations
attending Carlo Borromeo's solemn entry
into Milan on 23 September 1565, after his
election as cardinal.[10] Among his other du-
ties and responsibilities Borromeo served
as titular head of the important Abbey of
Nonantola, near both the Secchia and the
Scoltenna Rivers; he had stayed at the ab-
bey en route to Milan from Rome. It may
be, then, that the madrigals were con-
ceived to grace a banquet or some similar
festivity honoring Borromeo. Morell's hy-
pothesis, moreover, should alert us to the
possibility that Gabrieli's sojourn in
Milan—for it is likely that Andrea was
in the city when his cycle was first per-
formed—may have introduced the com-
poser to the work of Milanese musicians
like Vincenzo Ruffo, Gioseppe Caimo,
Pietro Taglia, and Simone Boyleau, whose
interests in a simple musical style and the
intelligibility of the text were encouraged
by Cardinal Borromeo. Borromeo was in-
volved with such issues at the time in con-
nection with the discussions at the Coun-
cil of Trent about the function of music in
sacred services. The style of *Per monti e*
poggi, in short, may derive as much from
the orientation of the Milanese composers
among whom Gabrieli found himself as
from the aesthetic demands of a festive
piece written to celebrate a political event.

In six *partes*, one for each strophe of
the poem, with the sixth *pars* including,
as well, the final three-line *commiato*,
Gabrieli's setting of the sestina, with its
frankly declamatory music, reflects the
fact that the characters are intended to be
speaking to one another. Many motives
and phrases are filled with repeated notes
or concise rhythms suggestive of speech
patterns, but the composer does not at-
tempt to make palpable in musical terms
the element of dialogue. The two speakers,
it is true, alternate stanzas, but the shep-
herdess, for example, does not sing either
in a higher tessitura or in a different style
from that of the shepherd; Gabrieli did not,
in short, try to characterize either of the
two speakers. Moreover, he made no at-
tempt to reflect the poetic artifice of a
sestina in his musical setting. Instead, he
followed the standard sixteenth-century

convention of setting each line to new music. There is no thematic recall from stanza to stanza, the repeating final words of each line do not call forth the same or even similar music, and there is not even any clear-cut parallelism in the phrase structure or tonal scheme of each of the stanzas. Gabrieli's principal attempt to fashion the six pieces into a unified cycle, it would seem—beyond, of course, writing each stanza in the same mode and with the same clefs—comes from his pairing of stanzas (the statements of the shepherd and the replies of the shepherdess) through their final cadences. Each of the shepherd's stanzas ends on a degree other than the final G (the first stanza with a half cadence on D, the third with a half cadence on A, and the fifth with a Phrygian cadence on A), while each of the shepherdess' replies closes off a part of the poem with a cadence on the final, and thus divides the whole sestina into three groups of two stanzas each.

Gabrieli's setting of *Per monti e poggi* is thoroughly madrigalian. That is, the composer has written music to fit the accent patterns, syntax, and rhetoric of particular lines of poetry, while at the same time taking account of the form of the sestina by following, for the most part, the standard sixteenth-century convention of setting one line of poetry to one phrase of music, a convention that is violated when the sense of the text extends to part of the next line. The tension between the demands of the syntax and the demands of the poetic form makes itself felt, for instance, at the end of stanza 4 (all of which is reproduced as fig. 1). Gabrieli divided most of the six-line stanzas of the sestina into three groups of two phrases each by his placement of cadences and his manipulation of textures, a division that corresponds to the organization of ideas and images in the poetry, where each pair of lines encompasses a single clause, or at least ends with a comma or a period. The fourth stanza, however, is divided by its sense and its syntax into two groups of three phrases each, since the third line, "Felici voi, et voi beati colli," not only supplies yet another item of the landscape for the shepherdess to address but also provides the explanatory exclamation "Felici voi" to describe the

riverbanks, the woods, and the hills. Following the syntax and rhetoric of the poem, Gabrieli also divides his music into two groups of three phrases. The first two phrases, it is true, form a pair. Andrea has written a relatively elaborate exordium at the beginning of the stanza, with a clear-cut point of imitation on "Amorosette e ben fiorite rive," but the phrase ends with an inconclusive and rhythmically weak cadence on the final in measure 6, overlapped with the second phrase, whose melodic material is not nearly as clearly profiled. The imitation in the second phrase is approximate at best, although the phrase cadences strongly and decisively in measure 11 on B-flat, traditionally an important secondary point of repose in the second mode. The first two phrases are run together because they make one unit of sense, and to them Gabrieli added as codetta and culmination the more homorhythmic third phrase, clearly celebratory since it shifts momentarily into a triple mensuration; this third phrase closes off the first half of the stanza in measure 14 with a clear-cut point of articulation, the most important medial cadence of the stanza on the confinal of the mode, D.

The second half of the stanza offers a series of short declamatory phrases, which eventually cadence on the final of the mode in measure 23, at the climactic exclamation of line 5: "O quante piagge." But then purely formal claims evidently took over in Gabrieli's mind, for the strength of the cadence clearly separates what follows from the preceding clause. That is, Andrea set the phrase that begins "Invidiarebbon voi" as an elaborate (and independent) peroration, even though it completes the sentence beginning "O quante piagge." He did this, I suspect, because he wished to shape the entire sestina by making a full formal closure, with the last line of the fourth stanza repeated in its entirety. It is the first such full formal closure of the cycle, a gesture he repeated only at the very end, in the sixth and final stanza. In short, Gabrieli shows himself to be sensitive to rhetoric and meaning, although on occasion, as at the end of this stanza, he needed to balance such considerations against the desire for purely formal design.

1. Andrea Gabrieli, *Per monti e poggi*, stanza 4

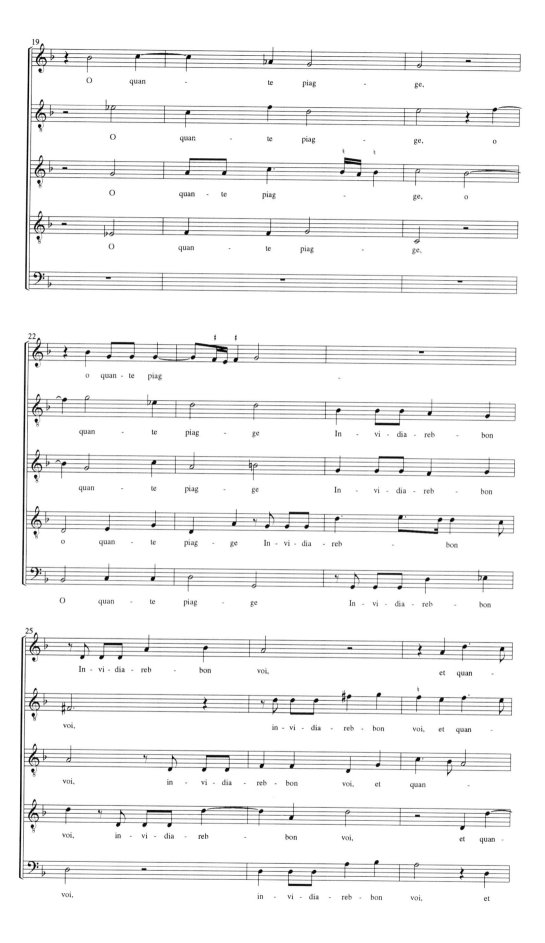

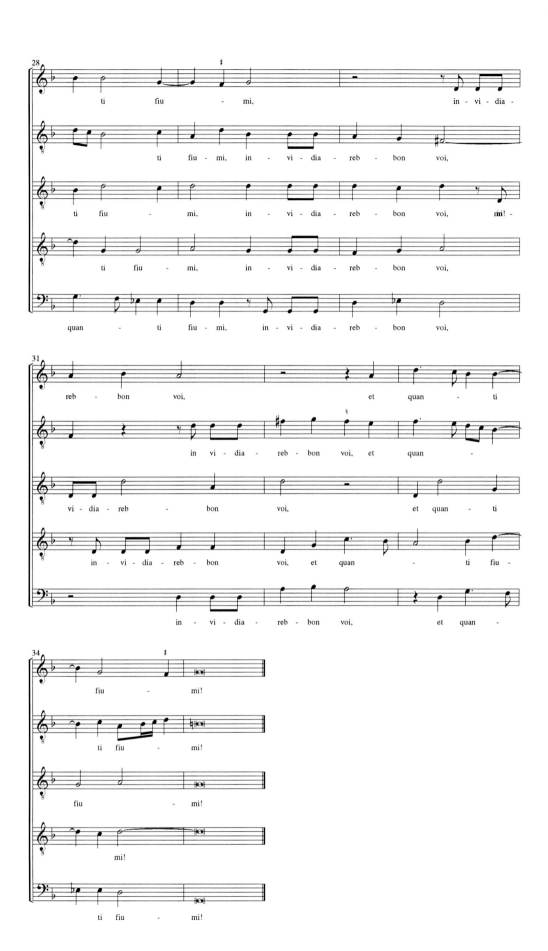

It is Gabrieli's care to distinguish between commas, semicolons, and periods by grouping phrases or parts of phrases into larger units that gives shape to his music; he established his readings of the poems partly by the placing, character, and rhythm of the cadences and partly by the manipulation of texture and contrasts in contrapuntal technique. What is specifically madrigalian in such sixteenth-century music is the composer's concentration on particular words, phrases, and poetic lines, rather than on purely formal elements of musical design. In short, Gabrieli and his contemporaries made little use of what is in fact one of the most important techniques throughout the history of Western music for giving compositions form and shape: significant formal repetition, a technique antithetical to the aim of supporting, enhancing, and elucidating particular lines of text.

To be sure, there are repetitive elements in Gabrieli's madrigals, not only the exact or varied repetition of final phrases that constitutes full formal closure in much music throughout the sixteenth century but also the repetitions inherent in the technique of imitation, where the same thematic material is passed from voice to voice. Moreover, Gabrieli, like many of his contemporaries, regularly exploits what might be called the technique of developmental or extending repetition. Indeed, one of the principal ways he supplies rhetorical emphasis to a phrase or even a whole line of text is by repeating a two- or three-bar contrapuntal passage at the same pitch or transposed—mostly with the voices exchanged, or with some other sort of variation—as a way of emphasizing an idea or merely of extending the section of music. He uses this technique, for example, in setting the last line of the second stanza of *Per monti e poggi*, "T'invita a meriggiar / in questi boschi" (fig. 2). Both halves of the line are repeated. It is easiest to see the repetition in the second half of the line in the voice that is at the bottom of the texture (for this is bass-oriented music). Gabrieli first presents the closing motive on the final (in the bass, measures 31 to 32), then on the fifth scale degree (in the tenor, the third voice from the bottom,

measures 33 to 34, with some of the same or similar contrapuntal lines above it), and then again on the final (in the bass, measures 35 to 37, once again with some of the counterpoint repeated), as a way of making a formal closure somewhat less decisive than that in stanza 4 (fig. 1). This sort of developmental and extending repetition permeates, in fact, the entire sestina cycle, and most of Gabrieli's other five-voiced madrigals as well. It was a standard technique of madrigal composers in the 1560s and thus distinguishes Gabrieli from earlier composers but not from his contemporaries.

The presence of all these kinds of repetitions, however, still does not alter the fact that mid-sixteenth-century composers took an essentially new compositional approach to every line of poetry they set. It was their concentration on reflecting grammar and rhetoric in music that constituted the essential syntactical features of the genre, rather than word painting, those vivid characterizations of particular words and phrases by striking musical analogues that we call madrigalisms. Madrigalisms were, for the most part, merely decorative features of somewhat less than central importance to the style, even though they are the details that invariably elicit the most attention from commentators.

A sophisticated and careful reading of the text is precisely what is new in the sixteenth-century madrigal, especially from the time of Willaert, and it was surely the sensitivity of the musical interpretation to the poetry that led Einstein to consider Gabrieli as Willaert's successor, even though the two are very different in style.[11] Willaert offered a true connoisseur's reading of the poem. His elocution is diffident and refined, without Gabrieli's more vivid characterization of individual words and phrases. Gabrieli's music places more emphasis on bright harmonic color, textural contrast, lively rhythms, and clear formal articulations, while at the same time offering an equally careful reading of the poem. The harmonic vocabulary of the two composers also differs considerably, not least because by the 1560s Gabrieli made such extensive use of developmental and extending repetitions, with their tendency to

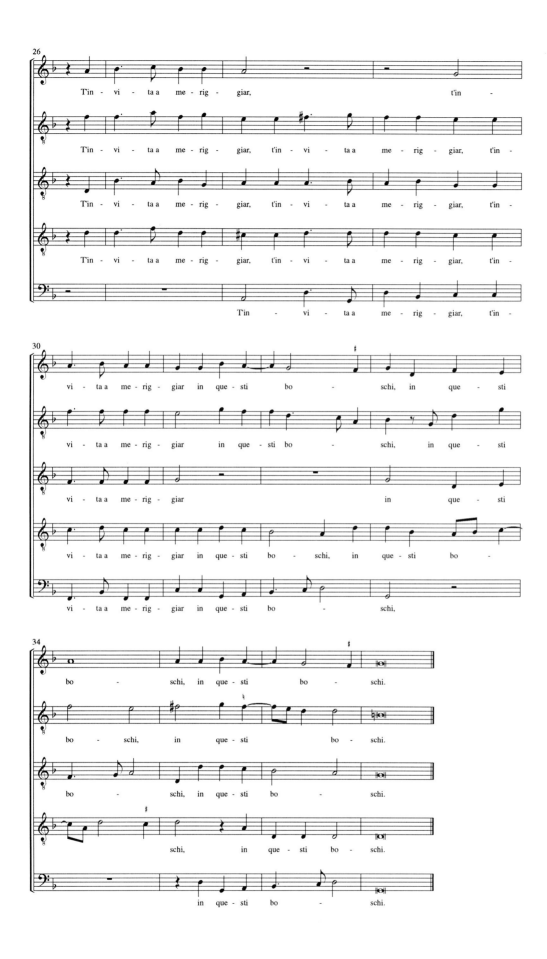

2. Andrea Gabrieli, *Per monti e poggi*, stanza 2, measures 26–37

focus and clarify the nature of various standard chordal progressions, and partly because he radically increased his use of formulaic harmonies. Indeed, between the time of Willaert and that of Gabrieli, a standard sixteenth-century harmonic language, not yet codified or even satisfactorily described by music scholars, had developed.[12] This harmonic language combined a number of dialects in common usage at the time, particularly (1) what we might call the "normal" contrapuntally derived simultaneities typical of the first half of the century, (2) the expressive experiments with harmony, including chromaticism, associated especially with the Italian madrigalists, and (3) the formulaic harmonies of the so-called "Italian tenors," those arias like the folia, the Ruggiero, and the several passamezzi. The first point of imitation in fig. I shows very well Gabrieli's typical vocabulary of contrapuntally derived chords. Not all the simultaneities can be explained very convincingly as the 5-3 sonorities recommended, for example, by Pietro Pontio.[13] Some seem merely to be the result of the concurrence of imitating themes, and movement by second is just as common as movement by fourth or fifth. Fig. I shows, too, that even in a piece reflecting what must be Gabrieli's high style formulaic harmonies intrude, as, for instance, at the setting of "Felici voi" in measures II to I4, where the

sequence of falling fourths, the ensuing circle of fifths, and the final cadential formula all derive from the sorts of arias cultivated by the sixteenth-century *improvvisatori*. And even in so relatively bland and celebratory a style as that of *Per monti e poggi*, there are purple passages in which Gabrieli has taken some pains to express an image forcefully by harmonic means, as in his evocation of uncouth cliffs, "Per strani rupi," shown in fig. 3, which Einstein cites as the extreme limit of Gabrieli's chromaticisms. Einstein notes at the same time that the passage is immediately repeated at a different pitch and with the voices exchanged, doubtless to offer an opportunity to the listeners to hear it again and thus to comprehend it better, while at the same time mitigating (through repetition) its harshness.[14] This is the sort of harmony that is the mainstay of composers of madrigals in the second half of the sixteenth century, who used an extensive vocabulary of striking and chiefly harmonic figures to make palpable such highly charged images as those of sweetness, anger, cruelty, or sorrow, creating as they did so a whole system of musical signs and symbols, a veritable sixteenth-century *Figurenlehre*.

Per monti e poggi is the only setting of a pastoral poem and the only madrigal cycle in Gabrieli's first book of madrigals in five voices. As the very last piece as well as the longest in the volume, it occupies a posi-

3. Andrea Gabrieli, *Per monti e poggi*, stanza I, measures I2–I6

tion of honor and importance. Its equivalent in Gabrieli's second book of madrigals for five voices, at least so far as length is concerned, is the setting in five *partes* of Jacopo Sannazaro's eclogue *Alma beata e bella*. Andrea may never have intended to make public this madrigal, however, for it appears only in the third edition of the volume, published for the first time in 1588, after Andrea's death, edited presumably by his uncle, Giovanni Gabrieli.[15] Most likely, it had originally been intended for performance at some Venetian academy for an audience of cultivated literati and music lovers. It, too, is pastoral in nature. It is an elegy that the shepherd Ergasto sings at the tomb of Androgeo to the sound of the soft-toned cornamuse and that forms the climax of the fifth chapter of *Arcadia*. *Alma beata e bella* is the only setting Gabrieli made of any poem by Jacopo Sannazaro, the late fifteenth-century Neapolitan poet who more than anyone else established the classicizing pastoral mode in the Italian Renaissance.[16]

By my own definition, though, *Alma beata e bella* is only partly madrigalian, or rather its madrigalian qualities are strongly tempered by elements of significant formal repetition. The text of the first of its five stanzas reads as follows:[17]

Alma beata e bella
Che da'legami sciolta
Nuda salisti ne' superni chiostri,
Ove con la tua stella

Ti god'insieme accolta,
Et lieta vai scherzand'i pensier nostri,
Quas'un bel sol ti mostri
Tra li più chiari spirti,
E coi vestigii santi
Calchi le stell'erranti,
E tra pure fontane e sacri mirti
Pasci celesti greggi,
E i tuoi cari pastori indi correggi.

(Blessed and beautiful soul who, freed from bonds, rose naked to the heavenly cloisters where, welcomed with your star, you rejoice together, and happy you make light of our cares; you show yourself like a beautiful sun among the bright spirits; and with saintly footprints you tread the wandering stars; and among pure fountains and sacred myrtles you graze your celestial flocks, and thence govern your dear shepherds.)

Like the first stanza, each of the following begins with a pair of tercets of varying line length but with parallel construction and rhyme scheme: abC abC. Fig. 4, the beginning of Gabrieli's setting of the first stanza, demonstrates how he has simply repeated the music of the first tercet for the second tercet, beginning in measure 10.[18] Parallel construction in the poetry in this case calls for musical repetition.

Figs. 4, 5, and 6 juxtapose the beginnings of Gabrieli's settings of the first, third, and fifth stanzas of *Alma beata e bella* and show how the composer has begun each of the *partes* in the same way, not by using the same thematic material for each, but

4. Andrea Gabrieli, *Alma beata e bella*, stanza 1, measures 1–18

5. Andrea Gabrieli, *Alma beata e bella*, stanza 3, measures 1–15

by basing them all on almost the same formulaic harmonic pattern. In the first stanza Gabrieli states the pattern most simply and repeats it almost literally; his technique in reusing the pattern in later stanzas is rather freer. In the third stanza a slightly simplified version of the first phrase of the model underlies both of the first two phrases of the reworking, and the original second and third phrases are combined to serve as the third phrase of the reworking; on repetition the pattern is broken, doubtless for rhetorical reasons, to express the sense of interruption at the exclamation in line 6, "Ahi, cruda morte." In the fifth stanza Gabrieli expands each of the model's phrases and begins the third phrase with a new point of imitation (measure 7 on and 21 on).

The modeling of one phrase on another evident in these three stanzas demonstrates beyond the shadow of a doubt that Gabrieli did not have thematic relationships in mind; instead he was evidently thinking in terms of a bass-oriented pattern, in short, of a series of chords. The passage offers important evidence for the formulation of a history as well as a taxonomy of sixteenth-century harmony. Indeed the nature of the harmony throughout *Alma beata e bella* confirms the predominantly formulaic character of the chord progressions in the cycle. Progressions by fourth and fifth, chains of ascending or descending fourths, progressions

around the circle of fifths, and the frequency of various conventional forms of cadence (or cadential harmonies) are present not only in the opening phrases but throughout each of the parts.[19]

Alma beata e bella differs from *Per monti e poggi* in its texture and rhythmic character as well as in the formulaic character of its harmonies. The prevailing movement by minim makes the rhythmic character solemn and chantlike, as befits an elegy, but it hides the complexity of the counterpoint and especially the varieties of developmental and extending repetitions that Gabrieli makes use of. The madrigal cycle is of a considerably more complex rhythmical and textural character than it seems at first glance.

Beyond the modeling of the opening pair of tercets in stanzas 1, 3, and 5, there are no other significant formal relationships in the five madrigals that make up *Alma beata e bella*. No section in the cycle recalls any other, and stanzas 2 and 4 break the pattern established in the other stanzas. Their parallel tercets at the beginning are each set to different music, and the openings of stanzas 2 and 4 are not modeled on each other or on any other part of the cycle. Even the pairs of rhyming lines in the middle of stanzas 3 and 4, in which the same music is immediately repeated to new lines of poetry (the music is, needless to say, completely different in the two stanzas), do not seem to be instances

6. Andrea Gabrieli, *Alma beata e bella*, stanza 5, measures 1–29

of formally significant repetition, but rather examples of repetition for rhetorical emphasis.[20] It is as true for this cycle as for *Per monti e poggi* that the composer controlled the pace of his music and extended and developed themes and contrapuntal passages to give greater or lesser emphasis to certain words and phrases. And, as we have seen, he was even capable of breaking the pattern of formulaic repetition that he had already established in order to make a suitable musical analogue to the interrupting exclamation, "Ahi, cruda morte." In short, it is only the repetitions of the formulaic harmonic patterns at the beginning of every other stanza that give the cycle its ABACA form.

The formal and stylistic qualities that make *Alma beata e bella* an essentially different kind of composition from *Per monti e poggi* involve questions of the nature of significant formal repetition and whether such formalism is antithetical to the spirit of the sixteenth-century madrigal. Is *Alma beata e bella* any the less madrigalian because at least a part of the music seems to be composed over a newly invented or pre-existent pattern of chords that forms the basis for more than one unit of the music? Gabrieli shapes even the precomposed musical patterns to conform to his reading of the rhetoric of the poem. On the one hand, some sixteenth-century composers seem to believe in the ideal (never explicitly articulated at the time in quite this way) that madrigals should involve music newly composed for a particular set of words and somehow expressive of those words; on the other hand, there also exists in the sixteenth century a purely formalistic music, most of it in low or middle style, strophic songs, or improvised repeating formulas, in which the music was made to fit more or less any set of words with the same general structural features. *Alma beata e bella* exists between these two extremes. This tension between what I have called the madrigalian and the formulaic has, of course, characterized many musical cultures, and various musical genres, expressed as the conflicting demands of a free flow of ideas in a literary text and all the static or purely formal repetitive strategies that give music its special character.

More prosaically, how are we to understand the repetitions in *Alma beata e bella?* What can Gabrieli have meant by them? Indeed, what can explain the rather spare and austere texture of much of the madrigal? The answer has precisely to do with the pastoral character of the madrigal. The kinds of repeating formulas to which Gabrieli alludes in his madrigal were associated in the minds of Italian Renaissance listeners not only with the fairy-tale world of *Orlando furioso* and various other epic tales written in ottava rima but also more generally with the gods and goddesses of the ancient world. Apollo, Orpheus, Venus, Aurora, and many other ancient gods, goddesses, and heroes regularly appeared on the sixteenth-century Italian stage, singing verse in ottava rima to the lute or, more characteristically, the *lira da braccio*, that classicizing sixteenth-century version of the medieval fiddle, or to the accompaniment of a viol consort or some other ensemble of instruments.[21] Although many of their poems have survived, almost none of the music to which they sang has come down to us, probably because they did not perform composed music in the high style, but declaimed their ottava rimas to some semi-improvised repeating musical formula. Indeed, we can assume that wherever we see a figure from the ancient world playing a *lira da braccio* in a Renaissance painting, manuscript illumination, or woodcut—as, for example, in Giovanni Bellini's *Orpheus* and in the enigmatic *Hour Glass* by the circle of Giorgione[22]—he or she should probably be understood to be declaiming ottava rimas to formulaic arias: melodies or bass patterns very much like those that underlie significant portions of Gabrieli's *Alma beata e bella.*

In the second half of the sixteenth century, at least from the time of Antonio Barrè's *madrigali ariosi* of the 1550s and 1560s, and perhaps inspired by the experiments of a circle of Neapolitan and Roman virtuosi and dilettanti to set to arias not only the ottava rimas of the epic but also the finest high-style Italian poetry—son-

nets by Petrarch, canzone by Pietro Bembo, and eclogues by Sannazaro—composers began to incorporate aria-like elements into their own high-style musical works. Melodic and harmonic formulas began to invade even the incipiently virtuoso madrigals of northern Italy. Gabrieli's setting of *Alma beata e bella* is a relatively early instance of this trend.[23]

The classicizing view of rustic life that informed the sixteenth-century pastoral tradition, albeit derived from Theocritus and Virgil, was created by various Italian literati of the Renaissance: Agostino Beccari, Tasso, and Guarini, among others. The earliest of these interpreters of the antique pastoral mode was Sannazaro. In setting an eclogue from Sannazaro's *Arcadia*, Gabrieli was evidently trying to find appropriate musical garb for a classicizing poem, and he did this by adapting to his madrigalian purposes the kind of formulaic music that Italian musicians in the Renaissance associated with ancient gods, goddesses, heroes, or, as we now can see, shepherds. *Per monti e poggi* has a rustic setting, but it is not a pastoral madrigal in the sense I have just suggested. It is instead typical of Gabrieli's highest style in celebratory music for political events.[24] Several other five-voiced madrigals by Gabrieli are set to poems expressing love for Aminta, Tirsi, Filli, or some other shepherd or shepherdess, and although the beloveds' names are rustic, their music exemplifies Gabrieli's madrigalian high style.[25] A few of the five-voiced madrigals, such as *Vaghi augelletti, che per valli e monti* in Gabrieli's second book, evoke a happy bucolic world with appropriately easygoing and jolly counterpoint.[26] But only the solemn, chantlike *Alma beata e bella* can be called a "true" pastoral madrigal (or at least a true pastoral elegy), in the sense that the composer has provided a perfect musical analogue for the classical trappings of the poem by incorporating into the madrigalian fabric of his setting the classicizing declamation formulas he associated with the ancient world.

1. David Rosand, "Giorgione, Venice, and the Pastoral Vision," in Robert C. Cafritz, Lawrence Gowing, and David Rosand, *Places of Delight: The Pastoral Landscape* [exh. cat., Phillips Collection and National Gallery of Art] (Washington, 1988), 20–81, esp. 23–30.

2. The standard work on the madrigal remains Alfred Einstein, *The Italian Madrigal*, trans. Alexander H. Krappe, Roger H. Sessions, and Oliver Strunk, 3 vols. (Princeton, 1949). A recent book on the madrigal, which touches on pastoral imagery, is James Haar, *Essays on Italian Poetry and Music in the Renaissance, 1350–1600* (Berkeley and London, 1986). For the most informative recent discussion of pastoral elements in the madrigal see Nino Pirrotta, *Li due Orfei: da Poliziano a Monteverdi* 2d rev. ed. (Turin, 1975), translated into English by Karen Eales as *Music and Theatre from Poliziano to Monteverdi* (Cambridge, 1982).

3. Andrea Gabrieli, *Complete Madrigals*, 12 vols. in 8, ed. A. Tillman Merritt (Madison, Wis., 1981–1984). The most extensive discussions of Gabrieli and his madrigals appear in Antonio Daniele, "Teoria e prassi del madrigale libero nel Cinquecento (con alcune note sui madrigali musicati da Andrea Gabrieli)," in *Andrea Gabrieli e il suo tempo: Atti del Convegno Internazionale (Venezia 16–18 settembre 1985)*, ed. Francesco Degrada (Florence, 1987), 75–169; Paolo Fabbri and Antonio Vassalli, "Andrea Gabrieli e il madrigale: Interferenze musica, letteratura e società," in *Andrea Gabrieli 1585–1985: Volume pubblicato in occasione del XLII Festival Internazionale di Musica Contemporanea, Venezia, 12 settembre, 1 ottobre 1985* (Venice, 1985), 47–57. For the most recent studies of Andrea Gabrieli's biography see Martin Morell, "New Evidence for the Biographies of Andrea and Giovanni Gabrieli," *Early Music History* 3 (1983), 101–122; Martin Morell, "Andrea Gabrieli, 1585–1985, note biographiche," in *Andrea Gabrieli 1985*, 21–28; Martin Morell, "La biografia di Andrea Gabrieli: nuove acquisizioni e problemi aperti," in Degrada 1987, 19–41.

4. Einstein 1949, 2:520.

5. Quoted by Einstein 1949, 2:521.

6. The volume was the second Gabrieli had had published and the first devoted entirely to madrigals. Morell, "Gabrieli, . . . note biografiche," in *Andrea Gabrieli 1985*, 23, lists Gabrieli's *Cantiones sacrae quinque vocum* (Venice, 1565) as the first publication devoted exclusively to his music. The contents of Andrea's first madrigal book are given in Emil Vogel, Alfred Einstein, François Lesure, and Claudio Sartori, *Bibliografia della musica italiana vocale profana pubblicata dal 1500 al 1700*, 3 vols. (Staderini, 1977), 1: 677–78, no. 1032. The cycle *Per monti e poggi* appears in a modern edition in Gabrieli 1981–1984, 3–4: 94–113.

7. The text and translation are given as they appear in Gabrieli 1981–1984, 3–4: xxv–xxvi, save that the name of the river in stanza 6 has been changed from Ambria to Lambro (see note 8).

8. Merritt transcribes the name of the river in stanza 6, line 3 (given as "Lambr'" in the set of part books), as a contraction of L'Ambria. The Ambria is a small stream in Lombardy near Bergamo, represented in, among other places, *Grande Atlante d'Italia de Agostini* (Novara, 1987), 314–315, map 4, square I-f. The poet is more likely to have intended the much larger river Lambro, which flows into the Po near Milan, represented in *Grande Atlante d'Italia* 1987, 322–323, map 8. The Lambro is not far from the Ticino and both are in Milanese territory. The Ticino (or Tesin) is also represented in *Grande Atlante d'Italia* 1987, map 8. The Secchia and the Scoltenna are represented in *Grande Atlante d'Italia* 1987, 334–335, 340–341, maps 14 and 17, respectively.

9. Much more attention has been given to Tuscan and especially Florentine celebrations, partly because they are better documented. The best bibliographical study of Venetian theatrical music in the late sixteenth and early seventeenth centuries remains Angelo Solerti, "Le rappresentazioni musicali di Venezia dal 1571 al 1605," *Rivista musicale italiana* 9 (1902), 502–558, and the studies cited in Ellen Rosand, "Music in the Myth of Venice," *Renaissance Quarterly* 30 (1977), 511–537.

10. Morell, "Biografia di Andrea Gabrieli," in Degrada 1987, 19–41. Morell's suggestion is more convincing than that given in Einstein 1949, 2: 535, proposing that the cycle was intended for the arrival of a papal prelate in Bergamo, or than that given by Fabbri and Vassalli 1985, 49, who propose that the cycle celebrated a marriage between families in Modena and Pavia.

11. For two recent essays on Willaert's madrigal style see Howard Mayer Brown, "Words and Music: Willaert, the Chanson, and the Madrigal about 1540," in *Florence and Venice, Comparisons and Relations: Acts of Two Conferences at Villa I Tatti in 1976–1977*, vol. 2: *Il Cinquecento* (Florence, 1980), 217–266; Martha Feldman, "Venice and the Madrigal in the Mid Sixteenth Century" (Ph.D. diss., University of Pennsylvania, 1987). The extent to which Gabrieli was influenced by Milanese composers, with their greater simplicity of style, remains to be studied.

12. For an attempt to describe one variety of sixteenth-century harmony, with special emphasis on the *madrigali ariosi*, published by Antonio Barrè in Rome in 1555 and later, see my essay "Verso una definizione dell'armonia nel sedicesimo secolo: sui 'madrigali ariosi' di Antonio Barrè," *Rivista italiana di musicologia* 25 (1990), 18–60. I am preparing an edition of Barrè's *madrigali ariosi* in collaboration with Giuseppina La Face and John Steele.

13. For Pontio's statement that composers should take care to write complete 5-3 sonorities when the counterpoint is for four voices, see Pietro Pontio, *Ragionamento di Musica* (1588; reprint, in facsimile, Basel, London, and New York, 1959), 150–151: "Sarà cosa ragionevole, ch'il compositore nelle sue compositioni habbia risguardo, che, quando quattro parti canteranno, frà esse vi si truovi la Terza, & la Quinta" (It

will be judicious if a composer took care in his compositions, wherever four voices sing, to include a third and a fifth).

14. Einstein 1949, 2: 535.

15. The madrigal is published in a modern edition in Gabrieli 1981–1984, 5–6: 28–49. Like many other madrigal cycles of the sixteenth century, *Alma beata e bella* does not include music for the *commiato*, the brief final stanza of the poem. On the publishing history of the second book of madrigals for five voices, and the possibility that Giovanni was responsible for the 1588 edition, see Gabrieli 1981–1984, 5–6: xi–xii.

16. For a list of modern editions of Sannazaro's *Arcadia*, an English translation of the work, and an introduction suggesting Sannazaro's importance in literary history see Jacopo Sannazaro, *Arcadia and Piscatorial Eclogues*, trans. Ralph Nash (Detroit, 1966).

17. The text and translation are given as they appear in Gabrieli 1981–1984, 5–6: xxii.

18. Figs. 4, 5, and 6 are reproduced as they appear in Gabrieli 1981–1984, 5–6: 28–29, 36–37, 44–46.

19. Similar formulaic harmonies appear in Gabrieli's other madrigals, some of which are organized with significant formal repetition in the same way as *Alma beata e bella*. See, for example, the sonnet setting, *Giovane bella, cui col suo candore*, nos. 6–7 in Gabrieli's first book of madrigals (Gabrieli 1981–1984, 3–4: 20–26), where the second couplet is sung to the same music as the first; or see the setting of Gottifredi's madrigal *Donna, per acquetar vostro desire*, no. 12 in Gabrieli's first book (Gabrieli 1981–1984, 3–4: 42–45), where the last two lines, parallel in construction to the first two, are set to the same music as the beginning. It remains to be seen just where, how, and why Gabrieli made use of such repetitions and whether or not such repetitions can be correlated either with the extensive use of formulaic harmonies or with certain kinds of texts.

20. In stanza 3 (Gabrieli 1981–1984, 5–6: 37–38, measures 20–24) the same music is used for the two seven-syllable lines: "Chi vedrà mai nel mondo" and "Pastor tanto giocondo." In stanza 4 (Gabrieli 1981–1984, 5–6: 42, measures 30–42) similar music (but completely different from that in stanza 3) is used for the two lines "Nè gl'animai selvaggi / Uscir in alcun prato" and for the lines "Nè greggi andar per monti, / Nè gustaro herbe o fonti." It might be argued that the second example of repetition is in fact formally signif-

icant, since it takes up so substantial a part of the stanza.

21. On the repeating formulas of the sixteenth century see Nino Pirrotta, "Early Opera and Aria," in *New Looks at Italian Opera: Essays in Honor of Donald J. Grout*, ed. William W. Austin (Ithaca, N.Y., 1968); for an exhaustive study of one such formula see Warren Kirkendale, *L'aria di Fiorenza id est Il ballo del gran duca* (Florence, 1972). A convenient table of the four most common bass patterns may be found in Gustave Reese, *Music in the Renaissance*, rev. ed. (New York, 1959), 524.

On the association of the formulas with gods and goddesses see Howard Mayer Brown, "Petrarch in Naples: Notes on the Formation of Giaches de Wert's Style," in *Altro Polo: Essays on Italian Music in the Cinquecento*, ed. Richard Charteris (Sydney, 1990), 16–50, and the studies cited there. On the *lira da braccio* see the studies cited in Howard Mayer Brown, "Lira da braccio," in *The New Grove Dictionary of Music and Musicians*, ed. Stanley Sadie, 20 vols. (London, 1980), 11: 19–22.

22. The two paintings are reproduced in Cafritz et al. 1988, 43, 47, figs. 32, 36.

23. On aria-like elements in the high-style madrigal of the second half of the sixteenth century and the contributions of Barrè and the Neapolitans to the formation of a new contrapuntally animated chordal style see Brown 1990.

24. I do not mean to imply, however, that Gabrieli's celebratory motets are necessarily simpler or more homophonic. An unusually large number of his madrigals appear to have been written for particular occasions or refer to particular people. His oeuvre should be studied as a whole to determine what sorts of stylistic differences exist among compositions with various kinds of text.

25. For example, *Aminta mio gentil* and *Chiedendo un bascio alla mia cara Aminta*, nos. 13, 31–32, in Gabrieli's first book (Gabrieli 1981–1984, 3–4: 46–49, 114–21); and *Tirsi vicino a morte* (clearly a reference to Guarini's "Tirsi morir volea"), no. 1 in Gabrieli's third book (Gabrieli 1981–1984, 5–6: 57–60). *Mentre la greggia errando*, no. 2 in the third book (Gabrieli 1981–1984, 5–6: 61–64), treats of a shepherd's love, but without mentioning the name of a particular shepherdess.

26. *Vaghi augelletti*, which mentions the shepherdess Clori, is published in a modern edition in Gabrieli 1981–1984, 3–4: 167–170.

Frontispiece: Giovanni Bellini, *Orpheus*, c. 1515, oil, National Gallery of Art, Washington, Widener Collection (detail)

SATIRO.

CORIS.

DAMETA.

MONTANO.

TITIRO.

ERGAS.

MIRT.

LINCO.

SILVIO

CA

LOUISE GEORGE CLUBB
University of California, Berkeley

Pastoral Elasticity on the Italian Stage and Page

I n 1598, according to Angelo Ingegneri, nothing but the popularity of the pastoral kept the theater alive and gave dramatists a hope of seeing their works performed:

Chiara cosa è che, se le pastorali non fossero, si potria dire poco men che perduto a fatto l'uso del palco, e'n conseguenza reso disperato il fine de i poeti scenici.[1]

(Clearly, if it were not for pastorals, it could be said that the practice of staging plays had all but ceased and consequently the aim of dramatic poets had been rendered impossible to fulfill.)

Ingegneri's famous observation on the supremacy of the pastoral play in the Italian theater by the time he published his treatise on dramatic poetry and the staging of plays does not announce an overnight sensation. There was already a long history of shepherds on the Italian stage and a longer one in literature if we count all the kinds of lyric poetry about love in the country and the imitations of Virgil's eclogues written before the fifteenth century But the Renaissance was the heyday of the pastoral in literature, and the developments in drama reported by Ingegneri are a measure of the enthusiasm of an entire age.

The depiction of the physical natural world that seems the essence of pastoralism in Renaissance painting, however, was neither the primary gain nor the goal of the Italian literary regeneration of Arcadia. Nature as an object of representation and the mystic or rustic relationships belonging to the Other Place constituted by a country scene were sometimes present in medieval Latin and pre-Renaissance Italian writing. An outdoor space, a pleasant semi-solitude, a distance from the city or court or church or battlefield or any other locale of societally determined *negotium* is perennially desirable for giving fictive room to contemplation, recreation, or decision that requires internal debate. And the appearances of all landscapes of the mind, their ideal beauties, and the manner of being that inhabits them inevitably have some features in common with all other such landscapes, regardless of period.

The difference in the Renaissance was that a changed perception of the past, a historical awareness, nourished new bonds with classical culture and attempted to acculturate nature—that is, to connect modern representation of it with precedents in antiquity. The innovation of Renaissance literary pastoral was principally structural: it offered an open form and unlimited scope for allusion within the classical mode that commanded quattrocento investigation and emulation. Authorized by a reception of Virgil not alien to Paul Alpers' reading of the *Eclogues* in our time, Italian pastoral invited both the simpler substantiality of Theocritus' *Idylls* and the complicated profusion of Renaissance *contaminatio*.[2]

In the quest for a cultural continuum Jacopo Sannazaro metamorphosed Virgilian

eclogue, with its Theocritan ghosts, into a capacious vehicle for linguistic experiment and for fusions of the genres of lyric, dialogue, and narrative. The immeasurable importance of his *Arcadia* to the fashioning of literary language is causally connected with his choice of pastoral content, his decision to appropriate Latin, pagan, rural terms for communication in a vernacular, Christian, urban society intellectually exercised by the *questione della lingua*, the debate about language that showed a determination to express Italy's cultural unification nearly four hundred years before political unification was nominally completed. What William Kennedy calls the "self-reflexivity and topical referentiality" of the pastoral mode, "where allusion enables the author and the audience to share their awareness of a common source,"[3] had impressed themselves on the Italian literary imagination and practice during the century that separates Sannazaro from Ingegneri and his friend Torquato Tasso.

In *Della poesia rappresentativa* Ingegneri values both reading and staging, but his main concern is for the play in performance. He does not champion everything belonging to the theater (indeed he blames the run-of-the-mill professional actors for the decline in which he purports to find comedy); he speaks only for literary playwrights, "poeti scenici." He writes as a director and dramatist and as a frontline theorist in the war over the genre of tragicomedy. In attributing moral and social value (especially benefits for the "vita civile") to drama, even pastoral drama, which, more than comedy and tragedy, aims at "diletto," Ingegneri is a mainstream drama critic for whom Arcadia is a place of delight, but for a useful purpose.

The theater, flourishing under pressure simultaneously to fulfill and to surpass a blueprint for drama polemically extrapolated from Aristotle's *Poetics*, found in the pastoral mode the materials for the missing third genre fit to represent what the emerging rules about genres forbade to comedy and tragedy.[4] With the treatises of Aristotle, Horace, and Donatus as handbooks and with a new abundance of classical models of comedy and tragedy available, Renaissance research and development in a technology of the theater gradually formulated a comedy of cityscapes populated by a bourgeoisie in domestic contests about marriage and money, and a tragedy of palace courts where matters of state, ambition, desire, conscience, and power collided. Both genres were shaped by principles of unity of time, place, and action; rational divisions and disposition of parts; and a concern for plausibility manifest in requirements of verisimilitude and decorum. Especially after Francesco Robortelli's commentary on the *Poetics* in 1548, the ideal of structure was clarified and exemplified by Sophocles' *Oedipus Rex*. Neither genre so defined could accommodate actions that were frankly unverisimilar; excepting only those phenomena of tragedy that manifested divine will, plots were held within the bounds of physical reality.

Nevertheless, as the texts of pastoral plays reveal, there was in the theater an aspiration to represent realities not directly accessible to the physical senses, especially two such realities. The more immediate of these was the interior world of emotion, in particular love and its related feelings, running a gamut of psychological refinements and variations. No romantic comedy or tragedy of love could fully satisfy the desire of dramatist and audience alike for a "regular" genre that could concentrate on emotion without having to offer a mirror of custom, according to the formula for comedy, or a purgation of pity and terror, as tragedy required. A need was felt for a genre that could function as the vehicle of love, with love itself as a protagonist, without the distraction of the social or political considerations held to be appropriate to the other two genres. The pastoral world was seen as the home of natural simplicity and the naked heart.

The idea of an invisible reality was extended outward, furthermore, to a circumambient truth envisaged as giving form and meaning to life and its tangled action. This was a reality of abstract pattern, visible only through the eyes of the mind, "gl'occhi dell'intelletto," the neoplatonic phrase that was reiterated in innumerable pastoral plays by the imagery of blindness and by a choreographed confusion of plots, apparently chaotic except to the enlightened

spectator, who was supposed capable of discerning in them a pattern of higher meaning that accorded with the providential plan of a divinity.

In addition to a utilitarian elasticity in the new genre—Ingegneri points out that pastoral drama can be well produced inexpensively, given the shepherds' simplicity of garb and setting (276)—playwrights were offered broad convenience in the hospitable rural scene, unrestricted by protocol that forbid mixtures of social ranks, of public matters with private, of the tragic with the comic, or of the supernatural and the mystical with the everyday and the ribald. Ingegneri himself emphasizes structure, disposition, and interrelation of parts, giving advice on pastorals by referring continually to *Oedipus Rex*. His linking pastoral with tragic drama is not unexpected, inasmuch as the origin of the treatise lay in his experience as choragus for the much-acclaimed opening of the Teatro Olimpico of Vicenza with a performance of Giustiniani's adaptation of Sophocles' tragedy.[5] But Ingegneri's extending to pastoral drama the structural imperative of what Aristotle had classified as the best kind of tragedy shows how far the concern with form went in his day. He expects any serious dramatic work to be capable of sustaining the kind of analysis he makes of *Oedipus Rex*, and he flatters Ferrante Gonzaga, count of Guastalla, by praising the tragic grandeur of his "famosissima" pastoral *Enone* and adding that if the illustrious and excellent prince had deigned to give him a copy of this play, *Oedipus* could have been dispensed with as a touchstone (298).

Although Gonzaga's pastoral paragon is lost to us, we may measure the theatrical scope that Ingegneri sought in Arcadia by his own *Danza di Venere, pastorale*, published in Vicenza in 1584. It is not the kind of pastoral drama that could as well be called a "tragedia ne' boschi di lieto fine" (a sylvan tragedy with a happy ending), as he says admiringly of *Enone*, but it is structurally tight and literarily polished, allusive, and calculated. Given the very nature of the genre that Ingegneri praises, *Danza* does not require expensive sets and conceivably could be produced in good weather in a garden with only a few props

and some lengths of gauze draperies and home-woven garlands for costumes. It is unlikely, however, that the courtiers who first played it for Rainutio Farnese, duke of Parma, so limited themselves. If the pastoral play permitted great economy, it also invited sumptuousness in design of abundantly varied rural landscapes and trappings both elegant and ingenious, as well as expensive visual special effects: waterfalls and rivers from which deities might emerge, costumes for humanoid characters such as cloven-hooved satyrs, and for animal, vegetable, and mineral transformations of nymphs and shepherds.

If we sample critical taste at the turn of the seventeenth century by pooling Ingegneri's preferences among the "terza spezie di drama" (272) with those of Orlando Pescetti, Giovanni Paolo Trapolini, and Francesco Belli,[6] some of the pastoral dramatists we have to conjure with are: Antonio Ongaro, Gabriele Zinano, Nicola Degli Angeli, Francesco Bracciolini, Cristoforo Castelletti, Cesare Cremonini, Carlo Noci, Pietro Cresci, Giovanbattista Pona, Cesare Simonetti, Isabella Andreini, Diomisso Guazzoni, Francesco Contarini, Marcello Ferro, Muzio Manfredi, Scipione Manzano, Giovanbattista Leoni, and, of course, Tasso, Battista Guarini, and Guidubaldo Bonarelli.[7]

In Cresci's *Tirena* and Pona's *Tirreno* we find examples of effects that could be brought off either with a gesture or, budget permitting, with a large expenditure: Cresci's nymph, who turns into a stream to avoid rape (III.1), could disappear into an appointed receptacle either without fanfare or with a giant water spectacle; Pona's Cupid, who turns a fountain to flame (V.3), giving visible form to the power of Venus and to the Petrarchan antitheses of the poetic text (fire/water, hot/cold), might do this by performing in a basin some simple chemical demonstration of ignition of liquid, by introducing a large-scale fiery extravaganza, or by whatever intermediate means the expense account would bear.

Ingegneri's *Danza di Venere* has as its centerpiece a round dance involving all the characters, human and otherwise, creating a physical image of the neoplatonic theme of venereal power moving discordant ele-

ments into concord (III.3). Aside from the cost of rehearsing, this effect could have been very economically achieved, especially when the performers were courtiers not requiring to be paid overtime, but the opportunity it presented for elaborate and expensive display is nevertheless obvious. Neither comedy nor tragedy allowed so much leeway, committed as they were, respectively, to the city and the court for settings and kinds of action. In the rural landscape of Arcadia, magic, fantasy, and symbolic dancing could be introduced without breach of verisimilitude, much as in the *locus amoenus* of a Giorgione painting nudes and fashionably dressed lute players could consort on the grass. Most important, both the *favola*, that is, the plot about nymphs and shepherds, and the magic incidents and spectacles of such pastoral plays have as their object of representation the workings of the heart, made visible in the third genre as they could not be in the first and second.

But in constructing an emblem, both decorative and philosophically serious, of the neoplatonic psychology of love, Ingegneri is doing something that he does not write about in his treatise. None of the other theorists of the pastoral wrote about it either: the assumption of substance, of some degree of "utile" or precept, needed no declaration, for it was inherent in the late Renaissance view of literary art and of the allusive pastoral mode. Overt recognition of the pastoral mode as signifier appears casually when required by the circumstances, as in Grazzini's description of G. B. Cini's *intermedi*, presented with Francesco D'Ambra's comedy *La cofanaria* at the wedding of Francesco de' Medici and Giovanna of Austria in 1565. Linking the comic plot with the elaborate *intermedi* drawn from the story of Cupid and Psyche and culminating in the appearance of Hymen with a pastoral retinue that included Pan and nine musical satyrs, Grazzini explains that the divine actions in the *intermedi* represent the motivation of the human action in the comedy:

con intenzione di far parere che quel che operavano gli Dii nella favola degl'intermedii, operassino, quasi costretti da superior potenza, gl'uomini ancora nella commedia.[8]

(intending to show that what the gods did in the plot of the intermedi, the humans also did in the comedy, as if forced by a higher power.)

The pastoral plays distinguished by Ingegneri, Pescetti, Trapolini, and Belli have various agendas, depending on their provenance. Much is to be learned about the genre by study of local contexts,[9] but the differences owed to milieus only increase the significance of the common features. They reveal an agreement on the basic lineaments of the Arcadian scene and the requirement of unified classical dramatic structure dependent on Aristotelian and Horatian principles. They also testify to an expectation of inclusiveness, of the pastoral play's special ability to expand as well as to contract. All these dramatists write with Empsonian intentions *avant la lettre*, that is, neither for nor about the ostensible subject, for they themselves and their audiences belong to the courtly literate class that claims knowledge of the frame of reference, of the pre-texts in this highly intertextual genre, and they expect to recognize their own interests costumed as those of shepherds. Sometimes they can expect to see more than their general concerns, to see individual portraits of themselves, for one of the pastoralists' options was to follow Virgil and his medieval successors in using shepherds as mouthpieces. Sometimes encomium is the message, solemn and allegorized as in Bernardino Cenati's *La Silvia errante, arcicomedia capriciosa morale*, published in Venice in 1605, a commonplace-enough pastoral despite its subtitle, were it not that the author appends a dedication announcing that it is really the story of the benevolent actions of the patriarch elect of Venice.

Sometimes the *drame à clef* character of a work is complimentary, advisory, teasing, or self-exhibiting, as in Tasso's references to members of the Este court, to himself as Tirsi, probably to Guarini as Batto, to G. B. Pigna as Elpino, and to Sperone Speroni as Mopso, or as in Ingegneri's undoubted reference to himself as the aging (he was thirty-four) chorus leader Leucippo, who bewails his "Smarrito Ingegno," having lost his wits for love in the best Ariostean—and pastoral—fashion.

Occasionally we can glimpse gossip and backbiting behind the Arcadian veil. The prologue to Zinano's *Caride* is spoken by the figure of Virgil, who expects historical truth to be latent in pastoral depictions—"Anco'io copersi / Sotto favole finte historie vere, / E Sotto rozzi casi illustri fatti" (I too covered true histories with fictional plots)—but recognizes that his latest successor Zinano—"De l'antiche orme mie nuovo seguace" (a new follower in my ancient footsteps)—proposes to exceed the limits of pastoral fiction and refer more openly to his patrons, the Este and the Gonzaga of Virgil's own Mantuan "patria," semidivinities whom he would have praised above Augustus himself. But to the celebration of the regime and reminders of the playwright's value to it, Zinano adds another kind of personal flavor, more particularly mischievous than that of universal satire, in his delineation of several figures: the Satiro who is explicit about his willingness to dispense with youth and chastity in nymphs—he likes them all as long as they're fat; the censorious old virgin Eura; the shepherdess Melia, not yet fallen into age but described as falling—a "ninfa cadente"—not at all shy of sex, on the contrary, she has had to take to cosmetics, false hair, and padded clothes in order to remain active and competitive in the field; and the shepherd Olindo, who marries her at the end, convincing himself that her character has been reformed by true love. Even at this distance in time such characterizations smack of in-jokes and satire at the expense of personalities at the court of Mantua.

Other pastorals show that the elasticity of the third genre allowed it to represent in texts and spectacles not only the social and psychological subjects suggested by encomia, counsel, gossip, and neoplatonic visions but also philosophical and theological conceptions of human nature. One example is the *favola silvestre* of Cremonini, known as a "diehard Aristotelian."[10] If the story is true that he refused to look through his friend Galileo's telescope so as not to be confused by the false testimony of the senses, Cremonini presents an extreme case of the application to daily life of the widespread conviction that truth is to be obtained only through the eyes of the intellect. This doctrine belongs to a general late Renaissance mind-set and is voiced in many comedies and tragedies, but it may be said to be the natural content of the dramatic pastoral. The belief that divine providence in a Christian era displaces the classical idea of fate and limits the action of chance or fortune was most clearly represented in plots moving from troubles through deadly menace to a happy ending—that is, in the movement of tragicomedy. The kind of tragicomedy that most easily carried theological allusions was the genre that not only was developed from antiquity for its power of allusion but that in Christian times invited the symbolism associated with the pastoral world of the Old and New Testaments equally, encompassing the original Garden, the shepherd kings, the shepherds to whom the angels sang the Gospel, and the Good Shepherd himself. The parallel with Eden waited like a static charge within late sixteenth-century representations of Arcadia; the charge was released often and to various ends. Trapolini, also a Paduan Aristotelian, explicating his pastoral *Tirsi*, uses the episode of Celia's transformation into a plant as a result of offending the goddess Diana to demonstrate that man resembles God through reason, bestowed at the Creation by divine grace to elevate human life beyond the vegetative state.[11]

Cremonini's *Le pompe funebri* is more philosophical than theological, as might be expected from such a pure rationalist (destined, in fact, to be suspected by the Inquisition of philosophically libertine atheism), but his pastoral drama relies on the proven capacity of the genre to support both intellectual and spiritual weight. He uses the rites and conventions, topoi and machinery of Arcadia almost lightly, certainly humorously, yet does so for the purpose of examining such matters as the relation of faith to reason and of religious cult to society. An expository dialogue between a priest of Jove and his acolyte sets forth the proposition that religion is God's art for the control of the violent contrasts in nature and for the order and form of the human community, that its rites, principally the annual song contests and funeral

games of the play's title, are to be understood as structures decreed for human benefit by the law of providence (1.2). Such questions and others, treated in a pastoral love story replete with woodland deities, Silenus and mischievous baby satyrs or "satirini," ghosts, transformed trees, and other stage lumber, might be expected to have seemed monstrous even to a seicento audience; to baroque drama, after all, theoretical principles of the unities, verisimilitude, and decorum remained vital. But, quite to the contrary, Cremonini's play figures on more than one contemporary critic's list of the best pastorals.

The substance of Cremonini's philosophical probings is much more commonly expressed in general theological terms and in references to providence and human blindness, to the deception of the physical senses by appearances, and to spiritual recognition of the higher reality seen by the Great Playwright in the sky who plans happy endings. Usually the doctrine is made explicit in the final scenes, but often the entire play is laced with such ideological references. Noci, Pona, and many others demonstrate this habitual contemporary notion, but of course the prime example is the pastoral tragicomedy that was a byword of European culture for about two centuries: Guarini's *Il pastor fido*.

For this play Tasso's *Aminta* served as a kind of essence or abstract, a pre-text tracing a conversion to love that triumphs over violence and death, leading blind humans from the labyrinth of their own confusion to the fulfillment of a supernatural design for happiness. Guarini develops this pattern into a network of ignorance and deceit, misunderstood Sophoclean oracles, and final redemption of the polluted Arcadian paradise from an ancient curse through the self-sacrificing love of a semi-divine faithful shepherd resurrected from apparent death. By exploiting opportunities for polyvalency and by the sheer abundance of his material, Guarini fully utilizes the elasticity of the pastoral landscape. The Arcadia of *Il pastor fido* is a Counter-Reformation courtly postlapsarian Eden, cursed like Oedipus' Thebes, where "virgin human nature"[12] struggles instinctively against original sin and the

sophisticated intellectual errors to which it leads. The erotically charged situations, the symbolic spectacle of blindman's buff, and the labyrinthine plot acquire psychological and religious resonance by being enclosed in pastoral spaces. Its hospitality to universal interior visions makes Arcadia the setting where love and providential design can best be imagined, literally given images.

Of the three canonical theatrical scenes authorized by Vitruvius and illustrated in Sebastiano Serlio's *Il secondo libro di perspettiva*—the *scena comica* street scene (fig. 1), the courtly *scena tragica* (fig. 2), and the rustic *scena satirica* (fig. 3) (first pub-lished with his *Il primo Libro di architettura* in 1545 and redrawn in the Latin translation of 1569)—only the last offered the idea of inner labyrinths, the heart of man and the mind of God, a truly theatrical substance. The pleasance and the surrounding woods are universal places; the regulation cottages are closer to the archetypal idea of a dwelling than are the cinquecento houses or palaces of the comic and tragic scenes; the usually added altar or temple to Pan, Venus, or Diana is a more generic representation of religious cult than some well-known church in a piazza setting. In regular, or erudite, comedy characters frequently exclaim "In che labirinto mi

trovo!" but to have to say this on a set representing some familiar Roman, Florentine, or Venetian architectural monuments underlines the discrepancy between the represented reality and the state of mind expressed. Not so in Arcadia. There, when the spectators hear prayers for deliverance from a labyrinth of misconceptions and the god of love reveals a benign plan, with or without Christian overtones, the visible reality onstage and the invisible reality presented to the mind suddenly coalesce.

Guarini's phenomenally popular play has been said to incarnate baroque eroticism in the theater, but the capacity of its setting is such as to allow it also to receive the heavy weight of a confluence of major aesthetic and intellectual currents in Counter-Reformation Italy, of poetics and an ideology of neomedievalism and universalism in religious thought, carried over into political hopes for world reunification led by a Catholic monarchy. In the polysemous space opened by *Il pastor fido*, the striving of playwrights and theorists to constitute a third "regular" theatrical genre could be joined with the collective Tridentine response to Lutheran denial of free will and Calvinistic ideas of predestination, against which Catholic policy encouraged the arts to reiterate the doctrine of a divine providence that guarantees the freedom of the human will to cooperate by virtuous action in the plan of salvation.

A hint of Renaissance awareness of the pastoral scene as a peculiarly capacious mental landscape is to be found in the way that plays were illustrated. In the seicento it would not be uncommon to print plays with copies of the scene designs for particular productions, but earlier pictures of specifically theatrical scenes were rare. A few editions of cinquecento comedies were illustrated with woodcut depictions of stock characters in stock situations, some of which reappeared in other texts with minimal appropriateness. A very early example is from the da Sabio brothers' Venetian edition of Bernardo Dovizi, Cardinal Bibbiena's *Calandra* in 1526; it shows five characters moving against a curtained backdrop, through which another character peeks (fig. 4). In the same year these printers used the woodcut again for the

anonymous comedy *Floriana*. Sixty-five years later three other printers in Venice shared a series of twenty-nine woodcuts to illustrate unrelated comedies: Castelletti's *Torti amorosi* and Sforza Oddi's *Prigione d'amore* in 1591 and Curzio Gonzaga's *Gl'inganni* in 1592. The same woodcuts were shuffled and redeployed for every scene in each of the three plays, and in some of the images the number and type of speakers did not quite correspond to those in the text. The different architectural perspectives in each picture leave no doubt that the series did not prescribe the details for a specific setting or record a particular production but was intended for general use in illustrating printed comedies. The most significant thing for comedy about the content of these woodcuts is that they attempt to represent the action as it would appear on the stage. Donatus' precept, "mirror of custom and imitation of life," was the *sine qua non* of cinquecento comedy, and these illustrations maintain the idea of verisimilitude by showing actors against a perspective scene as a sort of

4. Anonymous woodcut from Bernardo Dovizi, Cardinal Bibbiena, *La Calandra, comedia nobilissima e ridiculosa, tratta dallo originale del proprio autore,* act 5 (Venice, 1526)
Folger Shakespeare Library, Washington

5. Anonymous woodcut
from Curzio Gonzaga,
Gl'inganni, comedia, act 5,
scene 3 (Venice, 1592)
Folger Shakespeare Library,
Washington

6. Anonymous woodcut
from Giovanni Paolo
Trapolini, *Antigone, tragedia*,
act I (Padua, 1581)
Folger Shakespeare Library,
Washington

snapshot of what the spectators would see in a theater: a Serlian street set on which characters converse (fig. 5).

The same approach was used in illustrations of tragedy, which are rarer still. A characteristic one precedes the opening act of the unique edition of Trapolini's *Antigone* in 1581; as in the series of woodcuts for comedy, the scene is a stage set and corresponds to Serlio's model of the proper setting for the genre: a *prospettiva* of courtly architecture, displayed as a portrait of theatrical scenery with an actor declaiming his lines (fig. 6)—not necessarily a specific place, but a "real" one existing in physical nature and in a moment of actual time as perceived by the senses. The reader is invited to imagine what he would see physically if the page were a stage, rather than to construct an image of the text as an unfolding narrative.

Per Bjurström has written that the early cinquecento perspective staging constitutes an illusionistic step toward modern theatrical realism, but also that the seicento use of spatial planes to symbolize time planes was a means of liberation from the servile imitation of reality that could be imposed by a strict regard for verisimilitude.[13] Because Bjurström's subject is the relation of scene design to painting and theory of art, his examples come from depictions of stage sets, including seicento productions designed by Gianlorenzo Bernini, Francesco Guitti, and Giacomo Torelli. When scrutiny is shifted to the way in which the stage was presented on the page in the cinquecento, the representation of time reveals an ontological difference in the perception of the reality of the pastoral world and a less stringent interpretation of the demands of verisimilitude.

Serlio's *scena satirica* had authorized a woodland stage set for the performance of pastorals; yet although cinquecento book illustrations of pastoral plays include the scenic features and stage properties he prescribes—the trees, rocks, hills, mountains, greensward, flowers, and rustic cottages, as well as the temples, grottos, altars, woods, and clearings specified by playwrights[14]—they diverge from contemporary book illustrations of comedy and tragedy by depicting chronologically separate parts

Offiamo dire che el precedente capitolo fia
ſtato quaſi una ppoſitione di tutta lopera p
laquale lauctore non ſolamēte dimoſtra con
brieue parole quello che per tutta lopera ha
bia adire: Ma anchora la ragione perche tiene tale ordi
ne: Deſtoſſi lappetito ricercando il ſuo bene: & illumi
nato dalla ragione fuge la ſelua: & ſaliua al monte doue
uedea el ſole. Ma per la uia dele fiere: dalle quali gli fu
uietato el ſalire. Ilche ſignifica che cognoſciuto ma non
molto diſtinctamente chel ſommo bene confiſteua in
fruire idio: cercaue la cognitione di quello nella uita ci
uile doue regna la ragione inferiore: Laquale ſpeſſo e
ingannata dal ſenſo: Et doue eſſendo le uirtu ciuili non
perfecte molto poſſono le perturbationi dellanimo le
quali cercando piacere honore & utile non ſeguitano
eluero gaudio: Ne anchora eluero utile che non ſi puo
mai ſperare da lhoneſto. Ne el uero honore elquale
non altro che la uera & ſincera laude per ſe medeſima
poſto che non ſi cerchi ſeguita la uirtu come lombra el
corpo & e premio depſa uirtu & non ſi debba ne puo
dare ſe non a buoni. Ma in luogo di queſte tre ſegui
tano la uolupta del corpo la poſſeſſione de beni cadu
chi & terreni: cioe lauaritia & finalmente la gloria ua
na del mondo che e lambitione. Non puo adūque lamē
te humana con la ſola ragione inferiore & nella uita ci
uile oue molto poſſono le pturbationi genitrici de tutti
euitii uenire al ſole. Ma pure eſſendone cupida merita
eſſere foccorſa da Virgilio cioe dala ragione ſuperiore
& della doctrina. Queſta gli dimoſtra che uolédo anda
re al paradiſo: cioe alla felicita e neceſſario prima paſſa
re p linferno & pel purgatorio cioe deſcédere nella co

*Salire el mõ
te che ſigni
fica*

*La uolupta
del corpo*

Virgilio

1 O giorno ſenãdaua & laer brũo
togliena gli aial che ſóno in terra
dalle fatiche loro et io ſol uno
Mapparechiaua a ſoſtener la guerra
ſi del camino et ſi de la pietate:
che ritrarra la mente che non erra
Omuſe o alto ingegno hor maiutate
o mente che ſcriueſti cio chio uidi
qui ſi parra la tua nobilitate:

gnitione de uitii & conoſciutogli purgarſene. Da qli rimaſa purgata la mēte poi facilmēte uenif alla co
gnitione delle coſe diuie doue confiſte la beatitudine. Et bene pmette Virgilio a Dãthe menarlo ſicu
ro pel linferno & pel purgatorio ma confeſſa non lo poter menare al paradiſo perche chome habbia
b iii

7. Anonymous woodcut from Dante Alighieri, *La divina commedia: Inferno*, canto 2 (Venice, 1491)

of the plot simultaneously, repeating the characters when necessary in a receding perspective format that makes no claim to duplicate a stage set. This kind of visual representation is not a mirror image of the theatrical scene; it treats space exclusively as an expression of time and forms the image not as a reminder of realistic staging but as a mental visualization of the order of events in the plot. Although this mapping of time was used in the Renaissance with greater sophistication of technique and organization, it had been a familiar medieval method of representing narrated events as an aid to the imagination. Therefore it is not surprising to find it employed in the earliest Italian printed books. In a well-known incunabulum, the Benalius and Capcasa *La divina commedia* published in Venice in 1491, for example, a naive woodcut imitating the format of an illuminated initial of a manuscript shows both the meeting in *Inferno*, canto 2, of Dante and Virgil and, farther off, the meeting between them and Beatrice, which is prepared for by Virgil's speech in canto 2 but actually takes place much later in the poem, near the end of the *Purgatorio* (fig. 7).

This method served Sebastian Brant in 1502 for the two-hundred-odd woodcuts illustrating his famous Strasbourg edition of Virgil's complete works, in which he applied it equally to the *Eclogues* and the *Aeneid* without distinguishing between genres. Each of the pastoral dialogues is accompanied by a picture that includes speakers and the contents of their speeches in a diminishing uphill format, also giving, as Eleanor Leach has observed, "visual articulation to images that appear in the poems as imaginary images, thus organizing mental space as real space."[15] The constantly increasing reality given to the pastoral space in illustrations, however, did not take it in the direction pursued by illustrators of comedy and tragedy. Although

the 1496 Strasbourg edition of Terence's comedies, reflecting the medieval use of these works as Latin school texts, contains woodcuts of receding perspectives in which past events appear in the distance, it is significant that in the sixteenth century, when the staging of plays became common, new editions of Terence were usually illustrated with separate pictures of individual moments in the plot and eventually with sets in the Serlian manner.[16]

For visualizing narrative works, however, the imaginary compound landscape continued to be the preferred method. Typical are the full-page woodcuts adorning the first edition of Sevin's translation of Boccaccio's *Filocolo*.[17] Used by a group of printers, they were taken from a series of eighty-one blocks executed by various artists for the express purpose of illustrating romances. One of the characteristic woodcuts in the French *Filocolo* shows a knight in the foreground reclining under a tree while his horse grazes nearby; in a background of diminishing perspective four episodes of chivalric errantry are disposed on a road winding up to a chapel, topped by a combination moon-sun, indicating the passage of time between textual episodes.

The earliest illustrations of Ariosto's *Orlando furioso* were likewise receding perspectives of multiple scenes disposed to signify time passing between episodes; the picture accompanying the central canto in the 1548 Giolito edition presents a foreground dominated by the mad Orlando tearing up the pastoral *locus amoenus*, this climax preceded by events shown in graduated size in the background (fig. 8). The great Harington translation of the *Furioso* in 1591 was adorned with English copies of Girolamo Porro's copper engravings from the 1584 edition of Francesco de Franceschi. Harington ordered them himself and called attention, as Ariosto's Italian editor Ruscelli had done before him, to the use of perspective:

that (having read over the booke) you may reade it (as it were againe) in the very picture, and one thing is to be noted which every one (haply) will not observe, namely the perspective in every figure. For the personages of men, the shapes of horses, and such like, are made large at the bottome and lesser upward, as if you were to behold all the same in a plaine, that which is nearest seemes greatest and the fardest shewes smallest, which is the chiefe art in picture.[18]

The plate to canto 5 furnishes the entire story of Ariodante and Ginevra disposed from foreground to background (fig. 9). The same plan is observed in Tasso's *Geru-*

8. Anonymous woodcut from Ludovico Ariosto, *Orlando furioso*, canto 23 (1548; reprint, Venice, 1552)
Bancroft Library, University of California, Berkeley

IN QVESTO VENTESIMOTERZO LO AVTORE DOPO
le feelerità di Gabrina , & la liberation di Zerbino : alquale è ritornata la tanto da lui defiderata Ifabella,Nel la perfona di Orlando per amore diuenuto pazzo ci infegna,quanto ne gli humani petti habbia potere quefta mirabile pasfione : contra laquale ne il dono dell'intelletto ne fortezza , che fia in noi (ambedue fi fatti effetti in Orlando affigurati)le piu uolte fi poffono difendere.
CANTO VENTESIMOTERZO.

salemme liberata; a typical illustration from the 1590 edition shows all of canto 7 (fig. 10), from the beginning in which Erminia disguised as a knight takes refuge in the pastoral ambience of a hospitable old shepherd, to Rinaldo, in the next plane, fighting with Rambaldo outside the walls of Armida's castle as Armida watches from the ramparts, through the action of the whole canto to the storm aroused by devils in the farthest distance of the receding perspective.

This narrative method of illustration was also considered appropriate for pastoral drama. The 1583 Aldine edition of Tasso's *Aminta* has a simpler series of this kind in which pictures forecasting events in every act are matched at the end of the act by illustrations for the final choruses; in these the receding perspective regresses in time, alluding to the foregoing scene and signifying memory rather than foresight or prevision. Two of these choral woodcuts reappeared fourteen years later in Ranieri Totti's *Gli amanti furiosi*, *favola boscareccia*, both of them linked inappropriately with solo scenes (fig. 11).

Giovanni Battista Aleotti's celebrated engravings for the 1602 Venetian edition of *Il pastor fido* demonstrate the preferred method of illustrating the pastoral play in its prime. Directed first to the center foreground for the dialogue between Silvio and Linco, who move to the right on their way to hunt the boar with dog and companions, the reader's eye and imagination are led next to Ergasto and Mirtillo, the "pastor fido" himself, conversing slightly to the left and back, and thence by a zigzag course in time through the other scenes of the first act: Corisca the deceiver declares her motives, the patriarchs Titiro and Montano confer about the heavenly oracle and send the servant Dameta on an errand, and the satyr's soliloquy completes the exposition in the fifth and last scene before the choral ode that ends act I (fig. 12).

This handful of illustrations suggests a hypothesis: that although the three "regular" dramatic genres shared basic formal principles and were all actually performed onstage, the pastoral play of the cinquecento was differentiated from the other two as the genre in which the imagination

was invoked as by a narrative, and which invited depiction for a beholder placed at a providential distance rather than in the immediacy of the theater. In pastoral-play illustrations the action is laid out as a theatrical one, according to act and scene division, but instead of being shown in snapshots of historical clock-time, it is disposed in clusters of images offered simultaneously on perspective maps of the fictional time to viewers placed outside of that time. The format reinforces the genre's announcement of "time out"—for thought, understanding, and, in the pas-

9. [Thomas Coxon?], copperplate engraving (copied from Girolamo Porro) from *Ludovico Ariosto's "Orlando furioso" Translated into English Heroical Verse by Sir John Harington*, canto 5 (London, 1591)
Bancroft Library, University of California, Berkeley

toral generally and onstage uniquely, for growth, for healing sleep and dreams, and for change. At its farthest spiritual reach the pastoral play represented religious conversion, sanctification, or confirmation, as in Nicolò Tagliapiera's *Virginia tentata e confirmata, favola rappresentabile*. With slight changes of costume, nymphs and shepherds become saintly nuns and monks, magicians become holy hermits, satyrs are turned into devils, and the pastoral landscape functions as usual, even onstage, as an invitation to the reader to form an interior vision on his own time (fig. 13).

Although we can dispute neither the status of the pastoral world (at least that of "soft" pastoral) as *locus amoenus*, both in its absolute sense and as a contrast to other *loci*, nor an increased interest in natural scenery in the Renaissance, both as a source of pleasure in itself and as stimulus to artists' skills in exploiting classical sources of inspiration, it seems that to literary art the amenity of the delightful place was less important than the liberty it afforded. Post-Renaissance criticism has often taken the pastoral, especially pastoral drama, to be the vehicle of pure escape, or perhaps impure escape, from social propriety to licentiousness or from a complex and dangerous world of late Renaissance religious and political turbulence, militancy, and severity into an uncontroversial and

protected environment of harmless voluptuousness. Undoubtedly this amorous spirit helped make pastoral drama a sweeping success at cinquecento wedding festivities. Certainly the Arcadian places of the page and the stage are hospitable to *volupté*, but escape into them is liberating from more kinds of repression than merely sexual ones. The pastoral landscape is forever the place where release from some kind of oppression is imagined; in the Renaissance the escape was neither solely from serious content nor into it but, rather, into the freedom to choose.

11. Anonymous woodcut from
Ranieri Totti, *Gli amanti
furiosi, favola boscareccia*,
act 2, scene 1 (Venice, 1597)
Folger Shakespeare Library,
Washington

12. Giovanni Battista Aleotti,
copperplate engraving from
Battista Guarini, *Il pastor fido,
tragicomedia pastorale . . .
di bellissime figure in rame
ornato . . .* , act 1
(Venice, 1602)

13. Anonymous woodcut
from Nicolò Tagliapiera,
*Virginia tentata e confirmata,
favola rappresentabile*, act 1
(Venice, 1625)
Folger Shakespeare Library,
Washington

1. *Della poesia rappresentativa e del modo di rappresentar le favole sceniche*, in Ferruccio Marotti, *Lo spettacolo dall'umanesimo al manierismo. Teoria e tecnica* (Milan, 1974), 275. Hereafter page numbers in the text refer to this edition.

2. Paul Alpers, *The Singer of the Eclogues: A Study of Virgilian Pastoral* (Berkeley, Los Angeles, and London, 1979). For Theocritus I refer to Thomas G. Rosenmeyer, *The Green Cabinet: Theocritus and the European Pastoral Lyric* (Berkeley, Los Angeles, and London, 1969).

3. William J. Kennedy, *Jacopo Sannazaro and the Uses of Pastoral* (Hanover, N.H., and London, 1983), 7–8.

4. For fuller discussion of this issue see chapter 6 of my *Italian Drama in Shakespeare's Time* (New Haven, 1989), some of which I paraphrase in the next paragraphs.

5. He declares the connection in a letter to the members of the Accademia Olimpica, reprinted by Alberto Gallo, *La prima rappresentazione al teatro Olimpico con i progetti e le relazioni dei contemporanei*, preface by Lionello Puppi (Milan, 1973), xxiv–xxv.

6. Like Ingegneri, each proposes a canon of "critic's choices": Orlando Pescetti, *Difesa del Pastor Fido tragicommedia pastorale del molto illustre Sig. Cavalier Battista Guarini da quanto gli è stato scritto contro da gli Eccellentiss. SS. Faustin Summo e Gio. Pietro Malacreta, con una breve risoluzione de' dubbi del molto Rev. Sig. D. Pagolo Beni* (Verona, 1601), 180; Giovanni Paolo Trapolini, *Tirsi, egloga boschereccia tragicomica* (Treviso, 1600), dedication [1598]; Francesco Belli, *Catarina d'Alessandria, tragica rappresentatione . . . rappresentata dall'Accademia de' Concordi* (Verona, 1621), dedication.

7. Antonio Ongaro, *Alceo, favola pescatoria* (Venice, 1582); Gabriele Zinano, *Il Caride, favola pastorale* (Reggio, 1582); Nicola Degli Angeli, *Ligurino, favola boschereccia* (Venice, 1574); Francesco Bracciolini, *L'amoroso sdegno, favola pastorale* (Venice, 1597); Cristoforo Castelletti, *L'Amarilli, pastorale* (Ascoli, 1580); Cesare Cremonini, *Le pompe funebri, overo*

Aminta, e Clori, favola silvestre (Ferrara, 1590); Carlo Noci, *La Cinthia, favola boscareccia* (Naples, 1594); Pietro Cresci, *Tirena, favola pastorale* (Venice, 1584); Giovanbattista Pona, *Tirrheno, pastorale* (Verona, 1589); Cesare Simonetti, *Amaranta, favola boscareccia* (Padua, 1588); Isabella Andreini, *Mirtilla, pastorale* (Verona, 1588); Diomisso Guazzoni, *Andromeda, tragicomedia boscareccia* (Venice, 1587); Francesco Contarini, *La fida ninfa, favola pastorale* (Vicenza, 1595); Marcello Ferro, *La Chlori, egloga pastorale* (Venice, 1598); Muzio Manfredi, *La Semiramis, boscareccia* (Bergamo, 1593); Scipione Manzano, *Aci, favola marittima* (Venice, 1600); Giovanbattista Leoni, *Roselmina, favola tragisatiricomica* (Venice, 1595); Torquato Tasso, *Aminta, favola boscareccia* (Cremona, 1580); Battista Guarini, *Il pastor fido, tragicomedia pastorale* (Venice, 1590); Guidubaldo Bonarelli, *Filli di Sciro, favola pastorale* (Ferrara, 1607).

8. "Descrizione degl'intermedii rappresentati colla commedia nelle nozze dello illustrissimo ed eccellentissimo Signor Principe di Firenze e di Siena," in Antonfrancesco Grazzini, *Teatro*, ed. Giovanni Grazzini (Bari, 1953), 559.

9. Marzia Pieri's *La scena boschereccia nel rinascimento italiano* (Padua, 1983) offers a basis for such study.

10. Eric Cochrane, *Florence in the Forgotten Centuries 1527–1800: A History of Florence and the Florentines in the Age of the Grand Dukes* (Chicago and London, 1973), 171.

11. Not content with the genre's tacit allegorical potential, Trapolini advertises on his title page: "Tirsi, egloga boschereccia tragicomica . . . oltre le allegorie poste nel fin dell'opera vi sono anco interposti gli argomenti, over sommarij a ciascun'atto, & altre cose notabili: Con l'intervento di un'echo doppio; cosa non meno piacevole, che morale, & accomodata ad ogni stato di persone."

12. "La nostra natura quasi vergine senza lisci" (our nature like a virgin without embellishments) is Guarini's description of the proper subject of pastoral eclogue in *Il Verato ovvero difesa di quanto ha scritto*

M. Giason Denores contra le tragicomedie, e la pastorali, in un suo discorso di poesia (Ferrara, 1588), 11v.

13. Per Bjurström, "Espace scénique et durée de l'action dans le théâtre italien du XVIᵉ siècle et de la première moitié du XVIIᵉ siècle," in *Le lieu théâtral à la renaissance*, ed. J. Jacquot, E. Konigson, and M. Oddon (Paris, 1964), 76–78.

14. Serlio, *Il secondo libro di perspettiva* (Venice, 1560), in Marotti 1974, 201, lists "arbori, sassi, colli, montagne, erbe, fiori e fontane . . . capanne alla rustica." Stage directions and dialogue throughout the plays attest to the general need for these features and for the "tempio . . . grotta . . . selva, fonte, prato" listed by Alvise Pasqualigo, *Gl'intricati, pastorale* (Venice, 1581), A8.

15. Eleanor Leach, "Illustration as Interpretation in Brant's and Dryden's Editions of Vergil," in *The Early Illustrated Book: Essays in Honor of Lessing J. Rosenwald*, ed. Sandra Hindman (Washington, D.C., 1982). Leach is quoted by Annabel Patterson, *Pastoral and Ideology: Virgil to Valéry* (Berkeley, Los Angeles, 1987), 94, in the course of her reading of these illustrations as an exegesis of pastoral in the Servian tradition, with conclusions that clearly could be illuminatingly applied to many theatrical pastorals of the later Renaissance.

16. Representative illustrations of editions from 1496 to 1614 are provided by T. E. Lawrenson and Helen Purkis, "Les éditions illustrées de Térence dans l'histoire du théâtre: Spectacles dans un fauteuil?" in Jacquot, Konigson, and Oddon 1964, 1–24.

17. Giovanni Boccaccio, *Le Philocope de Messire Iehan Boccace Florentin, contenant l'histoire de Fleury & Blanchefleur, divisé en sept livres traduictz d'italien en francoys par Adrian Sevin* (Paris, 1542). Described and illustrated in *Catalogue of Illustrated Books 1491–1759* [sale catalogue 165, E. P. Goldschmidt] (London, n.d.), 34–35.

18. *Ludovico Ariosto's "Orlando furioso" Translated into English Heroical Verse by Sir John Harington (1591)*, ed. Robert McNulty (Oxford, 1972), 17.

LOUISE K. HOROWITZ
Rutgers University

Pastoral Parenting: L'Astrée

L iterary scholars share with art historians the unquestionably difficult task of coming to terms with the meanings of pastoral. Titles alone serve to convey the imprecision of our thinking on this subject. In *The Pastoral Landscape*, for example, the title of two concurrent exhibitions in 1989,[1] emphasis is shifted onto the substantive "landscape," thereby withering the potential potency of its modifier. Similarly, *Le genre pastoral en Europe du XVe au XVIIe siècle*,[2] a critical work of 1980, focuses our attention on the reassuringly familiar literary term of genre and thus reduces any "anxiety" caused by the floating adjective. We are on terra firma: "landscape" and "genre" situate us squarely and securely in our respective domains of scholarship.

A reading of the foregoing studies confirms this tergiversation. *Le genre pastoral* contains some thirty separate essays covering, among others, Tasso, Cervantes, and d'Urfé; Milton, Shakespeare, Marvell, and Sidney; Quinault, Rotrou, Racine, Molière, and La Fontaine! Everyone, it seems, was a pastoralist at heart, in part! So too with *Places of Delight*, the publication accompanying *The Pastoral Landscape* exhibitions,[3] which tackles the pastoral landscape from Giorgione to Cézanne; includes religious art and georgic representation; moves from fifteenth-century Venice to the nineteenth-century Lackawanna Valley; studies works in which there are no human figures (while insisting that "human reference" is pastoral's ultimate meaning) as well as ones in which there are very small figures consumed by a vastly dominating landscape; but which, finally, chooses to highlight artists such as Giorgione, Titian, and Manet, who portray nudity on a scale so massive as to reduce everything else to "background," both formally and psychologically.

Part of the problem arises from a tendency to focus on specific conventions of pastoral art forms rather than on analysis of the fundamental conditions of pastoral. It has traditionally been sufficient to encounter a bucolic setting for the term "pastoral" to rush to mind. Yet as one literary critic has argued, "the conventions themselves must be seen as the outcome of something which is much more fundamental . . . an impulse which is buried in the human psyche."[4] This Jungian view is fundamental to an understanding of both setting and subject, for in this perspective pastoral art resonates with myths of childhood and the atavistic longings of the subconscious, clamoring throughout our lifetime for a resolution that is forever denied. "Pastoral" in this sense posits a zero-degree Desire, untainted by Civilization that has rendered us prisoners of "duty, the father-principle and rational thinking."[5] The pastoral landscape—in painting as in literature—both reflects and generates these longings. Within its frame lies imagination, the momentary illusion of

free play, wishes born of infantile projections that endure deep within us, eternally seductive, abolishing "time, law, and taboo."[6]

This article seeks to delineate the pastoral base of Honoré d'Urfé's novel *L'Astrée*—not the obvious conventions (which nonetheless all appear in d'Urfé's massive *opus*), but rather its essential dreamscape. I do not believe that the majority of art historians have adequately probed the imaginative atmosphere that infuses the works they study in great detail. Content to describe "landscape" from *without*, they have failed to illuminate the *inner* landscape of the canvas' imaginary haven. It is perhaps critically safer to avoid such analysis, since it cannot ever be factually proved, but this type of avoidance leaves readers hungry for a more substantial as well as suggestive accounting. This paper, therefore, has two principal goals: on the one hand, to delineate d'Urfé's pastoral fabric, his rendering of unconscious impulses within the framework of the pastoral; on the other hand, to analyze the undoing of this pastoral fabric so artfully created—and then destroyed—by d'Urfé. In *L'Astrée* the taboos that pastoral would dispel surface once more, challenging the momentary and illusory suppression and abolition of temporal, spatial, and psychological boundaries.

L'Astrée, d'Urfé's novel in four very—one should say interminably—long volumes, was the work of a lifetime. The first volume appeared in 1607, the second in 1610, the third in 1619, and the fourth was published posthumously in 1627.[7] D'Urfé died in 1625, before completing his novel. Sequels were written, by his secretary and by others, but d'Urfé had had ample time, almost twenty years, to conclude his great work. If he did not, it may be for reasons other than an untimely death. Pastoral may require an "unfinished" status, for consummation and conclusion rupture its inherent properties of wish, dream, and bearer of truth forever beyond resolution.

In our time *L'Astrée* is rarely read in its entirety. To the modern reader the work is repetitive and monotonous. Even most scholars of French literature are familiar with only excerpted editions of the novel, all of which falsify its structural premise of mass and repetition. Matters were entirely different, however, in d'Urfé's day. *L'Astrée* was one of the most popular and coveted works of post-Renaissance Europe. The French literate public eagerly awaited the promised new episodes. German aristocrats, while they waited, liked to act out the work, dressing up as the shepherd Céladon, the shepherdess Astrée, and their many pastoral friends. (Such playacting only serves to confirm the fundamental pastoral fantasy: escape from the binds of "civilization.") Despite d'Urfé's inordinate popularity, however, the pastoral as novel never succeeded in France after *L'Astrée*. It developed, instead, as a dramatic form, and even as theater it was short-lived, overtaken by tragedy, which had always been hovering at the perimeters of Arcadia.

Structurally *L'Astrée* is an intercalated novel. The individual story is its base, but the many tales that compose the book are not narrated sequentially. Stories interrupt stories that interrupt stories, and many of the longest narratives span all four volumes. Conclusion, which in this case would mean marriage and sexual consummation, is inevitably denied. D'Urfé's universe is word heavy, and it requires and receives a superb orchestration. There are several primary stories and many more secondary tales, the latter often duplicating the essentials of the former but in harsher, more violent tones. All recount repetitively and obsessively the theme of passionate love gone awry.

D'Urfé's pastoral conventions are, for the most part, solidly traditional. Fifth-century Forez (the area of southeastern France that was d'Urfé's homeland) is the familiar *locus amoenus*, replete with flora, fauna, and fountains. A river, the Lignon, traverses the countryside, dividing d'Urfé's Arcadia in two: the left bank, home of the shepherds and shepherdesses, and the right, where dwells the queen of the nymphs, Amasis. Furthermore, adhering closely to pastoral literary convention, these shepherds and shepherdesses are not the descendants of sheep and goat tenders, but rather of knights and their ladies, who formerly had elected to abandon the tur-

moil of court life, of "civilization," in favor of a perceived bucolic serenity. Thus does noble essence illuminate peasant status: there is nothing "georgic" about d'Urfé's world. In this idyllic paradise the shepherds, shepherdesses, nymphs, and their assorted advisers compose songs, recite poetry, and above all discuss and debate the fine points of their primary subject: love. In fact, at the conventional level, d'Urfé's only significant departure from pastoral tradition is his refusal to utilize classical antiquity's satyr. Other literary forms, principally a strain of more realistic fiction, had accustomed the French readership to a less "primitive" expression of pansexuality. Thus, the theme of lustful infidelity is conveyed not by the familiar man-beast figure of the satyr, but by the character Hylas, whose ardent support of free love runs decidedly counter to the neoplatonic claims that form the philosophical base of the encyclopedic novel.

This article considers only one part of d'Urfé's work, that section forming the dominant story as well as providing the work's title, the love match between the shepherd Céladon and the shepherdess Astrée. Theirs is a tale of thwarted love, thwarted initially from the outside by the couple's parents, thwarted ultimately from within by Astrée (and perhaps by Céladon as well). Parents and parent substitutes are a disturbing menace in L'Astrée, often behaving much like their counterparts in the fairy tales of the age. In this instance Céladon's father, Alcippe, and Astrée's father, Alcé, banned the love match because of an old rivalry and jealousy. They had both once loved Amarillis, who ultimately chose Alcippe. Early in the novel Alcé dies, but Alcippe, Céladon's father, maintains the ban. Alcé, Alcippe—the choice of like-sounding names is deliberate. They are intended to confuse, or, rather, simultaneously to conceal and reveal d'Urfé's fundamental pattern of blurring, a pattern that is essential to his exploitation of pastoral.

Banned, the love relationship between Astrée and Céladon nonetheless flourishes with subterfuge, until Astrée comes to believe, on the most spurious information, that Céladon has been unfaithful to her. As a consequence she proclaims that he must never reveal himself to her again, unless she so orders. Céladon jumps into the river Lignon, and thus begins a long series of adventures that culminates in a decision by Céladon to disguise himself as a druid princess, "Alexis," and thereby enjoy a proximity to Astrée that is otherwise denied him.

The long, titillating passages of travesty-come-transvestism are the best parts of L'Astrée. It is here that the author is able to generate a highly charged textual experiment, wherein all forms of sexuality are at once present and yet repressed: hetero-, homo-, auto-, and incestuous sexuality. They are, however, wholly free of any moral charge, indeed of any label. The reader, too, experiences this total sexual atmosphere liberated from the divisions and categories devised, for clarity, by "civilization." D'Urfé chooses no such clarity. Rather, his book becomes a multilevel fantasy, an erotic production of a limitless Desire. Desire here is ambiguous, linked neither to individual character nor to gender. It is a floating, undifferentiated mass and sustains fantasy projections uncensored by conscious dicta. What emerges are the freest and most complete erotic reveries.[8]

This confused, diffuse situation, moreover, never corrects itself. Astrée can accept Céladon only as a travesty. When, indeed, his disguise is revealed, she bans him once again, ostensibly because of her new-found modesty upon discovering that she had been intimately cohabiting with Céladon, not with "Alexis." However, as many d'Urfé scholars have remarked, Astrée's various cases against Céladon are never very strong. Her first ban follows a slight rumor of infidelity by Céladon, born of a situation that Astrée herself has orchestrated in order to fool Alcippe. Nor does she ever bother to clarify the misunderstanding with Céladon. Much later, after the travesty is uncovered, she again prohibits Céladon from approaching her. Yet to the attentive reader it is all too apparent that throughout the long disguise episode Astrée is at least subliminally aware of Céladon's strange tactic. Indeed the Alexis episode is not the first time such transvestism occurs. Céladon and Astrée's first encounter is in just such circumstances. In that

episode Céladon masquerades as a girl whose task it is to judge the fairest (naked) shepherdess of all. Thus Astrée's *story* has a *history*, and narratively both she and we are prepared for the mad Alexis adventure.

Above all else, *L'Astrée* is a novel of travesty. Males are regularly disguised as females, and vice versa. Céladon is dressed as a woman for most of the novel. D'Urfé offers a decidedly imprecise and fluid world, which some have labeled "pre-oedipal" for its apparent lack of sublimated differentiation. But it is also clear that the tensions of this undifferentiated universe sustain a manifest taboo, and Astrée's repeated refusal of Céladon may be the surest sign of such denial. The union of shepherd and shepherdess is prohibited by both Alcé and Alcippe. Alcé, in death, becomes indistinguishable from Alcippe by virtue of their names, a "coincidence" that signals their shared status as Father, giver of laws. Travestied, however, *Alcé* is also *Céla*don, through a not so subtle tinkering with the latter's first four letters. Disguise is the essence of d'Urfé's novel, and the author sustains this pattern through costume, toying with names, and also grammar. Céladon, for example, is "she" throughout the long travesty episode, a grammatical sign that destroys identity. In d'Urfé's universe, metamorphosis is multiple and vertiginous. The ultimate *Al* word—Alcé, Alcippe—in this instance the very sign of patriarchy, the sign of Father, is itself travestied to form "Al-exis," a "female" male whose assumed identity and behavior now incorporate an odd but all too apparent maternal presence into the realm of the Father. Indeed, the long period of cohabitation provides a strange mixture of male voyeurism and lesbian bonding—and also, given the many examples of tenderness and care, a specifically maternal quality. In part 4, Astrée has a richly imaginative dream that forms an important metonymic commentary on the entire travesty episode. Through both theme and form d'Urfé creates an undifferentiated haze, and Astrée's reverie conveys a distinct pattern not only of gender blurring but also of parent-child merger. The dream episode, which shows d'Urfé to have fully grasped that which we have learned to label unconscious desire,

reveals an indeterminate number of male/female, mother/father, parent/child associations. In d'Urfé's fictional universe males *are* females, fathers *are* mothers, children *are* parents, and yet at the same time they are "themselves." There are no barriers, no limits, no boundaries.

On the surface this pattern of disguise and transformation, permitting the freest erotic reverie, would seem to run counter to the ostensible pastoral base of a simple, "natural" harmony. However, such is the case only if we apply cultural, moralistic standards to the term "natural" (which of course is a non sequitur). In *L'Astrée* there is a specific rapport between the pastoral format and d'Urfé's exploration of a multifaceted and therefore "natural" desire. The dreams of love encountered within this fictional haven are situated in a pastoral framework because both love and pastoral are expressions of a lost "paradise," which they, as creative acts, may (momentarily) restore. In the traditional Freudian perspective the sense of "finding" that one experiences in romantic love is ultimately a refinding, a perception of having regained an idyllic moment of union. The paradisical harmony that emanates from pastoral art is, in *L'Astrée*, the artistic dream of a former, lost haven, the explicit recognition of a desire never to be fulfilled, yet never, as dream, to be denied.

This analysis is sustained by a consideration of two significant quotations. The first comes from the brochure accompanying *The Pastoral Landscape* exhibitions; the second is from the domain of psychoanalysis and appears in an earnest effort to explicate systematically, from a Freudian basis, the nature of romantic passion:

It was an idyllic word infused with emotional, amorous, and nostalgic longings of mankind.

Love arises from within ourselves as an imaginative act, a creative synthesis, that aims to fulfill our deepest longings and our oldest dreams.[9]

By their concentration on deep and amorous "longings" and on the imaginative creations born of these profound but unutterable yearnings, both passages suggest a decidedly regressive pattern, in a nonpejorative sense. Love and pastoral are imag-

inative acts that permit a perceived—if illusory—"return" to an earlier state, to a golden age, which in myth, as in life, the mind schematizes as the moment of plenitude prior to an essential schism. The creature portrayed by Aristophanes in Plato's *Symposium*, seeking to unite with its lost other half, is the traditional, mythical example of this drive to merge, to recreate the state of existence prior to Zeus' decision to cut primordial man (four hands and four feet, two faces) in half. As formulated in the *Symposium*, this myth suggests that erotic love is linked to an earlier moment of life.[10] The idyllic pastoral is also an expression of the fundamental, lifelong search for harmony and union, for the urge to satisfy what Plato called "the ancient need." In *L'Astrée* the pastoral motive functions not only as setting but as bearer and conveyer of a unity specifically but subliminally sustained by fantasies of oedipal fulfillment. The anagrammatic name-play—*Alcé*, Cé*lad*on, *Alexis*—is the sign for these incestuous reverberations, which are at once generated by and ultimately, if still hesitatingly, censored in d'Urfé's text.

The pastoral base of *L'Astrée*, the naturally beautiful paradise that d'Urfé creates, is in fact its own sign, a code whose hidden meaning is the revelation of an all too "natural" desire. The sublime pastoral setting gives birth to the sexual reveries that dominate the text. Ultimately, it is far less the charms of rustic life that intrigue d'Urfé than the possibility of exploring textually the longings that lie concealed in pastoral art. In *L'Astrée* such exploration is multisided, if indivisible. Dreams of total sexuality, the ultimate in romance, are born of and by the pastoral setting.

Mitchell Greenberg has stated in an excellent study of *L'Astrée* that by refusing to divide the desiring world between male and female and between parent and child, in announcing itself as pre-scission, *L'Astrée* "formally and thematically, posits the impossibility of subjectivity founded on the internalization of difference as sublimation of oedipal sexuality."[11] Up to a point, he is correct. The base of *L'Astrée*, conditioned by a pastoral code allowing for the freest reign of the imagination, for the satisfaction of "ancient need," *is* wholly

undifferentiated. The harmony and calm that emanate from d'Urfé's novel (and perhaps from pastoral in general) are a clear reflection of a regained integrity, or at least the illusion of it. I would add to Greenberg's astute analysis that of Roland Barthes:

Besides intercourse . . . there is that other embrace, which is a motionless cradling: we are enchanted, bewitched: we are in the realm of sleep, without sleeping, we are within the voluptuous infantilism of sleepiness: this is the moment for telling stories, the moment of the voice which takes me . . . this is the return to the mother. . . . In this companionable incest, everything is suspended: time, law, prohibition: nothing is exhausted, nothing is wanted: all desires are abolished, for they seem definitely fulfilled.[12]

So much of *L'Astrée*, indeed the entire travesty episode I have discussed, is akin to this mood of suspended taboo, of gratified desire in dream, of an enchanting sleeplike state—in short, of the "companionable incest" to which Barthes tantalizingly refers. The Alexis episode, or at least large portions of it, occurs in a dreamscape of sleep and repose. Astrée is always about to sleep or is just waking. The mood is one of diffuse and hazy blending, reflecting the dream of essential merger that permeates Western thought from Plato to Freud. Psychoanalysis offers us only a reformulated expression of myth's longstanding, fundamental revelation:

Merger may most readily be expressed through physical means, but its actual locus is within the psyche. It is there that the fluidity of ego enables the kind of interpenetration of selves that constitutes merger. The repository of meaning is located in the merger itself, in the lover's internal psychic process. Merger is in part surrender to a person, but primarily it is surrender to love's powers. Merger enables the lover not only to cross the personal boundary separating the self from the beloved, but also, in the act of losing the limited, mundane self, to refind an earlier self. . . . lost as a consequence of age and experience (and of the differentiation of the personality. . . .)[13]

Céladon and Astrée exist in that mutual embrace, that state of fundamental, essential union beyond, or before scission. Céladon is at once Céladon, Alcé, Alexis, and

even, as he switches their clothing, Astrée. He is child and father; he is male and female; "she" is mother. Astrée's situation is equally ambiguous, for d'Urfé cannot or will not say whom she desires (Céladon? Alexis?). Denied gender and therefore identity, merged in an interlocking that is primarily infantile and only nascently genital, the characters appear to float in their hazy slumberland of fulfillment and gratification. "It is not every day," states Lacan, "that you encounter what is so constituted as to give you precisely the image of your desire."[14]

Yet these links are too clear to be sustained or to bear fruit. Only in fantasy, in the Alexis fantasy, may the dream endure. Beyond its parameters lies the world of waking and recognition. Indeed Céladon *is* Alcé, *is* Alexis, and *is*, to Astrée, the One she may not have, beyond the limits of her fantasy dream, beyond imagination (the French word *l'imaginaire* captures best my meaning here). In this strange novelistic world there may be detected a close relationship between d'Urfé's vision and that suggested by Bertrand Jestaz in his review of a book on Giorgione's *The Tempest*. Questioning the author's contention that the painting depicts Adam and Eve, Jestaz writes: "Et j'y retrouve un caractère notable de l'art vénitien de cette époque ou du *giorgionisme*, qui est le divorce entre l'état d'âme des personnages et la situation ou l'action dans laquelle ils se trouvent impliqués: un détachement de la réalité immédiate qui laisse entière liberté au coeur et à l'esprit."[15] (I detect an important trait of Venetian art of this era or of "giorgionisme," a divorce between the figures' mood and the situation or act in which they are involved: a detachment from reality's immediacy that permits a total freedom for the heart and mind.) This detachment of what is happening from the characters' frame of mind or mood, a detachment that liberates the imagination, is as central to *L'Astrée* as it is to Giorgione's art.

In d'Urfé's hands *L'Astrée* does not end. There is no closure, merely denial. Astrée's rejection of the character represented by the *Al* configuration (Alcé, Alcippe, Céla-

don, Alexis) is the sign of an emerging but still developing taboo—one that will become ever more assertive in seventeenth-century France. Astrée's refusal, however subliminally or subconsciously perceived and revealed, is the persistent and instinctive denial of an infinitely playful but ultimately (within the confines of civilization) dangerous game. This is why the travesty episode is contained wholly within a pastoral frame, which is itself a bearer of nostalgic and regressive desires. In d'Urfé's novel, as Gérard Genette has written, "all the old flows into all the new," as one era moves toward another, as classical discourse erupts out of this last-stage Renaissance text.[16] It is sufficient to contemplate the theater of Jean Racine, writing a half century later, to see what happened to the pastoral dreams of *L'Astrée*. Incestuous longing lies at the heart of Racine's plays— brother for brother in *La Thébaïde* (itself directly under the oedipal wing); stepmother for stepson in *Phèdre*; mother for son in *Britannicus*. But French classical tragedy will have none of it. Thésée, king and father, returns to rupture Phèdre's dream of union with Hippolyte. Here incestuous guilt replaces the momentarily freewheeling incestuous play of *L'Astrée*. This monumentally significant shift parallels closely the rise of the absolute monarchy in France. Simultaneously the law of the Father emerges in the age's sociopolitical and therefore "real" world *and* in its literary production. Indeed the corpus of French classicism is nothing less than a testament to the powers of repression, both sexual and political. The return of the father *and* the denial of a merged, prehierarchical existence are the hallmarks of that body of writing. Classicism divides, categorizes, and labels, and it signals by this structural rigidity an end to the hazy undifferentiation so characteristic of *L'Astrée*.

What then are the "places of delight"? A certain landscape, perhaps, but also the map that is the unconscious mind. The book, too, is giver and bearer of this fantasy pleasure, and no less than it the canvas, our legacy from Giorgione to Matisse.

NOTES

1. At the Phillips Collection and the National Gallery of Art, Washington, D.C.

2. Centre d'études de la Renaissance et de l'age classique; actes du colloque international, 1978 (Saint-Etienne, 1980).

3. Robert C. Cafritz, Lawrence Gowing, and David Rosand, *Places of Delight: The Pastoral Landscape* [exh. cat., Phillips Collection and National Gallery of Art] (Washington, 1988).

4. Myriam Yvonne Jehenson, *The Golden World of the Pastoral* (Ravenna, 1981), 13.

5. Jehenson 1981, 14.

6. Roland Barthes, *Fragments d'un discours amoureux* (Paris, 1977), 121. This work is translated by Richard Howard under the title *A Lover's Discourse, Fragments* (New York, 1978). Howard translates the French passage "le temps, la loi, l'interdit" as "time, law, and prohibition," 104. I believe that "taboo," rather than "prohibition," best captures Barthes' intention here.

7. Honoré d'Urfé, *L'Astrée*, ed. Hugues Vaganay, 5 vols. (Geneva, 1966). The fifth volume is wholly that of Balthazar Baro, d'Urfé's secretary. For a more detailed analysis of *L'Astrée*, see Louise K. Horowitz, *Honoré d'Urfé* (Boston, 1984).

8. See Louise K. Horowitz, "Where have all the 'old knights' gone?: *L'Astrée*," in *Generic Transformation from Chrétien de Troyes to Cervantes*, ed. Kevin Brownlee and Marina Scordilis Brownlee (Hanover, N.H., 1985), 263.

9. *The Pastoral Landscape* [exh. brochure, Phillips Collection and National Gallery of Art] (Washington, 1988); Ethel Spector Person, *Dreams of Love and Fateful Encounters* (New York, 1983), 31.

10. Person 1988, 84.

11. Mitchell Greenberg, "*L'Astrée*, Classicism, and the Illusion of Modernity," *Continuum* 2 (1990), 17.

12. Barthes, trans. Howard, 1978, 104.

13. Person 1983, 127–128.

14. Jacques Lacan, *Le Séminaire* (Paris, 1973), 1:163, cited by Barthes, trans. Howard, 1978, 20.

15. Bertrand Jestaz, review of Salvatore Settis, *L'invention d'un tableau, "La Tempête" de Giorgione, Bulletin monumental* 146 (1988), 168.

16. Gérard Genette, "Le serpent dans la bergerie," in Honoré d'Urfé, *L'Astrée* (Paris, 1964), 8.

Frontispiece: Giovanni Bellini, *Orpheus,* c. 1515, oil, National Gallery of Art, Washington, Widener Collection (detail)

W. R. REARICK
University of Maryland

From Arcady to the Barnyard

That contributors to this volume encounter some difficulty in defining the meaning of pastoral landscape is, in part, due to the role that Renaissance Venice played in the revival and diffusion of this theme in the Western tradition.[1] Venetians were notoriously imprecise about the exact significance of many works by their most celebrated artists. When Vasari visited the city in 1548 to gather information for the first edition of his *Lives of the Most Eminent Painters, Sculptors, and Architects*, he was shocked to find that his inquiry about the program of Giorgione's façade frescoes for the Fondaco dei Tedeschi was met with a casual shrug; the Venetians neither knew nor did they seem to care about the meaning of these famous paintings.[2] For them it was sufficient that the works be beautiful; for Vasari, who gave priority to *disegno* over *colore*, a clearly defined illustration of a precise literary source was a sine qua non for such a public work. Venetian scholars and chroniclers were equally at a loss when it came to citing the titles of privately owned paintings. Marcantonio Michiel was reduced to describing what he believed he saw in the little picture by Giorgione that he was shown in the Palazzo Vendramin barely twenty years after the artist's death.[3] Even Gabriele Vendramin seemed not to know what his treasure represented, and today Michiel's choice, *Tempesta*, remains the title of the work. In fact this problem of recognition is scarcely surpris-

ing in light of the fact that Giorgione substituted the youth for a female nude half way through the painting of *Tempesta*, a change so substantive that we cannot avoid the conclusion that the artist modified the subject of his work at least once while it was in progress.[4] This approach seems to have been surprisingly general in the early cinquecento, the years that are the particular concern of this paper; for this reason we cannot simply claim to be in search of a specific definition of the meaning of pastoral landscape, but must rather recognize that conditions allow for the possibility that none ever existed.

Neither Venetian artists nor their cinquecento critics would have understood the term "pastoral landscape" from the works shown in the exhibition of that name held in 1988 at the National Gallery of Art and the Phillips Collection in Washington; nor would they have found a concise explanation of the term in the publication accompanying the show.[5] Although it is not the intent of this essay to suggest a comprehensive definition of pastoral landscape, the evidence of Venetian cinquecento works of art, seen in light of their authorship, chronology, and context, suggests certain aspects of a Venetian view of this theme—a view palpably present in early cinquecento Venetian art but evanescent in its character and meaning. Landscape or *paesaggio* was, for Venetians, simply an indication that the theme repre-

sented was in a nonurban setting; that is what Michiel meant when he described Giorgione's painting as "el paesetto in tela cun la *Tempesta*, cun la cingana et soldato." Pure landscape in the modern sense did not, of course, exist for the early cinquecento, and the use of a country environment was always dependent on its appropriateness to the artist's subject. However, the painter might draw, or occasionally even paint a landscape in the course of preparing his picture.[6] By about 1500 such settings had gradually evolved from a very subsidiary role in the background to become an enveloping part of many compositions, a meaningful and expressive component of the ensemble.

Shepherds are the indispensable element in Venetian pastoral landscape; before 1500 they were almost invariably relegated to a secondary place in the depiction of the Nativity, the Annunciation to the Shepherds, or the Adoration of the Shepherds. This last subject did not, however, become widely popular in the Veneto until well after the turn of the century, in a period in which shepherds had already become familiar in their classical-literary guise. In their secular role shepherds are brought forward even to the point of pushing their natural habitat into a very secondary place.

Jacopo Sannazaro, Neapolitan by birth but Venetian in print, wrote his *Arcadia*, a free variation of Virgil's *Eclogues*, in the last decade of the quattrocento, but it was published in incomplete form in Venice in 1502 and in an integral version in 1504.[7] His image of arcadian shepherds engaged in idyllic dalliance in a rustic environment has multiple sources both in literary prototypes of classical antiquity as well as in later exempla such as Petrarch, but its impact must be seen in the context of a revived enthusiasm for the *Eclogues* themselves. Manuscripts by and about Virgil were in circulation—for instance Petrarch's copy of Servius' *Commentary*, with a fine illumination by Simone Martini. Artists are unlikely to have enjoyed ready access to such precious volumes, and their awareness of Virgil must have been closely related to printed editions. The *Eclogues* appeared in editions printed in Venice during the first decades of the cinquecento.[8]

Giorgione was, by the end of the cinquecento, credited with the primary role in creating the visual counterpart of the literary-poetic arcadian mode. In reality the enigmatic magician from Castelfranco seems not to have been influenced by the books published during the decade of his artistic activity; nor did his works make a significant contribution to the pastoral tradition. Among the paintings that are, in the view of this author, entirely or in significant part by Giorgione, none is pastoral in character. The so-called *Tempesta* is still the subject of discussion, but its roots in a chivalrous, courtly tradition set it apart from the early cinquecento interest in an arcadian imagery. Giorgione's only known drawing was traditionally called *Il Pastorello* (Boymans-van Beuningen Museum, Rotterdam), but recent observations have shown that a bird at the top center is of significance to its true subject. Neither Elias fed by a raven nor Aeschylus killed by a turtle dropped by an eagle is a satisfactory explanation of the subject of the work, but when one returns to the earliest given title, one finds a more reasonable iconography.[9] The Greek shepherd Ganymede was spied upon by Jupiter, who, in the form of an eagle, carried him off to Olympus. This was a familiar neoplatonic allegory of the beauty of immortal spirit and one destined for representation by some of the most heroic of Renaissance masters. Giorgione may place his *Pastorello* outside the walls of Montagnana, but his subject remains firmly within the scope of Ovidian mythology. Otherwise, all of his surviving pictures are either religious or secular in subject.

It must be observed that in these early cinquecento works Giorgione's integration of figure and landscape did much to prepare the way for the pastoral landscape in its authentic form. Landscape, however, like every other aspect of Giorgione's work, was subjected to an oblique abstraction, in this case excluding a direct response to nature fundamental to the true pastoral image. This intellectual construct is consonant with Giorgione's training under Carpaccio and his formative experience in Bologna with Ercole Roberti and Lorenzo Costa. The later, darkly monumental de-

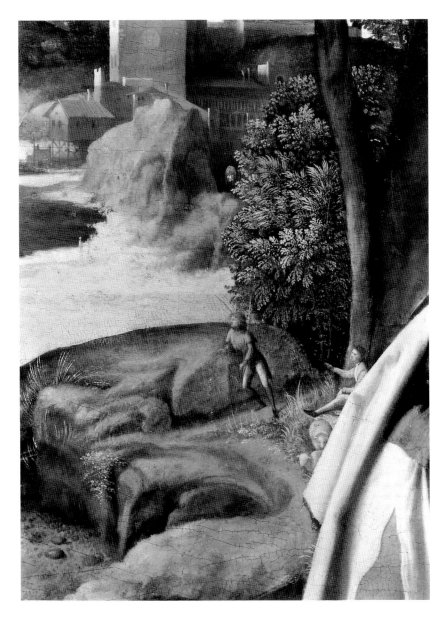

I. Titian, *The Adoration of the Shepherds* (detail), c. 1506, oil on wood
National Gallery of Art, Washington, Samuel H. Kress Collection

orderly diagonal recession with the major figures in the right foreground is closely modeled on Bellini's pictures, for instance his *Saint Jerome* (National Gallery of Art, Washington), painted in 1505 while Titian was an apprentice in his shop, Titian's *Adoration* is at once pictorially softer, spatially more pliant, and pungently responsive to the expressive potential of landscape. The pair of shepherds in the foreground is appropriately rustic, with torn clothing, pilgrim hat, and reverent demeanor, but the figures are crisp, elegantly contoured, and strong in color. In the middle distance (fig. 1) two other shepherds with their sheep gaze toward the annunciatory angel; this is the traditional place for the antecedent episode, but here it is daringly intersected by the standing shepherd in front. Distantly reflective of similar figures in earlier works of Giorgione, these lithe and supple forms bespeak a more aggressive, extroverted type found repeatedly in Titian's immediately subsequent works.

It was about two years later, in 1508, that the young Titian came into contact with the Paduan dilettante and engraver Giulio Campagnola. An enigmatic figure but a characteristic product of the intellectual university environment of Padua, Giulio was born in about 1482 into a fairly cultivated Venetian family. He is reported to have been sent to Mantua in 1497 to develop his skills as an engraver.[12] After a visit to Ferrara in 1499 he was recorded in 1507 again in Venice, but it seems that he found a congenial environment in the humanist circles of Padua, where he was known not only as a linguist but also as a fine amateur musician. At first he learned by copying the engravings of Dürer, but by about 1505 he obtained a drawing from Giovanni Bellini (formerly Holland-Martin collection, London) that he engraved as Ganymede, substituting a landscape from Dürer's *Madonna with a Monkey* for Bellini's softly atmospheric setting, which did not lend itself to the engraver's medium. It was perhaps this contact that brought Titian, Bellini's apprentice, to Campagnola's attention, for in 1508 when Campagnola set about executing a print of *Saint John the Baptist* after a drawing by or after Mantegna, he again needed a land-

velopments of his brief career set him even farther apart from the novel elements developing in the workshop of Giovanni Bellini.[10]

Titian, rather than Giorgione, assumed leadership in the formulation and dissemination of the pastoral tradition in early cinquecento Venice. Born in about 1489, sent from his Dolomite valley to Venice where he was probably an apprentice in Giovanni Bellini's shop between 1503 and 1506, the young Vecellio painted one of his earliest independent works, the *Adoration of the Shepherds* (National Gallery of Art, Washington), in about 1506.[11] Although its

2. Titian, *Saint John the Baptist* (detail), c. 1509, pen and ink
Musée du Louvre, Paris

3. Giovanni Bellini,
Madonna and Child (detail),
1509, oil on panel
Detroit Institute of Arts

scape setting and this time turned to Titian for it.[13] Drawing the outline of the figure centered on his sheet (fig. 2), Titian surrounded it with a freshly evocative brush and wash pastoral environment, one in which he developed the background of the *Adoration*, including the shepherds and sheep, here grown fuller bodied but still recognizably rustic like their predecessors. Their presence is justified by the Baptist's role as prophet and predecessor who announces the arrival of the Messiah. (These same shepherds appear in a similar role and position in the Nativity.) More significant is Titian's delicately atmospheric, stippled touch, which gently evokes the organic natural patterns of undulant hills, lush forest, bushes, broken tree trunks, and the drama of a cloudy sky. With its Dürer-inspired wooden buildings and the relaxed shepherds, this drawing seems the first true pastoral landscape. Its impact, through Giulios' print, may be gauged by

Bellini's signed and dated *Madonna and Child* (fig. 3) of 1509, in which, at right, similar shepherds and flocks populate a gently bucolic countryside.[14] Bellini was, at the age of about seventy, still not only receptive to new directions in painting but ready to develop them into a rich and personal vision of the pastoral landscape.

Titian and Campagnola continued their collaboration over the next few years. The younger draftsman supplied the engraver with a sketch of a goat in a landscape (fig. 4), which Campagnola combined with a reclining figure, probably also based on a Titian drawing, in the old shepherd print of about 1510 (fig. 5).[15] Contrary to the way he had used Titian's drawing for the print of Saint John the Baptist, the engraver here reversed his model and in the process misinterpreted more of its details than he had in the Baptist print. The subject of the print of an old shepherd remains obscure, but the absence of any discernible religious

4. Titian, *Goat in a Landscape*,
c. 1510, pen and ink
Musée du Louvre, Paris

5. Giulio Campagnola,
Menalcas, engraving
Metropolitan Museum of Art, New
York, Harris Brisbane Dick Fund

symbol suggests a secular theme. Indeed, Virgil's *Eclogues* provide a literary clue to its meaning, specifically the ninth eclogue in which old Menalcas, the poet who played a pipe, laments the loss of his farm. Perhaps the very absence of narrative events in Virgil's poem prompted the dreamy, discontinuous effect of the piping shepherd, his goats, and their dilapidated mountain farm setting. It was, in any case, a pivotal work in the metamorphosis of Christian shepherds at the Nativity to arcadian rustics in a Virgilian idyll.

Titian may have fled the plague in Venice that killed Giorgione in the late summer of 1510, but by at least 1 December of that year he was at work in Padua and had resumed his involvement with printmakers. Although this involvement would continue intensively for a decade and involve anonymous cutters of woodblocks, his executants were some of the most prominent graphic artists of the time, among them Marcantonio Raimondi, Ugo da Carpi, and, again, Campagnola. Titian provided Raimondi with a drawing of Saint Jerome (Gabinetto Disegni, Galleria degli Uffizi, Florence, no. 14284 F) and very slightly later drew an analogous pen sketch of a goat in a landscape with a fragmentary portrait (fig. 6).[16] For da Carpi he supplied some random sketches that were recompiled for the monumental *Sacrifice of Abraham* woodcut; he again used his familiar shepherd and sheep for the upper left block. Most important for the arcadian tradition, however, was the technically and iconographically innovative print by Campagnola, *Mopsus and Menalcas* (fig. 7).[17] Again it seems to illustrate a moment in the *Eclogues*, here the middle passage of the fifth poem in which old Menalcas, lulled by the beauty of young Mopsus' song of lament for Daphnis, says: "Tale tuum carmen nobis, divine poeta, quale sopor fessis in gramine, quale per aestum dulcis aquae saliente sitim restinguere rio. nec calamis solum aequiperas, sed voce magistrum."[18] In the country setting bearded Menalcas dozes at Mopsus' feet as the youth indulgently listens to his compliment for the song he has just piped and sung, one written on beech bark from the stump on which he leans. The languorous aura of lingering music, a hint of antique and thus remote homoeroticism, and the studied rusticism—no harsh labor here—combine in an image that is clearly of Titian's invention. Campagnola's remarkable stages of experiment in the print's sev-

eral states must mirror his gradual search for a medium capable of capturing Titian's stippled use of brush and wash.

The *Campagno della Calza* that Titian had frescoed on the Merceria façade of the Fondaco dei Tedeschi between 1508 and 1509 is similar in type to Campagnola's print. Although the original is almost totally obliterated and Antonio Maria Zanetti's engraving of 1760 suggests little of its pictorial character, we have a more subtle transcription in Zanetti's original drawing (fig. 8), which he made directly from the fresco before it was detached and overpainted.[19] Closer, however, to Campagnola's *Mopsus and Menalcas* are the shepherd figures in Titian's *Flight into Egypt* of about 1511, in his *Concert Champêtre* of about 1512, and most explicitly in his *Judgment of Paris* of 1512, an important picture known today in several copies as well as a drawn variant by Domenico Campagnola (fig. 9).[20] One might therefore suggest that Titian provided Campagnola with a drawing of about 1511–1512 for *Mopsus and Menalcas*, and that it was probably executed with the brush tip in a stipple technique recalling Titian's earlier landscape for *Saint John the Baptist*. Campagnola first engraved it in a primarily linear interpretation, gradually reworking the plate toward the stippled, atmospheric last state. *Mopsus and Menalcas* shows Campagnola at his most experimental, but it was Titian's drawing that provided the model. Soon afterward, close to 1514, when Campagnola reworked the figure as a *Shepherd with a Viol* (fig. 10), he reverted to a more linear handling.[21] Nonetheless, both Titian's original Virgilian imagery and Campagnola's dissemination of it through his prints had an immediate impact on artists in the Veneto and even beyond.

A typical example of this response may be found in the work of Andrea Previtali, who was born in Bergamo a little after 1480. Previtali's earlier works are conservative reflections of Giovanni Battista Cima da Conegliano and Bartolomeo Montagna, with a touch of the more innovative color of Lorenzo Lotto. Around 1511 Previtali became aware of Titian, by way of Giulio Campagnola's prints, as well as Titian's paintings, and perhaps Titian's drawings as

7. Giulio Campagnola,
Mopsus and Menalcas,
c. 1512, engraving
Cincinnati Art Museum, Bequest of Herbert Greer French

8. Antonio Maria Zanetti, after Titian, *Compagno della Calza*, 1760, pencil
Private collection, Venice

9. Domenico Campagnola, *The Judgment of Paris*, c. 1517
Musée du Louvre, Paris

10. Giulio Campagnola, *Shepherd with a Viol*, c. 1514, pen and ink
Ecole des Beaux-Arts, Paris

well. The result is that Previtali's pictures abandon monumental figures compressed on the front plane and experiment instead with small, poetic players who are surrounded by an evocative and idyllic landscape environment. His subjects, too, shift, encompassing one of the arcadian poems by Tebaldeo in a set of four little paintings of Damon and Thyrsis.[22] Here the influence of both Titian and Campagnola is grafted onto his quattrocento technique, assumed but not assimilated. A residual memory of Giorgione as well suggests the enthusiasm with which Previtali threw himself into his new mode. He would improve his technique and enrich his prettily florid palette in arcane allegorical pictures that were doubtless made to embellish small caskets or *cofanetti* in which precious objects or manuscripts were preserved.[23] When he attempted to move to larger-scale canvases such as the *Shepherd* (Herbert F. Johnson Museum of Art, Cornell University, Ithaca) it is obvious that he was discomfited by the unwonted size and lost his grasp of organic form.[24] This is even more apparent when he worked on large narrative subjects such as the *Crossing of the Red Sea*, and the *Christ in Limbo*.[25] Here, as in a third work

II. Giulio Campagnola,
Mopsus and Menalcas (detail),
c. 1512, oil on canvas
National Gallery, London

from this set (formerly Wildenstein Gallery, New York), little figures in episodic compilations rush aimlessly about in landscapes traversed by surreal and arbitrary flashes of illumination. This sequence of pictures by Previtali may be dated between about 1511 and 1518. Other conservative or older painters made a similar effort to bring their range of subject and pictorial handling into line with this pastoral current, more often than not with similarly dispiriting results.

Giulio Campagnola himself made at least one significant and typically eclectic and naive contribution to painting in the new mode. The small picture (fig. 11) is popularly called the *Tramonto*, a descriptive title like that of the *Tempesta*, though here less appropriate. The true subject of the work, however, remains elusive.[26] The principal figures at the left are obviously reversed variants of those in Campagnola's engraved *Mopsus and Menalcas*—closer, perhaps, to those in Titian's original drawing, which might have been in reverse of

the print. Previous attempts to identify them as Aeneus and Anchises or Saint Roch are unconvincing, and the probability remains that again a Virgilian theme is intended. What complicates the problem are the other secondary but clearly significant figures, a mounted warrior who attacks a dragon at right, an anchorite in a cave still farther to the right, and a bizarre birdlike creature at bottom center. Are they Saint George, Saint Anthony or Jerome, a demon, or none of these? There is no ready answer, but the mixture of literary and religious elements is not uncharacteristic of the cavalier attitude of Venetians to orthodox iconography in straightforward visual form. As a painter Campagnola emulates Titian's color and texture with surprising proficiency, offering a rich and evocative imitation of the master in works such as the *Noli Me Tangere* (National Gallery, London), the *Rest on the Flight into Egypt* (Marques of Bath, Wilton House), or the lost *Judgment of Paris*. His graphic abstractions, however, transform Titian's mobile

luminosity into idiosyncratic mannerisms, as exemplifed by the splayed, compressed, fan-shaped bushes, the additive pattern of flattened leaves on the tree, and the undulant molding of the rocks in *Mopsus and Menalcas*. These conventions, found in both Campagnola's prints and his drawings, are antithetical to Titian's swift mobility both in paintings and drawings. In view of the painting's dependence on the Virgilian print and its contact with Titian at a specific moment in that artist's pictorial evolution, it is reasonable to date *Mopsus and Menalcas* to about 1512.

Campagnola is last heard of in 1515, when Aldo Manuzio dictated in his will of 16 January that Giulio should cut the majuscules to be used at the Aldine press. At some point, perhaps in 1512, Campagnola adopted a talented orphan called Domenico, then twelve years old, whom he instructed in drawing and printmaking. The point of transition between the older and younger artist is usually held to be the drawing of the so-called *Two Philosophers* (Département des Arts Graphiques, Musée du Louvre, Paris), which is pricked for transfer on its left side and was thus printed at least once in experimental form.[27] It is entirely characteristic of Giulio, and shows exactly the conventions we have noted in *Mopsus and Menalcas*. Its figures are, however, rather more conservative and reminiscent of the decorative sketches by Giovanni Cariani of around 1510 to 1511. The powerfully evocative landscape sketch on the verso of the Louvre sheet is a reflection of a more advanced Titian style, and it remains more logical to date it close to Giulio's last year, about 1516. Young Domenico assumed responsibility for the completion of the print, but he substituted a quartet of musicians of a type already studied by Giulio in the *Shepherd with a Viol*.[28]

The family association between the Campagnola and Titian did not end with Giulio's demise; indeed by 1517 Domenico was working in such close association with the older master that it is clear that he was at least temporarily privy to his studio, his drawings, and his ideas. In 1517 and early 1518 Domenico produced an astonishing thirteen engravings and an even greater number of drawings. Although the prints are about evenly divided between religious and secular subjects, only one continues the theme of a young, musical shepherd begun by Domenico's surrogate father.[29] In this evanescent line engraving (fig. 12) Domenico repeats Giulio's motif of a young shepherd with pipes in the company of an elderly, bearded man, but he seems unsure of his exact subject—the old man wears a tasset but is not otherwise characterized as a soldier; the two figures are accompanied by a singularly strange dog; and certain forms elide into ambiguity. Still, the Virgilian tone remains palpable. Many of Domenico's drawings of these years are

12. Domenico Campagnola, *Mopsus and Menalcas*, engraving
National Gallery of Art, Washington, Rosenwald Collection

13. Domenico Campagnola,
Thyrsis and Corydon, c. 1518,
pen and ink
British Museum, London

14. Domenico Campagnola,
Thyrsis and Corydon, c. 1518,
pen and ink
British Museum, London

certainly more overtly illustrative of the *Eclogues*. One rapidly improvisational pen sketch surely represents Thyrsis, who crowns Corydon victor in the singing contest in the seventh eclogue.[30] Another more studied pen drawing (fig. 13) shows two shepherds directly engaged in the musical contest, the phallic implications of the pipes here made explicit.[31] In a quite elaborately finished pen sheet (fig. 14) the shepherds discard poetic implication for a direct kiss.[32] Prominently signed by Domenico, this is a connoisseur's sheet, a finished work of art in itself and not a preparation piece. Its erotic implications should be understood in the neoplatonic context of the time—ambiguous perhaps, but easily couched if need be in a transcendent philosophical exegesis. In any case, Titian would hardly have considered his pastoral images in such terms.

In about 1518, with Domenico Campagnola evidently banished from his shop, Titian turned his attention to the epic cycle of mythologies commissioned by Alfonso d'Este for his *studiolo* at Ferrara, and for a time the pastoral idyll of Virgilian tone fell into abeyance. Even Domenico seems to have lost interest in a direct arcadian mode, allowing it to be diluted into a sort of proto-savoyard ensemble of picturesque vagabonds; Ruzante had replaced Virgil as his Paduan muse.

If, during the years between 1506 and about 1516, Titian had been instrumental in giving the arcadian world of Virgil and Sannazaro a modern visual form, he was, for a longer span, also interested in a related aspect of this sylvan tradition. Pan, Silenus, Marsyas, and a host of satyrs from classical literary sources including secondary allusions in the *Eclogues*, had long been known to humanists in the Veneto. By 1500 these were frequently incorporated into contemporary allegorical texts, such as Francesco Colonna's *Hypnerotomachia Poliphili*, which was published by Aldo Manuzio in 1499. Antique sculptural representations of satyrs—fragmentary full figures and reliefs in marble as well as small bronzes—seem to have been known in the Veneto at least from the mid-quattrocento. Jacopo Bellini included five adult and three juvenile satyrs in his *Triumph of Bacchus*

(Musée du Louvre, Paris), a drawing that may be based on a classical relief, and Giovanni derived his own *Triumph of Bacchus* (Accademia, Venice) in part from his father's drawing or from its sculptural source, although he chose to omit the satyrs. Paduan manuscript illuminators frequently added satyrs as marginal decor, illustrated books published in Venice during the last quarter included pictures of satyrs, and Mantegna and his followers provided the humanist-antiquarian Gonzaga court at Mantua with a host of hooved humanoids.[33] Lorenzo Lotto included one in the cover of his portrait of Cardinal Bernardo de' Rossi of 1505, and in another portrait cover of the same period he added a satyress. In these same years satyrs, some with families, burgeon in prints, first in the engravings of Jacopo de' Barbari but quickly also in prints by Dürer, Benedetto Montagna, and others.[34] There is no evidence that Giorgione ever represented a satyr in any of his works. In two early paintings, the *Trial of Moses* (Galleria degli Uffizi, Florence) and the allegorical fresco frieze (Museo Civico, Castelfranco), Giorgione seems to allude to satyrs without, typically, making their meaning clear. The explicit satyr themes in drawings after paintings attributed to Giorgione in the inventory of the Vendramin collection in Venice in 1627 may be discounted since none is demonstrably after a known work by Giorgione.[35] Most of these sketches seem to be dependent in some way on inventions by Titian; however, none of Titian's very early works deals with satyrs. It was around 1511 that the master from Cadore drew his famous *Two Satyrs in a Landscape* (fig. 15).[36] Lolling comfortably in the same evocative pastoral environment that Titian had provided for Giulio Campagnola in these same years, the powerfully characterized sylvan creatures at once established vital, living prototypes that immediately replaced the antiquarian counterfeits of the previous half century. That they also were inspired by a sculptural model is suggested not only by the fact that Titian repeated the satyr seen from the back in the fictive marble relief in the *Annunciation* (Duomo, Treviso) painted a few years later, but also by the associations with specific sculp-

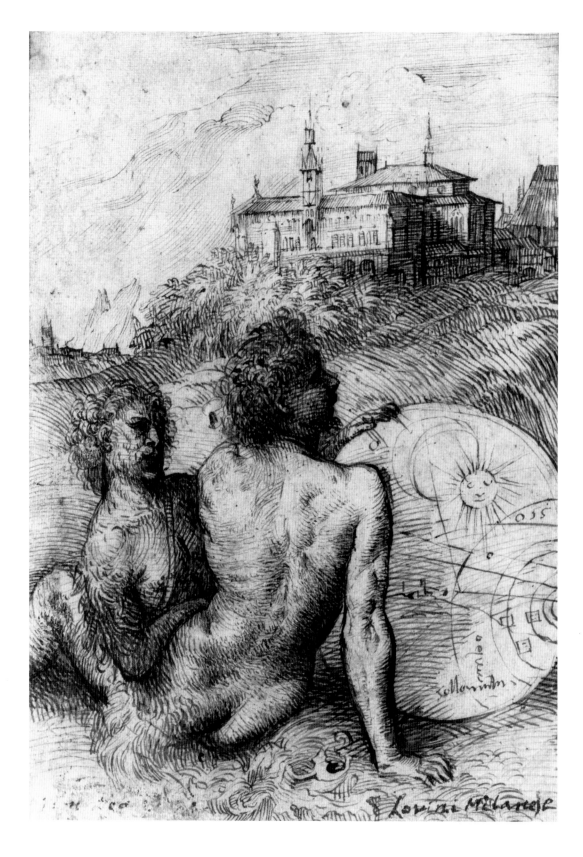

15. Titian, *Two Satyrs in a Landscape*, c. 1511, pen and ink
Yvette Baer Collection, Stone Mountain, Georgia

tural projects undertaken in Padua soon afterward.

Andrea Briosco, called Riccio, was born in Padua in about 1475.[37] He was apprenticed to Bartolomeo Bellano and succeeded him after 1496 in the completion both of the Roccabonella monument in San Francesco, Padua, and of the cycle of bronze reliefs in the Santo, begun in 1480. He was, therefore, only slightly older than Giulio Campagnola and, like the engraver-dilettante, must have been at home in the humanist-antiquarian circles of Padua. His small bronze satyrs are notoriously difficult to date, and their first secure context is as shackled symbols of the sensual pagan world at the second stage of the giant bronze paschal candlestick in the Santo, which was modeled and cast between 1507 and 1516. The well-established mastery of form in the candlestick satyrs suggests that they were not the very first of Riccio's satyr bronzes. In fact Riccio's earliest works do not seem to have included the motive of the satyr for which he was destined to become famous. Some of his first small bronze statuettes depict gently poetic shepherds, usually with panpipes, seated in attitudes that suggest the musical episodes that were the subjects of Titian's drawings and Giulio and Domenico Campagnola's prints during the years between about 1509 and 1517. The principal difference is that Riccio depicts them nude, doubtless the sculptor's conscious antiquarian choice when illustrating a classical theme. Their only close relative in painting is the nude youth in Titian's *Three Ages of Man* (National Gallery of Scotland, Edinburgh) of about 1512. Since that picture was, we believe, contemporary with Titian's *Two Satyrs in a Landscape*, Titian's Paduan association with Giulio Campagnola might at this point have extended to the sculptor Riccio, who equally frequented the learned circle of humanists in the university community. Although it quite evidently dates later and revises the drawn model, Riccio's elaborate incense burner with a seated pair of satyrs on the lid (fig. 16) uses the motive of the *Two Satyrs* drawing, making an effective translation of the forest creature seen from the back into three-dimensional form.[38]

Titian's fascination with satyrs developed over several years in evocative drawings such as the *Satyr and Goat in a Landscape* (Frick Collection, New York) of about 1515 to 1517 and in the cycle of mythologies painted for Alfonso d'Este, culminating not only in the *Bacchus and Ariadne* (National Gallery, London) but especially in his repainting of Bellini's *Feast of the Gods* (fig. 17).[39] There he added a vigorously energetic trio of satyrs who swing and frolic through the forest with primal abandon. Titian probably reworked his teacher's painting during his Ferrarese sojourn of 1523, and it is significant that satyrs seem then to have passed out of his repertory until his last years when, in the *Marsyas* (Státní Zámek, Kroměříž), a profound nostalgia for his youthful inspirations brought them back in awesomely mythic form. Significantly one of two intervening occurrences of satyrs is in the *Jupiter and Antiope* (Musée du Louvre, Paris), in which it was precisely the *Two Satyrs in a Landscape* that provided him with the satyr seen from the back. Much of *Jupiter and Antiope*, including the satyrs and Antiope, had been formulated around 1512 to 1516, only to be incorporated around 1540 to 1542 into the *maniera* company seen today. The other instance of a satyr is the famous large drawing *Nymphs and Satyrs in a Landscape* (Musée Bonnat, Bayonne). Here the components are equally traceable to inventions of the second decade of the cinquecento, but the dense complexity of the penwork suggests a date closer to 1565. In fact Lodovico Dolce has the protagonist of his *Il dialogo dei colori* of 1565 describe a work of Titian in terms nearly identical to the subject of the Bayonne drawing.[40] The arcadian character of this text seems clearly to derive from Sannazaro, Virgil, and Philostratus. The latter described an ancient Greek painting of this subject, and Titian's drawing is evidently an effort to conjure up that classical prototype—yet another instance in which the arcadian mode was regarded by Venetians as an archaeological topos. The late date of Dolce's text underlines the probability that artists, and in particular Titian, played a significant role in the propagation of this idea during the first quarter of the century.

Although the leadership in establishing the pastoral theme, both in its Virgilian and satyr forms, clearly belongs in large measure to Titian during the first quarter of the cinquecento, its vogue was limited, even among the master's most devoted followers. Palma il Vecchio picked up at least part of the lascivious satyr imagery in his *Allegory* (Sarah Campbell Blaffer Foundation, Houston), but the group at the left of the painting is made up of a garlanded lyre player, probably Apollo, who listens to a player of panpipes who ought to be Marsyas but who has human feet rather than the usual hooves.[41] The arbiter, a female, can hardly be King Midas or any of the other traditional observers of the Apollo-Marsyas contest. That this slip is due to ignorance of types is belied by the figure of a correctly formed satyr who loses in combat to a classical hero type at right. Clearly Palma's theme must have been intelligible to him, although it remains inscrutable to us. Palma, like Titian, seems to have lost

16. Andrea Briosco, called Riccio, *Incense Burner* (detail), c. 1525, bronze
Metropolitan Museum of Art, New York, Robert Lehman Collection

17. Titian over Giovanni Bellini, *The Feast of the Gods* (detail), c. 1523, oil on canvas
National Gallery of Art, Washington, Widener Collection

interest in this pastoral imagery shortly
after 1520. Even Lorenzo Lotto, whose pre-
cocious satyr pictures preceded those of
Titian by a few years, abandoned such sub-
jects even sooner than Titian did and never
returned to them. With the advent of a
younger, more strenuously *maniera* gener-
ation after about 1535, the pastoral tradition
might seem to have been destined to pass
into history as a delicately ephemeral epi-
sode of exceptionally short duration; but
this is to forget the constantly revitalizing
force of Titian.[42]

At a date that is still debated but that
must be very close to 1525 Titian supplied
drawings and, given its majestic composi-
tional sweep, the general order on which a
woodcut was based.[43] Once again tradi-
tional iconographical categories seem to
have been treated with such cavalier lati-
tude that we are left with a merely descrip-
tive title, the *Milkmaid* (fig. 18). The peas-
ant woman milking the cow at right, the
boy who feeds the goats and sheep at cen-
ter, and the livestock at left might well
seem to be simple pastoral components of a
scene of peasant genre, but the horse that

gallops away and, especially, the heraldic
eagle are clearly emblems of a more spe-
cific import. That it is Jupiter disguised as
an eagle come to admire Ganymede is pos-
sible, but the staffage is too numerous and
distracting, especially by comparison with
Giorgione's restrained drawing of that
mythological subject. It might be an impe-
rial allegory with the eagle representing
Charles V, whose invasion of northern Italy
set the French occupiers to flight in 1521.
But again, the rustic setting makes an im-
probable environment for such a political
allegory. It is precisely this barnyard sim-
plicity that strikes a new and highly origi-
nal note in this woodcut.[44]

Sannazaro's *De Partu Virginis* was pub-
lished in Venice in 1526. His frankly Vir-
gilian Latin text offers a hymn to the new-
born Christ that is derived from the fourth
eclogue and is intoned by the shepherds
Agon and Lycidas, the protagonists of the
third and ninth eclogues.[45] The very fact
that Sannazaro writes in Latin and takes
for granted the reader's familiarity with
Virgil's poems indicates a shift from the
simplicity of his vernacular pastoral of

twenty years before. Familiarity with Virgil assumes more academic and artful literary attitudes. Just as in the years following the publication of *Arcadia* it was Titian who elided the shepherds of the Nativity into those of Arcady, so Sannazaro returns to their common pastoral setting in a reversal of that metamorphosis. Titian, however, was simultaneously working yet another transformation of a bucolic literary prototype.

Whatever the arcane symbols of the *Milkmaid* woodcut might mean, its forms are in an unmistakably new mode. Here the rustics do not simply sing and pipe in a languorous twilight; they work. Milking and feeding their livestock, these peasants are energetically engaged in agrarian life. Their simplicity is, however, seen in heroic terms, their labor ennobled by the majestic unity between man and his environment. The rarefied poetry of the *Eclogues* has given way to the strenuous reality of the *Georgics*. Virgil's *Georgics* were known in Venice at the beginning of the cinquecento, but they seem to have been less attractive models than the *Eclogues*. By the time Sannazaro had brought the pastoral full circle as a literary mode with his conflation in 1526 of the Nativity and the *Eclogues*, Venetian humanists were ready to explore the other face of rural life. Just as artists had gone to Dürer a generation earlier for the rustic cottages that appear in the distance in their pastoral reveries, so they went again to the North for models for the harsher reality of peasant life. Although there can be little doubt that Titian knew Lucas van Leyden's *Milkmaid* of 1510, he did not choose to emulate the realistic asperity of that engraving, which, in any case, cannot have been inspired by Latin poetics. A certain Northern impulse toward the more mundane aspects of country life is nonetheless present in Titian's imagery, and the impact of his woodcut, apparently negligible in the decade in which it was done, would become more apparent a few years later by way of yet another Dutch artist of a much younger generation.

Lambert Sustris may have been an associate in Titian's studio during the final years of the fourth decade of the cinquecento, but between about 1541 and 1543 he was working in Padua, where he clearly saw and was strongly influenced by the works that Giuseppe Porta, newly arrived from Rome with Francesco Salviati, was producing there in those years. The conjunction of Dutch realism, Titianesque landscape tempered by Domenico Campagnola's prosy expansiveness, and an elegantly mannered female type in the spinner suggests that the remarkable woodcut *Landscape with a Plowman* was done by Sustris around 1544 to 1545.[46] This print, once attributed to Titian, Campagnola, and more recently to Porta himself, seems on the surface more aggressively rustic, since the clumsy plowman occupies such a dominant place in the foreground. In fact this planar compression is a *maniera* device and the grandly heraldic oxen are elaborately stylized by comparison with Titian's more naturally observed animals. The high-fashion spinner and her nude children are derived directly from Porta's elegant prints, and the refined and spacious landscape owes more to Campagnola's decorative pattern than it does to Titian's vigorous dramatization of nature. This pallid transformation, at once simpler and more accessible as well as less pregnant with meaning and expression, was easily imitated, as a wide range of woodcuts of rustic themes attest. The *Hare Hunter*, the *Old Woman and Child on Horseback*, the *Boy Driving a Calf*, and other woodcuts reflect the *Plowman*, but their rougher cutting and derisive caricature of peasant types strikes a new, unsympathetic note.[47] The *Hare Hunter* is dated 1566 on the block. Formal elements of the full set are more directly related to Campagnola than to either Titian or Sustris, and although the woodcuts are usually attributed to Nicolò Boldrini, probably correctly, their sources might be rather earlier than the inscribed date. Although attention was certainly on more heroic public images during the turbulent years of 1525 to 1555, the *maniera* episode in Venice, these modest images of peasant life were circulated widely as a sort of underground current that kept the bucolic tradition poised for its own revival.

Jacopo dal Ponte, known as Bassano, was born in Bassano in about 1510.[48] His train-

ing with his father was conservative and provincial, hardly incorporating developments in Padua or Venice. His native curiosity, however, turned his interest to the capital by 1533, and it was the by-then-celebrated Titian who became at once his ideal and mentor. Remaining quietly at home in his native village, Jacopo gained a sophisticated awareness of distant developments by way of prints; but quite aside from such exotic windows onto the great world far away he remained profoundly tied to a candid and direct transcription of the natural world that surrounded him. Complex and experimental *maniera* episodes were destined to evolve as Jacopo's pictorial curiosity explored some of the most adventuresome paths that painting was to probe in the mid-cinquecento, but his dedication to his pastoral environment repeatedly prompted him to collect and study woodcuts after Titian's designs. He adapted figures from several prints after Titian, most particularly from the *Triumph of Christ*, which served as a model from his youth on. As an entrepreneur head of a family shop that served local patrons with a remarkable variety of needs—from altar pictures and allegorical façade frescoes to painted candlesticks and designs for marzipan—Jacopo was severely limited in his choice of themes. Until late in his career, when direct contact with Venetian clients expanded his range, he seldom depicted mythological subjects, and whatever literary interest he might have had in Sannazaro, not to mention Virgil, found no outlet in his work. Indirectly, however, the pastoral imagery as conceived by Titian and disseminated by Giulio and Domenico Campagnola must have been known to him, although its rarefied aura of nostalgic reverie cannot have appealed much to his more candidly rustic taste. Jacopo preferred to recast biblical subjects in a rural environment based directly on his concentrated observation of his native region. The simplicity of this approach permitted him to move from religious pictures to straightforward depictions of a pair of prized local hunting dogs without any apparent diminution of his intense pictorial conviction. His clear-sighted return to the unadorned biblical text equally suggests that he was at least sympathetic to the contemporary Protestant fidelity to scripture rather than theological glosses. Despite some extravagantly original stylistic experiments normally designated mannerist but essentially personal in character, Jacopo's dedication to the normal look of the world around him never faltered; this juxtaposition of the natural and the artificial creates some of the most striking images in mid-cinquecento painting in the Veneto.[49]

If Jacopo Bassano remained indifferent to the poetic pastoral per se and represented satyrs, as far as we know, only as supports to escutcheons, the shift from the *Eclogues* to the *Georgics* in Venetian literary and artistic circles between about 1525 and 1560 did not go entirely unnoted in his provincial village.[50] It was, in fact, during the years just before and after 1560 that Jacopo came to the renewed attention of Venetian connoisseurs, providing them with a few altar pictures but furnishing private collectors in particular with smaller-scale biblical paintings cast in a rustic mode. In 1566 Vasari noted, with evident distaste, the widespread Venetian vogue for Jacopo's peasant genre subjects; it is significant that Vasari's sole reference to Jacopo came at the end of his Life of Titian.[51] Jacopo's personal association with the older master must have begun early in his career, but around 1560 it became closer and both painters exchanged ideas anew. It is unclear whether Jacopo owned and borrowed from the *Milkmaid* woodcut (fig. 18) before these years, but he clearly knew it by about 1564 when he conceived his *Sower* (fig. 19).[52] Nothing of Titian's invention is copied directly in this painting, but Titian's milkmaid is reversed and still recognizable in details such as the folds of her skirt, and a few particulars of the livestock seem to derive from Titian's example. Following his compositional order of placing the thematic key, the sower, in the middle-ground and filling the foreground with staffage—in this instance the farmer's family, who have just unharnessed the plow team and are preparing lunch—Jacopo might well have painted the biblical parable of the sower, as has generally been thought since the Jacopo Bassano exhibition in Venice in 1957. However, an attentive reading of Virgil's

passage in the *Georgics* that treats the plowing techniques necessary to prepare soil for field crops, the best procedures for sowing various types of seed, and the dangers to these seeds from voracious birds shows that much more of Jacopo's picture can be accounted for in that text than in the Bible.[53] In the case of both Jacopo and Titian some uncertainty must remain, but it is quite possible that both Titian's woodcut of the milkmaid and Jacopo's painting of the sower are inspired by Virgil's agricultural poem.

Jacopo had already taken command of a large and productive family shop when he painted the *Sower*, and he as well as various of his sons and followers repeated the subject of that painting many times over. His own small version of the subject (fig. 20) reduces the staffage, emphasizes the farming aspect, and minimizes the birds. It is therefore even closer to the Virgilian text. The later shop versions continue this type. Other than in this case Jacopo does not appear to have taken any significant interest in the Latin poets as sources, but of all the works he might have known, the *Georgics* was certainly most sympathetic to his own view of the world. His pictures found a responsive clientele among Venetian humanists familiar with Virgil and collectors of woodcuts after Titian and Sustris, as Vasari remarked when he noted that this type of Bassano could be found in private collections all over Venice.

Of all intellectual centers in Europe, Padua was the most propitious for an interaction of classical literature and antique art with contemporary poetry and a vigorous and enterprising visual idiom. Venice provided the matrix of talent and patronage as well as the catalyst of a vital publishing industry. Together these two contrasting but complementary cultural environments combined to encourage a free evocation of the ideal arcadian world of shepherds, music, and poetry. Its halcyon years, from 1508 to 1518, were few, but the imagery was destined for metamorphosis.

If rustic genre in the georgic mode began in the 1530s in Venice, crested with the popular peasant genre paintings by Jacopo from about 1560, and was disseminated through-

19. Jacopo Bassano, *Sower*, c. 1564, oil on canvas
Thyssen-Bornemisza Collection, Lugano

out Europe by the end of the century, the Venetian interpretation was but one of a complex of visual evocations of rustic landscape that was evolving in Europe in the cinquecento. It was, however, the strand that was destined to fascinate future generations and through them to take a preeminent place in the pastoral tradition.

Just as the Venetian public and Venetian artists alike were prepared to treat subjects with a cavalier disregard for a rigidly programmatic correspondence between image and idea, so their free and often vague concern with meaning was more than compensated for by an unmistakable if nonverbal potency of evocative expression. Perhaps one day a more attentive reading of text and image will clarify the evolution of the pastoral landscape, but for now its poetic metamorphosis from arcady to the barnyard is most pungently illustrated by its art.

20. Jacopo Bassano, *Sower*, c. 1567, oil on canvas
Museum of Fine Arts, Springfield, Massachusetts, James Philip Gray Collection

NOTES

1. This paper remains substantially as presented at the National Gallery of Art on 21 January 1989. I am grateful for the expert and stimulating suggestions of John Dixon Hunt, editor of this publication.

2. Giorgio Vasari, *Le vite de' più eccellenti pittori, scultori ed architettori* (1550; 2d ed., Florence, 1568), reprint, ed. Gaetano Milanesi, 9 vols. (Florence, 1906), 4: 91.

3. Marcantonio Michiel, *Der Anonimo Morelliano*, ed. T. Frimmel (Vienna, 1888), 106.

4. The most recent and still unpublished analysis of the meaning of the *Tempesta* is by Daniel Lettieri, "Traditions for Giorgione's Tempesta," (Ph.D. diss., Yale University, 1984). His exposition of the work as a *pittura come poesia*, a complex of "highly evolved, widely disseminated traditions of antiquity and the Renaissance" is compelling, although too little emphasis is given to its earlier format.

5. Robert C. Cafritz, Lawrence Gowing, and David Rosand, *Places of Delight: The Pastoral Landscape* [exh. cat., Phillips Collection and National Gallery of Art] (Washington, 1988).

6. Although Jacopo Bellini never made an independent landscape drawing, country and city settings alike are accorded detailed study. The impulse to landscape drawings per se may have come from Dürer when he visited Venice in 1494. By 1500 they are rather frequent among Venetian draftsmen, including watercolor studies in the manner of Dürer—for example, the seacoast by Marco Basaiti. See W. R. Rearick, *Tiziano e il disegno veneziano del suo tempo* (Florence, 1976), 25–27, 31–33.

7. Jacopo Sannazaro, *Liber Pastorale Nominato Archadio de Jacobo Sanazaro neapolitano* (Venice, 1504); trans. R. Nash (Detroit, 1966).

8. For discussion of the Venetian editions of the *Eclogues* see G. Mambelli, *Gli annali delle edizioni Virgiliane* (Florence, 1954).

9. Bert Meijer, "Due proposte iconografiche per il 'Pastorello' di Rotterdam," in *Giorgione: Convegno Internazionale di Studi* (Castelfranco, 1979), 53–56; S. Carezzolo et al., "Castel S. Zeno di Montagnana in un disegno attribuito a Giorgione," in *Antichità Viva* 17 (1978), 40–52.

10. W. R. Rearick, "Chi fù il maestro di Giorgione?" in *Giorgione: Convegno 1979*, 187–193.

11. National Gallery of Art, Washington. Sydney J. Freedberg, *Painting in Italy, 1500-1600* (Harmondsworth and Baltimore, 1971), 87; for the more common attribution to Giorgione see Terisio Pignatti, *Giorgione*, 2d rev. ed. (Milan, 1978), 102.

12. Paul Kristeller, *Giulio Campagnola: Kupferstiche und Zeichnungen* (Berlin, 1907); Jay A. Levenson et al., *Early Italian Engravings from the National Gallery of Art* (Washington, 1973), 390–413.

13. W. R. Rearick, *Biblioteca di disegni: Maestri Veneti del cinquecento*, vol. 1 (Florence, 1976), 8–9, 24–26.

14. Terisio Pignatti, *Giovanni Bellini* (Milan, 1969), 108, no. 193.

15. Harold E. Wethey, *Titian and His Drawings* (Princeton, 1987), 151; Maria Agnese Chiari, "Per un catalogo ragionato dei disegni di Tiziano," in *Saggi e Memorie di Storia dell'Arte* 16 (1988), 35–36; Konrad Oberhuber, *Disegni di Tiziano e della sua cerchia* (Vicenza, 1976), 68–69.

16. Chiari 1988, 37. This sketch, discovered by the present writer in 1987, has been discussed in detail in W. R. Rearick, "Titian Drawings: A Progress Report," *Artibus et Historiae* 23 (1991), 9–37.

17. Levenson et al. 1973, 400; Cafritz et al. 1988, 50.

18. Virgil, *Eclogues*, trans. H. Rushton Fairclough, Loeb Classical Library (1916; rev. ed., Cambridge, Mass., and London, 1942), V. 45–48: Your lay, heavenly bard, is to me even as sleep on the grass to the weary, as in summer-heat the slaking of thirst in a dancing rill of sweet water. Not with the pipe alone, but in voice do you match your master.

19. This drawing is analogous to the sheet published by David Alan Brown, "A Drawing by Zanetti after a Fresco on the Fondaco dei Tedeschi," *Tiziano e Venezia* (Vicenza, 1980), 513–522.

20. Pignatti 1978, 151; Hans Tietze and Erica Tietze-Conrat, "Domenico Campagnola's Graphic Art," *Print Collector's Quarterly* 29 (1939), 451–452.

21. Oberhuber 1976, 54–55.

22. In the National Gallery, London; Cafritz et al. 1988, 45.

23. The allegorical pictures are in the Museo Civico, Padua, and in the Phillips Collection and National Gallery of Art, both Washington, D.C.; Pignatti 1978, 133, 145–146.

24. Cafritz et al. 1988, 53.

25. Both in the Accademia, Venice. Sandra Moschini Marconi, *Gallerie dell'Accademia di Venezia: Opere d'arte del secolo XVI* (Venice, 1962), 179–180.

26. Pignatti 1978, 110–111.

27. Hans Tietze and Erica Tietze-Conrat, *The Drawings of the Venetian Painters of the XV and XVI Centuries*, 2 vols. (1944; reprint, New York, 1970), 2: 136.

28. Levenson et al. 1973, 410–413.

29. Levenson et al. 1973, 426–427.

30. The sketch is in the Albertina, Vienna. See Rearick 1976, 35; Oberhuber 1976, 122–123.

31. Oberhuber 1976, 121–122.

32. Oberhuber 1976, 119.

33. For manuscript illumination see Giordana Mariani Canova, *La miniatura veneta del rinascimento, 1450-1500* (Venice, 1969). I appreciate Lilian Armstrong's willingness to discuss with me satyrs in Venetian book illustration during the second half of the quat-

trocento. Ronald Lightbown, *Mantegna* (Berkeley and Los Angeles, 1986), is the most recent work on that subject.

34. Levenson et al. 1973, 320, 326, 366, 448.

35. Pignatti 1978, 163.

36. Wethey 1987, 167–168.

37. John Pope-Hennessy, *Italian Renaissance Sculpture* (New York, 1958), 85–87, 366. Manfred Leithe-Jasper, *Renaissance Master Bronzes* [exh. cat., National Gallery of Art] (Washington, 1986), 26–27, 110–119, 281.

38. I am particularly grateful to Laurence Kanter, curator of the Lehman Collection, Metropolitan Museum of Art, for facilitating my study and the photography of this work. A second version, rougher in casting and finish, is in the same collection, and a third, still poorer in quality, belongs to the National Gallery of Art. Douglas Lewis kindly informed me of Manfred Leithe-Jasper's oral attribution of this last piece to Agostino Zoppo. The name of Severo da Ravenna has also been suggested, but even though a relatively late date for these extant examples seems probable, the satyr figure on the lid is a type datable to around 1515 to 1520.

39. Rearick 1976, 10–11, 27; Wethey 1987, 159; Chiari 1988, 47. The splendidly frolicsome satyrs that Titian added to Bellini's *studiolo* picture are now more visible as a result of the restoration recently carried out by David Bull, to whom I owe the photograph here reproduced.

40. Lodovico Dolce, *Dialogo di M. Lodovico Dolce nel quale si ragiona della qualità e proprietà dei colori* (Venice, 1565), 51; Rearick 1976, 31.

41. Cafritz et al. 1988, 46. A pen drawing, wrongly called Saint Jerome, now in the Ian Woodner Family Collection (Cafritz et al. 1988, 65–66), was confirmed as a work of Palma il Vecchio by its juxtaposition with the Blaffer *Allegory*. Another novelty of *The Pastoral Landscape* exhibition, the *Saint John the Baptist Preaching in the Wilderness* (Piero Corsini, New York), is a rather early work by Marcello Fogolino, a charming mixture of Lorenzo Lotto and Lucas van Leyden; see Cafritz et al. 1988, 33.

42. For the *maniera* in Venice see Rodolfo Pallucchini, *Da Tiziano a El Greco: Per la storia del manierismo a Venezia, 1540–1590* (Venice, 1981), 11–68; W. R. Rearick, exhibition review, *Burlington Magazine* 123 (1981), 699–703.

43. David Rosand and Michelangelo Muraro, *Titian and the Venetian Woodcut* [exh. cat., National Gallery of Art] (Washington, 1976), 140–145. Although the old tradition of Titian's authorship of the design and Nicolò Boldrini's cutting of the block has recently been challenged, I believe that Titian assembled various pen studies—among them the *Castle* (Musée Bonnat, Bayonne), the *Tree* (private collection, Paris), and the *Eagle* (private collection, Washington, D.C.)—and at least supervised their assemblage for the cutter. The drawing for the complete composition (Musée du Louvre, Paris) is, as was first observed by Peter Dreyer, "Tizianfälschungen des sechzehnten Jahrhunderts," *Pantheon* 38 (1979), 365–375, a later, conscious fake. Boldrini, I believe, cut the block early in his career and under the direct supervision of Titian himself, capturing with remarkable elan the master's sweeping vision in the rustic ensemble.

44. The woodcut is doubtless one of those works alluded to by Vasari 1568, 5: 433, when he noted "molti paesi" by Titian. In the modern literature it is dubbed simply *La Mungiatrice*, or the *Milkmaid*, although Rosand in Cafritz et al. 1988, 67, places it squarely in the literary tradition of the *Georgics*. Rosand does not, however, attempt a direct textual comparison, perhaps because, as with the *Eclogues*, Titian did not regard his imagery as an explicit illustration of an exact passage in Virgil's text but rather chose to synthesize the various aspects of the poem into a poetic image that would be evocative rather than illustrative of its source.

45. Cafritz et al. 1988, 63.

46. In the British Museum, London. See Rosand 1976, 172–173; Cafritz et al. 1988, 70, fig. 59. For Sustris see Alessandro Ballarin, "Profilo di Lamberto d'Amsterdam (Lamberto Sustris)," *Arte Veneta* 16 (1962), 62–82; and the forthcoming study by Vincenzo Mancini.

47. Rosand 1976, 253–259.

48. W. R. Rearick, "Jacopo dal Ponte," in *Dizionario Biografico degli Italiani*, vol. 32 (Rome, 1986), 181–188.

49. W. R. Rearick, "Jacopo Bassano and Mannerism," in *Cultura e società nel rinascimento tra riforme e manierismi* (Florence, 1984), 289–311.

50. Rearick 1986, 181.

51. Vasari 1568 (1906), 4: 91.

52. W. R. Rearick, "Tiziano e Jacopo Bassano," in *Tiziano e Venezia* (Vicenza, 1980), 371–374.

53. L. P. Wilkinson, *The Georgics of Virgil: A Critical Survey* (Cambridge, 1969), 226–234. Virgil's emphasis on different methods of plowing and sowing, and his precautions against ravenous birds are particularly emphasized in Jacopo's various treatments of this theme.

DAVID ROSAND
Columbia University

Pastoral Topoi: On the Construction of Meaning in Landscape

Perhaps few themes in the history of Western art are as seductive as pastoral landscape. As a genre, landscape itself extends an overt invitation to the viewer to suspend disbelief and enter a notional world on the other side of the picture plane. When modified as "pastoral," landscape seems to make that invitation all the more compelling. A landscape so identified or recognized adds to its natural setting particular social and cultural values, a temporal dimension that puts its image beyond immediate reach, makes it available only to the imagination. And through that distance such a landscape acquires a poetry of nostalgia for the unrecoverable. Pastoral becomes generally equated with the Edenic, with a lost world of natural innocence. More specifically, the literary formulation of pastoral values has so penetrated Western culture as to invite the immediate evocation of poetry, of particular poetic voices, when viewing a painted landscape. Theocritus, Virgil, Sannazaro, and their lyric heirs have taught us to respond to such imagery and have given us the vocabulary with which to articulate that response.

In front of pastoral images we willingly participate in fictions that, despite their obvious conventionality, satisfy longings apparently natural to the human condition, however much defined by artifice both literary and pictorial. Willingly we ignore the art, make it transparent. Anxious to partake of an artificial nature invested with deep cultural value, we proceed right through the picture plane; we look longingly beyond the surface of the painting, drawing, or print. Focusing on thematic iconography, we readily surrender to the invitation of the images; projecting ourselves beyond those framed and matted surfaces into the subject matter, we willingly enter the imagined landscapes of a fictive Arcadia.

Now, projection of this sort is hardly inappropriate. The pastoral tradition itself is made of such fictions and operates through such seduction. Its very point is to offer a world that is not quite our own, a natural world that is not, an artificial construct that seems all nature. Very much a product of the fervid imagination, the pastoral landscape satisfies imagination's desires. But in yielding so readily to this artful nature, we may miss the very art of it. In suspending disbelief, we may put our critical faculties on hold; in so willingly projecting our own imaginations, we may fail to perceive the mechanics of imagining—that is, the art.[1]

In revisiting *The Pastoral Landscape* exhibition, I propose to focus on that art, on the ways in which what we may call "pastoral occasions" permit the construction of meaning in landscape. I am concerned with the degree to which pictorial representation, however ultimately based upon literary conception and inspiration, acquires its

1. Giorgione (?), *The Adoration of the Shepherds*, c. 1505/1510, oil on wood

National Gallery of Art, Washington, Samuel H. Kress Collection

own expressive momentum. Certain structures that we may recognize as pastoral invest painted landscape with particular meaning; having become part of the painter's vocabulary, they enable his own, essentially pictorial articulation and manipulation of pastoral significance. I shall argue for a meaning that is carried by visual structures and itself becomes inherently visual, operating within its own, pictorial conventions of pastoral.

But what, exactly, do we mean when we call a landscape "pastoral"? In the first instance, "of or pertaining to shepherds," to quote Webster's, hence, "relating to rural life or scenes." Not particularly discriminating, perhaps, but a beginning. Thematically, literary convention dictates a world of leisure (*otium*), a natural world beyond the socio-economic cares of the city (*negotium*): strictly speaking, there should be no real work, no physical exertion in the pastoral.

Of course, the world of the eclogue, especially Virgil's, is hardly so simple. Modern criticism—from William Empson to Raymond Williams—has succeeded in undermining such comfortable definitions, analyzing the social and ethical complexities and contradictions hidden behind such categories and extending the problem well beyond the classical tradition.[2] My own immediate concern, however, is not so much definitional as operational, less generic than modal. I am here interested less in the broader social implications of the notion of pastoral than in particular developments in landscape painting that, it seems to me, are essential to the investiture of meaning in such art. Conventions of representation, of spatial organization and pictorial construction, that were founded in a perception of the world dependent upon the poetic imagination, I shall argue, conditioned the possibilities of meaning in landscape.

The evidence of *The Pastoral Landscape*

exhibition suggested—as it was intended to—that the term "pastoral" itself is best reserved in the pictorial arts for certain kinds of compositional structures. The pastoral landscape tends to be more intimate than panoramic, to feature certain places within its domain as the immediate setting or backdrop to the figures—for those it must have; these places are usually marked by a dominant tree or grove, and a stream is likely to run through the gentle hills. These are essential components of the *locus amoenus*, the setting for pastoral inaction. In the distance the buildings of a town or village serve as foil to the natural locale, defining its quality of escape, confirming its difference. These, of course, are

2. Detail of fig. 1

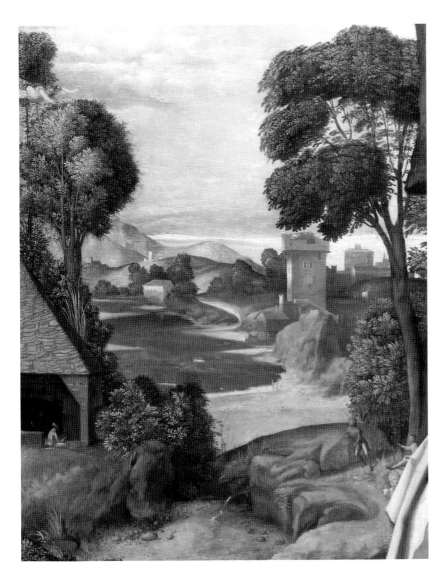

rather general characteristics of the pastoral landscape—not too wild, not too distant, a natural world within reach—and their very generality suggests the obstacles to any search for greater generic precision.

In the exhibition—especially the first part, at the National Gallery of Art, devoted to "The Legacy of Venice"—and in the accompanying book, we were concerned to differentiate within this broad generic typology certain subcategories that, we thought, articulated the expressive possibilities of the pastoral and its extended inflections: the pastoral concert, the courtly pastoral, the pastoral epyllion, the religious pastoral, the georgic or hard pastoral (accommodating work), and the satyric landscape.[3] Offering a critically useful taxonomy, if not an absolute guide, such thematic distinctions correspond to what we may term pastoral occasions. These are the situations that call into being a painting dominated by landscape and, inflecting that landscape, infuse it with particular possibilities of meaning. Manifesting the mechanics of meaning in landscape, they afford a way both of interpreting landscape imagery and, more interesting still, of comprehending the conception of such imagery, its making—that is, its art.

To exemplify the problem of the hermeneutics of landscape, I will focus on works by two artists operating within the tradition that they so powerfully determine: Titian and Rembrandt. Each offers the opportunity to consider the ways in which pastoral conventions, narrative occasions, and structural *topoi* carry the possibilities of meaning, establishing the basis for pictorial thinking in landscape.

I

The first case involves religious pastoral. This modal variant comprehends several thematic motifs: the saint in the landscape, for prime example, an analogue to the shepherd in his pleasant place—the figure isolated within the larger landscape setting by a special closure, by a cave or cliff if not a grove. In defining this category, we could cite Saint Jerome's own letters, positive as well as negative, in favor of such isolation.[4]

Another occasion for religious pastoral, pertaining more directly to shepherds, is the story of the Nativity, especially as narrated in the Gospel of Luke (2:8–20). With its emphasis on humility it is there cast in essentially pastoral terms. The heavenly announcement of the birth of the Child in a manger, "good tidings of great joy," is made first to shepherds "abiding in the field, keeping watch over their flock by night."

Perhaps nowhere does the pastoral imagination appropriate the Christian story as deliberately and as profoundly as in Jacopo Sannazaro's long Latin poem on the virgin birth, *De Partu Virginis* (1526). Inspired by Virgil, Sannazaro explicitly renews the pastoral character of the Nativity when he christens the blessed shepherds Lycidas and Aegon, names taken straight from the eclogues. And the song given to them in praise of the Child actually paraphrases Virgil's fourth eclogue. Translating the values of the classical pastoral to a new realm and era, the pagan shepherds in

attendance upon the Child bear special and poignant witness to the fulfillment of the prophecy. The poetic conventions of the pastoral tradition prove remarkably adaptable, accommodating new expressive needs and giving voice to new values.[5]

Pictorially the pastoral implications of the situation are more fully realized when, following Byzantine tradition, the Nativity takes place in a cave rather than in a manger, that is, in a landscape proper. In the National Gallery of Art's own *Adoration of the Shepherds* (fig. 1)—a painting now generally attributed to Giorgione but which Berenson (and others) thought to be by the young Titian[6]—the rustics adore the Child in the foreground. Behind, another pair of shepherds, resting in the shade of a large tree before a grove, receives the heavenly announcement from an angel entering from the upper left corner of the composition (fig. 2): "And, lo, the angel of the Lord came upon them, and the glory of the Lord shone round them." The annunciation to the shepherds traditionally animated the

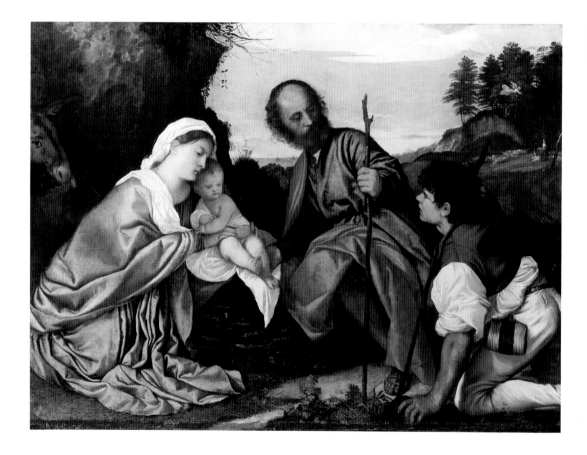

3. Titian, *The Holy Family and a Shepherd*, c. 1510, oil on canvas
National Gallery, London

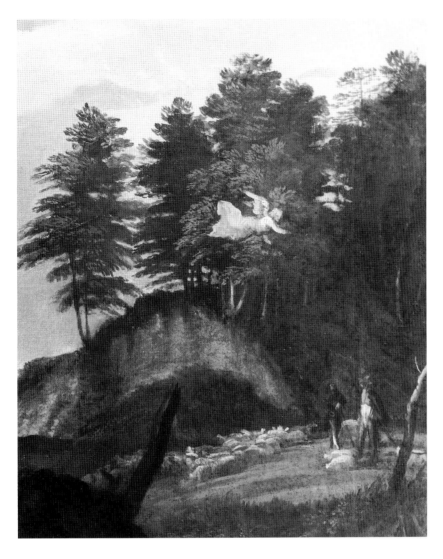

4. Detail of fig. 3

(fig. 5), the landscape setting, especially the sky, is fully animated.[8] To the herdsmen in the middle distance an angel appears with the "good tidings," and their gestures in turn acknowledge the angelic salutation (fig. 6). It is the presence of the angel, essential protagonist of the narrative of the pastoral annunciation, that so clearly transforms sky into heaven: through that angelic presence the natural becomes divine. Such transformation, however, only confirms the celestial source of heavenly grace: a shower of divine radiance, immediately behind her head, sanctifies the Virgin; and the Child's gesture, answering that luminous descent, confirms that selection of his mother.[9] Although we have passed beyond the modesty of pastoral to a higher meaning in the landscape, the very interpretability of the landscape itself is here initiated by the significant motif of the shepherds, a pastoral motif in the most literal sense. Their relationship to the natural—or, rather, celestial—ambience is what specifically opens the landscape to interpretation.

We can test this reading by following Titian's own variation on the theme in another version of the composition, recently acquired by the Kimbell Art Museum in Fort Worth (fig. 7).[10] Our interest is less immediately with the major changes in the foreground group—of the Madonna and Child, Saint Catherine(?), and the young John the Baptist—than with those in the containing landscape. It was typical practice in Titian's workshop to produce such variations on a popular theme.[11] Sometimes the work of replication was left to studio assistants. In this case, however, it seems clear from the intelligence and consistency of the changes that the master himself was deliberately exploring the possibilities of variation and its consequences.[12] The major change, in our context, involved the elimination of the announcing angel; formally its visual weight is replaced by the added tree. The leading shepherd remains, however, his gesture of acknowledgment now vestigial (fig. 8).

The fuller consequence of the elimination of the angel involves the heavens themselves. No longer is natural sky made

background landscape and sky of Nativity representations in the early Renaissance, but here the grouping creates a motif of pure pastoral ease.

It is not surprising, then, to discover the annunciation to the shepherds occurring frequently in the background of Venetian pictures of the Virgin and Child in a landscape—itself a pastoral occasion, like the Rest on the Flight into Egypt: with figures, isolated and protected, in repose in a landscape (figs. 3, 4).[7] On the theological level, of course, it functions as a narrative prolepsis, temporalizing the central icon by evoking the historical moment of the Nativity.

In Titian's *Madonna and Child with the Young Saint John the Baptist and Saint Catherine of Alexandria in a Landscape*

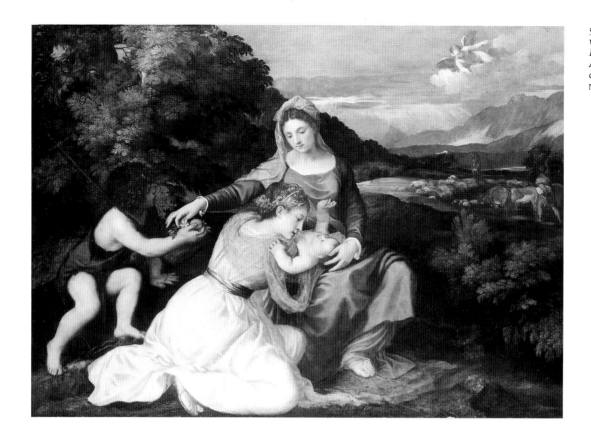

5. Titian, *Madonna and Child with the Young Saint John the Baptist and Saint Catherine of Alexandria in a Landscape*, c. 1530, oil on canvas
National Gallery, London

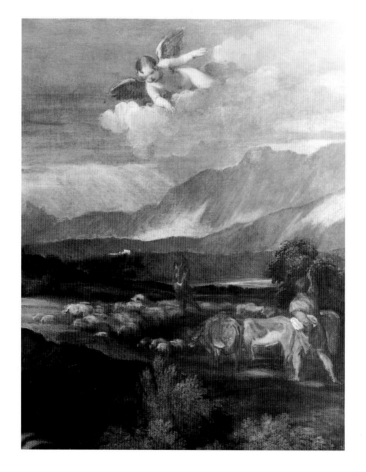

6. Detail of fig. 5

7. Titian, *Madonna and Child with Saint Catherine(?) and the Young Saint John the Baptist in a Landscape*, c. 1535, oil on wood
Kimbell Art Museum, Fort Worth

8. Detail of fig. 7

divine by the angelic presence. And Titian evidently responded, pictorially, to the new situation. In the London canvas (fig. 5) the sky is rendered with expensive ultramarine blue; its brightness (however much exaggerated through aggressive cleaning) declares the richness of that celestial setting, the source of heavenly light. In the Fort Worth panel that setting has been, as it were, desanctified. Through the loss of the signaling angel and the elimination of the rain of grace above the Virgin, it has lost its holy status. Consonant with this change, the Christ Child has lowered his upraised arm: now turning to the adoring female saint, he no longer participates in that divine axis initiated by the celestial light above; he no longer acknowledges that source of heavenly grace or its special object, his mother.

The celestial radiance and the Child's gesture effectively render the London picture a celebration of the Virgin, and the annunciation to the shepherds, by its own allusion to the Nativity, confirms Mary's special role in the scheme of salvation. In the Fort Worth version the focus has shifted more directly to Christ himself. And the infant Saint John, no longer attendant primarily upon the Virgin, plays his prophetic role more directly and earnestly: he no longer casually carries the light cross that is his attribute as prophet of the Passion of Christ but instead brings to the Lamb of God the dread gift of the sacrificial lamb.

The exchange of the gift of a lamb or a kid was well established in the social economy of pastoral poetry, and such an offering readily lent itself to the special relationship of John to his younger cousin.[13] In Titian's painting, however, this pastoral gesture of gift-giving acquires new affect through the somber aspect of the little Baptist's face, revealing his awareness of the significance of the gift, sign of the sacrifice to come. As an ornithological footnote, beautifully painted, Titian balances the lamb with a finch, whose association with brambles and thorns, as well as the red spot in its plumage, made it a most efficient symbol of the Passion (fig. 9).[14]

But the most significant change in mood occurs in the sky, deprived, as we have

9. Detail of fig. 7

noted, of its divinity. Instead of the lapis lazuli brilliance of ultramarine blue, Titian uses a more common azurite in the Fort Worth panel.[15] In place of the celestial celebration of the London picture, "the glory of the Lord [that] shone round them," he has painted a heavier gloom. The sky assumes a different role: no longer celebratory, it is weighted with new narrative significance. In a state of flux, its darkening clouds anticipate the time of the sacrifice of the Lamb of God: "Now from the sixth hour there was darkness over all the land unto the ninth hour." In place of the joyous heavenly glory of Luke we find the ominous meteorology of Matthew (27:45).[16]

Titian's art of theme and variation, when practiced by the master himself, in-

volves an exploration of pictorial possibilities, and the search for formal alternatives is inextricably bound up with an awareness of inflected meaning. In the transformation of the London *Madonna and Child with Saints* into the version in Fort Worth, into an image more dramatically charged, landscape plays a crucial role. Landscape could become the thematic base for major variations within the compositional structure precisely because its potential had been so clearly established in Titian's original conception, initially articulated through the pastoral situation of the annunciation to the shepherds with its corollary sanctification of the heavens. What pastoral thinking offered was a way of discovering and articulating meaning in landscape.

2

The second example of the problem of the hermeneutics of landscape involves two aspects of the pastoral pictorial tradition. First, a particular articulation of the *locus amoenus*, namely the grove, which enables a syntax of landscape construction; second, the essentially graphic nature of the transmission of pastoral structures, a fundamental axiom of the thesis of *The Pastoral Landscape* exhibition.

Essential to the pastoral landscape, at least on the basic operational level of our working definition, is that "pleasant place" set off from a harsher world, away from urban cares, comfortably enshadowed, protected from the glare and heat of the noonday sun, a place of ease. Within the pictorial requirements of landscape imagery, that place is most effectively and appropriately marked by a stand of trees, the thick grove that affords relief from the sun, marking a special spot in the larger terrain.[17] It is not surprising, then, that the grove itself emerges as an independent motif, a topic of special study by Venetian artists in the early sixteenth century—at times as eloquent as the human figure.[18] It is a topic they hand on to subsequent generations of artists.

At the beginning of the tradition stands the shadowy figure of Giorgione, whose achievement in creating a landscape of secular poetry receives its important confirm-

ation in the more securely attributable work of Giulio Campagnola and, of course, Titian. This is a tradition disseminated especially by graphic means: the engravings of Giulio, the woodcut designs of Titian and Domenico Campagnola. And the drawings of these masters carry the inventions of the Venetians directly into the studios of later artists.

The tradition culminates in Watteau's graphic activity as Venetian disciple, assiduously copying and varying the many drawings by Titian or Domenico Campagnola to be found in eighteenth-century Paris in the great collection of Pierre Crozat. P. J. Mariette attests that Watteau copied them all, and the Comte de Caylus adds that "Watteau was charmed by the fine inventions, the exquisite landscape backgrounds, the foliage, revealing so much taste and understanding, of Titian and Campagnola, whose secrets he was able to explore in these drawings."[19]

What we find, then, is a basically academic situation: the landscape drawings and prints by the Venetian masters of the sixteenth century had become, in effect, an academy for later artists. From these models one learned to draw the essential elements of landscape—trees, trunks, branches, and especially foliage. The particular graphic patterns devised by the early Venetians—who themselves had learned much from the prints of Dürer—were to serve as the elemental units of a landscape alphabet. Their drawings and the prints that reproduced their designs became the primers, the model books for eager students—even advanced students like Watteau, who translated the penmanship of these graphic exempla into the softer lines of red chalk, making them very much his own.

The didactic role of Venetian graphics had become well established by the end of the sixteenth century. In Bologna the Carracci mastered the lessons to great effect; for them the Venetians set up the kind of exercise in landscape that would serve to loosen the draftsman's hand and his graphic imagination. By 1604, in the syllabus of *Het Schilderboeck*, the Dutch Carel van Mander explicitly recommends woodcuts by Titian as landscape models;

10. Rembrandt van Rijn over Domenico Campagnola(?), *Landscape with Houses and a Watermill by a Stream*, c. 1652–1654, pen and brown ink, white body color, on brown paper
Szépmüvészeti Muzeum, Budapest

11. Rembrandt van Rijn, *Saint Jerome Reading in an Italian Landscape*, c. 1653–1654, etching, drypoint, and burin
Pierpont Morgan Library, New York

they can, he writes, "instruct us in this matter."[20] Such prints recorded those graphic patterns, the looping calligraphic marks and undulating parallel lines, that signified foliage or bark, cloud or embankment. From such models one learned to draw.

The inventory of Rembrandt's possessions prepared in 1656 included "one very large book," item 216, "with almost all the work of Titian"—that is, we may assume, the Venetian's woodcut designs and engravings after his compositions.[21] The most intriguing, as well as most immediate document of Rembrandt's close attention to the Venetian graphic tradition is the complex drawing in Budapest that once belonged to the Dutch master himself (fig. 10).[22] Representing a hilly landscape with houses and a watermill by a stream, the basic drawing has been tentatively attributed to Domenico Campagnola. Its distinctively Venetian graphic structures, however, have been subjected to Rembrandt's own corrective will: over the regular network of curved hatching and crosshatching and relatively delicate foliate markings, a more vigorous pen has imposed a new strength; its bolder and more muscular linework has infused the original modest landscape with unsuspected en-

ergy. In general, we know Rembrandt's direct graphic intervention on the drawings of his own students, and his lesson on the Budapest sheet may well have been intended as such a studio demonstration.[23] Here, however, the master's criticism reaches back to a much earlier exercise. By its very active engagement with a representative example of the Venetian tradition, Rembrandt's editorial intervention confirms the continuing validity of that tradition; this drawing offers full testimony to the pedagogic function of Venetian landscape graphics.

Still more eloquent testimony is to be found in Rembrandt's own work. On the purely technical level of graphic representation, especially in drawing, his recognition and exploitation of the weighted value of the pen stroke, of its independence as a mark, relate to the aesthetic economy of Venetian landscape penmanship, further crystallized in the graphic structures of the woodcut. Considering this relationship, and particularly its dynamic manifestation in the Budapest sheet, Kenneth Clark suggested that we can "begin to understand why Rembrandt, with his unequalled gifts of direct notation, yet felt the need to master a way of rendering landscape by which the terrain was modeled more firmly and the eye was concentrated on a single unit of trees and buildings. This lesson," Clark continues, Rembrandt "then applied to his own observations, giving them a more poetic and, so to say, ideal character, but very seldom betraying by an obvious reference how much Venetian *poesie* had influenced his style."[24]

Within Rembrandt's graphic work the Venetian affinity is clearest in two types of image: the saint in a landscape and the landscape with cottage. And these return us to that aspect of the pastoral we may call its articulating function. Although they are iconographically distinct, the two themes are structurally related, and that relationship confirms their essentially pastoral character. In each, a space is marked out, privileged, within the larger expanse of landscape. Saint Jerome reading (fig. 11) or Saint Francis praying (fig. 12) finds his

12. Rembrandt van Rijn, *Saint Francis beneath a Tree, Praying*, 1657, drypoint, etching, and burin
Allen Memorial Art Museum, Oberlin College

13. Titian(?), *Landscape with Buildings and Lovers Embracing*, c. 1515, pen and brown ink
Trustees of the Chatsworth Settlement, Derbyshire. Photograph: Courtauld Institute of Art

14. Rembrandt van Rijn(?), *Landscape with Buildings and Lovers Embracing*, c. 1650–1655, pen and brown ink over slight indications in red chalk
Trustees of the Chatsworth Settlement, Derbyshire. Photograph: Courtauld Institute of Art

special place in the landscape, protected from the sun by the shade of a grove or before some hollow in which he has set up his "oratory," as Jerome himself refers to his place of penitence in nature.[25] Protestant Holland is not likely to have inspired the hagiography of these subjects. Rather, Rembrandt took his inspiration from the example of older graphic models—like Titian's woodcut, which was certainly to be found among the contents of item 216 of the inventory of 1656.[26] In such models Rembrandt found epitomized a basic pictorial structure, the kind of pastoral occasion that sets the human figure in intimate rapport with the landscape. We may well appreciate these feeling images as the natural expression of the humanity of Rembrandt's art, but we will miss their fuller significance if we overlook their position in the tradition of the pastoral. Whatever the motivation for his search for meaning in the natural world, Rembrandt discovered the means of articulating it through the pastoral structures he inherited—and, of course, made his own.

As we have already seen, the Dutch master knew Venetian drawings first hand. In the Devonshire collection at Chatsworth are two small drawings, nearly identical in composition, representing a landscape with buildings and, in the left foreground, a pair of lovers embracing in the shadow of a tree (figs. 13, 14). Both had been attributed to Titian until James Byam Shaw suggested that one was actually a copy after the Venetian by none other than Rembrandt.[27] Here we confront just the kind of exercise that was to contribute so much to the education of Watteau. The copyist responds to the basic graphic structures of the Venetian's vigorous penmanship, in which he finds anticipated his own instincts as a draftsman. Rembrandt (assuming that he is indeed the copyist) is attentive to the shorthand notation for foliage, the undulations that define topography, the dragged lines that create shadow under the eaves of a roof or under a crown of foliage—systems of representation in which the individual stroke of the pen retains its distinctive identity, the mark its independence. The disciple, in other words, responds to the art of the drawing.

But the thematic content of the design is equally relevant. Like the graphic style, it relates directly to Rembrandt's own interests, interests we might fairly call pastoral. I refer to the amorous couple not quite lost in the shadows—a motif Rembrandt had included in many of his own compositions, as in the grand etching known as the *Three Trees*. Even more significant than the lovers, per se, is their situation: in the shade of a tree—a quintessentially pastoral topos. By marking out a spot within the landscape, a *locus amoenus* no matter how modest, it articulates the larger landscape, makes it accessible to sentiment. It is, in fact, through his own very special development of this topos that Rembrandt adds significant new possibilities to the pastoral tradition and to our understanding of it.

In the 1640s and 1650s Rembrandt dedicated much energy to graphic landscapes, in both drawing and printmaking. One motif in particular emerged as a dominant concern in this imagery, the peasant cottage (fig. 15). Hardly Rembrandt's invention, the thatched-roof hut boasts a long pedigree in preceding Netherlandish art—for example, in the work of Jacques de Gheyn II or of Hendrik Goltzius.[28] It can be traced back into Italy, especially in the work of Giulio and Domenico Campagnola, and, eventually, to one particularly influential German source, the prints of Dürer. Among the recommendations offered by van Mander was that the artist introduce into his landscapes "strange and quaint shepherds' huts or farm hamlets in caves or hollow trees."[29] It was, in every sense, a commonplace.

What Rembrandt did was liberate the motif itself. Partly by reducing the presence of the human figure he allowed the cottage to emerge as the real protagonist of his designs, the expressive and dramatic focus. And in granting it that pictorial independence, he invested it with new affective potential. Initially these quaint structures offered him picturesque models for graphic exploitation, textured surfaces demanding and inspiring free but controlled patterns of scribbling and hatching. But in the course of such exploitation he seems to have developed a rather special sense of these structures, which become increas-

ingly sentient in his renderings. Isolating, exposing them, he in turn provides them with shelter, with ambient protection, by setting them under the shade of overarching foliage—that is, within a grove (fig. 16). Nestled within accommodating shadow, beneficiary of Rembrandt's drypoint burr, the cottage itself becomes a pastoral occasion; it enjoys a relationship to its immediate surroundings not unlike that of the saint in the landscape, set off from a larger world, protected—at once the inhabitant of and location of a Batavian *locus amoenus*.[30]

Beyond those of his predecessors, Rembrandt's privileged cottages acquire a sensibility and affect, a humanity. That we so readily accord them life and feeling is owing, in large measure, to their situation: protected, they are by implication vulnerable. The very physicality of the cottage's relationship to the ambient shadow, to the trees that set it off and give it shelter, assumes an intimacy whose resonance is positively emotional. I am not suggesting that Rembrandt consciously intended to extend what we now recognize as a pastoral pictorial tradition—although behind his intense commitment to the subject of the protected cottage there may well be deeper personal motivations to explore. I do think, however, that his ability to conceive such images depended upon his sustained professional experience of that tradition, that the situation he creates—the protected object in a landscape—depends upon the kind of visual structure we have identified as pastoral.

But now this structure, only distantly dependent on literary association, is essentially pictorial. Having, in the course of its Renaissance development, acquired a resonance from that association with the terms and values of pastoral poetry, it has, as it were, gained its own momentum; it has become a part of the basic vocabulary taught to artists, a fundamental element in the construction of more complex pictorial statements. This is its articulating function. However dependent on the aura of its literary origins, its appeal is neither symbolic nor allegorical, not metaphorical but rather directly affective. Operating on a fundamentally mimetic level, a Rembrandt cottage, in effect, reinvokes the essential aspects of the pastoral tradition, inviting the viewer to project self into landscape, thereby to rediscover the situation of the *locus amoenus*. Such a structure—like the "sacred nodes" of ancient Roman mural painting—through its own, visual independence, enables meaning in the landscape.

15. Rembrandt van Rijn,
A Cottage among Trees,
c. 1650, pen and brown ink
and brown wash
Metropolitan Museum of Art,
New York

16. Rembrandt van Rijn,
*Landscape with Three Gabled
Cottages beside a Road*, 1650,
etching and drypoint
Yale University Art Gallery, New
Haven, Fritz Achelis Memorial
Collection

NOTES

1. This was certainly the problem with the critical reception accorded the exhibition *The Pastoral Landscape* in the national press. The reviewers plunged enthusiastically into the fictions of the imagery, abandoning critical responsibility to indulgence. The headline over John Russell's Sunday piece in the *New York Times* (13 November 1988, section 2, 35) celebrated "Centuries of Blue Skies O'er a 'Pastoral Landscape'"—the orthographic archaism was evidently thought appropriate. In *Time* magazine, 5 December 1988, 101, the headline to Robert Hughes' review was distinctly more mod than that of the quaintly literate *Times*: it boldly hawked Renaissance Arcadia as "The Club Med of the Humanists." The notion of pastoral has clearly lost none of its allure in our industrial century.

2. See, in particular, William Empson, *Some Versions of Pastoral: A Study of the Pastoral Form in Literature* (London, 1950); Raymond Williams, *The Country and the City* (New York, 1973). More recent consideration of the historical and ethical complexities of pastoral thought: Andrew V. Ettin, *Literature and the Pastoral* (New Haven and London, 1984); Annabel Patterson, "Pastoral versus Georgic: The Politics of Virgilian Quotation," in *Renaissance Genres: Essays on Theory, History, and Interpretation*, ed. Barbara Kiefer Lewalski (Cambridge, Mass., and London, 1986), 241-267. On the classical tradition itself, see especially Thomas G. Rosenmeyer, *The Green Cabinet: Theocritus and the European Pastoral Lyric* (Berkeley, Los Angeles, and London, 1969); Paul Alpers, *The Singer of the Eclogues: A Study of Virgilian Pastoral* (Berkeley, Los Angeles, and London, 1979); Ernst Robert Curtius, *European Literature and the Latin Middle Ages*, trans. Willard R. Trask (New York, 1953), chap. 10, "The Ideal Landscape."

3. See David Rosand, "Giorgione, Venice, and the Pastoral Vision," in Robert C. Cafritz, Lawrence Gowing, and David Rosand, *Places of Delight: The Pastoral Landscape* [exh. cat., Phillips Collection and National Gallery of Art] (Washington, 1988), 21-81.

4. Saint Jerome, Letters 22, 43; cited in Cafritz et al. 1988, 65-66.

5. On Sannazaro's *De Partu Virginis* see William J. Kennedy, *Jacopo Sannazaro and the Uses of Pastoral* (Hanover, N.H., and London, 1983), 180-224.

6. For a review of opinions see Terisio Pignatti, *Giorgione*, 2d rev. ed. (Milan, 1978), 102; Fern Rusk Shapley, *National Gallery of Art: Catalogue of the Italian Paintings*, 2 vols. (Washington, 1979), 2:208-211.

7. In the London *Holy Family and a Shepherd* the worshipful approach of the young shepherd confirms the picture's conceptual base in the theme of the Adoration of the Shepherds. On the painting itself see Cecil Gould, *National Gallery: The Sixteenth-Century Italian Schools* (London, 1975), 267-268; also Harold E. Wethey, *The Paintings of Titian, I. The Religious Paintings* (London, 1969), no. 43.

8. Gould 1975, 278-280; Wethey 1969, no. 59.

9. Further on Titian's light as form and symbol see David Rosand, *Painting in Cinquecento Venice: Titian, Veronese, Tintoretto*, 2d ed. (New Haven and London, 1985), 69-75, on symbolic landscapes and the Virgin Mary, 107-111.

10. The painting was published by Keith Christiansen, "Titianus (Per)fecit," *Apollo* 125 (March 1987), 190-196.

11. The popularity of the basic invention is attested by the numerous variants and copies, listed by Wethey 1969, 105, to which might be added, just for the record, yet another, a copy of the variant at Hampton Court, itself already a pastiche: see Giuliana Ericani, "L'arredo della villa: scultore, affreschi e dipinti," in *Villa Pindemonte a Isola della Scala* (Cerea, 1987), 173, 175, n. 44.

12. Moreover, the fact that the Fort Worth picture is on wood panel, suggesting a deliberately commissioned work, argues against its being a mere studio variant.

13. As in the National Gallery's little picture, *Madonna and Child and the Infant Saint John in a Landscape*, attributed to Polidoro Lanzani; Rosand in Cafritz et al. 1988, 62-63, fig. 44. On the attribution of this picture, once optimistically assigned to Titian himself, see Shapley 1979, 1:249-250.

14. On the symbolism of this bird see Herbert Friedmann, *The Symbolic Goldfinch: Its History and Significance in European Devotional Art* (Washington, D.C., 1946), 7-35.

15. I would like to thank John Brealey of the Metropolitan Museum of Art, who supervised the cleaning and restoration of the painting, for discussing its materials and technique with me.

16. In view of this transformation of the sky into a sign of the Passion, the tree that now rises so willfully against that ground might be read as symbolic of the Cross, as suggested during discussion at The Pastoral Landscape symposium. Although its prominent placement—substituting, we recall, for the eliminated angel—suggests a certain weighting, I am not persuaded that such symbolic algebra necessarily informs Titian's landscape here. Such an equation is functionally different from the natural affect of the dramatic darkness of the heavens.

17. Isolated in descriptions of landscape imagery from Vitruvius to Alberti, the grove was one of the standard articulating units in the landscape painting of Roman antiquity, a clear sign of the "idyllic." On the vocabulary of such modal signs see the paper by Bettina Bergmann in this volume.

18. For illustrations and further references see Rosand in Cafritz et al. 1988.

19. Quoted by Robert C. Cafritz, "Rococo Restoration of the Venetian Landscape and Watteau's Creation of the Fête Galante," in Cafritz et al. 1988, 151, 153.

20. Chapter 8 of "Den Grondt der Edel Vry Schilderconst," the theoretical treatise in verse of Carel van

Mander, *Het Schilderboeck* (Haarlem, 1604), is devoted to landscape. An English translation will be found in Christopher Brown, *Dutch Landscape: The Early Years, Haarlem and Amsterdam 1590–1650* [exh. cat., National Gallery] (London, 1986), 35–43; the phrase quoted is on 39.

21. Walter L. Strauss and Marjon van der Meulen, *The Rembrandt Documents* (New York, 1979), 371.

22. See Robert C. Cafritz, "Reverberations of Venetian Graphics in Rembrandt's Pastoral Landscapes," in Cafritz et al. 1988, 131–147.

23. See Peter Schatborn, *Bij Rembrandt in de Leer/ Rembrandt as Teacher* [exh. cat., Museum het Rembrandthuis] (Amsterdam, 1985).

24. Kenneth Clark, *Rembrandt and the Italian Renaissance* (New York, 1966), 111–112.

25. On the narrower meaning of the motif—potentially contained, I would argue, by its larger pastoral elaboration—see Susan Donahue Kuretsky, "Rembrandt's Tree Stump: An Iconographic Attribute of St. Jerome," *Art Bulletin* 56 (1974), 571–580.

26. For Titian's woodcut see David Rosand and Michelangelo Muraro, *Titian and the Venetian Woodcut* [exh. cat., National Gallery of Art] (Washington, 1976), no. 22.

27. James Byam Shaw, "Titian's Drawings: A Summing-up," *Apollo* 112 (December 1980), 390. More recently both drawings have been given to Titian himself by Harold E. Wethey, *Titian and His Drawings* (Princeton, 1987), 44–45, nos. 34, 34a, who also lists three further versions of the design, illustrating two.

28. See Peter Schatborn, *Landscapes by Rembrandt and His Precursors* [exh. cat., Museum het Rembrandthuis] (Amsterdam, 1983), and, most recently, Walter S. Gibson, "'Pleasant Places': Some Dutch Landscape Drawings in the Cleveland Museum of Art and Their Antecedents," *Drawing* 12 (July–August 1990), 25–29. For the archaeology of the motif see Boudewijn Bakker, "Langhuis and Stolp: Rembrandt's Farm Drawings and Prints," in Cynthia P. Schneider et al., *Rembrandt's Landscapes: Drawings and Prints* [exh. cat., National Gallery of Art] (Washington, 1990), 33–59.

29. Van Mander 1604, chap. 8, 31; translation in exh. cat. London 1986, 40. On the dialectic between natural observation and imaginative invention see David Freedberg, *Dutch Landscape Prints* (London, 1980).

30. The relationship of Rembrandt's graphic landscape imagery to literary convention and sensibility has been briefly considered by Eleanor A. Saunders, "Rembrandt and the Pastoral of the Self," in *Essays in Northern European Art Presented to Egbert Haverkamp-Begemann* (Doornspijk, 1983), 222–227, and more pointedly by David Freedberg in a lecture delivered at the Museum of Fine Arts, Boston, in March 1988: "The Landscapes of Rembrandt and Constantijn Huygens: 'Eenen Lust om te sien.'" For more general consideration of the theme, but with little attention to landscape, see Alison Kettering, *The Dutch Arcadia: Pastoral Art and Its Audience in the Golden Age* (Totowa and Montclair, N.J., 1983).

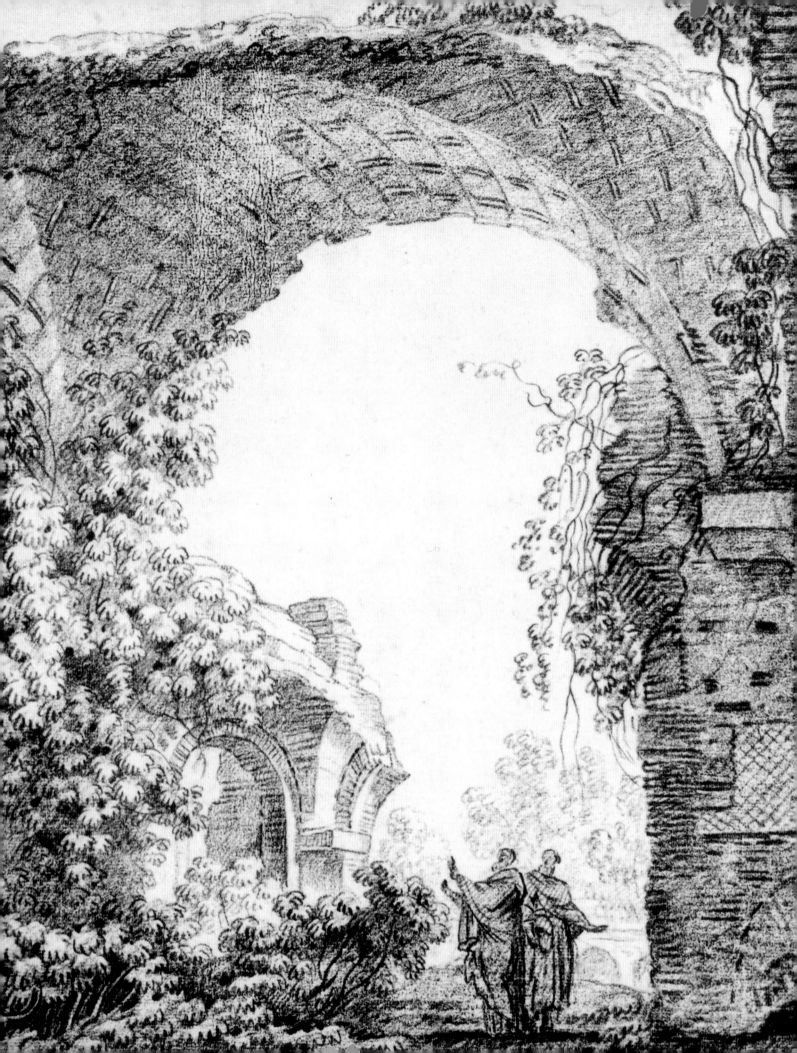

JOHN PINTO
Princeton University

Pastoral Landscape and Antiquity: Hadrian's Villa

P oetic and visual expressions of the pastoral most commonly include certain essential elements: verdant fields evoking a *locus amoenus*, populated by placid sheep and carefree shepherds. But in addition to the natural components of the pastoral, architectural forms often appear to telling effect. The shrines that animate so many sacral-idyllic landscape compositions provide ample evidence that in antiquity architecture already played a prominent role in visual expressions of the pastoral.[1] Renaissance artists such as Giorgione and Giulio Campagnola included architecture as a passing reference to a more complex and demanding world, the familiar reality of which is in fundamental contradiction to the pastoral.

Some of the greatest landscape painters of the classical tradition introduced architectural ruins into their compositions, none more hauntingly than Claude Lorrain. Claude's *Landscape with Nymph and Satyr Dancing* offers a distillation of his beloved *campagna*, replete with wandering goats, a Roman bridge and temple, and distant vistas extending to the horizon (fig. 1). Here we have nature in its most pleasant guise, peopled by figures whose lives retain simplicity of occupation and material possessions, but with evidence of previous hu-

man presence in the natural scene. The composition goes beyond the mere representation of natural forms, for on them the weight of human history and tradition has been subtly imposed, producing a highly allusive landscape.

The introduction of architecture, or—perhaps more appropriately—the ghosts of architecture, adds a dimension that makes explicit some of the contradictions within the pastoral tradition. Much of what the pastoral stands for becomes obvious through contrast: the simplicity and beauty of a life in nature always imply the complication and harassment inherent in the life of the city, among human affairs. The growth and promise of new life evoked in the greenery of the fields must simultaneously prompt thoughts of mortality and decay as nature follows its inevitable cycle. Ruins or other evidence of past human glory emerge as a logical visual foil to the present perfections of the pastoral scene.

A well-known variation on this pastoral theme, Nicolas Poussin's *Arcadian Shepherds*, intensifies the contrast between the life of pastoral ease and the natural processes of decay and mortality (fig. 2).[2] In the Musée du Louvre version of the work, four Arcadian shepherds have happened on a sepulchral monument and are absorbed in the contemplation of the idea of mortality. They are not terrified or dismayed by this unexpected discovery: rather they

*For James S. Ackerman
on his seventieth birthday*

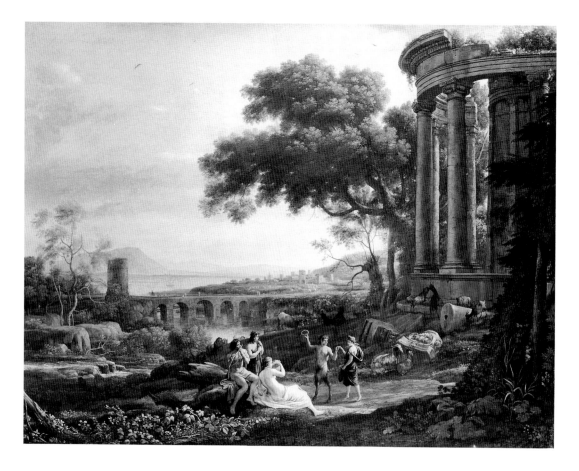

1. Claude Lorrain, *Landscape with Nymph and Satyr Dancing*, 1641, oil on canvas
Toledo Museum of Art, Gift of Edward Drummond Libbey

discuss it calmly among themselves, the tomb and their melancholy attitudes setting the mood. "Even in Arcady," that mythical realm of happiness and perfection, "I, Death, hold sway."

The intrusion of mortality into Arcadia, of course, is evident in Virgil's *Eclogues*, and the darker aspect of the pastoral was taken up again in the Renaissance by Jacopo Sannazaro, in whose vision of Arcadia architectural forms, including tombs, figure prominently. The contrast between fertility and organic decay, between the bliss and melancholy of pastoral sentiment, naturally found expression in the iconography of landscape gardens. A fine example is Vicino Orsini's *Sacro Bosco* at Bomarzo, laid out around the middle of the sixteenth century. A memorial to Orsini's wife, Giulia Farnese, looks out over the garden, encouraging the visitor to meditate on life's vicissitudes and to compare them with the unbroken cycles of nature (fig. 3). In another part of the garden the visitor confronts what appears to be an overturned

fragment of an Etruscan tomb hewn from the living tufa (fig. 4). In actual fact this relief derives from the well-known frieze of marine figures that once adorned the Island Enclosure of Hadrian's Villa (fig. 5).[3] In the middle of the sixteenth century, as Margaretta Darnall and Mark Weil observe, the resemblance between the Bomarzo tomb and the Hadrian's Villa frieze would have been much closer, because the imperial villa was an overgrown wilderness, strewn with fragments rising from the ground like outcroppings of rock.[4]

The pastoral dimension of Hadrian's Villa is the focus of this discussion, specifically the villa's crucial role in linking landscape, antiquity, and the pastoral. Its connection to the enigmatic emperor and its setting in a landscape of great natural beauty ensured that it was visited by generations of artists, writers, and patrons. It is significant that most of these visitors came out to the villa from Rome, leaving the city behind them to experience the ruins set within fields in which rustic shepherds

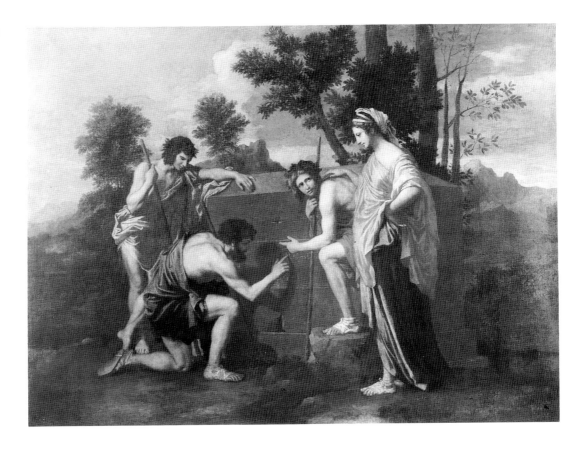

tended their flocks and farmers' ploughs turned up tesselated pavements and fragments of statuary. There, for a space of time, they were transported into a three-dimensional arcadian setting; rather like Poussin's shepherds, they wandered over the vast site so richly strewn with mementos of the past. For over four centuries visitors came to the villa to speculate on its form, to muse on its imperial associations, and to ponder the implications of its decay. What they saw—magnificent ruins in an arcadian setting—helped establish the connection between landscape and antiquity, which emerged as one of the central manifestations of the pastoral.

Hadrian's Villa stands as a singular example within the pastoral tradition. From its inception it was a pragmatic manifestation of the pastoral. Architecture, after all, is not merely cerebral or sensual: it must always serve a practical function. Thus while Hadrian certainly employed his villa as an arcadian retreat and may have also intended it to be a metaphorical expression of his own life and travels, it also had to operate as a center of governmental administration. It embodies within itself the contradictions of the pastoral mode: it was simultaneously Hadrian's rural seat of government and his escape from the cares of Rome and the empire.[5]

But once Hadrian himself was gone, what kinds of responses and meditations did the villa provoke? It was a powerful stimulus for countless visitors. Yet did they see it primarily as a pastoral setting, a benign and pleasantly evocative landscape? Did they concentrate on its political or historical implications? What did they bring to it from the preoccupations of their own times? What did they read into it? By taking a sampling of responses from the Renaissance to the early nineteenth century, some light can be shed on these questions. Let us first, however, look at the villa itself.

Located south of the town of Tivoli about twenty-two kilometers east of Rome, Hadrian's Villa remains one of the

most beautiful sites in the Roman Campagna. A view taken from the slopes of Monte Rispoli shows the entire expanse of the villa; the outskirts of Rome appear on the western horizon (fig. 6). Another view, taken from atop the great Western Belvedere of the villa, shows the ruins set against the background of the Sabine hills (fig. 7). Both views emphasize the remarkable extent to which the design of Hadrian's Villa represents an inspired integration of architectural structure with the contours of the land.

A portion of Giovanni Battista Piranesi's 1781 plan of the site illustrates the disposition of the principal terraces and groupings of buildings that comprise the core of the villa, which the emperor Hadrian laid out between A.D. 117 and 133 (fig. 8).[6] The villa's ancient limits are difficult to define, but it likely occupied more than three hundred acres—nearly twice the area of Pompeii. Hadrian situated a variety of discrete architectural forms—strongly differentiated enclosures, pavilions, and peristyles—in unanticipated sequences across a vast, broadly terraced park. With no grand *allées* the villa revealed itself only as it was traversed; its design is one of considerable subtlety.

Following the abandonment of the site in late antiquity, more than a millennium passed before the first modern impressions of the villa were recorded. Late in the summer of 1461 Pope Pius II, that remarkable and prescient Renaissance observer of the landscape, visited the site and meditated on the ephemeral nature of material splendor, introducing a theme that artists and poets have continued to explore:

About three miles from Tivoli the Emperor Hadrian built a magnificent Villa like a big town. Lofty vaults of great temples still stand and the half-ruined structures of halls and chambers are to be seen. There are also remains of peristyles and huge columned porticoes and swimming pools and baths, into which part of the Aniene was once turned to cool the summer heat. Time has marred everything. The walls once covered with embroidered tapestries and hangings threaded with gold are now clothed with ivy. Briars and brambles have sprung up where purple-robed tribunes sat and queen's chambers are the lairs of serpents. So fleeting are mortal things![7]

3. Temple dedicated to Giulia Farnese Orsini, *Sacro Bosco*, Bomarzo
Author photograph

The overgrown walls of the Southern Range convey a better sense of the appearance of the villa in Piccolomini's day than do the present well-maintained ruins on state-owned land, but still today at the villa, as in Agostino Penna's nineteenth-century print of the Island Enclosure, one can happen upon coiling snakes and muse on the growth and decay of empires (figs. 9, 10).

The vast extent of the villa's ruins alone would have sufficed to attract the attention of humanists such as Piccolomini, but the villa's associations, through an ancient

4. Etruscan tomb, *Sacro Bosco*, Bomarzo
Author photograph

5. Frieze from the Island Enclosure, Hadrian's Villa
Author photograph

text, with one of the most renowned Roman emperors gave it a special resonance. Among the imperial biographies comprising the *Historia Augusta*, a late fourth-century collection drawn from earlier sources with little regard for historical accuracy, is a short passage in which the villa figures:

His Villa at Tibur was marvellously constructed, and he actually gave to parts of it the names of provinces and places of greatest renown, calling them, for instance, Lyceum, Academia, Prytaneum, Canopus, Poecile and Tempe. And in order not to omit anything, he even made a Hades. [8]

Around the middle of the sixteenth century Pirro Ligorio, the Neapolitan architect and antiquarian who played a formative role in the study of Hadrian's Villa, assigned the sonorous names mentioned in the *Historia Augusta* to specific parts of the villa, thereby determining the way artists and scholars would refer to them down to the present day.[9] Two of Ligorio's designations, the Vale of Tempe and the underworld (*inferos*), proved particularly influential in shaping the way visitors have interpreted the villa. If Hadrian really did name parts of his villa as the text suggests, we may follow Ligorio in identifying the East Valley as his Vale of Tempe (fig. 11), an attractive vista when seen from the Northeast Belvedere but hardly suggestive of the scale and drama of the Thessalian original. Ligorio considered the Underground Galleries forming a vast quadrilateral on the villa's southern periphery to have been Hadrian's underworld (fig. 12). The contrast between the rich, open countryside without and the cool, shady realm within could not be more pronounced—the one teeming with verdant life, the other still and void of any living thing. In this way did the themes of mortality and the underworld come to be associated with specific portions of Hadrian's Villa. Ligorio's manuscripts circulated widely in the sixteenth century, and there is evidence to suggest that they may have prompted the inclusion of these themes in Renaissance gardens such as that of Bomarzo.[10]

In 1870 the Italian state acquired much of the land that once belonged to Hadrian's Villa, and over the last century it has made

6. View of Hadrian's Villa, from the flank of Monte Rispoli
Author photograph

7. View of Hadrian's Villa, from the Western Belvedere
Author photograph

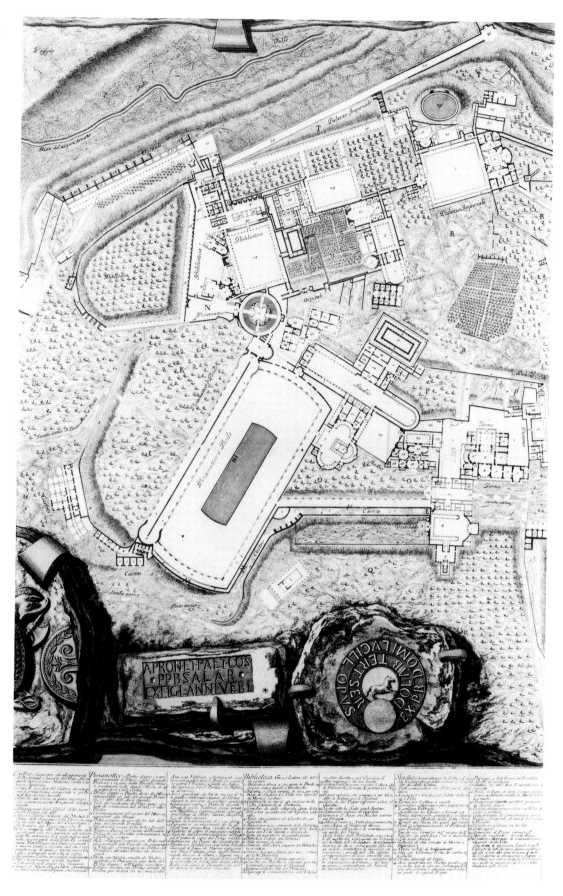

8. Francesco Piranesi, *Pianta delle fabbriche esistenti nella Villa Adriana*, 1781, plate 2

9. Southern Range of Hadrian's
Villa, viewed from the east
Author photograph

10. Agostino Penna,
View of Island Enclosure
at Hadrian's Villa

From *Viaggio pittorico della Villa
Adriana* (1831), 1:12

11. East Valley, Hadrian's Villa
Author photograph

12. Underground Galleries,
Hadrian's Villa
Author photograph

most of the ruins accessible to increasing numbers of visitors. Prior to 1870, however, the experience of visiting the site was considerably different. A fuller understanding of how the ruins comprising Hadrian's Villa appeared prior to 1870 helps to explain how they were interpreted in this period. By the early seventeenth century the ridge occupied by the villa had fallen into the hands of some forty-five different landowners, whose tenant farmers cultivated fields and pastured sheep within carefully divided enclosures, their picturesque outbuildings nestled among the ruins.[11] Some of the ruins later provided the foundations for permanent farm buildings, like the Casino Fede built above the *nymphaeum* of the Doric Tholos (fig. 13), and the *casale* Liborio Michili erected over the Service Quarters.

Around 1725 Count Giuseppe Fede began to buy up as much of the site as he could, but even within his contiguous holdings—formerly the property of eighteen different owners—the ruins were separated both visually and physically by fences and hedgerows.[12] Around the middle of the century the count planted the long cypress avenue leading up to the East-West Terrace from below the Casino Fede; this remains one of the most picturesque features of the villa (fig. 14). In spite of Count Fede's efforts at consolidation, however, at the end of the century the villa was still broken up into seven large private holdings further subdivided by the enclosures of numerous tenant farmers. This explains why most eighteenth- and nineteenth-century visitors to the site rarely saw the villa in its entirety and why most descriptions stress the sequential—as opposed to the overall—nature of the experience. In such accounts what figure most prominently are the briars and creepers, the snakes and scorpions, and the difficulty of coming to grips with the site.

By 1756 both Hubert Robert and Honoré Fragonard were in residence at the French Academy in Rome, engaged in formulating a new interpretation of the landscape in which ruins play a poetic role.[13] In 1760 both artists made repeated visits to the Campagna south of Tivoli, using as a base the Villa d'Este, which the Abbé de Saint-

13. Casino Fede,
Hadrian's Villa
Author photograph

14. Cypress *allée*,
Hadrian's Villa
Author photograph

Non had rented for the summer. The re-
sults of their sketching trips rank among
the most sublime landscape drawings of
any age. In one of Fragonard's views the
ruined seating of the North Theatre forms a
concavity embracing a group of colossal cy-
presses that serve to anchor the composi-
tion on the right (fig. 15).[14] The Casino
Fede, set against an enfolding screen of
boughs, occupies the center, while to the
left several figures emerge from the shad-
owy depths of the theater's vaulted sub-
structures. The airy, arching silhouettes of
great trees activate the skyline, completing
a compelling image of natural beauty
nourished by fragments of the remote past.
By the middle of the eighteenth century
the remains of Hadrian's Villa, rising out of
a wild and luxuriant setting, provided a
powerful stimulus to the layout of pictur-
esque landscape gardens in which sham ru-
ins played prominent roles.

Hubert Robert's sketch of the Scenic Tri-
clinium elaborates on the picturesque ap-
pearance of the ruins, as may be seen by
comparison with a view of the same fea-
ture drawn by the Bergamask architect
Giacomo Quarenghi in 1777 (figs. 16, 17).[15]
Hubert Robert animates the great hemi-
cycle of the triclinium with rustics and
transforms its massive overhanging vault
into a delicate rococo canopy of vines
blowing in the breeze. Quarenghi, in con-
trast, emphasizes the massiveness of the
structure, his composition tying it to the
earth rather than to the sky. Both artists
are clearly fascinated by the forces of na-
ture as they reclaim even the most impres-
sive works of man.

In 1775 the French painter Louis Chaix
sketched a charming view of the Larger
Baths (fig. 18).[16] The immediacy of Chaix's
composition is for the most part the result
of his unusual angle of vision, off-center
and close to the ground. As a result the
viewer is encouraged to feel a part of the
scene and becomes almost subsumed by
it. *Vedute* such as these convey a vital im-
mediacy and a sense of the organic interac-
tion between natural forces and manmade
structures that are essential ingredients of
the place. This is why visitors today react

16. Hubert Robert, View of
Scenic Triclinium at Hadrian's
Villa, drawing
Bibliothèque municipale, Besançon

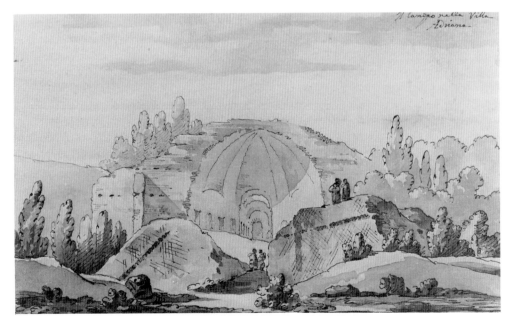

17. Giacomo Quarenghi, View
of Scenic Triclinium at
Hadrian's Villa, 1777, drawing
Biblioteca Civica, Bergamo

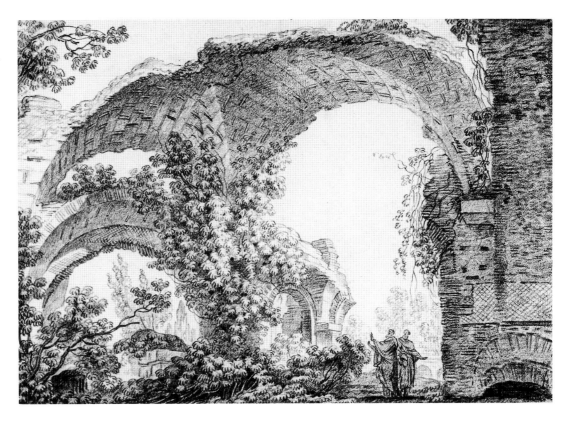

differently to Hadrian's Villa from the way they do to other archaeological sites like Ostia and Pompeii, where the bond between nature and artifact has, of necessity, been irreparably broken.

Of all the artists and archaeologists who have studied Hadrian's Villa, Piranesi emerges as the villa's most inspired interpreter. His systematic study of the villa began in the 1740s, and over the next three decades he made repeated sketching expeditions to Tivoli, often in the company of foreign artists such as Charles-Louis Clérisseau and Robert Adam. Piranesi's biographer J. G. Legrand provides a colorful account of one such outing to the villa, on which Piranesi was accompanied by Clérisseau and the landscape painter Claude-Joseph Vernet. Legrand recounts that in drawing and measuring the villa they "were obliged to cut their way through the undergrowth with hatchets, and then to set fire to the area they had cleared so as to burn out the snakes and scorpions."[17]

In the last decade of his life Piranesi was preparing a comprehensive publication on Hadrian's Villa, which was never finished owing to the artist's death in 1778. This publication would have included the great plan of the villa issued posthumously in 1781 by Piranesi's son Francesco, of which we have already seen a portion (fig. 8).[18] An artistic and archaeological tour de force, the plan reconstructs the remains of the villa in its totality and relates them effectively to the contours of the land. By employing sophisticated graphic conventions, Piranesi succeeded in achieving precisely the kind of unified image that proved so elusive to visitors on the site.

As part of the same project Piranesi produced ten printed *vedute* of the villa. His view of the East-West Terrace, perhaps more than any of his other representations of the villa, conveys a wonderful sense of its magnificent setting (fig. 19). The dramatic diagonal recession of the Ambulatory Wall quickly draws the eye to the mountains south of Tivoli, dominated by the Monte Rispoli, which provide a background for the more elevated eastern portions of the villa. In the middle ground a

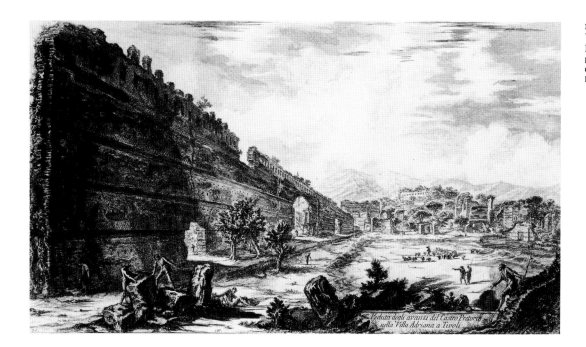

19. Giovanni Battista Piranesi,
View of East-West Terrace at
Hadrian's Villa, etching
Resource Collections of the Getty
Center for the History of Art and the
Humanities

shepherd pastures his flock on the site of the reflecting pool that marks the longitudinal axis of the terrace.

Piranesi's *veduta* depicting the octagonal hall of the Smaller Baths was perhaps the last of the series to be etched (fig. 20). Through his unparalleled mastery of composition, light, and shadow, gained in the course of a lifetime spent observing Roman architecture and capturing its essence on the etched plate, Piranesi brilliantly renders the undulating masonry envelope that molds this centralized space in a way that no photograph can possibly convey. Piranesi's interpretative talents seem especially well suited to the organic nature of this structure, the walls of which appear to pulse with movement while its vaults arch upward like the boughs of mighty trees to meet in an airy crown of foliage.

Jacques Gondoin, a contemporary of Piranesi, also undertook a survey of Hadrian's Villa. Several graffiti at the villa bear witness to Gondoin's intense work there between 1762 and 1763, when he was a *pensionnaire* at the French Academy in Rome. After leaving the incomplete results of his survey in the hands of Piranesi, Gondoin returned to France where he began to design classical buildings like the École de Chirurgie, which included a *nymphaeum*-like fountain of Aesclepius. In the

years before the Revolution, Gondoin prospered, so much so that when he returned to Rome for a second time in 1775 he tried to buy the entire site occupied by Hadrian's Villa. He eventually retired to his country estate on the banks of the Seine at Vives-Eaux, near Melun. Here, according to Quatremère de Quincy,

[when he] retired from the world in the midst of the woods that surrounded him, he spent his whole time in giving his tastes and studies an asylum worthy of the arts, which became for him in a small scale what the Emperor Hadrian had made on a large scale, the abridged collection of all the memories of his journeys.[19]

On the eve of the Revolution the terraces and park at Vives-Eaux were already laid out, but the house was unfinished. Gondoin survived the Terror by masquerading as the poor gardener of the estate, on the grounds of which he continued to live, patiently awaiting the end of the Revolution. His chateau and gardens at Vives-Eaux no longer survive, but they were not the last evocation of Hadrian's Villa to be constructed in France.

In 1807, shortly after his eleven-month circuit of the Mediterranean recorded in his *Itinerary from Paris to Jerusalem*, Chateaubriand began to lay out his own version of Hadrian's Villa. With both the substantive remains of the villa and the

passage from the *Historia Augusta* in mind, he transformed the Vallée-aux-Loups, seven miles southwest of Paris between Chatenay and Sceaux, into an evocation of his life and travels. He embellished his chateau there with a Grecian porch supported by caryatids and planted the park with cedars from Lebanon, pines from Jerusalem, a laurel from Granada, and a magnolia from the Empress Josephine's garden at Malmaison.[20]

Chateaubriand's descriptions of his visit to Hadrian's Villa in 1803 shed light on his interpretation of the site. While there he was caught in a shower of rain, as a result of which he took cover in one of the bath complexes:

a vine had penetrated through fissures in the arched roof, while its smooth and red crooked stem mounted along the wall like a serpent. Round me, across the arcades, the Roman country was seen in different points of view. Large elder trees filled the deserted apartments, where some solitary black-birds found a retreat.

The fragments of masonry were garnished with the leaves of scolopendra, the satin verdure of which appeared like mosaic work upon the white marble. Here and there lofty cypresses replaced the columns, which had fallen into these palaces of death. The wild acanthus crept at their feet on the ruins, as if nature had taken pleasure in re-producing, upon the mutilated chefs d'oeuvre of architecture, the ornament of their past beauty. The different apartments and the summits of the ruins were covered with pendant verdure; the wind agitated these humid garlands, and the plants bent under the rain of Heaven.

While I contemplated this picture, a thousand confused ideas passed across my mind. At one moment I admired, at the next detested Roman grandeur. At one moment I thought of the virtues, at another of the vices, which distinguished this lord of the world, who had wished to render his garden a representation of his empire. I called to mind the events, by which his superb villa had been destroyed. . . . While these different thoughts succeeded each other, an inward voice mixed itself with them, and repeated to me what has been a hundred

20. Giovanni Battista Piranesi, View of Smaller Baths at Hadrian's Villa, etching
Resource Collections of the Getty Center for the History of Art and the Humanities

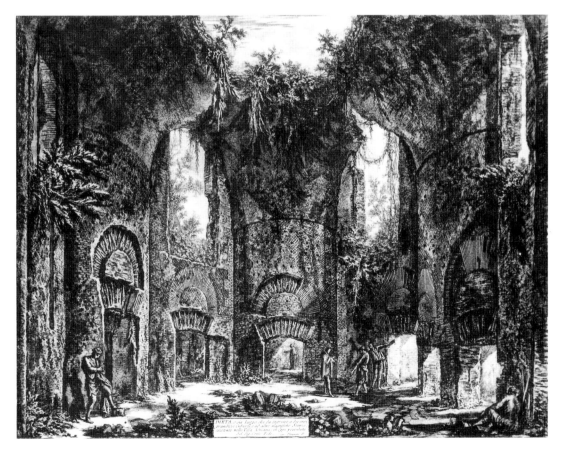

*times written on the vanity of human affairs.
There is indeed a double vanity in the remains
of the Villa Adriana: for it is known that they
were only imitations of other remains, scat-
tered through the provinces of the Roman em-
pire. The real temple of Serapis and Alexandria,
and the real academy at Athens no longer exist;
so that in the copies of Hadrian you only see the
ruins of ruins.*[21]

Throughout this description Chateau-
briand's diction underscores his ambiva-
lence: words and phrases such as "serpent,"
"deserted," "solitary," "palaces of death,"
and "mutilated" balance those such as "re-
treat," "garnished," "satin," "pleasure,"
"ornament," "beauty," "garlands," and
"rain of Heaven." Here we have again the
contradictions always implied within the
pastoral tradition: complex and simple, ur-
ban and rural, urbane and unsophisticated,
real and manufactured, vain and humble,
temporal and eternal.

In Chateaubriand's *Voyage en Italie* he
continues his meditations with these
remarks:

*Many travellers, my predecessors, have written
their names on the marbles of Hadrian's Villa;
they hoped to prolong their existence by leaving
a souvenir of their visit in these celebrated
places; they were mistaken. While I endeavored
to read one of the names recently inscribed
which I thought I recognized, a bird took flight
from a clump of ivy, and in so doing caused sev-
eral drops of water from the recent rain to fall:
the name vanished.*[22]

Again, we have the preoccupation with
mortality that informs so much of the pas-
toral mode. Whether one leads the simple
life of a shepherd or the sophisticated life
of a Roman emperor, any man's time and
accomplishments will pass. In Hadrian's
grand design the struggle between the hu-
man desire for immortality and the inexor-
able cycles of nature endures. Generations
of artists who visited the site south of
Tivoli have been inspired to see landscape
and antiquity as complementary and pow-
erfully allusive forces. The results of their
vision have enriched the pastoral form as
they sought to explore and to express the
relationship between man and his natural
environment through the lens of architec-
tural ruins.

NOTES

1. See W. J. T. Peters, *Landscape in Romano-Campanian Mural Painting* (Assen, 1963); see also Bettina Bergmann's essay in this volume.

2. See Erwin Panofsky, *"Et in Arcadia Ego*: Poussin and the Elegaic Tradition," *Meaning in the Visual Arts* (Harmondsworth, 1970), 340–367.

3. John P. Oleson, "A Reproduction of an Etruscan Tomb in the Parco dei Mostri at Bomarzo," *Art Bulletin* 57 (1975), 410–417.

4. Margaretta J. Darnall and Mark S. Weil, "Il Bosco Sacro di Bomarzo: Its 16th-Century Literary and Antiquarian Context," *Journal of Garden History* 4 (1984), 15.

5. For an account of Hadrian's Villa as a working imperial court see Mary T. Boatwright, *Hadrian and the City of Rome* (Princeton, 1987), 138–150.

6. For general treatments of the site see Hermann Winnefeld, *Die Villa des Hadrian bei Tivoli* (Berlin, 1895); Pierre Gusman, *La Villa Impériale de Tibur* (Paris, 1904); Salvatore Aurigemma, *Villa Adriana* (Rome, 1961); Eugenia Salza Prina Ricotti, "Villa Adriana nei suoi limiti e nella sua funzionalità," *Atti della Pontificia Accademia Romana di Archeologia, Memorie* 14 (1982), 25–55. William L. MacDonald and this author are writing a book on Hadrian's Villa.

7. Aeneas Sylvius Piccolomini, *Memoirs of a Renaissance Pope: The Commentaries of Pius II*, ed. F. A. Gragg (New York, 1959), 193.

8. *Scriptores Historiae Augustae* 26.5; D. Magie, trans., *Scriptores Historiae Augustae* (London, 1921), I, 78–79.

9. Eugenia Salza Prina Ricotti, "Villa Adriana in Pirro Ligorio e Francesco Contini," *Atti della Accademia Nazionale dei Lincei, Memorie* 17 (1973–1974), 1–47.

10. Darnall and Weil 1984, 49.

11. F. Contini, *Adriani Caesaris immanem in Tyburtino Villam* (Rome, 1668), key. The survey preparatory to Contini's published plan was carried out in the 1630s.

12. G. Ristori-Gabrielli, *Pianta e misura della possessione spettante al Conte Giuseppe Fede* (Rome, 1770).

13. H. Burda, *Die Ruinen in den Bildern Hubert Robert* (Munich, 1967); J. De Cayeux, *Hubert Robert et les jardins* (Paris, 1987).

14. Alexandre Ananoff, *L'oeuvre dessiné de Jean-Honoré Fragonard*, 4 vols. (Paris, 1961), 2:116.

15. Sandro Angelini, *I cinque album di Giacomo Quarenghi nella Civica Biblioteca di Bergamo* (Bergamo, 1967).

16. J.-F. Mejanes, "A Spontaneous Feeling for Nature: French Eighteenth-Century Landscape Drawings," *Apollo* 104 (1976), 401–412.

17. Gilbert Erouart and Monique Mosser, "A propos de la 'Notice Historique sur la vie et les ouvrages de J.-B. Piranèsi': origine et fortune d'une biographie," *Piranèse et les Français, Colloque*, ed. Georges Brunel (Rome, 1978), 135.

18. Francesco Piranesi, *Pianta delle fabbriche esistenti nella Villa Adriana* (Rome, 1781).

19. Antoine-Chrysostome Quatremère de Quincy, *Recueil de notices historiques lues dans les séances publiques de l'Académie royale des Beaux-Arts à l'Institut* (Paris, 1834), 206–208. Author translation.

20. *Guide Bleu. Paris: Hauts de Seine, Seine-St. Denis, Val de Marne* (Paris, 1968), 659.

21. François Auguste René Chateaubriand, *Recollections of Italy, England and America* (Philadelphia, 1816), 27–28.

22. François Auguste René Chateaubriand, *Voyage en Italie* (Paris, 1969), 90. Author translation.

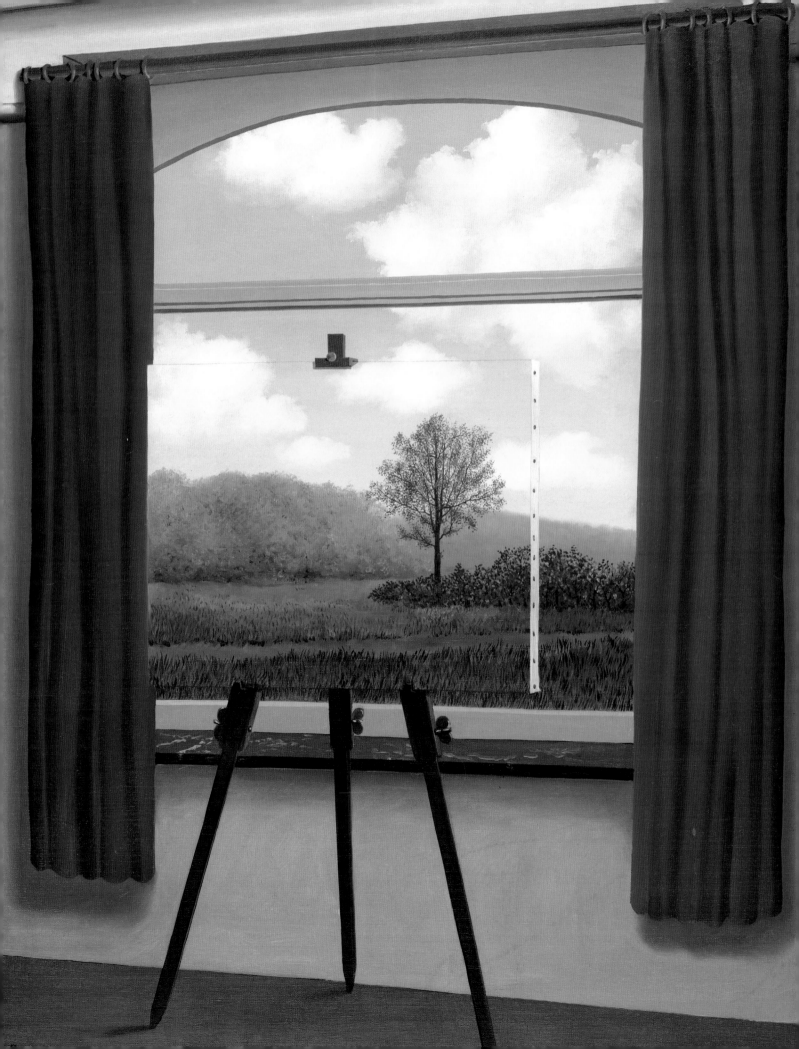

JEREMY STRICK
National Gallery of Art

Notes on Some Instances of Irony in Modern Pastoral

In his review of the Paris Salon of 1857, the French critic Jules Castagnary remarked on the increasing predominance of landscape painting, noting:

C'est une vérité vielle, que les églogues et les idylles ont presque toujours été le contre-coup d'agitations sociales. Froissés par le tumulte du monde, les poètes, les rêveurs se réfugient dans la paix des champs, dans la contemplation de la nature calme et sereine.[1]

Castagnary's account of the origin of pastoral as a flight from social unrest may have been based on an old truth, but his belief in pastoral's destination was distinctly reformist. Best known today for his championing of Gustave Courbet, Castagnary believed in a robust, democratic landscape pastoral, an art that would truthfully present a nature whose beauty would be accessible to all. The artist's escape into nature was, in a sense, strategic, for the representation of landscape would present society with a standard of truth and stable value. Pastoral would serve to heal and reform the society from which it originally fled.

Almost ninety years later, writing in the 26 January 1946 issue of the *Nation*, the American critic Clement Greenberg remarked:

What characterizes painting in the line Manet to Mondrian—as well as poetry from Verlaine through Mallarmé to Apollinaire and Wallace Stevens—is its pastoral mood. It is this that is mistaken for the "classical." And it is away from the pastoral, the preoccupation with nature at rest, human beings at leisure, and art in movement, that so much painting has turned of late.[2]

While for Castagnary pastoral was emerging as the dominant tendency in modern painting, for Greenberg pastoral had become the main line of modernist practice. Both critics viewed pastoral as a response to social strife, but Greenberg's view of that response was more nuanced and less optimistic. Pastoral, he explained in the same review,

depends upon two interdependent attitudes: the first, a dissatisfaction with the moods prevailing in society's centers of activity; the second, a conviction of the stability of society in one's own time. One flees to the shepherds from the controversies that agitate the market-place. But this flight—which takes place in art—depends inevitably upon a feeling that the society left behind will continue to protect and provide for the fugitive, no matter what differences he may have with it.

This feeling of pastoral security has become increasingly difficult to maintain in the last two decades. It is the dissipation of this sense of security that makes the survival of modern avant-garde art problematical.[3]

Pastoral, for Greenberg, was not a broad-based democratic art that would triumph over society, but rather an art that is at once at odds with and protected by society; an art implicitly critical and yet dependent.

1. Morris Louis, *Beta Kappa*,
1961, acrylic resin on canvas
National Gallery of Art, Washington,
Gift of Marcella Louis Brenner

Perhaps a more fundamental distinction between the views of the two critics is that Castagnary understood pastoral in literal terms, whereas Greenberg's pastoral was essentially formalist and metaphoric. Castagnary's realist pastoral saw the ancient play of shepherds in the sacred grove transformed into the straightforward depiction of the actual countryside. For Greenberg pastoral reclusion served as an appropriate metaphor for the turn of modernist painting away from the representation of the actual world and toward a preoccupation with its own means and materials.

Greenberg's understanding of pastoral most probably depended upon the broad definition provided by William Empson's influential *Some Versions of Pastoral.* And Greenberg's choice of pastoral as a metaphor must surely have been influenced by his taste for Matisse. Matisse not only painted works in what Greenberg called a "pastoral mood" but many of his key works depict the most traditional pastoral subjects. If Matisse is used as a standard of modernism, then so too must pastoral be used.[4]

Mondrian, a central figure in Greenberg's modernist line of descent, presents us with another problem. To consider the Dutch painter's rigorous abstractions as in-stances of pastoral requires a very broad definition of the term. Mondrian's utopian idealism, wherein straight lines and primary colors partake of a universal order, may perhaps be understood as a form of pastoral in this sense: that it represents flight from the real world to a world of harmony and order.

Much of what follows depends on the use of Greenberg's broad or metaphoric understanding of pastoral. Such an understanding is significant in itself, as an historical object, but it is also acceptable within the terms elaborated by critics of literary pastoral since Empson. These critics have not hesitated to employ a very broad definition of the term, and their consensus has been recently summarized by David Halperin.[5] Surveying an extensive literature, Halperin arrives at a four-point synopsis of the terms in which pastoral is defined and employed. These four points deserve to be quoted in full:

1. Pastoral is the name commonly given to literature about or pertaining to herdsmen and their activities in a country setting; these activities are conventionally assumed to be three in number: caring for the animals under their charge, singing or playing musical instruments, and making love.

2. Pastoral achieves significance by oppositions, by the set of contrasts, expressed or implied, which the values embodied in its world create with other ways of life. The most traditional contrast is between the little world of natural simplicity and the great world of civilization, power, state craft, ordered society, established codes of behavior, and artifice in general.

3. A different kind of contrast equally intimate to pastoral's manner of representation is that between a confused or conflict-ridden reality and the artistic depiction of it as comprehensible, meaningful, or harmonious.

4. A work which satisfies the requirements of any two of the three preceding points has fulfilled the necessary and sufficient conditions of pastoral.[6]

While the first of Halperin's points pertains exclusively to subject, the second two refer equally to formal and representational structures. A significant strain of modern art can be seen to respond to the criteria of those second and third points. Mondrian's utopian geometry can thereby be understood as pastoral and, to take a more recent example, so can the Veil and Unfurled paintings of Morris Louis. In a painting like *Beta Kappa* (fig. 1) of 1961 Louis has soaked thinned acrylic paint into unsized canvas. The white canvas maintains a shining purity, while the stripes of color, fully absorbed into the canvas weave, seem warm and untainted. Entirely abstract, Louis' Veils and Unfurleds nevertheless have much of the feeling of landscape, and the angled stripes of paintings such as *Beta Kappa* remind us of the *repoussoirs* of classical landscape painting. Considering *Beta Kappa* against Halperin's four points, one could argue that the painting implicitly contrasts its concentration upon purely aesthetic issues of form and color with the nonaesthetic values that it systematically excludes. Moreover the painting forces a contrast between the purity and harmony of an art reduced to its essential features and the world that lies outside art.

If, in these critical terms, it is proper to describe Morris Louis' painting as a kind of pastoral, it is also proper to do so historically. Louis, of course, was well aware of Greenberg's criticism, and a significant body of his work adhered closely to that critic's precepts. The Veils and Unfurleds were painted at a moment when the broad definition of pastoral supplied by Empson and other literary critics, and reiterated by Greenberg, was widely accepted.

The notion of a formalist pastoral, however, has been applied to art made before the twentieth century. Thus Lawrence Gowing, in a recent catalogue essay on pastoral landscape, in effect traces the origins of the formalist pastoral, what he calls the "pastoral of paint," to Constable. Gowing explains:

In Constable's works the likeness to country and weather was accompanied, as his contemporaries complained, by an even more striking likeness to paint. In this tradition of landscape, paint became during the nineteenth century the means of an essential detachment.[7]

As it happens, some of the most interesting work on pastoral landscape published in the past few years has been contained in studies of English eighteenth- and nineteenth-century landscape painting, focusing in particular on Constable. These studies, written by John Barrell, Michael Rosenthal, and Ann Bermingham, agree with Gowing's characterization of Constable's detachment.[8] They interpret this detachment, however, as a response to a series of changes that transformed both the landscape and the society of Constable's native East Anglia. Ann Bermingham's fascinating *Landscape and Ideology* stresses the interplay between Constable's troubled relationship to his family and his difficulty in representing a landscape remade by laws of enclosure, an industrial economy, and the severe agricultural depression that followed the Napoleonic wars. To simplify a subtle and complex argument, what began for Constable as a flight from his family into nature became a flight from a transformed nature into paint.

I mention this account of Constable because it throws into sharp relief an essential quality of pastoral. While celebrating harmony and simple fulfillment, pastoral is generated by alienation and dissatisfaction. The ideal world of pastoral finds the real world wanting.

At the beginning of the modern tradition Constable provides one example of this as-

pect of pastoral; the late eighteenth-century French landscape painter and theorist Pierre-Henri de Valenciennes provides another. In his important treatise on landscape painting, *Elémens de perspective pratique*, published in 1800, Valenciennes devotes a chapter to pastoral. This genre, he notes:

est absolument idéal; et le paysage qui lui est propre devant être habité par des hommes, non pas tels qu'ils sont, mais tels que l'imagination suppose qu'ils pouvaient être, exige qu'il soit préparé pour recevoir de pareils mortels. Il faut que le peintre représente la belle Nature simple et majestueuse tout à la fois, telle enfin que le génie doit la créer sur la toile, puisqu'on ne la rencontre plus sur la terre.[9]

Rather than representing nature, the painter of pastoral must rely upon his imagination and the descriptions of pastoral poets. A trip to the lands that these poets describe will be of little use to the painter, because Arcadia, Valenciennes continues, isn't what it used to be:

Que sont devenus les bosquets odorans de Paphos et d'Amathonte! Qu'est devenue cette heureuse Arcadie que les Poëtes se sont plu à chanter à l'envi! Que reste-t-il de cette délicieuse vallée de Tempé, abritée par les monts Olympe et Piérus, arrosée par le fleuve Pénée, et couverte de bois épais et toujours verts! Les montagnes, les fleuves, les vallons existent encore, mais ne se ressemblent plus. La fertilité du sol peut s'être conservée, mais les productions n'y sont plus les mêmes. Au lieu des paisibles habitans qui chantaient leur bonheur et leur aisance, de misérables esclaves végètent dans l'ignorance et le besoin; et on est étonné, quand on parcourt ces contrées fameuses, de n'éprouver d'autre plaisir que la mémoire de leur ancienne splendeur. L'imagination, il est vrai, nous transporte dans le temps de leur gloire; on croit revoir tout ce qu'elles ont perdu: on interroge les rochers, qui sont restés les seuls témoins de cette grandeur passée. Le silence des vallons, l'aridité des plaines, la stagnation des eaux inspirent l'attendrissement et le regret; et vainement veut-on se représenter ces sites délicieux ornés de tout ce que la Nature peut offrir de plus riant et de plus varié; le regard ne se promène que sur un squelette décharné qui laisse à peine présumer ce qu'il fut au temps de sa brillante jeunesse.[10]

The harshness of Valenciennes' words seems partly occasioned by the needs of pastoral. Elsewhere in the lengthy treatise his descriptions of nature are positive, even effusive, and he credits the artist's joy in nature as the primary motivation for the landscape painter. Indeed, in a section of the *Elémens* detailing the travels recommended to complete the artistic education of the young landscape painter, Valenciennes describes Greece in lengthy and enthusiastic detail. In describing an absolutely ideal pastoral nature, however, Valenciennes finds that rhetoric demands the diminishment of the real.

This tendency of pastoral to contain a dark and disenchanted view has served as a point of focus and provided a generative theme for a number of essays by one critic of literary pastoral, Harry Berger, Jr.[11] Berger identifies two kinds of pastoral literature, which, adapting the terminology of Harold Bloom, he calls "weak" pastoral and "strong" or "metapastoral." Weak pastoral, in Berger's terms, is that which simply fulfills the conditions of Halperin's four points, opposing nature to culture, simplicity to sophistication, order to disorder. Such pastoral represents a special

2. Gustave Courbet, *Les demoiselles des bords de la Seine (Eté)*, 1856–1857, oil on canvas
Musée du Petit Palais, Paris

3. François-Louis Français,
Le jardin antique, 1841, oil
on canvas
Musée Louis Français, Plombières-
les-Bains

generated by disenchantment and mis-anthropy, may in fact be dystopias.

Berger's model of metapastoral helps account for a consistent strain of irony that has inflected many modern approaches to pastoral, both in landscape painting and in abstraction. Of course, not all modern pastoral is ironic. I see no irony in Louis' *Beta Kappa*, which seems to me an adequate example of the workings, at a high level of achievement, of weak pastoral. Constable's art, moreover, seems a complex and profound effort to locate and represent a modern landscape pastoral, rather than a critique of the pastoral impulse. What follows are several examples of metapastoral critiques.

Gustave Courbet's *Les demoiselles des bords de la Seine (Eté)* (fig. 2) of 1856–1857 provides a good example of the metapastoral in painting. The picture clearly makes reference to a common taste for images of undressed women at rest in a landscape setting. That taste was satisfied by works such as François-Louis Français' successful Salon painting *Le jardin antique* (fig. 3) of 1841, which is conceived within the terms of a traditional pastoral voyeurism. Asleep, Français' young woman cannot see the viewer who is permitted to gaze upon her. The voyeuristic element is partly masked, however, by the removal of the image into a fictional past of pastoral perfection. The sleeping woman is part of an ideal world of natural harmony, and the viewer's voyeuristic desire can be safely interpreted as a desire for that harmony, from which he is nonetheless shut off.

Courbet's painting, of course, is not a simple depiction of young women at rest. The women are engaged in a kind of occasional prostitution. Not undressed according to the acceptable conventions of artistic nudity, they are dressed in a manner calculated to affront: one in her underclothes, the other in a parodic hodgepodge of the latest fashions. In the boat pulled up on the riverbank we note a man's hat, suggesting that a customer is nearby. Courbet's partisans, notably the socialist philosopher Prudhon, saw in this painting an exposé of the decadence of contemporary morals. His detractors saw it as a manifestation of that decadence.[13] Both re-

world that stands in opposition to, and in criticism of the actual world.[12] Strong pastoral or metapastoral, by contrast acknowledges and criticizes the disenchantment that engenders weak pastoral. Metapastoral may treat the traditional pastoral themes and functions according to the traditional oppositions. The longings that weak pastoral expresses are similarly expressed by metapastoral. Metapastoral, however, criticizes the pastoral genre, explicitly demonstrating the tendency of pastoral to caricature the world that it opposes, and suggesting that pastoral utopias,

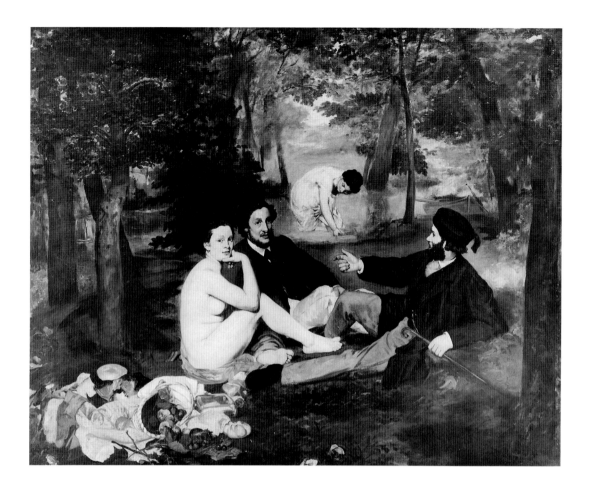

4. Edouard Manet, *Le déjeuner sur l'herbe*, 1863, oil on canvas
Musée d'Orsay, Paris

sponses are motivated by the fact that Courbet has exposed the voyeurism central to the pastoral tradition exploited by Français. The pastoral subject has been transformed by Courbet into a thoroughly modern image, disallowing voyeuristic distance. Presenting the young women as prostitutes makes explicit a relationship of desire that pastoral painting traditionally contained. Modernizing pastoral, Courbet addresses its underlying themes and motivation.

Much the same can be said of Manet's modern-dress version of the early sixteenth-century *Concert champêtre*, his *Déjeuner sur l'herbe* (fig. 4) of 1863, a painting that makes clear reference to Courbet's *Demoiselles* in such details as the foreground still life and the boat in the middle ground.[14] Clearly this is pastoral-about-pastoral, a painting that makes conspicuous its sources even while it transforms their meaning. The notion of pastoral's opposition of nature to culture is reversed, as

pastoral is shown to be an enactment of contemporary culture. Pastoral remove is punctured by the modern dress and by Victorine Meurant's piercing gaze.

Constable sought first an equivalent to pastoral in the accurate description of his native landscape but eventually came to find his pastoral in art; so too the metapastoral of Courbet and Manet is closely tied to their realist projects. Here, however, a realism not of nature but of culture undercuts the traditional terms of pastoral, even while preserving them.

The surrealism of René Magritte makes a different critique of pastoral. Magritte's *Human Condition* (fig. 5) of 1933 is best understood as an analysis of representation, or, rather, of the falsehood of representation. The painting set on an easel before a window seems contiguous at its edges with the portion of the landscape that it covers. We assume, therefore, that the painting represents the view that it hides. Of course, there is nothing behind the paint-

ing-within-the-painting. Our assumption, made repeatedly and even unwillingly, is the product of illusion.

We are reminded here of a passage from André Breton's *Surrealism and Painting*, a book published in 1928 that Magritte would surely have read:

il m'est impossible de considérer un tableau autrement que comme une fenêtre dont mon premier souci est de savoir sur quoi elle donne, autrement dit si, d'où je suis, "la vue est belle," et je n'aime rien tant que ce qui s'étend devant moi à perte de vue.[15]

Magritte seems to offer a literal description of Breton's conception of painting. Breton's statement suggests landscape, and his consideration of painting as a window that lets out onto an infinite view recalls

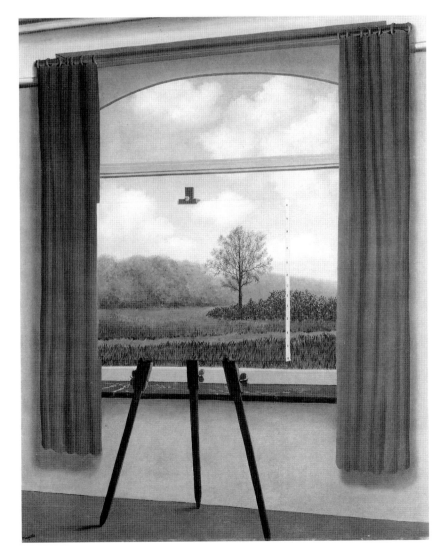

the pastoral notion of representation providing a view of a world separate and complete. Now windows provide an image of a view, even while they bar physical access. The only access provided by paintings to the world they represent is imaginative. Windows and paintings both can thus serve as signs of desire and alienation.

In responding to Breton's statement, Magritte has contextualized it. While the painting on the easel necessarily lacks a frame, there is another sense in which Magritte frames his image. Painting and easel are set within what seems to be a restrained, middle-class interior with a window that looks out upon a park. These elements suggest a suburban villa. Park and suburban villa can certainly be considered as late manifestations of the pastoral ideal. Through them urban culture created its own complementary and domesticated opposite. The illusionism that Magritte criticizes in *The Human Condition* is implicitly tied to this domesticated pastoral. The nature desired by middle-class culture, seen through the window, is the creation of culture. Illusionist representation, employed to depict objects of desire, ultimately represents only its own practice.

While Magritte addresses the relation between pastoral and illusion, the metapastoral of the French artist Yves Klein deals squarely with the issues of idealism and enchantment. Best known for his blue monochrome paintings, Klein invoked and satirized throughout his brief career the mystic ideal of the artist and the capacity of art to represent the ideal. While one could certainly discuss Klein's monochromes in terms of Empsonian pastoral, I want to consider another part of his oeuvre, the Anthropometries (fig. 6).

Klein carefully cultivated a mystique about himself and his art. Among his activities were the publication of photographs purporting to show himself levitating and an invention of a secret formula for a blue paint that he called International Klein Blue. This color, he explained, expressed a mystic purity. Klein used International Klein Blue to paint monochrome panels and, as of 1960, to make paintings of nudes. These latter works, which he called Anthropometries, are clearly related to

6. Yves Klein, *ANT 109,* 1961, dry blue pigment in synthetic resin on paper on fabric
Private collection

7. Henri Matisse, *La Chevelure,* 1952, painted, cut, and pasted paper
Private collection

Matisse's paper cutouts. Matisse's blue
cutouts of female figures, works like *La
Chevelure* (fig. 7) of 1952 stand as virtual
summations of the pastoral-idealist ten-
dencies of that artist's work. Rather than
cut out forms from pieces of painted paper,
however, Klein created his Anthropome-
tries by commanding his female models to
cover their bodies with his paint and then
directing them to press their bodies against
sheets of paper. On at least one occasion
Klein staged a public performance, care-
fully documented, in which, dressed in
tuxedo, he orchestrated his naked models
in the creation of a painting before mu-
sicians and a formally attired audience
(figs. 8, 9).

Visually Klein's Anthropometries ex-
plicitly recall the high idealism of Ma-
tisse's cutouts. Through his performance,
however, Klein insured an awareness of the
ridiculous circumstances of their making.
In a sense, like Courbet and Manet, Klein
inflected the ideal with the real. Here the

notion of art as a privileged, even sacred activity, a realm of pastoral purity and perfection, is transgressed by slapstick.[16]

The work of Robert Rauschenberg can also be considered in relation to pastoral. The images found in Rauschenberg's collages—images of nature, flight, and athletics—are frequently close to traditional pastoral subjects. Moreover, although Rauschenberg's works are always heterogeneous in imagery, they are always organized by a loose, syncopated grid system that provides unity—a kind of artistic order imposed upon the world of images.

The affinity of Rauschenberg's work with pastoral is announced in his remarkable early construction *Odalisque* (fig. 10) of 1955–1958. The assemblage consists of a four-sided box that sits on a column, which in turn stands on a pillow. The box, covered with magazine illustrations and painted in places, is surmounted by a rooster. *Odalisque* is a virtual compendium of pastoral subjects—sports figures, animals, nudes, even a reference to the artist's own work in a small reproduction of the *Female Figure (Blueprint)* of 1949. Along the top edge of one side of the box Rauschenberg has glued a fragment of a reproduction of the *Concert champêtre* showing the woman at the well. Taken by itself, this image might appear a relatively unimportant detail within the plenitude of images offered by the construction. As if to underscore its importance, however, Rauschenberg has affixed cut grass to the box below the image. The cut grass emphasizes the pastoral dimension of Rauschenberg's subject.

The notion of a pastoral construction—an object that exists in real rather than imaginary space—runs counter to an important strain of weak pastoral. Moreover, the various collage elements in *Odalisque* cannot be said to partake of the ideal: the rooster is stuffed, the grass is long dead, and the images are all torn from magazines. Nevertheless, the work constitutes a fascinating meditation on the possibilities and contradictions of contemporary pastoral. Instead of the idealized pastoral of

Louis, Rauschenberg ironically signals his intent to fashion a no less ambitious pastoral from the detritus of contemporary life.[17]

The instances of metapastoral described above all take an ironic view of traditional pastoral subjects and of the broader themes and forms that modern critics have defined as pastoral. If pastoral represents, in Castagnary's terms, a kind of escape, a flight from the world of social unrest, these artists show the ferment contained within that flight, one from which there is no escape.

10. Robert Rauschenberg, *Odalisque*, 1955–1958, mixed media
Museum Ludwig, Cologne

NOTES

1. Jules Castagnary, *Salons, 1857–1870,* vol. 1 (Paris, 1892), 17: It is an old truth, that idylls and eclogues have almost always been the consequence of social agitation. Jostled by the world's tumult, poets and dreamers find refuge in the peace of the fields, in the contemplation of a calm and serene nature.

2. Clement Greenberg, "Review of Exhibitions of Hyman Bloom, David Smith, and Robert Motherwell," in *Arrogant Purpose: 1945–1949,* vol. 2 of *Clement Greenberg: The Collected Essays and Criticism,* ed. John O'Brian (Chicago, 1986), 51.

3. Greenberg 1986, 2: 51–52.

4. Greenberg's understanding of Matisse and pastoral is explored in an unpublished article by John O'Brian, "Greenberg's Matisse and the Problem of Avant-Garde Hedonism." I am most grateful to the author for so generously making this work available to me.

5. David M. Halperin, *Before Pastoral: Theocritus and the Ancient Tradition of Bucolic Poetry* (New Haven, 1983).

6. Halperin 1983, 70–71. Cited in Harry Berger, Jr., "The Origins of Bucolic Representation: Disenchantment and Revision in Theocritus' Seventh *Idyll,*" *Classical Antiquity* 3 (1984), 4.

7. Lawrence Gowing, "The Modern Vision," in Robert C. Cafritz, Lawrence Gowing, and David Rosand, *Places of Delight: The Pastoral Landscape* [exh. cat., Phillips Collection and National Gallery of Art] (Washington, 1988), 227.

8. See John Barrell, *The Dark Side of the Landscape* (Cambridge, 1980); Michael Rosenthal, *Constable: The Painter and His Landscape* (New Haven, 1983); Ann Bermingham, *Landscape and Ideology: The English Rustic Tradition 1740–1860* (Berkeley, 1986).

9. Pierre-Henri de Valenciennes, *Elémens de perspective pratique, à l'usage des artistes, suivis de réflexions et conseils à un élève sur le genre du paysage,* 2d ed. (Paris, 1820), 398–399: [This genre] is absolutely ideal; and the landscape that is proper to it having to be inhabited by men, not as they are, but as the imagination supposes that they could be, it is required that it should be prepared to receive such mortals. The painter must represent beautiful nature as simple and majestic all at once, such as, finally, genius must create it on canvas, since one can no longer encounter it on earth.

10. Valenciennes 1820, 399–400: What has become of the fragrant groves of Paphos and of Amathonte? What has become of this happy Arcadia that the poets loved to compete in singing about? What remains of this delicious valley of Tempé, sheltered by Mounts Olympus and Piérus, watered by the river Pénée, and covered with woods that were thick and always green? The mountains, the rivers, the valleys exist still, but they are no longer like they were. The soil may still be fertile, but the produce is no longer the same. Instead of peaceable inhabitants who sang of their happiness and their ease, miserable slaves vegetate in ignorance and need; and one is astonished when one walks through these famous lands, to experience no other pleasure than the memory of their ancient splendor. The imagination, it is true, transports us to the time of their glory; one believes that one sees again all that they have lost: one consults the rocks, which have remained the only witnesses of this past grandeur. The silence of the valleys, the aridity of the plains, the stagnation of the waters inspire emotion and regret; and vainly one tries to imagine these delicious sites adorned with all the most pleasant and varied qualities that nature can offer; yet the gaze wanders over a fleshless skeleton that barely allows one to presume what it was at the time of its brilliant youth.

11. Berger's studies of pastoral themes and dynamics have covered a wide range of artists and writers, from antiquity through the Renaissance. A number of his Renaissance studies have recently been republished in two volumes. See Harry Berger, Jr., *Second World and Green World: Studies in Renaissance Fiction Making* (Berkeley, 1988); Berger, *Revisionary Play: Studies in the Spenserian Dynamics* (Berkeley, 1988).

12. These terms and ideas are thoroughly developed in Berger 1984, 1–39.

13. For a discussion of Courbet's painting and its reception, see the notice of Anne Dumas in *Courbet Reconsidered,* ed. Sarah Faunce and Linda Nochlin [exh. cat., Brooklyn Museum] (New Haven, 1988), 133–134.

14. The relationship between the two paintings is explored in Françoise Cachin's notice on *Le déjeuner sur l'herbe* in *Manet 1832–1883* [exh. cat., Galéries nationales du Grand Palais and the Metropolitan Museum of Art] (Paris, 1983), 165–172.

15. André Breton, *Le surréalisme et la peinture* (Paris, 1928), 12: It is impossible for me to consider a painting as other than a window, of which my first concern is to know *what it looks out upon,* in other words if, from where I am, "the view is lovely," I do love nothing so much as that which spreads out before me *until it fades from sight.*

16. This discussion of Klein depends particularly upon the documentation and interpretation of the artist put forward by Nan Rosenthal in "Assisted Levitation: The Art of Yves Klein," *Yves Klein 1828–1962: A Retrospective* [exh. cat., Institute for the Arts, Rice University] (Houston, 1982). Thanks go to Nan Rosenthal for her comments and suggestions offered at various stages of the preparation of this essay.

17. The relation of pastoral to assemblage is a complex topic deserving of fuller exploration. Pastoral themes make up an important part of the tradition of assemblage and collage art that, before Rauschenberg, includes the work of Kurt Schwitters, Max Ernst, and Joseph Cornell.

LEO MARX
Massachusetts Institute of Technology

Does Pastoralism Have a Future?

On this question, like most questions about pastoral, the experts disagree. At one pole of knowledgeable opinion there is the view, perhaps most clearly stated by Renato Poggioli, that the pastoral was virtually destroyed in the eighteenth century. In that era of scientific, industrial, and political revolution, when the prevailing European conception of humanity's relations with nature was transformed, traditional pastoral and its Virgilian conventions came to seem excessively, even ludicrously artificial.[1] It all but disappeared, according to Poggioli, leaving behind only ghostly, devitalized, largely unrecognizable intimations of the pastoral ideal. If we accept this account of the history, then the pastoral hardly can be said to have a future worth discussing.

At the other pole of informed opinion, we have William Empson's influential if paradoxical notion that the pastoral actually has flourished in the urban industrial wasteland. Of course Empson recognized that the advent of modernity had rendered obsolete what he called the "old" pastoral of shepherds, flutes, and flocks. But in Empson's view that passage of history, far from marking the end of pastoral, made possible its rejuvenation—the release of its energizing impulse from its long confinement within an outmoded, stultifying set of conventions. As a result pastoral—which is to say, that essential habit of mind—reappeared in new, more vital and relevant, if often unrecognizable forms. By the 1930s, Empson argued in *Some Versions of Pastoral*, pastoral had become almost ubiquitous. In that influential study of 1935 he selected for analysis various works that seldom if ever before had been associated with pastoral—*Alice in Wonderland*, Shakespeare's history plays, and such new genres as the documentary film and the left-wing "proletarian" novel—and he proceeded to demonstrate that they in fact could best be understood as disguised (or "covert") versions of pastoral.[2] If we accept Empson's account, then of course pastoral almost certainly has a future, perhaps even a long and promising one.

What are we to make of these contradictory judgments? Each is based on a radically different idea about what happened to pastoral with the onset of modernity, and it seems evident, on reflection, that this argument cannot be resolved by further examination of the historical evidence. The root issue is not one of fact but of theory. It is conceptual. To decide whether the essence of pastoral is inseparably bound up with abandoned conventions, as Poggioli believed, we would have to adopt a more or less explicit conception of its essence. What was—what is—the essential character of pastoral? We need to rethink the question, and not merely in the usual, narrow sense in which literary scholars, for example, distinguish between the pastoral and other literary forms. Since Empson, af-

ter all, the very status of pastoral as a formal entity, a genre or group of related genres, has been in doubt. To speculate sensibly about the future of pastoral, then, it is first necessary to answer a radical, ontologically prior set of questions: what sort of thing—what kind of entity—is pastoral? To what category of thought and practice does it belong?

I

To begin, let us attend carefully to the tacit answers of that undervalued critic, Shakespeare's Polonius. I am thinking of his seemingly nonsensical pronouncement when he rushes on stage, excited and breathless, to inform Hamlet of what he (Hamlet) already knows, that the players have arrived.

*The best actors in the world, either for tragedy,
comedy, history, pastoral,
pastoral-comical, historical-comical, tragical-
historical,
tragical-comical-historical-pastoral, scene in-
dividable, or poem unlimited.*
(Hamlet, II, ii, 385–390)

The first premise of Polonian critical theory is that drama is—and by implication all of the expressive arts are—a messy business. For whatever reason, incompetence or perversity, writers and artists simply will not confine their work to the categories favored by scholars and critics.[3] Not only do they heedlessly mix modes, but they constantly alter them. Almost every work, even a relatively pure specimen of, say, the pastoral-comical, evidently contributes to the unending transformation of this hybrid category.

Apart from his wise and refreshing insistence on the mutability of aesthetic kinds, the remarks of the discerning if pompous Lord Chamberlain strike me as particularly helpful in illuminating the nature of pastoral. Unlike critics who take an apologetic, condescending attitude toward pastoral, Polonius seems to recognize its potential seriousness, power, and heightened relevance in periods like the reign of Elizabeth I, when social change accelerates, cities grow rapidly, and an empire seems to be approaching the apex of its power. Thus he accords pastoral the status

of a mode comparable, in the universality of its appeal, to that of history, comedy, and tragedy. What requires particular emphasis is the clear implication that pastoral is not merely a genre but a mode. This is not to deny that in certain periods, such as the Renaissance, pastoral has been defined as—has indeed functioned as—a literary genre. In view of the overall history of pastoral, however, and the immense variety of forms in which the pastoral viewpoint has been expressed, it is difficult to quarrel with the Polonian notion that it has more in common with a mode like "the tragic" than, say, a genre like "the sonnet." A mode, as I am using the term then, is the broadest, most enduring and inclusive category of aesthetic kinds; it derives its character not from its formal properties, as a genre does, but rather from a special perspective on human experience, one that stresses the significance of certain conditions, aspects, or qualities of life to the relative neglect, necessarily, of others. This modal conception of pastoral accords with its long history of migrating from the classical shepherd poem to various other expressive forms, among them drama, painting, music, dance, the novel, film, landscape architecture, city planning, and political philosophy.

And yet, having suggested that pastoral is such a mode, I hasten to add that its essential character, as compared with the other modes invoked by Polonius, is peculiarly elusive. To be sure, concepts like tragedy, comedy, and history (or heroic or epic) are notoriously unstable; we know that their meanings have changed over time, and that to Arthur Miller, for example, tragedy does not mean exactly what it meant to Shakespeare or Aristotle. Nevertheless, it is possible to identify a more or less continuous, shared, if crude sense of what has been and still is meant in common parlance by the tragic. To see life as tragic, it has generally been agreed, is to emphasize the tyranny of circumstance in shaping human experience; the inextricable entanglement of our capacities for nurturance and destruction, good and evil, love and hate; and consequently the depleting sense of wasted energy, separation, and loneliness everyone inevitably suffers, all

of which is figured, in a tragedy's conclusion, by the overpowering fact of death. Regarding the viewpoint embodied in what Polonius called histories (an Elizabethan theatrical variant of the epic and chronicle play), we might agree that it focuses on the behavior of a people, its collective identity, and its struggle for survival as revealed by its conflicts with its enemies, and by the life stories of its heroes and leaders. As for the comic spirit, we generally assume that it highlights the satisfactions of human bonding and of communal solidarity, the recurrent renewal of vitality and the continuity between generations exemplified by the rites of love and marriage.

But what about pastoral? It seems far more difficult, for some reason, to identify a comparably crude but commonly accepted sense of the pastoral view of life. My impression is that today, in ordinary parlance, the word "pastoral" is taken as a reference to peaceful rural life. The most helpful recent scholarly effort to name the essence of pastoral is Paul Alpers' essay of 1982, "What Is Pastoral?"[4] Alpers is an accomplished classicist and student of Virgil, and his aim is to identify the pastoral's central, relatively constant distinguishing feature. After surveying the leading claimants to that role—among them, a longing after innocence and happiness, the Golden Age, the idyllic landscape, the conflict between Art and Nature, hostility to urban life, the ideal of contentment (otium)—he concludes that we can only get at the heart of pastoral by recognizing its historical roots in an art form—a kind of poetry— whose primary subject was the lives of shepherds.

Although Alpers does not reject the received idea that pastoral is a literary form, he nonetheless insists on the centrality, in defining its essence, of a particular way, or view, of life. Its preeminent feature, he argues, is its concern with the lives of shepherds, and all of its other characteristic features—formal, expressive, thematic—are subsidiary means of representing that way of life. It follows that pastoral, contrary to popular misconceptions, is not chiefly about nature or landscape, but a particular way of being in the world. This point deserves emphasis, since art histor-ians tend to assume that landscape is the decisive element in pastoral.[5] If we follow Alpers, however, we are justified in referring to landscapes as "pastoral" only "when they are conceived as fit habitations for shepherds or their equivalents." In his view, then, pastorals are works whose primary aim is to represent the way of life of shepherds or their surrogates, figures who in turn "are felt to be representative of some other or of all other men."

In spite of Alpers' formalist assumptions about the nature of pastoral as a genre, he virtually endorses the viewpoint Shakespeare put into the mouth of Polonius. He acknowledges that the essence of pastoral, like that of tragedy, is not any formal structure or convention, but a way or view of life that may be called *pastoralism*. We need that term, or one like it, to sharpen the distinction between the essential, long-lived, energizing mentality and (1) the many aesthetic forms or genres, such as poems or landscape paintings, and (2) the variety of particular works (*pastorals*), in which the mentality (*pastoralism*) has been given expression. "Pastoral," in other words, refers to the mode and to the subsidiary forms, works of art or particular embodiments, that lend expression to "pastoralism," the mentality or view of life.[6]

But this argument cries out for answers to a further set of questions. It hardly is enough to say that the key to the subject is pastoralism if, as seems evident, pastoralism outlasted its original association with the lives of shepherds. Even Alpers, who insists on the essential relationship between pastoral and shepherds' lives, but who also admires Empson, concedes that pastoralism can be and often has been represented by other, surrogate figures. In that case we need to know which attributes of shepherds' lives the surrogates represent. Besides, it seems probable that the pastoralism figured forth by the early shepherd poems had a prior, extra-literary history. All of this directs our attention to the origins and implications of the mentality itself, of pastoral-*ism*—as distinct, perhaps, from the literary conventions in which it received expression. Indeed this line of thought impels us to ask such basic questions as: Why shepherds? Why were they so

often selected as model or exemplary figures? What aspects of their occupations, their lives, real or imagined, initially made them favored subjects of representation, not to say idealization? In view of the shepherd figure's ubiquitous presence in Western thought and expression, both secular and religious, it is curious that these questions have so rarely been addressed.

One reason for our reluctance to pursue the subject, admittedly, is that all explanations of the origins of pastoralism must be largely conjectural. Nevertheless, a body of recent scholarship, usefully summarized and interpreted by David Halperin, lends support to a fresh and compelling genetic theory.[7] Halperin draws upon recent work in ancient history, anthropology, classics, and archaeology, all of which supports the view that pastoralism has a much longer history than had been supposed. Indeed a large body of evidence indicates that the peoples of the ancient Near East had begun to invest the herdsman with special religious, metaphysical, and political significance some two millennia before the figure acquired a unique poetic aura in the pastoral poems of Theocritus and Virgil. The work of Halperin and others contains a plausible hypothesis for explaining the emergence of pastoralism.

The key to this theory is the concept of the herdsman as a liminal, or threshold figure. As formulated by folklorists and ethnographers, notably Arnold von Gennep and Victor W. Turner, *liminality* refers to the peculiar attraction exerted by people who enjoy the status of, or are perceived to be, mediators—who seem to occupy the borderland—between such fundamental, distinct, yet in many respects opposed realms of being as nature and culture. "Liminality," according to Turner, may be seen as:

a period of structural impoverishment and symbolic enrichment. It is essentially a period of returning to first principles and taking stock of the cultural inventory. To be outside of a particularized social position, to cease to have a specific perspective, is in a sense to become (at least potentially) aware of all positions and arrangements and to have a total perspective.[8]

The shepherds of the ancient Near East who took the city's flocks into the countryside (as distinct from nomadic pastoralists), were especially eligible for the role of liminality. Seen from one perspective, they were representatives of the urban community whose mission was to protect its flocks from such hazards of untrammeled nature as storm, drought, and attacks by wild beasts. From another perspective, however, the shepherds might be regarded as privileged escapees from social complexity and constraint. Living lives of relative independence and self-sufficiency, they might indulge in such impractical but pleasurable pursuits as music, poetry, contemplation, or making love. Their situation, in short, invited idealization as a *via media* between ways of life characteristic of opposite settings, each with its positive and negative features: in the town the amenities and constraints of a complex, organized social order; in the countryside the freedoms, pleasures, and hazards of unspoiled nature.

Shepherds enjoyed an ideal liminality in a double sense. Their work placed them on two kinds of threshold: that between society and the surrounding environment (nature), and that between society and the transcendent or supernatural—the realm of divinity. In this last respect they resembled the holy men of late antiquity who also withdrew in the direction of nature and whose oracular wisdom was thought to derive at least in part from their access to the natural.[9] The herdsmen's similar act of disengagement no doubt accounts for the aura of magic and enchantment, a quasi-religious metaphysical potency, that so often hovers over pastoral figures.

To sum up, then, the essence of pastoralism is a sophisticated vision of the simple life led by a shepherd (or surrogate) figure, one who mediates between the imperatives of nature and culture, between the dangers and deprivations of the undeveloped environment (wild nature) and the excessive constraints of civilization. The pastoral way of life, or condition of liminality, is marked by a temporary disengagement from the workaday world and an enhanced state of self-sufficiency, leisure, and pleasure, especially the sensuous enjoyment of music, art, and lovemaking. When the figure of the shepherd disappeared from litera-

ture and art in the eighteenth century, many direct, overt links with ancient pastoralism were broken. But the appeal of shepherdlike liminality survived. In the modern era it continues to manifest itself wherever we become aware of a conflict between two ways of life, one identified with social complexity, the other with natural simplicity. Thus the continuing cogency of Erwin Panofsky's identification of Virgilian pastoral with imaginary environments that convey a sense of discrepancy, or "dissonance," demanding resolution, between their "supernatural perfection" and "the natural limitations of human life as it is."[10]

William Empson invoked a homologous, if excessively formulaic concept of liminality when he defined the essential habit of mind of pastoral as "putting the complex into the simple."[11] To be sure, pastoral, as conceived at this high level of abstraction, seems to include any work that converts the random specificity of raw experience into the highly selective, hence ordered and simplified patterns of art. What works of art, we might ask, do *not* in that sense involve "putting the complex into the simple"? Because of its generality Empson's definition is too porous, too indiscriminate, for practical use. Yet Empson's clever definition of this "trick of thought" (another of his characterizations of pastoral) does convey the ambivalence emanating from the idealized figure of the ancient herdsman, who could represent both a complex society and at the same time a simpler way, "closer," as we say, "to nature."

2

The American case illustrates the extraordinary resilience of pastoralism—its capacity for adaptation to new times, new places, new social and political situations. With the demise of the Old European shepherd convention in the late eighteenth century the mode was rejuvenated, and in the era when the American republic was founded it reappeared in new guises. Now pastoralism was embodied in fresh, New World images of an ideal liminality, a potential harmony between society and nature. As I have tried to demonstrate else-where, Thomas Jefferson and his contemporaries developed the idea of the new republic as a society of the middle landscape, midway between the artificiality of the *ancien regime* and the savagery of the western frontier—a blend of the best features of civilization (or art) and the best features of nature.[12] Under American conditions pastoralism took on a new, democratic literalism; instead of being a mere fantasy of the privileged and powerful, in which the ideal place represents a largely nostalgic retreat from social reality, it now was a future-oriented, relatively egalitarian, not infeasible vision of liminal possibility.

In nineteenth-century America, however, pastoralism was a minority viewpoint, adhered to chiefly by intellectuals, writers, artists, and other cultural dissidents. To many it provided an appealing alternative to the reigning ideology of progress, with its shallow utilitarianism, its negligent attitude toward the natural landscape, and its uncritical endorsement of the most rapid possible acceleration of the rate of economic growth and technological innovation. The economic goal of the pastoral alternative, as set forth by Jefferson in "Query XIX" of *Notes on Virginia*, was sufficiency, not the maximizing of productivity or consumption. It is a liminal goal in that it valorizes the threshold between scarcity and luxury, raw nature and overcivilization. That Jefferson was advocating a pastoral rather than a conventionally "agrarian" policy is indicated by his explicit rejection of the primacy of economic criteria in assessing the relative merits of social policies. He urged Americans to "let . . . [their] workshops remain in Europe" even if, as seemed likely, that policy resulted in a lower material standard of living. The economic "loss," he wrote, "will be made up in happiness and permanence of government."[13] As early as the 1780s Jefferson thus prefigured the familiar late twentieth-century conflict between economic growth and "quality of life" as primary goals of social policy.

Pastoralism of this antiprogressive sort has continued to be an identifiable strand in our adversary culture. It has served to express the resistance of individuals to in-

corporation in mechanical and bureaucratic systems of power. This mode of thought and expression comes down to us through, among others, the transcendental idealists, Emerson, Thoreau, and Whitman; the landscapists and planners (A. J. Downing and F. L. Olmsted), architects (Louis Sullivan and Frank Lloyd Wright), and architectural critics (Montgomery Schuyler and Lewis Mumford); and the beat writers and student radicals who associated themselves with the "revolt against the machine" in the 1950s and 1960s, all of whom were committed to some version of the "organic principle" as a guide to achieving harmony between mechanized means and "natural" ends. Thus Mario Savio's famous appeal in 1964 to the Berkeley student radicals to "put your bodies on the machine and make it stop" echoed Thoreau's injunction in "Civil Disobedience" (1845) to "let your body be a friction to stop the machine." Similarly, the anti-Vietnam War movement drew upon our native tradition of pastoral rhetoric with its penchant for "dropping out" and its slogan, "Make love, not war!"

During the nineteenth century the "classic" (canonized) American writers developed a hybrid form, the pastoral romance, which featured an action initiated by obedience to the pastoral impulse. Thus the hero characteristically sets the story in motion by obeying the urge, in the face of the increasing power and complexity of organized society, to withdraw in the direction of nature. Following the hero's disengagement from society, the central portion of the narrative in such works as *Walden*, "Song of Myself," *Moby-Dick*, and *Huckleberry Finn* recounts his modern version of the romance hero's "perilous journey," now an exploration of "nature" in search of an alternative way of life. Whereas European pastorals were enacted in what only could be thought of as imaginary landscapes, landscapes of mind, Thoreau asks his readers to credit the actuality of his two-year retreat, or "life in the woods" (the subtitle of *Walden*), as a literal "experiment" in living deliberately. The hero reduces the book's crucial lesson for coping with the complexities of a modernizing society to the quintessential pastoral injunction: "Simplify! Simplify!" *Walden*, the record of an experiment in which the hero remakes himself, is one of the few works of the American literary imagination, along with Sarah Orne Jewett's *Country of the Pointed Firs*, that might be called a "pastoral of success." "Success" in this context means that the enactment of the pastoral motive results in the discovery or achievement of a truly harmonious way of life.

But of course the conditions necessary for realizing the state of liminality in America proved to be elusive, and most of our pastoral romances reflect that fact. They characteristically are pastorals of failure. We also may refer to most of these works as "complex" pastorals in that they register, and in some sense come to grips with, the effective presence of the forces working against the realization of the pastoral motive. In complex pastorals like *The Scarlet Letter*, *Moby-Dick*, *Huckleberry Finn*, *The Great Gatsby*, "The Bear," or the typical Frost lyric, the pastoral ideal is invoked, it is true, but chiefly in order—as it turns out—to convey its unattainability. These works come closer to being pastorals of failure than of success, and may be taken as elegies for—or jeremiads about—the new nation's unfulfilled aspirations.[14]

3

Nineteenth-century American landscape painters also created a distinctive version of pastoral. They did so by introducing into their work, whose essential form they borrowed from the neoclassical pastoral landscapes of Nicolas Poussin and Claude Lorrain (especially Claude), potentially dissonant images of the emerging industrial technology. These new instruments of mechanized motive power—factories, steam engines, steamboats, railroads, especially the railroad—came to represent the complex world, a modern counterforce to the pastoral vision of natural simplicity like the worldliness represented, in preindustrial versions of pastoral, by the royal court or the city. In the dominant mid-century culture the railroad, embodiment of the most conspicuous attributes of industrial technology—steam, speed, iron, fire, smoke, noise—now became the preeminent emblem of progress.

In his essay of 1836 in praise of "American Scenery," Thomas Cole, leading spirit of the Hudson River School painters, expressed his fears about what Americans were doing to the national terrain. It was an age, he felt, "when a meager utilitarianism seems ready to absorb every feeling and sentiment, and when what is sometimes called improvement in its march makes us fear that the bright and tender flowers of the imagination shall all be crushed beneath its iron tramp." The "tramp" Cole heard was of course made by the iron horse, and at the troubled conclusion of the essay Cole underscored his impression that the beauty of the American landscape was "quickly passing away," the "most noble scenes" were being "made desolate," and often "with a wantonness and barbarism scarcely credible in a civilized nation."[15]

And yet when Cole introduced the image of the railroad into a painting, little of that feeling came through. In 1836 the Canajoharie & Catskill Rail Road had begun building a line within sight of Cole's home in the village of Catskill, and in fact the right-of-way cut across one of his favorite prospects. He was terribly upset, and in a letter he denounced the "copper-hearted barbarians" who were "cutting *all* the *trees* down in the beautiful valley on which . . . [he had] looked so often with a loving eye."[16] Yet the diminutive, unobstrusive train in his painting *River in the Catskills*, 1843 (fig. 1), scarcely conveys his sense of outrage, his conviction that the new power was a serious threat to the beauty, harmony, and order of nature. The contemplative axeman who calmly surveys the scene, the rower on the river, and the boy walking his dog all contribute to a conventional or pastoral sense of peace.

To be sure, when historians compare this painting with Cole's earlier treatment of virtually the same setting, *View of the Catskill, Early Autumn*, 1837 (fig. 2), they discover some evidence of Cole's altered feelings. Kenneth Maddox notes that in the later painting many trees have been cleared from the distant landscape and more houses have come into view.[17] The version of 1837, with its idyllic image of galloping wild (rather than iron) horses and of the woman offering flowers to the child, is more elegiac. It also is more conventional in the sense of employing the standard compositional features of the classic pastoral landscape, especially the repoussoir trees and the resulting framelike balance of vertical and horizontal lines, as in Claude's characteristic *Landscape with Merchants*, 1635 (fig. 3). Barbara Novak has noted several other possible consequences of Cole's hostility toward the railroad discernible in the painting of 1843: a greater horizontality (the usual tall trees are missing); and, in the left foreground, the stumps, fallen branches, and the axeman—all familiar icons of the ambiguous transformation of nature by the forces of "progress."[18]

The fact remains, though, that Cole's partly concealed little train hardly disturbs the placid rusticity that permeates the landscape. Nor does it effectively undercut the confidence, fostered by the dominant ideology of progress, that most Americans had in the essential compatibility between the expansion of industry and the beauty of landscape. The truth is that Cole's paintings belong to a fairly large group of American landscapes of that era in which a minuscule but centrally located locomotive is made to blend more or less seamlessly into a pastoral scene.[19] In some the train is all but invisible, as if designed to be part of a children's puzzle called "Find the Train." A striking example is Thomas Doughty's *"A View of Swampscott, Massachusetts,"* 1847 (fig. 4), in which our attention is drawn, because of its paradoxically central location at the apex of a broad inverted triangle of sunlit countryside, to a barely visible, diminutive smoking locomotive.

Why did the work of Cole and his colleagues fail to convey the fear Cole had so forcefully expressed in his essay of 1836? Far from conveying their anxieties about the new industrial power and its effect on the national scene, these artists seem bent on showing how easily and harmoniously it could be assimilated into the stock Claudian landscape. Some of the painters no doubt were constrained, or partly persuaded, by the prevailing faith in technological progress and by their desire to avoid offending wealthy patrons who were likely to be adherents of that faith. Then, too,

1. Thomas Cole, *River in the Catskills*, 1843, oil on canvas
Museum of Fine Arts, Boston, M. and M. Karolik Collection

2. Thomas Cole, *View of the Catskill, Early Autumn*, 1837, oil on canvas
Metropolitan Museum of Art, New York, Gift in memory of Jonathan Sturges by his children

3. Claude Lorrain, *Landscape with Merchants*, 1635, oil on canvas
National Gallery of Art, Washington, Samuel H. Kress Collection

4. Thomas Doughty, *A View of Swampscott, Massachusetts*, 1847, oil on canvas
Worcester Art Museum

they conceived of the very purpose of landscape painting—its essence—as the celebration of harmony between the worldly and the simple, the social and the natural, the present and the past. Was not the reconciling of those fundamental conflicts at the heart of classic pastoral, as exemplified, say, by the presence in the Claude (fig. 3) of the rich merchants and the castle ruins? The received conception of the form was irreconcilable with the image of a landscape devastated by the new power, and indeed many artists—perhaps more on the other side of the Atlantic—regarded the appearance of the railroad as an announcement of the death of pastoral. Thus Samuel Palmer, a painter influenced by William Blake's Virgilian woodcuts, in a letter of 1862: "Mr. Severn says this is a Claude country where you may see his very trees. Ah where is the Virgilian muse? At the railway whistle she fled forever."[20]

The fact is that the genre of landscape painting, and indeed art in general, was then widely conceived as a means of effecting the reconciliation of such fundamental conflicts. Ralph Waldo Emerson looked to the work of writers and artists as a virtual means of resolving the specific opposition between technology and nature. In "The Poet," 1844, he noted that readers "see the factory-village and the railway, and fancy that the poetry of the landscape is broken up by these." But that was the public's misconception, he argued, and it resulted from the novel character of these innovations and the fact that they were "not yet consecrated in their reading." They seemed ugly because they had not yet been redeemed from their condition of dislocation, or detachment, which is to say, from the divine order of things. But the poet or artist, "who reattaches things to nature and the Whole,—reattaching even artificial things, and violations of nature, to nature, by a deeper insight—disposes very easily of the most disagreeable facts."[21] Art, in other words, can help to overcome the dislocating effect of change by making available for society's emulation works that are, in effect, ideal symbolic reconstructions of reality. Thus the painter of pastoral landscapes exemplifies the possibility of reconciling the new machine power with the natural order.

Emerson's influential idealistic aesthetic helps to explain the way Cole and other painters responded to the appearance of the new technology in the landscape. Cole's treatment of the railroad in *River in the Catskills* (fig. 1) was aimed at reattaching a "disagreeable fact" or "violation of nature" to "nature and the Whole." Hence the aesthetically pleasing device of blending the inoffensive locomotive into the lines, shapes, and colors of the landscape—into the very tissue of organic nature. This strategy tends toward sentimental pastoralism—"sentimental" in that it denies or masks the power of the hostile forces that would impede the realization of the pastoral ideal. In painting, as in literature, the more interesting works are instances of complex pastoralism—"complex" in that they attempt to cope with, to represent the power of those antagonistic or destructive forces. In doing so they in effect adapted pastoral landscape painting to the discordant import of the new technologies.

According to the current consensus of informed opinion, the most powerful expression of complex pastoralism in nineteenth-century American landscape painting is probably George Inness' *The Lackawanna Valley* of around 1855 (fig. 5). The evidence suggests, however, that Inness owed the success of this work to external or extra-aesthetic influence—to economic pressure; indeed, his personal preference, if left to his own devices, was for incorporating the railroad in a far more conventional, even sentimental version of pastoral. His three later paintings entitled *Delaware Water Gap*, two in 1857 (fig. 6), one in 1861 (fig. 7), convey almost nothing of the new power's damaging potential; these are in fact bland and harmonious landscapes that might have been composed in accordance with Emerson's prescription for disposing of "disagreeable facts" that threaten to break up "the poetry of the landscape." In the painting of 1861, indeed, Inness goes further than either Cole or Doughty and introduces a gaudy rainbow to bless the new power with a touch of "the technological sublime."[22]

But Inness was not always left to his own devices. In accepting the railroad's commission to depict the site of its yards in

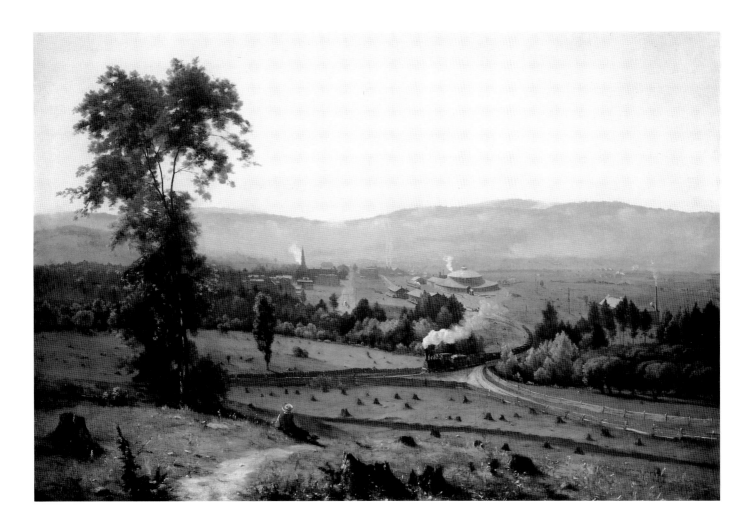

5. George Inness, *The Lackawanna Valley*, c. 1855, oil on canvas
National Gallery of Art, Washington, Gift of Mrs. Huttleston Rogers

Scranton, Pennsylvania—the company apparently hoped to use his work for advertising purposes—he in effect committed himself to a far greater degree of verisimilitude than he would have liked, or that was consonant with either the Emersonian aesthetic or the French Barbizon School style. (He had formed a favorable impression of the latter during his sojourn in France between 1853 and 1854.) The result, in any case, was a painting that lent itself to diametrically opposed interpretations. Some critics have praised Inness for his skill in assimilating the harsh utilitarian scene to the demands of the pastoral convention; others have called *The Lackawanna Valley* a "shocking picture," whose power derives from the "rudeness" with which it treats the pastoral convention.[23]

From one perspective Inness' painting may be said to retain many features of Claudian pastoral: the sense of balance cre-

ated by the work's overall horizontality (including the lateral sweep of the railroad tracks) in conjunction with the strong verticality of the repoussoir tree in the left foreground; the train's seeming to thread its way neatly into the countryside along a gently curving (rather than rectilinear) right-of-way; the fact that the railroad yard is enveloped by green woods, distant hills, and sky; the white puff of smoke in the middle distance setting off the silhouette of the church steeple; the quietude suggested by the placid cattle, undisturbed by the train; and the obligatory mood-setting shepherd figure who contemplates the scene.

But with a slight shift of perspective the railroad yards take on the aspect of a threatening military installation. Here, as in several other paintings of the period, such as Thomas Prichard Rossiter's dramatic, bleak *Opening of the Wilderness* of

6. George Inness, *Delaware Water Gap*, 1857, oil on canvas
James Maroney, New York

7. George Inness, *Delaware Water Gap*, 1861, oil on canvas
Metropolitan Museum of Art, New York, Morris K. Jessup Fund

about 1858 (fig. 8), we have the painterly equivalent of the popular American military rhetoric of the era, with its tacit definition of the "progress of civilization" and of the nation's "manifest destiny" as the "conquest of nature." The roundhouse has the aspect of a fortress; the smoke, jagged stumps, and denuded ground, like the oncoming train, register the aggressive penetration of the natural by the technological. What we see in the middle ground of *The Lackawanna Valley*, moreover, is not a single new invention, no mere steam locomotive, but a new kind of expansionary technological system represented by the many sheds abutting the roundhouse, several smoking trains, and on close examination, indeed, by the entire yellow-brown center of the landscape (fig. 9) from which nature's green has been eliminated and a nameless, centrifugal energy seems to emanate.[24]

Inness' painting exemplifies the adaptability of pastoralism to the conditions of industrialization that might seem to be inherently inhospitable to that ancient mode. In *The Lackawana Valley*, as in *Walden*, *Moby-Dick*, *Adventures of Huckleberry Finn*, *The Great Gatsby*, and other works by the "classic" American writers, Inness perforce has caught that poignant dissonance, a distinctive note of foreboding intermixed with the idyllic, that typifies many of the most affecting creations of the native imagination. Although Inness' success in transcending the limits of the sentimental pastoralism he favored is in large measure attributable to extra-aesthetic, economic influences—to constraints stemming from his commission by the company—the ambivalence of his response to the forces of change nonetheless is the key to his achievement in *The Lackawanna Valley*. The painting exemplifies the power of complex pastoralism. If it is the most affecting, powerful, and provocative work in this subgenre of machine-in-the-landscape paintings, this is largely because it captures the most subtle and profound aspect of its subject: the moral ambiguity, the intertwining of constructive and destructive consequences, which are generated by technological progress.

4

Does pastoralism have a future? If we accept the Shakespearean view that pastoralism is not a genre, form, or body of conventions, but a mode comparable in its enduring power with the tragic, comic, or epic modes, then how can we doubt that it has a future? Today the prevailing conception of humanity's relationship with nature—the most basic, least alterable source of our sense of liminality—is undergoing a transformation more radical than that of

8. Thomas Prichard Rossiter, *Opening of the Wilderness*, c. 1858, oil on canvas
Museum of Fine Arts, Boston, M. and M. Karolik Collection

the eighteenth century, when the pastoral also was radically transformed. Humanity, having believed through all of its history that it existed at the mercy of all-powerful natural forces, now suddenly finds the relationship reversed. Now we have plausible reason to think of ourselves as capable, for the first time, of inflicting irreparable damage upon—indeed, of making uninhabitable—the global environment. This wholly new conception of the precariousness of our relations with nature is bound to bring forth new versions of pastoral. After all, pastoral always has served to represent humanity's awareness of its location on thresholds between the complex and the simple, between art and nature.

But it will be said that such high seriousness would violate the spirit of sophistication, knowingness, and esoteric aestheticism that for so long had characterized the pastoralism of Western high culture. This is perfectly true. The new pastoralism

I am trying to imagine surely will be very different in viewpoint and in tone. But the difference will, I believe, prove to be less significant, finally, than the persistence of those underlying concerns that always have given the mode its distinctiveness. If pastoralism was able to survive the disappearance of the shepherd convention, it surely can survive this shift in point of view and tone.

To be sure, the pastoralism that is now emerging will no longer exhibit the conspicuously aristocratic, patrician, upper class, or elitist viewpoints that had been one of its hallmarks. As early as 1930 Empson suggested the dispensibility of that elitism in noting that one of the chief functions of the old pastoral was to promote the illusion of class harmony, the idea, as he put it, of a "beautiful relation between rich and poor."[25] But why assume that such a class bias is more essential to pastoral than to tragedy, comedy, or epic? In any case, it

was a peculiarity of the "old pastoral" and it has been losing credibility since the romantic movement and the demise of the shepherd convention. This is one reason why the usual left-wing criticism of the pastoral often seems misdirected and superficial.

More important, the left-wing critique of pastoral is unsatisfactory because it tends to invoke a simple representational criterion of value, as if pastoral could be discredited by demonstrating its lack of verisimilitude—that it falsifies social reality. Raymond Williams, John Barrell, and other critics on the left have taken pains to demonstrate that pastoral poets and painters have failed to reveal the true facts about rural class relations, work, and poverty. They surely are correct: pastoral has carried a heavy burden of upper-class prejudice and of unconcern for the actual conditions of rural life. The trouble with this approach to pastoral, however, is that practitioners of the mode rarely purported to be presenting a literal, naturalistic, or realistic account of shepherds' lives. Pastoral almost always has entailed an undisguised idealization of rural life, but the class bias in pastoral art, like that which pervades the art of most cultures, is not an integral feature of the mode. On the contrary, the tendency to idealization might well be seen by critics on the left not as a failed effort to transcribe reality, but rather as a vehicle of quasi-utopian aspirations without which no critique of existing culture can be effective or complete. On this point I would invoke E. P. Thompson's moving repudiation, in a reissue of his biography of 1955, of his own earlier dismissal of the utopianism of William Morris; in retrospect Thompson came to realize that the utopian strain in Morris' thought did not represent an avoidance of reality, but an effort to "educate desire." This view would seem applicable to the idealization inherent in complex pastoralism.[26]

In the United States, Jefferson, Thoreau, and many of the "classic" writers of the nineteenth century had begun the transition to a less class-bound, more democratic and socially inclusive expression of pastoral motives. By now that transition has been largely accomplished and presumably will be incorporated in the new versions of pastoral emerging today. The exact form that the new versions will take is of course unpredictable. But they surely will involve a recasting of the pastoral figure's liminality and an updating of certain other recurrent, more or less constant themes of this ancient view of life—for instance, the characteristic pastoral preference, in imagining relations between society and nature, for accommodation or harmony rather than domination or conquest; a preference, in projecting economic aspirations, for sufficiency rather than maximum production, consumption, or limitless growth; a preference, in the realm of individual morality, for the satisfactions of immediate, personal experience rather than for the triumphs of what the Elizabethans called "the aspiring mind"; and a like preference, in expressing epistemological desires, for workable ideas in the here and now rather than a permanently grounded, absolute, or context-free truth. It seems probable, in sum, that a twenty-first century version of pastoral will lend expression to a yearning for an altered relation to the natural, and to a heightened sense, in Thomas Pynchon's words, that "Somewhere among the wastes of the World, is the key that will bring us back to our Earth and to our freedom."[27]

1. Poggioli specified four cultural trends—the humanitarian outlook, the idea of material progress, the scientific spirit, and aesthetic realism—that proved to be fatally antipathetic to traditional pastoral. Renato Poggioli, *The Oaten Flute: Essays on Pastoral Poetry and the Pastoral Ideal* (Cambridge, 1975), 31–34.

2. William Empson, *Some Versions of Pastoral: A Study of the Pastoral Form in Literature* (London, 1950).

3. That Shakespeare's target here is the effort of critics to confine writers within set literary boundaries is suggested by Polonius' reference to "scene individable or poem unlimited"; that phrase usually has been taken as a reference to the players' willingness either to perform a drama that observes the classical unities ("scene individable") or, if desired, one that violates them ("poem unlimited").

4. Paul Alpers, "What Is Pastoral?" *Critical Inquiry* 8 (Spring 1982), 437–460.

5. That art historians regard landscape as the key to pastoral is abundantly illustrated by many of their observations in Robert C. Cafritz, Lawrence Gowing, and David Rosand, *Places of Delight: The Pastoral Landscape* [exh. cat., Phillips Collection and National Gallery of Art] (Washington, 1988).

6. This is a conception of the subject I have intermittently been developing since *The Machine in the Garden: Technology and the Pastoral Ideal in America* (New York, 1964); it was further elaborated in several essays reprinted in *The Pilot and the Passenger, Essays on Literature, Technology, and Culture in the United States* (New York, 1988), especially "Susan Sontag's 'New Left Pastoral': Notes on Revolutionary Pastoralism"; see also "Pastoralism in America" in Myra Jehlen and Sacvan Bercovitch, eds., *Ideology and Classic American Literature* (Cambridge, 1986), 36–69; and "The Railroad-in-the-Landscape: An Iconological Reading of a Theme in American Art," in Susan Danly and Leo Marx, eds., *The Railroad in American Art: Representations of Technological Change* (Cambridge, 1988), 183–209.

7. David M. Halperin, *Before Pastoral: Theocritus and the Ancient Tradition of Bucolic Poetry* (New Haven, 1983). See especially chap. 6, "Pastoral Origins and the Ancient Near East."

8. Victor W. Turner, "Myth and Symbol," *International Encyclopedia of the Social Sciences* (New York), 10:576–578; Turner develops the concept in *The Forest of Symbols: Aspects of Ndembu Ritual* (Ithaca, 1967), and *The Ritual Process: Structure and Anti-Structure* (Chicago, 1969); for the origin of the concept see Arnold van Gennep, *The Rites of Passage* (London, 1960).

9. Peter Brown, "The Rise and Function of the Holy Man in Late Antiquity," *Journal of Roman Studies* 61 (1972), 80–101.

10. Erwin Panofsky, "*Et in Arcadia Ego:* Poussin and the Elegiac Tradition," *Meaning in the Visual Arts* (Chicago, 1982), 300.

11. Empson 1950, 23.

12. Marx 1964, 73–144.

13. Adrienne Koch and William Peden, eds., *The Life and Selected Writings of Thomas Jefferson* (New York, 1944), 280.

14. Sacvan Bercovitch, *The American Jeremiad* (Madison, Wis., 1978).

15. Thomas Cole, "Essay on American Scenery," in John Conron, ed., *The American Landscape: A Critical Anthology of Prose and Poetry* (New York, 1974), 568–578.

16. See Kenneth W. Maddox, "Thomas Cole and the Railroad: Gentle Maledictions," *Archives of American Art Journal* 26 (1986), 2–10; Susan Danly, introduction to Danly and Marx 1988, 1–26. Emphasis in original.

17. Maddox 1986, 7.

18. Barbara Novak, *Nature and Culture: American Landscape and Painting, 1825–75* (New York, 1980), 162–163.

19. For a more detailed discussion of this group of paintings, see Marx, "The Railroad-in-the-Landscape: An Iconological Reading of a Theme in American Art," in Danly and Marx 1988, 183–208.

20. Samuel Palmer to William Linnell, January 1862, quoted by Annabel Patterson, *Pastoral and Ideology: Virgil to Valéry* (Berkeley, 1987), 289.

21. Ralph Waldo Emerson, "The Poet," *Selected Writings* (New York, 1981), 312.

22. This painterly idiom might be described as the graphic counterpart to "the rhetoric of the technological sublime," which is to say, a rhetoric designed to invest secular images of technology with the capacity to evoke emotions—awe, wonder, mystery, fear—formerly reserved for images of boundless nature or for representing a response to divinity. See Marx 1964, 195–207.

23. For a more detailed account of the painting's history and of the subsequent critical debate, see Nicolai Cikovsky, Jr., "George Inness's *The Lackawanna Valley*: Type of the Modern"; and Leo Marx, "The Railroad-in-the-Landscape," both in Danly and Marx 1988, 71–91, 183–209.

24. For the railroad as archetype of a new kind of technological system that "called forth" a new form of corporate management, see Alfred Chandler, *The Visible Hand: The Managerial Revolution in American Business* (Cambridge, 1977).

25. Empson 1950, 11.

26. E. P. Thompson, "Postscript: 1976," *William Morris: Romantic to Revolutionary* (New York, 1977), 763–810. For the left-wing critique of pastoralism see, for example, Raymond Williams, *The Country and the City* (New York, 1973); John Barrell, *The Dark Side of the Landscape: The Rural Poor in English Painting, 1730-1840* (Cambridge, 1980).

27. Thomas Pynchon, *Gravity's Rainbow* (New York, 1973), 525.

Contributors

Bettina Bergmann is the Idella Plimpton Kendall Assistant Professor of Art at Mount Holyoke College. She received her Ph.D. in 1986 from Columbia University and was visiting assistant professor in the department of fine arts at Harvard University from 1989 to 1991. The recipient of fellowships from Dumbarton Oaks, the American Academy in Rome, and the Getty Center for the Visual Arts, she is currently finishing a book on the Roman art of landscape for Princeton University Press and is working on a project on Roman interiors.

Howard M. Brown, Ferdinand Schevill Distinguished Service Professor of Music at the University of Chicago, has written extensively on the music of the Renaissance. His books include *Music in the French Secular Theater, 1400–1550, Instrumental Music Printed before 1600, Embellishing Sixteenth-Century Music, Music of the Renaissance,* and *A Chansonnier from the Time of Lorenzo the Magnificent,* which won the Kinkeldey Prize of the American Musicological Society for the best scholarly book of the year. He has taught at Wellesley College and at the University of London, where he held the chair as King Edward Professor of Music. He has served as president of the American Musicological Society, of which he is now an honorary member, and as vice president of the International Musicological Society.

He is a foreign honorary member of the Royal Musical Association, and in 1988 he was awarded the Galileo Galilei Prize by the University of Pisa for his contributions to the study of Italian culture.

Louise George Clubb is professor of Italian and comparative literature at the University of California, Berkeley, and general editor of the University of California Press series Biblioteca Italiana. Her books include *Giambattista Della Porta: Dramatist* (1965), *Italian Plays (1500–1700) in the Folger Library* (1968), *Della Porta: Gli duoi fratelli rivali/The Two Rival Brothers* (1980), *Italian Drama in Shakespeare's Time* (1989), and forthcoming, with Robert Black, *Romance and Aretine Humanism in Sienese Comedy, 1516.* Currently she is contributing to *The Oxford Illustrated History of the Theatre.*

Alfred Frazer is professor of art history and archaeology at Columbia University. Among his recent publications is *The Propylon of Ptolemy II, Samothrace.*

Louise K. Horowitz is professor and chair of French at Rutgers University, Camden, and a member of the Rutgers, New Brunswick, graduate faculty. A past recipient of fellowships from the Woodrow Wilson Foundation and the American Council of Learned Societies, she is the author of two books on seventeenth-century French liter-

ature: *Love and Language: A Study of the Classical French Moralist Writers* and *Honoré d'Urfé*. She recently contributed the article on d'Urfé to *A New History of French Literature*, published by Harvard University Press.

John Dixon Hunt is academic advisor to the Oak Spring Garden Library, Upperville, Virginia. He has taught English literature at universities in the United States, England, and the Netherlands, and from 1988 to 1991 was director of studies in landscape architecture at Dumbarton Oaks, Washington, D.C.

Eleanor Winsor Leach teaches Latin literature and Roman art at Indiana University, Bloomington. In addition to a variety of articles in both fields she has published two books concerned with landscapes in Roman literature and painting: *Vergil's Eclogues: Landscapes of Experience* (1974) and *The Rhetoric of Space: Literary and Artistic Representations of Landscape in Republican and Augustan Rome* (1988). She has held fellowships from the Guggenheim Foundation and the National Endowment for the Humanities, and will spend 1992–1993 with fellowships from ACLS and the National Humanities Center working on a book about Roman painting and Roman society. She has served as resident scholar in classical studies at the American Academy in Rome and as Blegen Distinguished Visiting Professor of Classics at Vassar College.

Leo Marx is William Kenan Professor of American Cultural History (emeritus) at the Massachusetts Institute of Technology. He is the author of *The Machine in the Garden: The Pastoral Ideal in America* (1964) and the editor (with Susan Danly) of *The Railroad in American Art* (1988) and *The Pilot and the Passenger: Essays on Literature, Technology, and Culture in the United States* (1988).

John Pinto teaches in the department of art and archaeology at Princeton University. He studied at Harvard and is a fellow of the American Academy in Rome. His primary field of interest is architecture in Rome between 1500 and 1750. *The Trevi Fountain*, his most recent book, was published by Yale University Press in 1986. Together with William L. MacDonald he has recently finished a book on Hadrian's Villa and its legacy.

W. R. Rearick is professor of Italian Renaissance art history at the University of Maryland. He is the author of numerous books and articles on Venetian painting and drawing, as well as exhibition catalogues devoted to Titian drawings, Paolo Veronese, and Jacopo Bassano. He is presently engaged on a book covering Venetian Renaissance drawings, 1400–1630.

David Rosand, professor of art history at Columbia University, was an advisor to the exhibition *The Pastoral Landscape: The Legacy of Venice and the Modern Vision*, 1988–1989, and a coauthor of the accompanying book, *Places of Delight* (1988). His other publications include *Titian and the Venetian Woodcut*, with Michelangelo Muraro (1976), *Painting in Cinquecento Venice: Titian, Veronese, Tintoretto* (1982), and *The Meaning of the Mark: Leonardo and Titian* (1988).

Jeremy Strick is the associate curator of twentieth-century art at the National Gallery of Art, Washington. He is the author of *Twentieth-Century Painting and Sculpture: Selections for the Tenth Anniversary of the East Building*, as well as articles on nineteenth-century landscape painting and landscape theory. He is preparing an exhibition at the National Gallery of the international school of open-air landscape painting in late eighteenth- and early nineteenth-century Italy.